Old Fremantle

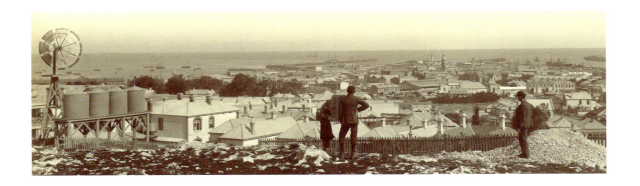

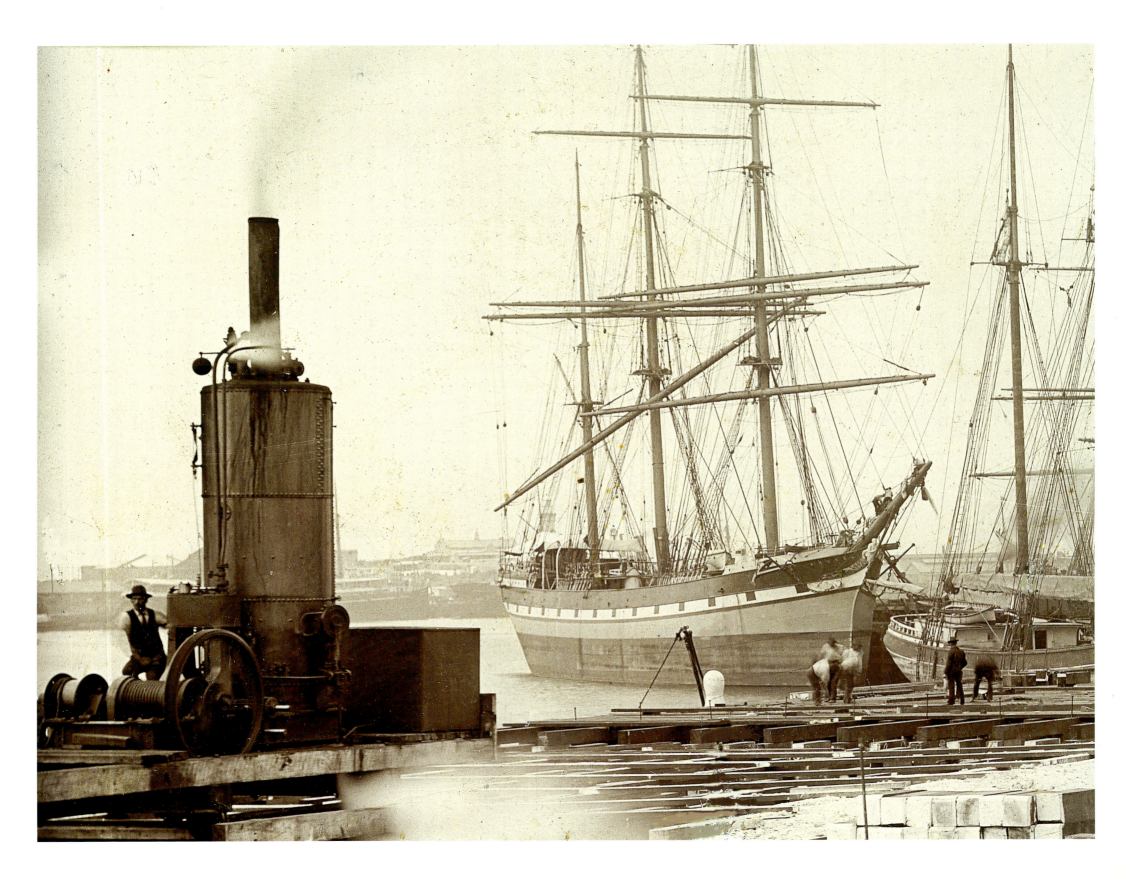

Old Fremantle

Photographs 1850–1950

John Dowson

University of Western Australia Press

First published in 2003 by
University of Western Australia Press
Crawley, Western Australia 6009
www.uwapress.uwa.edu.au

in association with John Dowson

This book is copyright. Apart from any fair dealing for the purpose of private study, research, or review as permitted under the Copyright Act 1968, no part may be reproduced by any process without written permission. Enquiries should be made to the publisher.

Copyright © John Dowson 2003
Revised and expanded edition 2004

National Library of Australia
Cataloguing-in-Publication entry:

Old Fremantle photographs 1850–1950.

Bibliography.
Includes index.
ISBN 1 920694 12 9.
ISBN 1 920694 13 7 (limited edition – 350).
ISBN 1 920694 26 9 (revised and expanded edition).

1. Fremantle (W.A.) – Pictorial works. 2. Fremantle (W.A.) – History. I. Dowson, John, 1947– .

994.11

Photographic editor: Pat Baker
Designed by John Dowson
Edited by Allan Watson
Prepress by Haymarket
Printed by Tien Wah Press, Singapore

Opposite: East Street, the boundary between Fremantle and East Fremantle, looking north to the savagely quarried hills at Rocky Bay, North Fremantle, c1900.

Frontispiece: Building North Wharf, c1900 (detail of page 20).

Cover: Fremantle from Monument Hill, c1899.

This book is dedicated to my angelic daughter Alisa, for whom I would do anything.

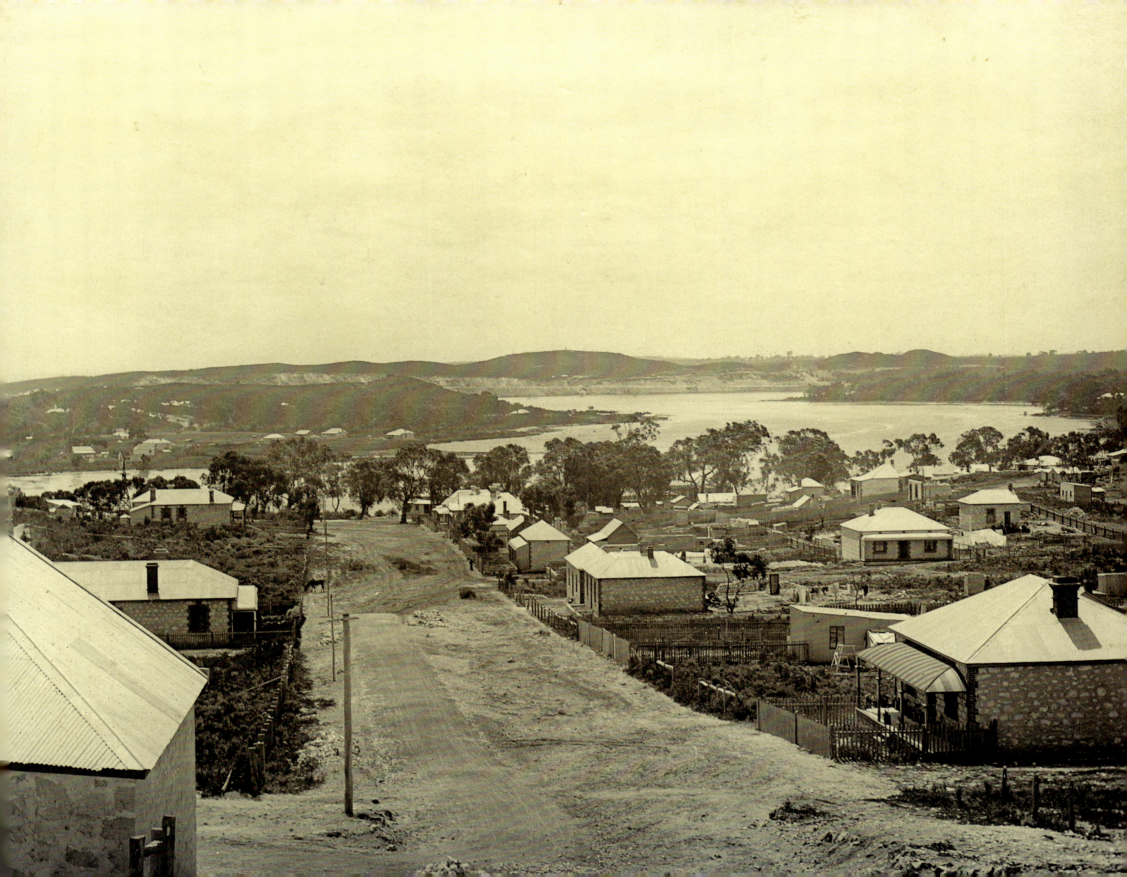

Acknowledgments

The generous support of the following sponsors is gratefully acknowledged:

MAJOR SPONSORS

Fothergills of Fremantle
Fremantle City Council
Fremantle Ports
Town of East Fremantle

SPONSORS

Peter Briggs
Mark Brophy Estate Agent
Carcione Group
Considine & Griffiths Architects
John Dethridge
The Esplanade Hotel
Larry Foley
Fremantle Chamber of Commerce
Fremantle Markets
The Fremantle Society Inc.
Fremantle Whaling Company
Victor Gubgub Pty Ltd
Nicolas Gurr
Janet Holmes à Court
David and Rosemary Johnston
McLeods Solicitors and Barristers
New Edition Bookshop
Victor Paino, Sealanes
Property Gallery
The Railway Hotel
Roma Restaurant
Rottnest Express
South Beach Village
University of Notre Dame Australia
WA Maritime Museum

Thanks are also due to the following:

Pat Baker has painstakingly analysed, checked, repaired, and tenderly cared for hundreds of historic photographs in preparation for publication. As photographic editor he has done a superb job. Editor Allan Watson has meticulously corrected and cajoled the publication into shape. This book relies heavily on the photographic archives of many institutions, in particular the Royal Western Australian Historical Society and the Fremantle Library Local History Collection. Chairman of the Society Lennie McCall has greatly assisted with access to images from an extensive early collection. Fremantle Council library staff, especially City Librarian Betty McGeever and librarians Loretta O'Reilly, Alison Bauer, Alison Gregg, and Larraine Stevens, have gone out of their way to provide images and aid research, and Councillor Helen Hewitt has shown strong support. The keen interest of the Town of East Fremantle is appreciated, especially that of Mayor Jim O'Neill and CEO Stuart Wearne. Professor Reg Appleyard has enthusiastically supported the project and gave detailed expert advice. Professor Bob Reece, whose superbly written *Place of Consequence* in 1983 opened many people's eyes to the past images of Fremantle, has willingly provided material. Staff at the Maritime Museum have shared research and ideas, notably Director Graeme Henderson along with Karen Jackson, Michael Lefroy, Sally May, and of course photographer Pat Baker. Extensive consultation took place with Fremantle Ports, notably with Alan Pearce and Ainslie de Vos. Many individuals freely loaned their precious photographs, particularly the Brown family, Angela Chaney, Bettine Chapman, Graeme Coward, Barbara Dudding, Richard Ferguson, Brian Griffiths, Netta Hedgeland, Renée Hirsch, the Humble family, Walter Murray, Robert Poore, Bruce Rocke, Noel Robinson, Grace Schultz, Veronica Stratton, Mae Wise, and Marie Louise Wordsworth. Thanks also to James Butterfield of the National Archives, East Victoria Park, Anthea Harris of the Perth Mint, Ruth Marchant James, Judy Wheeler, John Moynihan, June Shenton Turner, Patricia Brown, Joanna Sassoon, Sarah Irwin of Life Editions, Barry Green of Lamb Print, Greg Manzie of Glyde Gallery, Robert Grantham of Haymarket, Andrew Watson, Adele Gaskin, and Barbara Hearn. And, the sponsors, along with Phillip Adams and George Seddon, who are both frenetically busy, but who made time to write commentary. Dr Jenny Gregory and staff at University of Western Australia Press have been enthusiastic supporters.

Contents

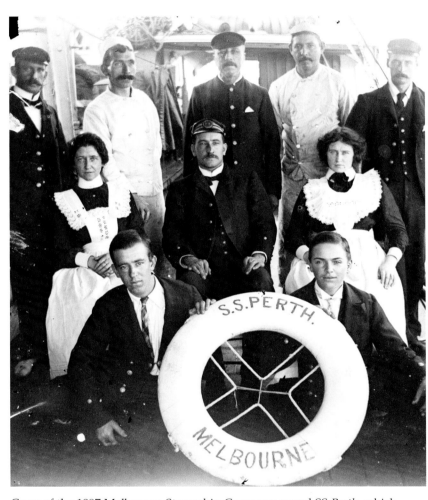

Crew of the 1897 Melbourne Steamship Company vessel SS *Perth*, which made numerous visits to Western Australia. From a glass photographic plate found in the cellar of the Forrester homestead near Geraldton.

Preface	9
The Art of Fixing a Shadow	10
Photographers of Fremantle	12
Phillip Adams *The Lure of Monochrome*	17
George Seddon *Fremantle: A Sense of Place*	18
Port	20
City	78
Home	138
People and Pleasure	152
Trains and Trams	170
Business	182
War	208
The Photographs	226
Select Bibliography	228
Index	229

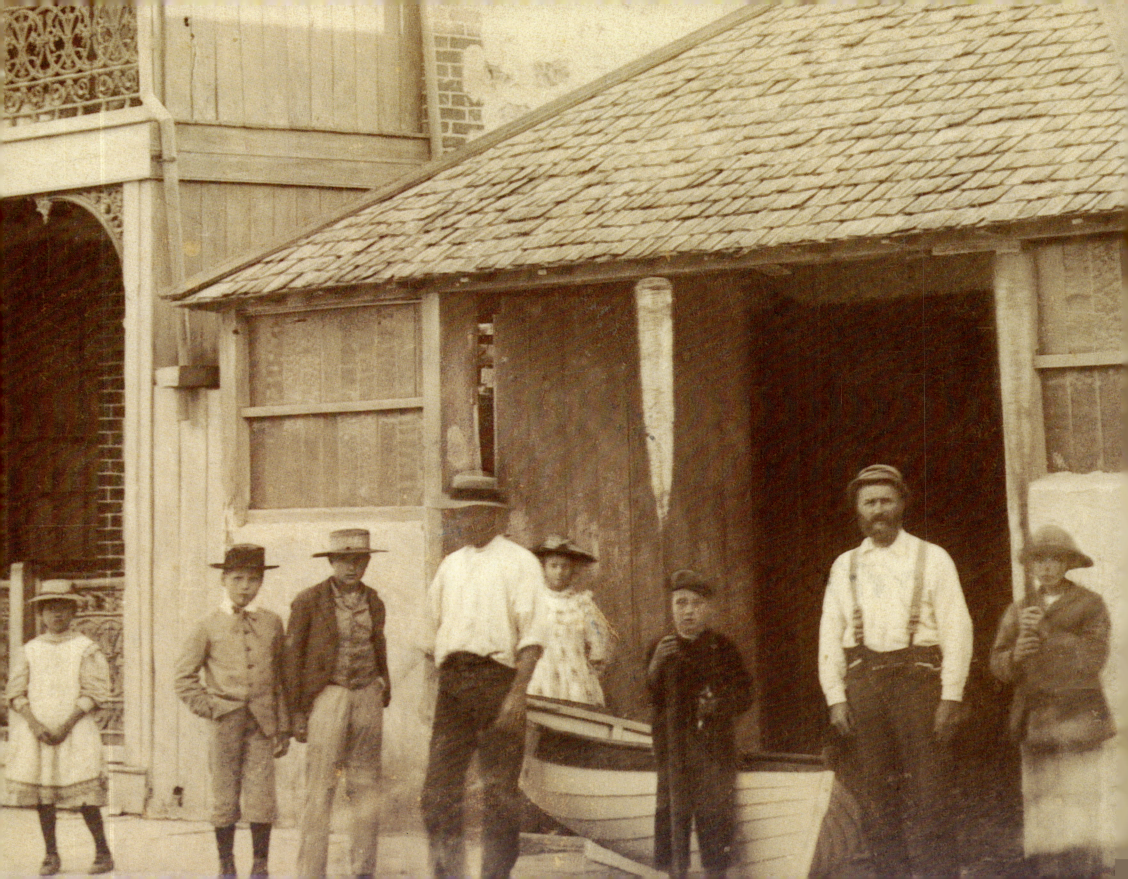

Preface

"And what is the use of a book," thought Alice, "without pictures or conversations?" Alice, being bored with what her sister was reading, followed a rabbit and fell down a hole. "Either the well was very deep, or she fell very slowly, for she had plenty of time as she went down to look about her, and to wonder what was going to happen next."

As I read *Alice in Wonderland* to my daughter Alisa I felt for Alice as, like her, I have tired of books, especially local histories, that forget to show the life of people through interesting pictures and real-life quotes. In doing this book I, like Alice, fell down a large hole. While Alice was not sure if she had landed in Australia or New Zealand, I certainly knew I had landed in Fremantle, but the search for and research about interesting images was exhausting as so little work has been done on our pioneer photographers and their work. Western Australia is poorly represented in the major histories of Australian photography, and this book has tried to address that issue, as far as Fremantle is concerned, by giving credit where possible to those behind the cameras. Importantly, an understanding of the photographer may help an appreciation of the pictures, untethered as they are from their original contexts.

At the time Lewis Carroll (the Revd Charles Dodgson), himself a famous photographer, had *Alice in Wonderland* published in London – in 1865 – Fremantle's most famous pioneer photographer, Stephen Montague Stout, was capturing the town for the first time with his camera.

This book is not a comprehensive history of Fremantle, though the city certainly needs one. It is a long time since the City of Fremantle commissioned J.K. Ewers to write his 1948 *The Western Gateway* (revised 1971), which focused rather tediously on tributes to the work of mayors and councillors. Here, with more than 240 photographs and just a few words (25,000), even the most jaded latte sipper or disengaged youth should find something arresting.

The selection of photographs for this book has been fairly subjective. The test for each one is that good images succeed at the general as well as at the specific level and the really good ones show inner significance through their outer form. And, my reader, I am sure Dodgson would agree that a photograph is really as much a looking glass as it is a window.

John Dowson

Opposite: Mews boat-builders in Henry Street (lot 59), c1885, at that time only metres from the river.

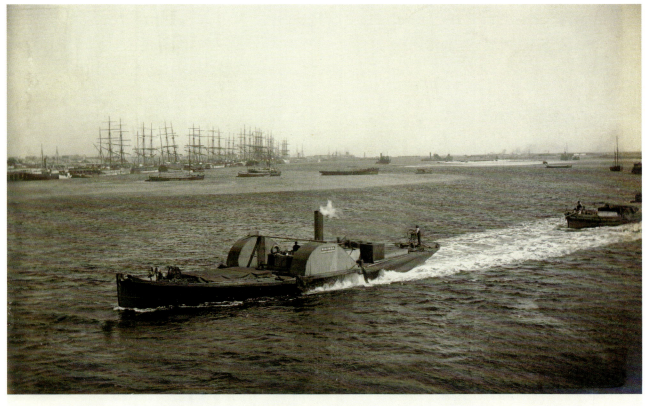

Left: Licensed Lighter No. 18, *Nirimba*, 1899.

The Art of Fixing a Shadow

William Henry Fox Talbot and Louis Jacques Mandé Daguerre independently announced their invention of photography in 1839. Talbot described his invention as "the art of fixing a shadow." Within two years the first photograph had been taken in Australia – in Sydney on 15 May 1841. During the 1840s seventeen photographers operated in the country, but none was based in Western Australia. Of the two hundred new practices that opened in the following decade only one was in this state – Samuel Scriven Evans ran a business from the Castle Hotel in Henry Street, Fremantle, for just a few weeks. The first recorded photograph taken in Western Australia is an 1853 image of Captain and Mrs John Septimus Roe and their family.

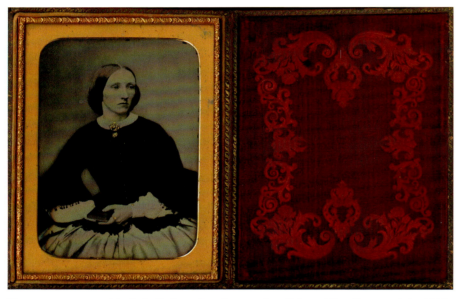

Daguerreotypes, with their "miraculous beauty," as Edgar Allan Poe put it in 1840, disappeared from use in Australia in 1860. Daguerre's 1838 prediction for the use of his own invention – "The leisured class will find it a most attractive occupation … the little work it entails will greatly please ladies" – did not eventuate. The Samson Collection includes this c1855 image of Mrs Ellen Brown.

The 1855 Paris Exhibition included photographs of Australian rocks. The earliest Australian panorama was taken in Hobart in 1856 and the first album of photographic views was published in 1858.

The bright clean air of Western Australia was ideal for photography, but the remoteness of the colony and the small population did not encourage professional photographers to establish studios or to remain here. Many of the early photos were portraits taken to be sent to relatives in Britain. Of the 130 Australian books containing original photographs that are known to have been published before 1900 only three were from Western Australia.

The mass market for photography was created by Kodak's release of the first roll film in 1888. When the Kodak pocket camera went on sale in Australia in 1895 for one guinea, three thousand sold within two months, a figure equalling the total number of photographers who had practised in Australia during the previous fifty years. Meanwhile, the popular press began publishing photographs in 1888 (*Sydney Mail*, 15 September). The first Australian colour prints appeared in 1905, though very few survive, and the only full-colour images in this book are a hand-coloured opalotype photograph on glass of bandmaster Patrick Fay from around 1896 and the studio portrait opposite.

The images in this book came from many sources, they cover a hundred years, and they represent the work of dozens of different photographers, many of whom cannot be identified. Most are not well known or their work instantly recognizable like a Max Dupain or a Frank Hurley might be. To appreciate the images in this book, it may be rewarding to ask the following question for each: "What was the function of this image in its own time?" Some historical notes are provided to help frame that response. The meanings of these images may be at one level self-evident, but the meaning may be affected, for example, by the fact that every image in this book, excepting Edna Jenkins's on the next page, was probably taken by a man.

Most of us today experience a diet of frenetic coloured images. How then do we respond to the frozen, monochrome moments of earlier days? Very early photographs required long exposure time, leading some modern-day viewers to mistakenly conclude that people then used to be humourless or pleasureless. In fact, the group photographs of a hundred years ago are often more human and stylish than the dreary and regimented school, sports, and business ones often taken today.

Relevant to the viewing response is the fact that some of the images in this book have been repaired before publication, having suffered deterioration or damage over the years. However, every effort has been made to reproduce what the photographer would have intended.

As we struggle today to create new and interesting photographs with the latest digital cameras, we can admire the skill of our pioneer photographers and the amazing results they achieved. We enjoy the window into another time. William Talbot wrote: "In examining photographic pictures of a certain degree of perfection, the use of a large lens is recommended, such as elderly persons frequently employ in reading. This magnifies the objects two or three times, and often discloses a multitude of minute details, which were previously unobserved and unsuspected. It frequently happens, moreover – and this is one of the charms of photography – that the operator himself discovers on examination, perhaps long afterwards, that he has depicted many things he had no notion of at the time…" Those words are still relevant: most of the images in this book show a high level of detail in their depiction of different times long gone, and most of us are curious.

Photography is also an art, and that was recognized at the Great Exhibition in London of 1851 when an international jury declared photography to be "the most remarkable discovery of modern times … It is likely that time will show that this beautiful compound of art and science will essentially cast its weight into the balance of art." (*Report by the Juries*, vol II, *Exhibition of the Works of Industry of All Nations*, London 1852)

Studio Portraits

Early photographs required long exposure time, and one Fremantle studio instructed its subjects thus: "The head-rest must be used, not to give the position but that you may keep it. The natural pulsations of the body cause it to move (in spite of the strongest will) sufficient to make your negative useless." In 1871 Edward Wilson, secretary of the National Photographic Association of the USA, explored this theme at greater length, publishing a wildly successful eight-page pamphlet for patrons of his studio so that they were well prepared for the photographic process of the time. Some extracts:

The day when a daub of black and a patch of white pass for a photograph, you are well aware has ended; for you will not receive such abominations yourself as likenesses of those near and dear to you …

To produce pictures different from these requires skill, good taste, culture, much study and practice, to say nothing of an expensive outfit and a properly arranged studio. With all these the photographer must know how to manage a most obstreperous class of chemicals, fickle as the wind, and, therefore, he needs all the assistance *from you* that you are able to give him in the sundry ways explained further on …

How to Come

Never come in a hurry or a flurry. *Red* takes *black*, and red faces make black. Moreover, if you are pushed for time, your pictures will present a worn and wearied expression, which you will not like, and which will *compel* you to take the time for another sitting. Ladies who have shopping and an engagement with the photographer on the same day, will please be careful to attend to the latter first.

How to Dress

Dress is a matter which should have your careful attention. The photographer is very much tried by his patrons sometimes, who place upon their persons, when about to sit for a picture, all sorts of gee-gaws and haberdasheries … Dress naturally, and *think* a little while you are about it.

The Children

We are always glad to take a reasonable amount of pains with children. They are subjects that make lovely pictures, but they are often difficult to secure … Never *threaten* a child if it won't sit, and never coax it with sweet-meats. Dress the little ones with care and good taste. Avoid startling plaids, and gaudy colors. Dark dresses should not be put on them. Let the photographer choose the position.

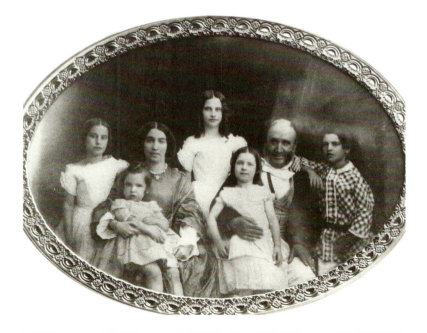

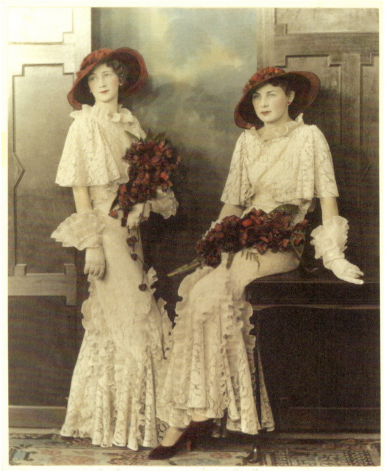

Above right: The oldest known Fremantle photograph – Lionel Samson's family in 1856.

Right: The only photograph in this book known to have been taken by a woman. Edna Jenkins, who ran a studio in Cantonment Street between 1930 and 1940 took this portrait of Jean Brown, on the left, and Marjorie Thornett, in 1933.

Photographers of Fremantle

Professional pioneers: The first "daguerreotype artist" to visit Western Australia was Robert Hall, in 1846. Photographers from Adelaide visited occasionally, and a New Yorker, Sanford Duryea of the Duryea Brothers, Adelaide, was in Perth between 1857 and 1859. But it was another New Yorker, Samuel Scriven Evans, who was the first to work in Fremantle. Though he arrived about ten years later, the name of Stephen Montague Stout is the best known among the pioneers. James Manning Jnr worked in Fremantle before opening a studio in Perth in 1868, the same year his sister established the Yeldham Photographic Gallery in her father's home in Cantonment Road, becoming Fremantle's first female photographer. Photographic materials were available in the town at D.K. Congdon's Medical Dispensary and Photographic Warehouse in 1866.

Early amateurs: As a gentleman amateur with good equipment, Alfred Hawes Stone (1801–1873) of Perth took superb photographs in the 1860s but few of Fremantle. He was not a blow-in from overseas but a long-term resident, having arrived within months of the settlement of the colony in 1829. Living in St Georges Terrace, Perth, and working as Master of the Supreme Court, he produced the best early photographic record of Perth and its surrounds. He is represented in this book by two of his Fremantle photographs. While he was at one time chief of police for the whole state, in contrast the other famous pioneering photographer, Stout, was an ex-convict. Later, John Coulsen Pearson (1866–1934) arrived in Australia from England and worked in the Fremantle railway workshops, which he photographed. His best work was done at Cottesloe Beach.

Samuel Scriven Evans

Evans arrived on 15 January 1853 aboard the *Abigail* from New Bedford, Massachusetts, USA. He opened the Daguerrian Gallery in March 1853 in the Castle Hotel, Henry Street, before moving to Perth in May. He advertised in *The Enquirer* that "likenesses can be taken with more perfection in the early part of the day, say, from 10 to 1." By 1855 he was working as a clerk in the Perth post office before becoming chief clerk to the WA Bank in 1862. He left for London on the *Bridgetown* on 11 January 1872. No examples of his photographic work have been found.

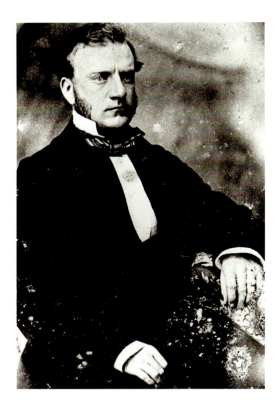

Stephen Montague Stout

Of fundamental importance to the story of photography in Fremantle is ex-convict Stephen Montague Stout (1831–1886). Having operated a boarding school for boys in the town, an enterprise for which he was commended by local identities Samson and Bateman, in 1864 he opened a photographic studio in Henry Street, later moving to High Street. He charged 7/6d for three *carte-de-visite* portraits and also sold "coloured photographs on glass by the new process, warranted not to fade." From Fremantle he would visit places such as Bunbury and Guildford for a week or so to fulfil commissions. He produced what are believed to be the earliest outdoor photographs of Fremantle.

One of only two people listed in the *Western Australian Almanack* for 1870 as a photographer, but noted as being at Bunbury and Australind, by the end of that year he had moved to Perth, where he continued both his photographic and his educational pursuits, establishing a Perth Academy in St Georges Terrace. He was for a short time also owner of the *Express* newspaper, printed in Perth in 1872. By 1880 he was embroiled in an embezzlement scandal in Geraldton, the same problem that had seen him transported from England. More information about Stout will be found on page 84.

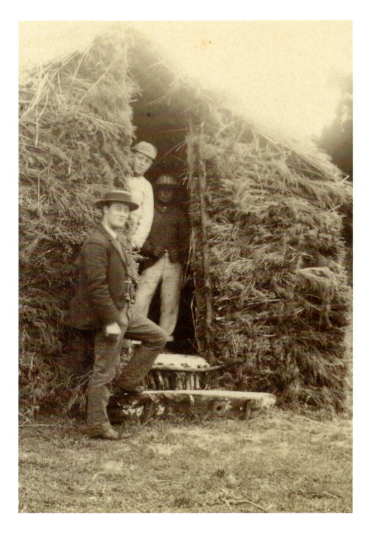

Charles Millington Nixon

Charles Nixon (born 1870) arrived in Western Australia in 1892. He was a prolific and influential photographer for many years, running his business from 7 William Street between 1893 and 1934. He was commissioned by the City of Fremantle in 1929 to provide the photographs for J.K. Hitchcock's *The History of Fremantle*, 1929.

Above left: S.M. Stout's wedding portrait, 1868.

Above: In this rare and interesting view (cropped) of a straw smallpox hut on Rottnest Island, a young and presumably fearless Charles Nixon is seen with reformatory inmates, c1895. Boys were sent to the island for various offences between 1881 and 1901.

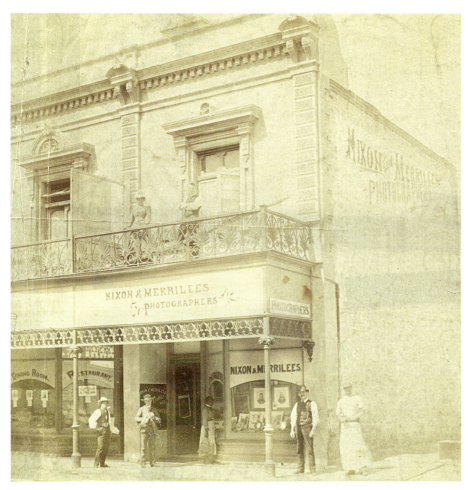

Nixon & Merrilees in William Street, c1898.

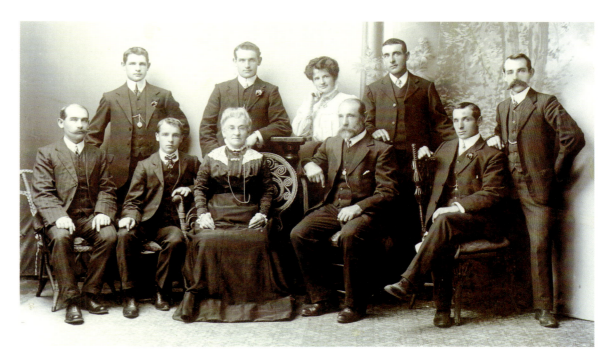

Alfred Osborne Charlton

A prominent portrait photographer, Charlton was cut down by the influenza epidemic of 1919 and died at the age of thirty-seven. He took the above photograph of his family in about 1907. With his parents, front centre, are (left to right) Walter, George, Ernest, Richard, Rosetta, Jack, Percy, and Alfred himself.

Stuart Gore

Having emigrated from England in 1913, Gore often worked as a freelance, in particular providing regular sports photographs to the *Western Mail*. He pioneered 16-mm movies and also helped develop aerial photography in Western Australia. He sold his first press photo to the *Sunday Times* in 1923 for five shillings. It featured a collision between a model T Ford and a truck in Fremantle, an event that was front-page news at the time.

Frank Peterson

Peterson began working with Arthur Fielding before entering into a partnership with Reg Harrison. Often broke, Harrison would insist on a deposit before shooting, and then scramble down to the pawnshop under the studio to get his lenses out of hock. Later they would go back. Peterson bought Harrison out and went on to be Fremantle's largest commercial photographer.

Fred Flood

Born in London in 1881, Flood migrated to Australia in 1912 with his wife and three children. He was employed by West Australian Newspapers in 1919, becoming the company's second full-time photographer. Until his retirement more than thirty years later he took thousands of photographs around the state, his work for the Christmas issues of the *Western Mail* being particularly notable.

Training in meticulous arts like calligraphy and watercolour painting helped Flood as a pictorialist, but as a news photographer he also had to work quickly – especially when covering sport, which he was involved in extensively. He is best known for his idyllic country scenes, but as a migrant himself he was a regular photographer of migrants and ocean liners at Fremantle harbour.

Izzy Orloff

Having arrived in Western Australia in 1910, Abraham ("Izzy") Orloff (1891–1983), a Russian Jew, returned to Europe some years later to study photography in Paris. By 1923 he had established a studio, La Tosca, in North Fremantle, which he moved a few years later to High Street, where he became pre-eminent in his profession.

He was a prolific recorder of people and events, but most of his later work has disappeared. The remaining collection, of around a thousand images, is held at the Battye Library and was the foundation for a 1989 book, *Izzy Orloff, Photographer: Images 1917–1935*, by Louise Hoffman and Chris Jeffery.

Above: Izzy Orloff stands in the centre of this study by Saxon Fogarty of passengers on a ship leaving Fremantle.

Saxon Fogarty

Born in Perth in 1908, Fogarty joined the Royal Australian Navy in 1926 and during World War II flew in unarmed reconnaissance Blenheims over Europe and, later, Walrus amphibians from battleships for the navy. After the war he ran a photographic service in Fremantle. Largely unheralded for his prolific photography, practised in and out of military service, Fogarty deserves far greater recognition. Much of his work is dramatic, evocative, and highly effective. For consistency and design quality his images are better than those of his well-known contemporaries Orloff and Gore.

Frank Hurley

Frank Hurley (1885–1962) is possibly the most famous photographer to have worked in Fremantle during the period covered by this book.

A prodigious output over fifty years included twenty books and work on more than sixty films. Traditional in views and values, he often liked to alter his images, especially the skies, and this brought him into conflict with people like Charles Bean, official historian during World War I, when Hurley was appointed official war photographer. At the end of his long career, which had included six trips to the Antarctic, he photographed Fremantle on the ground and from the air as part of a 400,000-kilometre photographic odyssey between 1946 and 1956. But by this late stage of his career his images were quite predictable and prosaic. For this reason he is represented by only one image.

Photographers of Fremantle

Alphabetical list, 1850–1950. Many Perth photographers also operated in Fremantle.

Adelphi Studio
 High Street, c1895
Bailey & Cameron
 101 High Street, 1902
Bell, A.
 94 High Street, 1905
Benson, A.E.
 97 High Street, 1916
Bertel & Williams
 High Street, 1897
Beste, Arnold T. (Beste & Jaggs)
 121 High Street, 1910
 97 High Street, 1913–1914
Cambie, Edward
 101 High Street, 1904–1906
 47 High Street, 1907
Cameron
 See Bailey & Cameron
Centenary Art Studio
 Attwell Arcade, 1931–1934
 6 Stirling Highway, North Fremantle, 1947–1949
Charlton, Alfred O. (Crown Studio)
 Victoria Avenue, North Fremantle, 1903–1919
Chopin & Gill
 c1870
Clarke, Charles L.
 Victoria Avenue, North Fremantle, 1921–1922
Clayfield, William
 121 High Street, 1907
Craig & Solin
 Fremantle and Kalgoorlie, 1898
Crown Studio
 See Charlton, Alfred O.
D'Alba, Lydia Burch
 1892
Donovan, William
 4 Market Street, 1933
Electra Portrait Parlours
 Imperial Chambers, Market Street, 1929
Elect Studio
 Market Street, 1925–1927
Evans, Samuel Scriven
 Castle Hotel, Henry Street, 1853 (6 weeks)
Felton, Grimwade & Brickford Ltd
 Fremantle and Perth
Fielding, Arthur M.
 1918–1922, partnership with Frank Peterson
 3 Dorothy Street, 1926–1928
 Market Street, 1933
Fielding Studio
 90 High Street, 1923–1930
 13 Adelaide Street, 1931–1932
 94 High Street, c1930s
Fogarty, Saxon
 Travelled extensively, opened photo service in Fremantle after World War II.
Fripp, Harvey E.
 Market Street, 1912
George, Bertram
 48 High Street, 1923
Gore, L.J.
 10 Market Street, 1929–1932
Greenfeld
 Wednesdays and Thursdays 1882–
Harrison, Reginald
 1922–c1923, partnership with Frank Peterson
 116 High Street, 1918
 Market Street, 1919–1921
 27 Market Street, 1941
Hatch, Arthur
 97 High Street, 1906–1912
Hitch, William F.
 97 High Street, 1915
Jackson, Arthur H.
 Henry Street, 1897
 7 William Street, 1935–1940
Jaggs
 See Beste & Jaggs
Jenkins, Miss E.
 Cantonment Street, 1930–1940
Lang, George H.
 35 Market Street, 1918–1922
 Melba Studio, 97 High Street, 1918–1932
La Tosca
 See Orloff, Izzy
Manning, Miss J. (Yeldham Photo Gallery)
 Cantonment Road, 1868–1869
Melba Studio
 See Lang, George H.
Merrilees, Henry (Nixon & Merrilees)
 See Nixon, Charles M.
Millington, W.G.
 121 High Street, 1902–1906
Modern Studio
 See Peterson, Frank
Morris, David L.
 47 High Street, 1910
 Market Street, 1913–1917
 97 High Street, 1917
Mott, Eric
 4 Market Street, 1936–1937
 6 Market Street, 1938–1949
Nield, James
 62a High Street, 1920
Nixon, Charles M.
 1893–1900, partnership with Henry Merrilees
 7 William Street, 1893–1900
 121 High Street, 1901
 7 William Street, 1902–1934
Orloff, Izzy (La Tosca)
 Victoria Avenue, North Fremantle, 1922–c1925
 133 High Street, c1925–c1970
Pearson, John Coulsen
 Amateur working-class enthusiast, 1890s
Peterson, Frank
 1918–1922, partnership with Arthur Fielding
 1922–c1923, partnership with Reginald Harrison
 Market Street, 1922–1936
 The Modern Studio, 10 Adelaide Street, 1937–1951
Royal Art Studio
 See Searle, Edward William
Searle, Edward William
 Royal Art Studio
Solin, P.O.
 See Craig & Solin
Stout, Stephen Montague
 Henry Street, then High Street 1864–c1869
Walker, Charles
 1920s
Webb & Webb
 101 High Street, 1899–1900
Williams, L. Gray & Co.
 121 High Street, 1899
Williams & Jackson
 Swan Chambers, Henry Street, 1898
Yeldham Photo Gallery
 See Manning, Miss J.

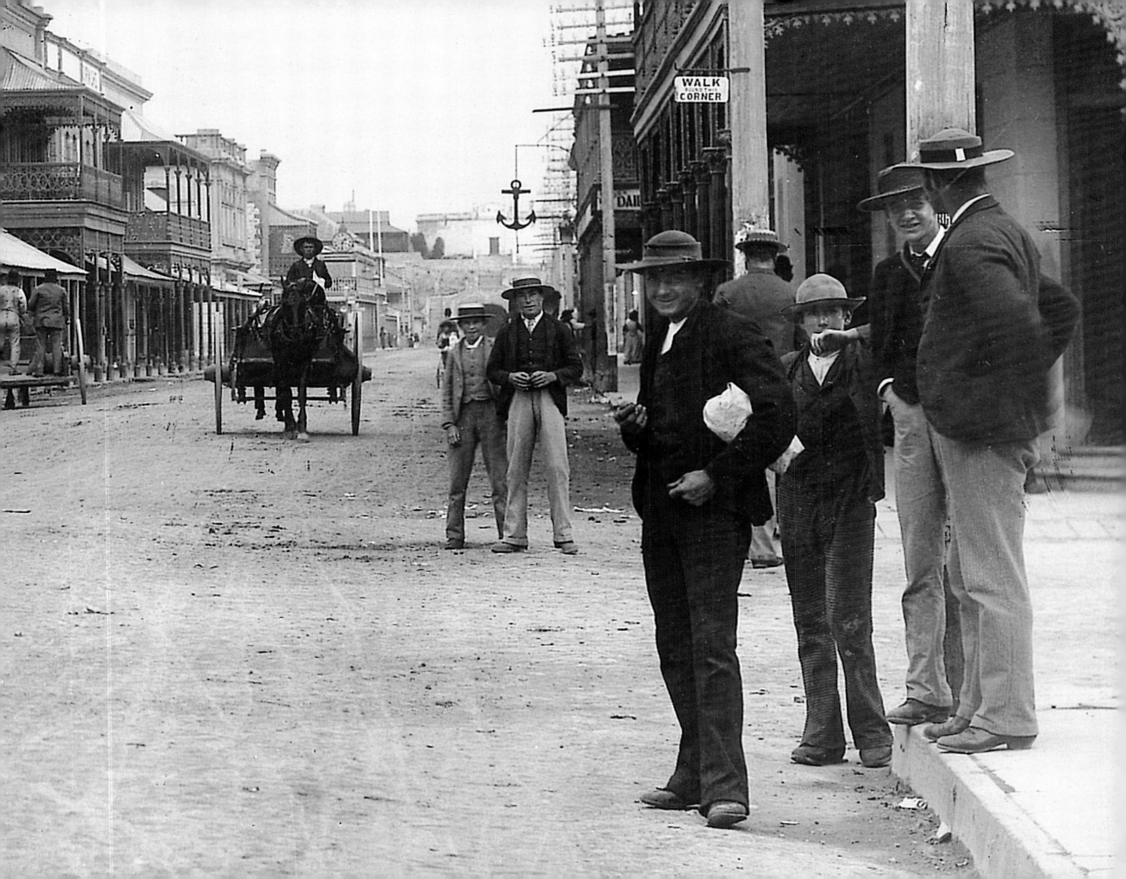

Phillip Adams
The Lure of Monochrome

In what is believed to be the first true photograph ever taken, the camera looks down on a Paris street. During the long exposure someone wandered into frame and out of it, leaving a ghostly trail on the emulsion. Thus the first human being to be immortalized in a photographic image is, at the same time, entirely anonymous.

The people and places we remember from a past coinciding with the beginnings of photography are contrastingly static. Not simply frozen: time is rendered as solid and substantial as sculpture. People pose, ramrod stiff, while the world around them gives an illusion not merely of permanency but of the eternal. Odd when precious little of that "built landscape" survives.

This in contrast to image-making in the twenty-first century, where it's a pictorial whirl, a kaleidoscope of trucking shots, tracking shots, and the misnamed steady-cam, further jiggled and juggled by tricks of optical printing and the computer. These days we like our images agitated and, in the best post-modern tradition, fractured.

Which brings us to John Dowson's book of old Fremantle, wherein all is certainty, a world peopled by rock-solid ghosts and the streetscapes they populated. In most collections of old photographs the buildings have long since fallen victim to the wreckers; but, Fremantle being Fremantle, much survives. So we can stand where the ghosts stood and see what the ghost had seen.

The absence of colour is, like the absence of movement, a blessing. I've always thought that the past should be in black and white to distinguish it from the polychromatic present. Attempts to "colourize" old black-and-white movies have turned *Casablanca* and *The Maltese Falcon* into insipid, pastel travesties – while authentic colour footage of World War II is thoroughly alarming. It makes it now instead of then.

That's another blessing of John Dowson's collection – the lustrous monochrome, often in the same shades of grey as a good headstone in an abandoned cemetery, is profoundly evocative. There's a line of demarcation between past and present that black-and-white photography marks – particularly in a world where we're bombarded with colours of excessive intensity and vulgarity.

In modern photography the so-called "stills" evoke the era of flash and motordrive, of 1000-second exposures at F16. And the over-energetic, almost cinematic use of photography is emphasized by the layouts of modern newspapers and magazines where, all too often, there's an effort to echo the sense of motion, of sequence, you get on the screen. Whereas the older photograph seems calmer, more contemplative, a meditation on the subject rather than something glimpsed from the corner from a cameraman's eye.

The past is, truly, another country. Whilst it's true that vividly coloured oils, frescoes and murals cross that boundary, it's better that photography does not. Along with the stillness of the image that forces and focuses concentration, monochrome separates history from here-and-now as sharply as night and day.

Dowson deserves our thanks as well as our congratulations. He casts a wide net, from the middle of one century to the middle of another, from a forgotten past to a past that many of us are old enough to remember. It is profoundly evocative. Past times live, breathe and touch the heart. To turn the pages of this splendid book is to grieve for what has been lost whilst marvelling at what has survived – in one of the most important places in the time and space of our nation.

Phillip Adams, a columnist for The Australian *newspaper since the 1960s, has written twenty books and made five films. Twice awarded the Order of Australia, he was named by the National Trust in 1998 as one of Australia's one hundred Living National Treasures.*

George Seddon
Fremantle: A Sense of Place

The choice of Perth as the capital of what was to be the Swan River Colony was a matter of chance, the outcome of limited knowledge and dubious assumptions: Albany and Bunbury had some significant advantages. Once the choice was made, however, it followed almost inevitably that Fremantle would be the port, despite its limitations of land and shelter, narrow peninsula and open roadstead. First the Short and then the Long Jetty were used to offload passengers and goods, the latter remaining in service until the Inner Harbour was constructed in 1897.

This album of superbly reproduced images rightly begins with the port activities, which dominated the life of Fremantle until the 1950s. The city now has a population of 24,173 in an area of 19 square kilometres extending well beyond the early boundaries of sea, river, and East and South Streets – the Fremantle of this book. It has multiple centres and is essentially a dormitory suburb, as are its neighbours. The port still dominates, but in a very different way, so the choice of 1950 as the terminus of this book is a wise one. It is a valuable record of a Fremantle that is no more but has left traces of its buildings and history, so well recorded here. Albany was a significant port of call until the Inner Harbour was built, but from the earliest years most goods and almost all immigrants arrived at Fremantle, and most exports left from it. It was the point of entry to the colony, and the shipping lists, where available, are an invaluable source of information to the local historian.

The images in this collection give a vivid impression of the life of the port, and they are full of people and activity. Sailors and wharfies ("lumpers"), both now gone, filled the pubs that once dominated the West End of town. An image like the unloading of a cargo of superphosphate from the *Blithewood* in 1909 (page 52) is powerful both because it shows the appalling working conditions within the hold, and because of the reminder that the agricultural economy was dependent on this essential supply for the state's indifferent soils.

There are images of wool exporting (page 206) and gold smelting (page 186); in a later section we see a haunting view of the Immigrants' Hostel, a bleak dormitory with

Looking east up High Street, c1912. The house "Lenaville" at 186 High Street has been restored twice, most recently by Professor and Mrs Seddon in 1990, and it has become their residence. The building beyond the house is known to many as Girton College, but it began in 1886 as Fremantle Grammar School.

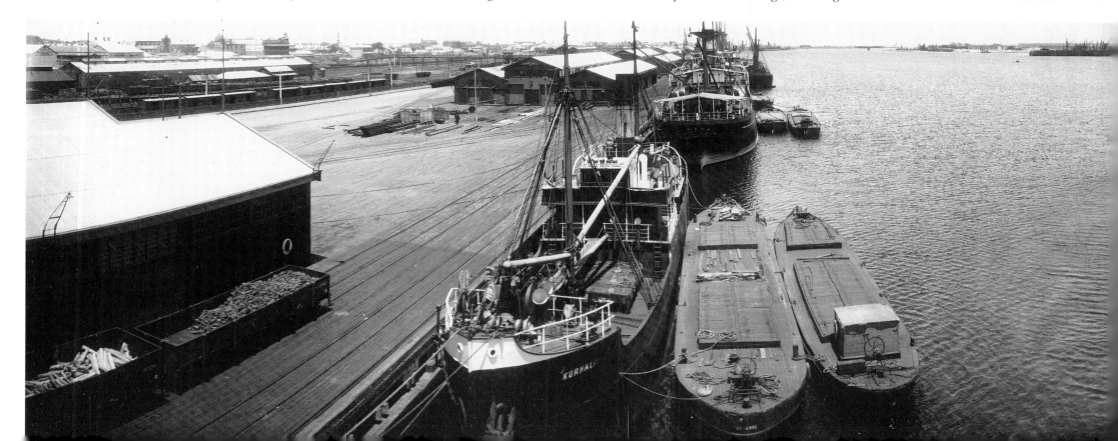

no privacy in what is essentially a shed (page 151). The last of the port-related images, although not in the Port section, is that of child migrants in 1947, just after the end of World War II (page 225).

Fremantle is no longer a significant entry point for people: road, rail and air have displaced this function. Road and rail from the eastern states have also taken over a fair share of the transport of goods. Fremantle Ports, to use the new name, still plays a key role in the state's economy, but with a dramatically reduced demand for labour. Container transport, highly mechanized handling systems and the growth of the North Wharf facilities have completely changed the impact of port on city: very few manual labourers are involved, and a continuing stream of heavy transport moves through old streets not designed for it. These photographs are a fine record of a vanished world.

The images in the sections *City* and *Home* are more familiar. The urban scenes of the first fifty years are very seductive, partly because they photograph so well, and partly because they show a Georgian or Regency restraint, proportion, feeling for scale, and harmony in the relations of individual buildings to their neighbours, thus creating streetscapes rather than the ostentation and individualism that has become the Australian norm. The uniformity of building materials is doubtless because there was little choice, but the effect is nevertheless one of harmony.

The buildings are undistinguished individually, and the criticism offered as "An Outsider's View" (page 81) that the Round House resembles "a stone gasometer" is not unreasonable, but it is this lack of striving for effect that makes the images so attractive. The reality was probably much less appealing, and the comment that the waste ground is "covered with stones, broken bottles, empty jam pots, old rags and a good quantity of bones" (page 82) sounds convincing – it would apply equally to Fremantle Park and the grounds of John Curtin High School today, if you added a generous supplement of paper and plastic in various guises.

There are, however, some fine images in this section, including an outstanding photograph of the Lunatic Asylum c1865 (page 85) showing the extensive forecourt that gave the building its proper setting. This was brutally truncated one hundred years later, when Ord Street was cut through to link with Hampton Road to create what has become since a major heavy transport route – a de facto Fremantle bypass.

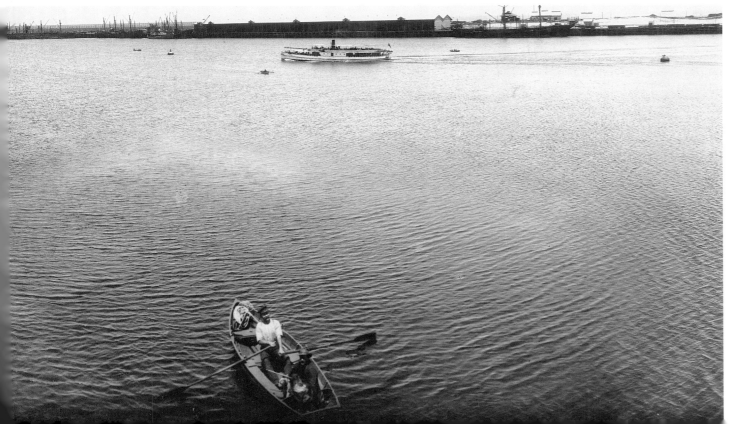

Another disfigurement of the structure of inner Fremantle, in what became a decade in which the city tried hard to destroy its best assets, is shown in the image of Kings Square in 1945 (page 137). The image shows the facades of Newman Street, which are in scale with the continuous two-storey profiles of High and Queen Adelaide Streets. These buildings were then demolished to eliminate the south side of the square and to make way for the unlovely bulk of the Myers and Queensgate buildings, the latter the obverse of a gate to anywhere at all. These structures are grossly incompatible with the scale of Fremantle, as are several blocks of flats of the same period. Fremantle will not make such mistakes again, but they are easier to make than to remedy.

A dramatic earlier change to the visual quality of Fremantle, but in this case one that is happily reversible, is the sudden disfigurement by overhead powerlines. They appear first in this book in the photograph of Wesley Church c1900, and then appear in most of the subsequent images of the built environment. These help to cast a retrospective glow over the early pictures, which are not so disfigured. The powerlines at last went underground in the West End, and the whole of Fremantle is to follow suit in the near future, which will do much for its physical appearance.

Two of the later sections of this splendid album are called *People and Pleasure* and *Business*. They are especially welcome in that the urban images are often unpeopled, a photographic convention of the day. One of the more poignant images is of the Italian fishing fleet in 1910. The caption tells us that in 1906 there were 246 licensed fishermen in Fremantle. Many of them were Italian and Portuguese, a reminder that the cosmopolitan flavour of the place owes so much to its migrants, and especially to the Italians, who began their migration one hundred years ago. Perhaps that is good note on which to end in these years of growing xenophobia.

George Seddon is internationally celebrated as a writer on planning and the environment. Author of many books, his contributions to an understanding of Western Australia include Swan River Landscapes *in 1970,* Sense of Place *1972,* A City and Its Setting *1987, and* Swan Song *1995.*

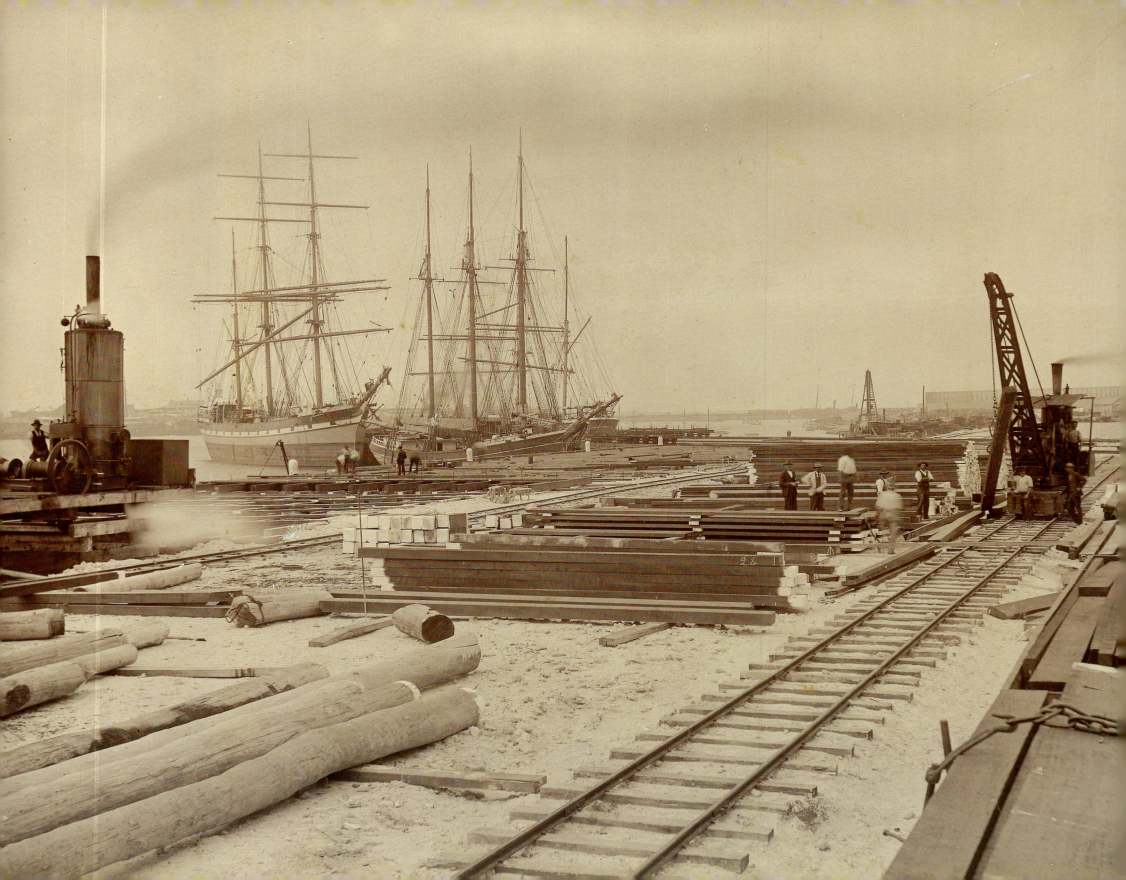

Port

The Port of Fremantle is not just a place where sea and land transport are joined like a knot. It is a centre with a passionate population engaged in political, economic, and social activity.

Engineer C.Y. O'Connor removed the limestone bar across the river and built a harbour that still works well a hundred years later. The port could well have been built elsewhere, and even after its completion there were repeated attempts to shift the harbour upriver, and so closer to Perth. Governor Stirling's choice of a site for Perth on the north bank of the river instead of the expected Heathcote location on the south meant that a river crossing was essential, and, once bridges had been built for road and rail, the expense of removing or replacing them kept the port from moving towards Perth and destroying the beautiful river in the process.

Fremantle Harbour opened in 1897 and the important mail boats abandoned Albany for Fremantle. At this time the only way to enter or leave Western Australia was through a seaport. There were no trains, planes, or automobiles to get anyone in or out of the state.

The Fremantle Harbour Trust was established in 1903 and, despite teething problems and accidents like the troopship SS *Ulysses* running aground near the entrance channel in 1916, and the SS *Polgowan*, full of TNT, catching fire at North Quay in 1918, by 1924 the 45,000-ton HMS *Hood* was able to swing safely around inside the harbour.

Cargo was king, and the passengers were treated like cargo. No passenger terminal was built until 1960, when the battle for human freight was already lost.

Opposite: Building North Wharf c1900.

Above left: Invitations to the commencement of the harbour works, on 7 November 1892, and to the official opening of the new port in 1897. The Highams were prominent storekeepers. Charlotte Shenton recalled the first of the events: "My husband and I were invited to be present at the ceremony of seeing the first boulder propelled from a truck by Governor Sir Frederick Broome. The sea was furious at such an invasion and gave some of the onlookers more than a sprinkle, the Governor among the number." (*West Australian*, 21 December 1935)

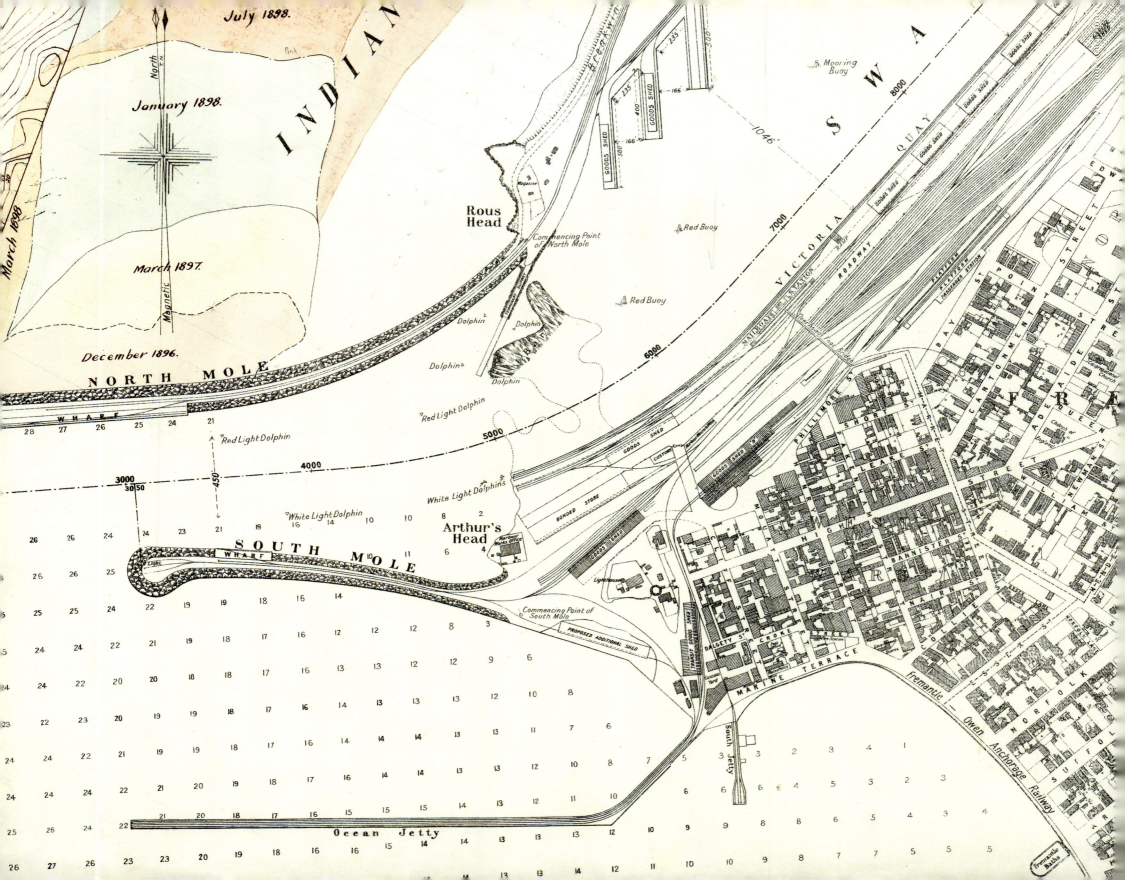

Port Progress

The map opposite represents ongoing works four years after the harbour was opened. The coloured areas north of the North Mole show the progressive dumping of spoil from dredging.

Part of the coraline limestone bar at Rous Head is still evident as an obstruction. The bar across the river had prevented anything but the smallest boats entering the river. Henry Trigg, Superintendent of Public Works fifty years earlier, had tried to blow up the bar but only succeeded in creating a small channel near Rous Head. It was this bar, and later the passenger and rail bridges built across the river, that saved the beautiful Swan River from access and thus from the severe damage that shipping would have inflicted.

The finger wharves shown on the plan were never built. The area of the mailboat station on Victoria Quay, with its link to Fremantle town via the footbridge, maintained its importance later as the immigration and tourism centre.

Extensive reclamation of the river occurred, to the extent of 20 acres on the north side and 54 on the south.

Opposite: Fremantle Harbour Works plan, December 1901.

Right: Plan of Fremantle, 1877, twenty years before the official opening of Fremantle Harbour. The Recreation Ground was soon afterwards replaced by a railway station. North of the river can be seen a boat haven at Rous Head, a small wharf at Water Street across from Ferry Point, and the primitive tramway from South Jetty to East Fremantle. The port began with the South (or Short) Jetty; then came the New (or Long) Jetty, which was later extended.

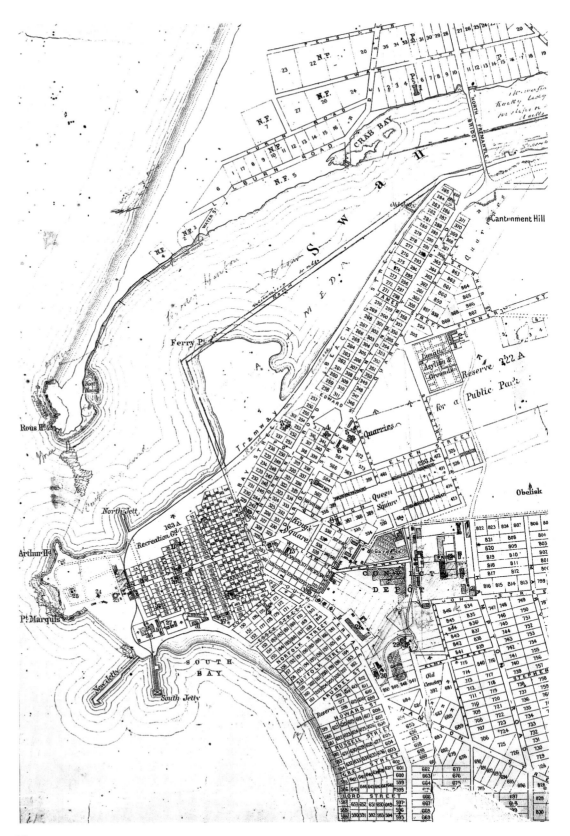

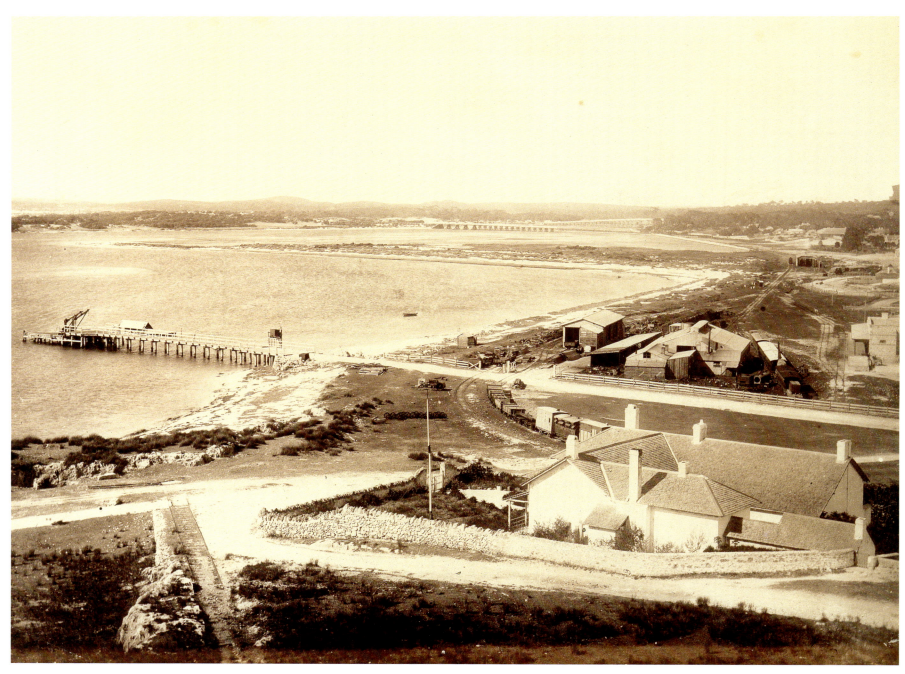

The Swan River from the lighthouse on Arthur Head, c1885. The River Jetty, convict-built in 1853, is on the left; beyond it are Ferry Point, then the 1880 railway bridge and in the distance the 1866 passenger bridge. In the foreground is the Government Cottage or Residency, built in 1851 for the water police, demolished 1967.

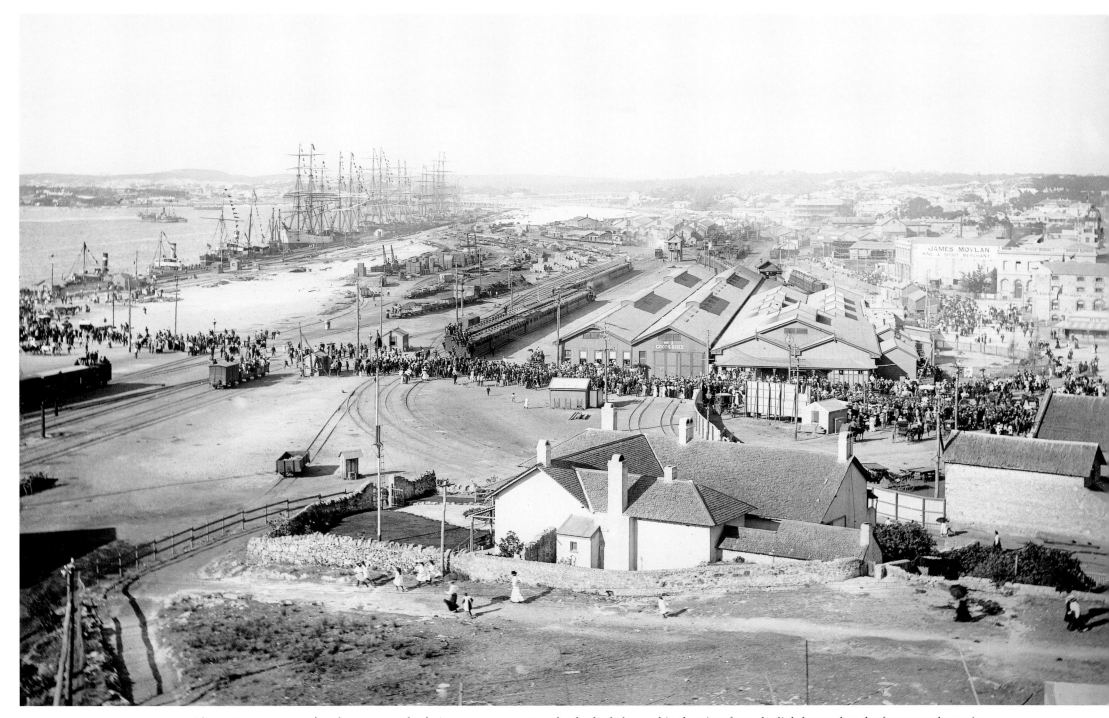

Almost twenty years after the scene on the facing page was captured, a lot had changed in the view from the lighthouse, but the foreground remains much the same. Here, in February 1900, some girls are running down the hill to farewell troops going to the Boer War. The men had not taken the train to the 1881 railway station on the right, but had marched from Perth. Western Australia sent a total of six contingents, amounting to 923 officers and men. Since the earlier photograph was taken, extensive river reclamation had been carried out and the harbour had been opened for three years.

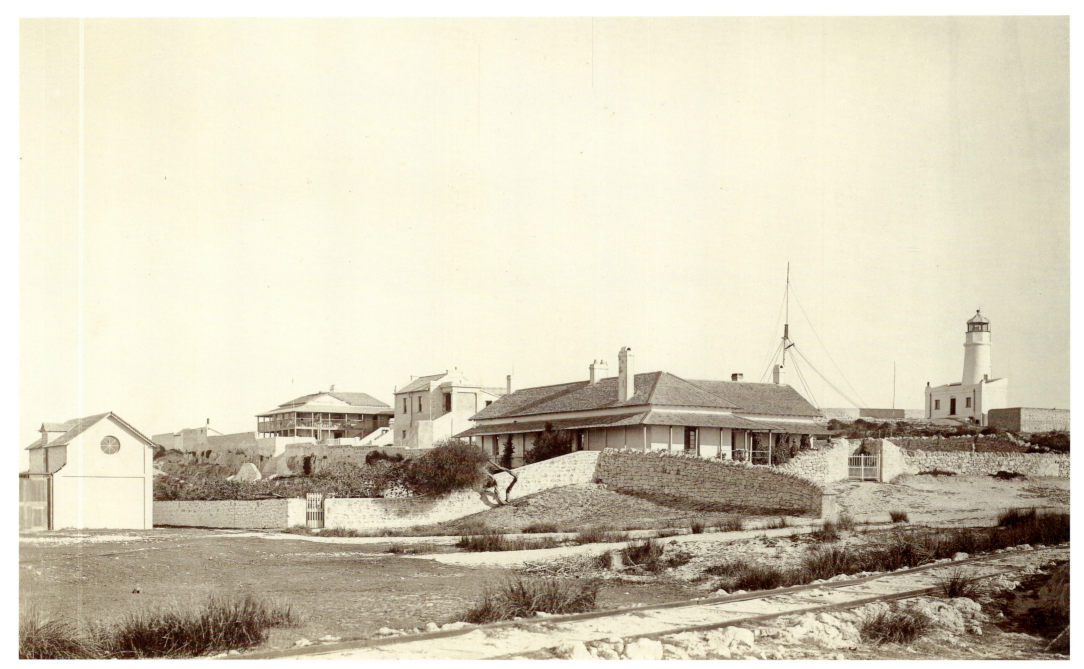

Government Cottage on Arthur Head, c1870. Built on marshy foreshore near the river jetty by the entrance to the Swan, it was probably the home of George Clifton from 1851 when he was Superintendent of the newly founded Water Police. It is conjectured that the building was used occasionally as a governor's seaside home, but by 1900 it was the Chief Pilot's house and then, in 1929, it became the Wharf Manager's residence. During World War II it was used by gun crews. After the war F.W.E. Tydeman, one of the most highly qualified engineers in Australia, moved in and then wrote a report on the port. Tydeman had come from India, where he had used 14,000 troops to repair the port of Bombay after an ammunition ship blew up, killing 15,000 people. In the 3-volume report, Tydeman noted the queuing of ships to enter the harbour, the lack of maintenance during the war, and the lack of mechanization. He was appointed general manager of the port after his predecessor, G.V. McCartney, who had been in the position since 1929, dropped dead on the steps of this house in 1950. On Tydeman's retirement in 1965 the building reverted to its original owners, the Water Police, before being demolished in 1967 and the hillside excavated. Left to right are George Shenton's stables, the first Fremantle courthouse (1835), here seen remodelled as the Harbour Master's residence, the steps of the Round House, and the second courthouse (1851). Far right is the first Arthur Head lighthouse, built 1851.

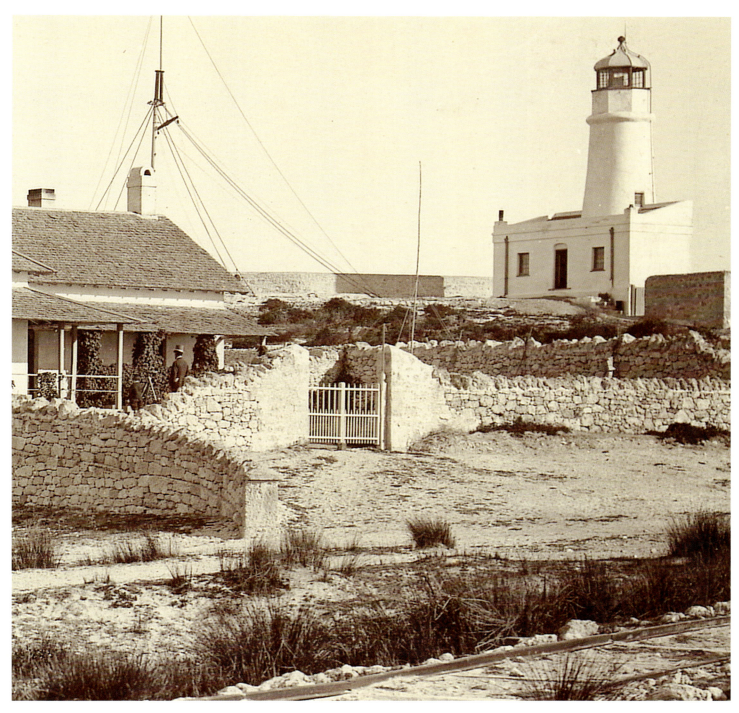

Detail from previous page. Note gentleman in top hat, boy also in formal wear, and telescope on tripod. Fremantle's first lighthouse, on the right, was operating in 1851, and in the following year Harbour Master James Harding wrote to the Governor asking for the lighthouse-keeper to be awarded more money: "The lamps require from their construction trimming every hour and the windows from the quantity of smoke require cleaning 3 times each night. Mr Peril has not had an assistant which from the necessity of his having to go into the town for water and firewood and the constant attention required to the lamps at night is very trying to one person."

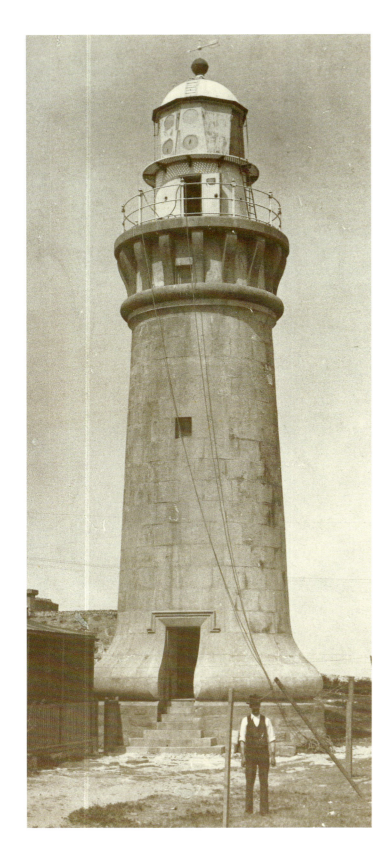

Arthur Head Lighthouses

Fremantle's first lighthouse was built west of the Round House in 1851 with wings extending north and south. It had been the site since the 1830s of a flagstaff and signal fires that had been used until that time for communicating with ships. The lighthouse was lit by whale and later mustard oil. A second lighthouse, pictured left, was constructed in 1879 with convict labour, also west of the Round House but north of the first. The tower of the first lighthouse was then truncated. The new lighthouse, towering 92 feet above high water mark and 72 feet above the ground, was powered by a dioptic light from Birmingham.

Construction of lighthouse-keeper's quarters beside the second lighthouse followed in 1881. The additional building led to a total of thirty-two residents, not including prisoners, living on what was often known as "Gaol Hill." In 1900 a time ball was constructed north of the second lighthouse and in 1903 relocated to the top of the remaining part of the original lighthouse. The time ball was dropped at midday each day to provide ships with an accurate time check.

All these structures were demolished in 1905 to make way for Federal defence fortifications known as the Fort Arthur's Head Battery, and the time ball ended up on top of the Harbour Trust building. In 1965 the land was vested in the Harbour Trust, which demolished this part of the headland and dumped it in the ocean.

Lighthouse joke: The *Herald* reported on 18 January 1878 that Dr Barnett had made the best joke at the Conundrum Night held at the Fremantle Oddfellows' Hall: "Why is the new Fremantle lighthouse like the Crown of an ancient British monarch? Because it is the principal ornament of Arthur's Head!"

Left: The second Fremantle lighthouse, built 1879.

Right: Two impeccably dressed heliograph operators at their station on Arthur Head near the lighthouse. Behind them is the lighthouse-keeper, telescope in hand; one of his tasks was to look out for heliograph flashes from Rottnest.

Opposite: The 1882 lighthouse-keeper's residence alongside the second lighthouse. To the rear can be seen the first lighthouse, now truncated and capped, and on the right is the time ball.

The Heliograph

The heliograph, or sun telegraph, flashed morse-code-like signals using sunlight. In the late 1870s the Governor of Western Australia, Sir Harry Ord, wanted to keep in contact with the mainland during the three months of each summer that he spent on Rottnest. A telegraph cable to the island was estimated to cost £3000, but he was able to obtain four heliographs for less than £100. Victoria was the only other state to order the devices. The system was first tried on 16 December 1879, just six weeks after the lighthouse pictured on the left was opened.

The heliograph and the daily voyage of the pilot boat kept the Governor in touch, but he was criticized by the press for wasting money and by others for delaying shipping through his daily use of the pilot boat to deliver documents. The lighthouse keeper had to watch for heliograph flashes from Rottnest as well as for ships; when a flash was seen, a telegraphist was fetched from the nearby post office in Cliff Street. For shipping signals to the mainland, flags were generally used.

Ord left Rottnest for the last time in March 1880 and the heliograph was then used mainly by the Rottnest Establishment (the prison) until the wreck of the *City of York* in 1899 prompted a revamp of harbour and pilot services.

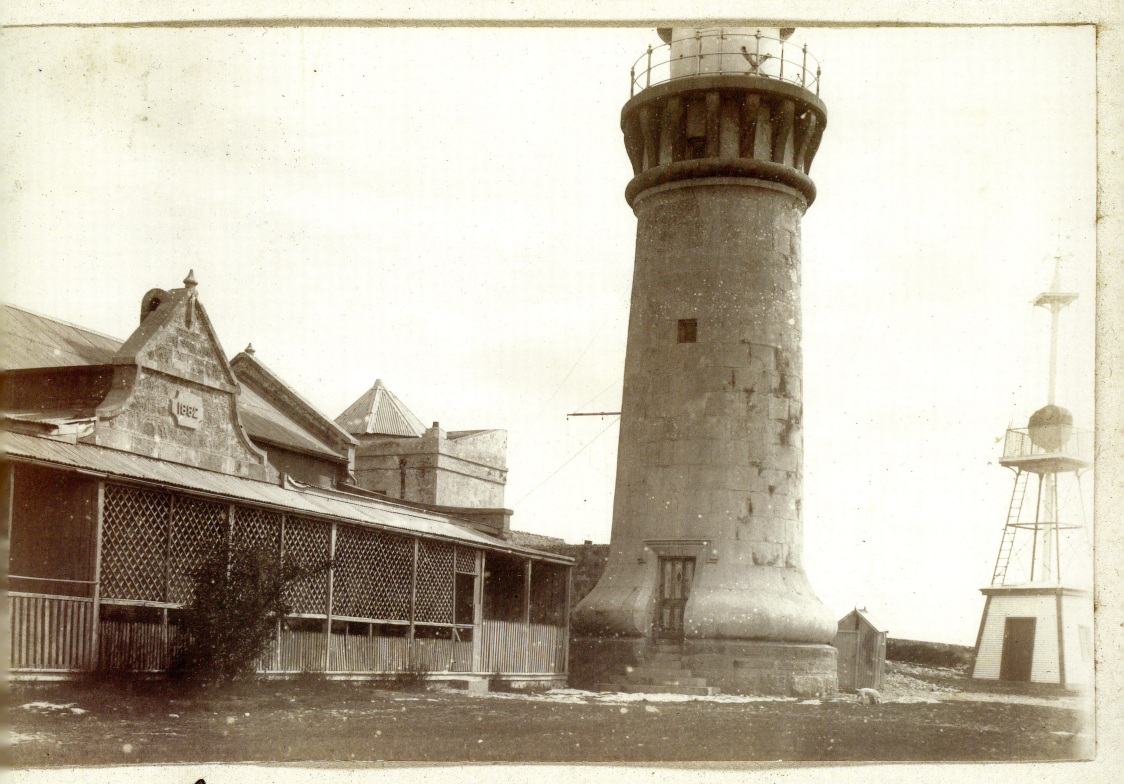

Lighthouse Fremantle. Oct 7. 1900

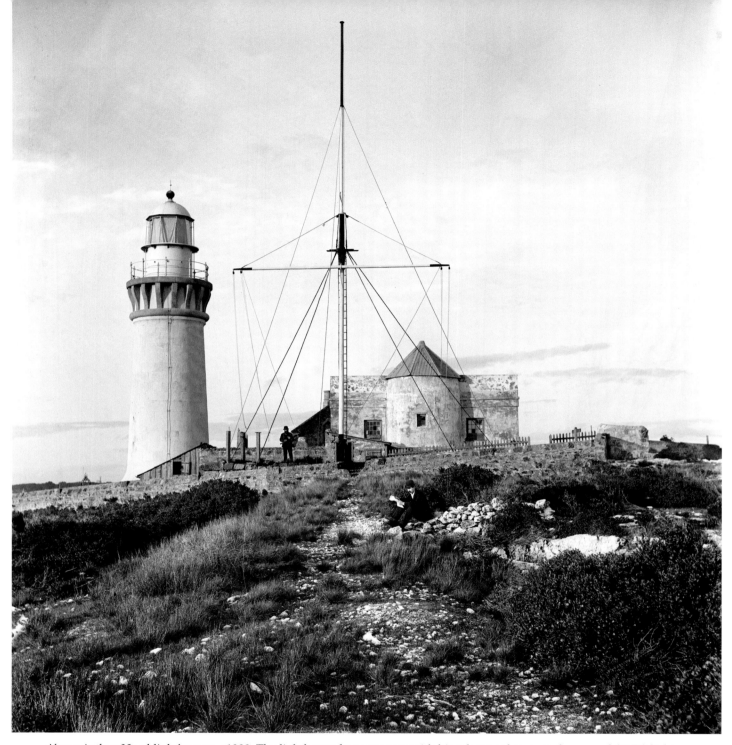

Above: Arthur Head lighthouses, c1900. The lighthouse-keeper poses with his telescope between the second (1879) lighthouse and its truncated 1851 predecessor. Both were demolished in 1905 to make way for the Fort Arthur's Head Battery.
Opposite: Detail of above, showing the dilapidated roofed remnant of the original lighthouse.

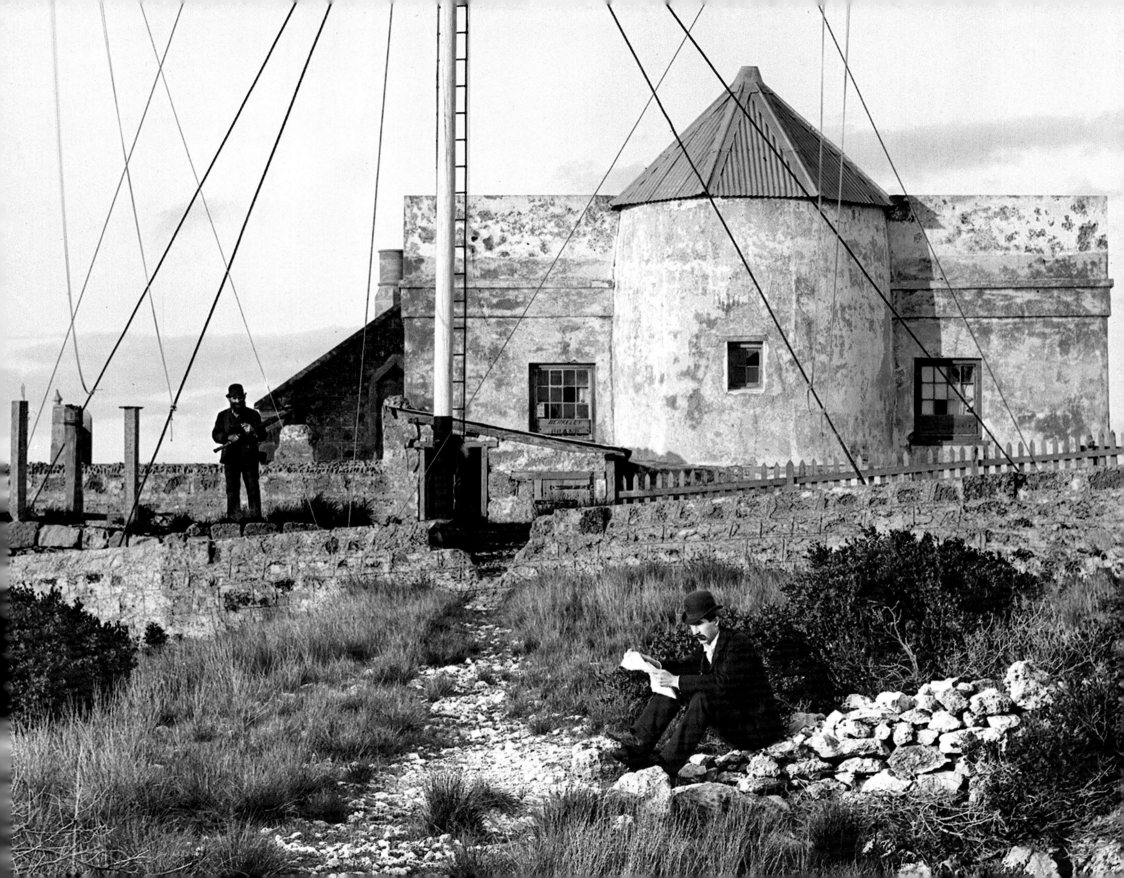

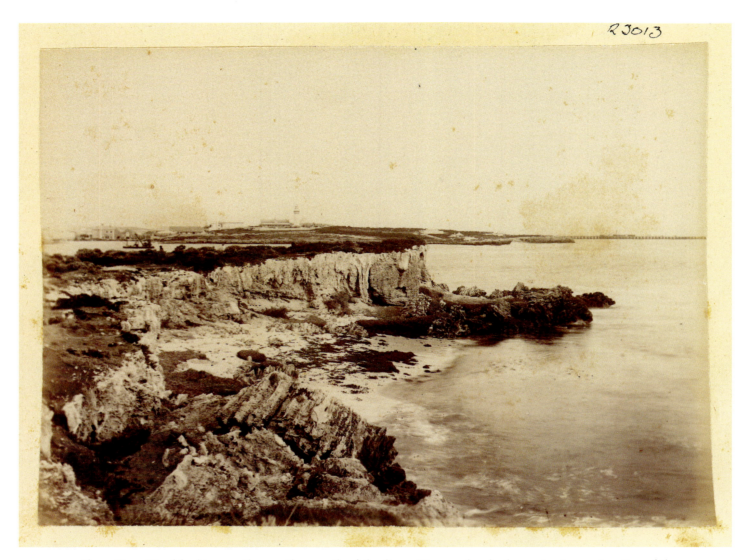

Above: Rous Head looking south over the mouth of the Swan River and a dredge, prior to construction of the North and South Moles. The 1879 lighthouse and the 1882 lighthouse-keeper's residence stand atop Arthur Head.
Opposite: Mews's boat yard (established 1860s) in Bather's Bay, c1880. From the very early days this beach was used for bathing, the men and boys keeping to one end and the women and girls to the other.

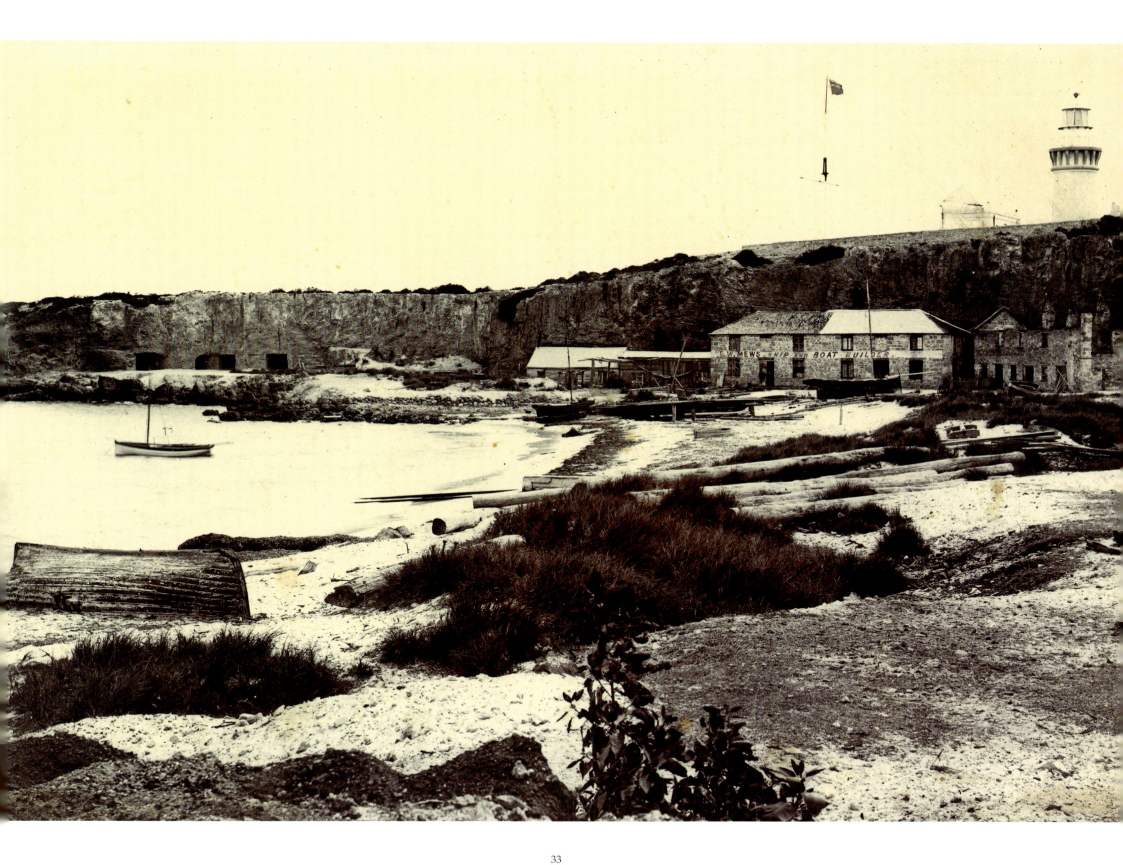

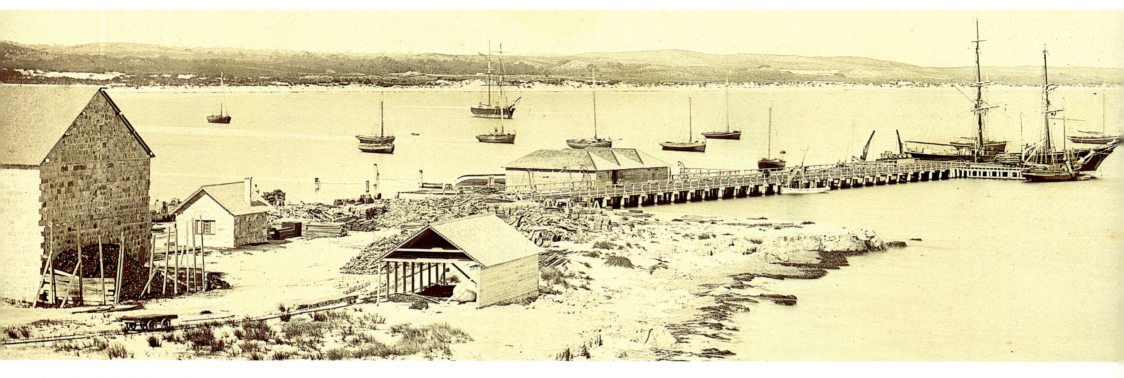

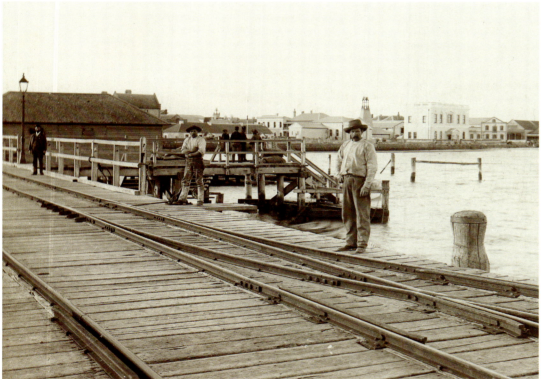

Above: South or Short Jetty. A very early view, c1870, before the Long Jetty was built on the right in 1873. Far left is the 1860-built "B" store, part of the 1851 Commissariat. The tramway with trolley was replaced with a railway around 1880. The point this side of the South Jetty is Anglesea Point, where the *Marquis of Anglesea* was driven ashore in 1829. The shipwreck became for a time the first prison and the first post office in the colony.

Left: South Jetty, also known as Short Jetty, c1900.

Opposite: Long Jetty, also known as New Jetty, c1898, one of the classic Fremantle photos. But most books have used a muddy copy and one in fact labelled this boy sitting on a ship's mast as "a lady rests on a pipeline." The Long Jetty, built in 1873 and extended twice until it ran over one kilometre into the ocean, was the economic pipeline for Western Australia, especially during the hectic gold-rushes, when thousands poured along this jetty and headed east.

D.B. Shaw, Master of the *Savanack*, hated his visit to Fremantle in 1892: "I would not come to this port again if they made me a present of the vessel. I never get any rest day or night. Keeps me all the time fixing something up. Fenders grind up as fast as I put them in … there is a lot of cargo that is windmills packed in crates. The stevedores knocked them to pieces in order to make good stowage. This is the worst damn hole I ever saw. No-one will do anything but work against the ship. There was one man sent in a claim for 4 pounds for a case of tinned fruit. I refused to pay it they summoned me to court and I had to pay … I was never so sick of a place in my life, and may the curse of Christ rest on Fremantle and every son of a bitch in it."

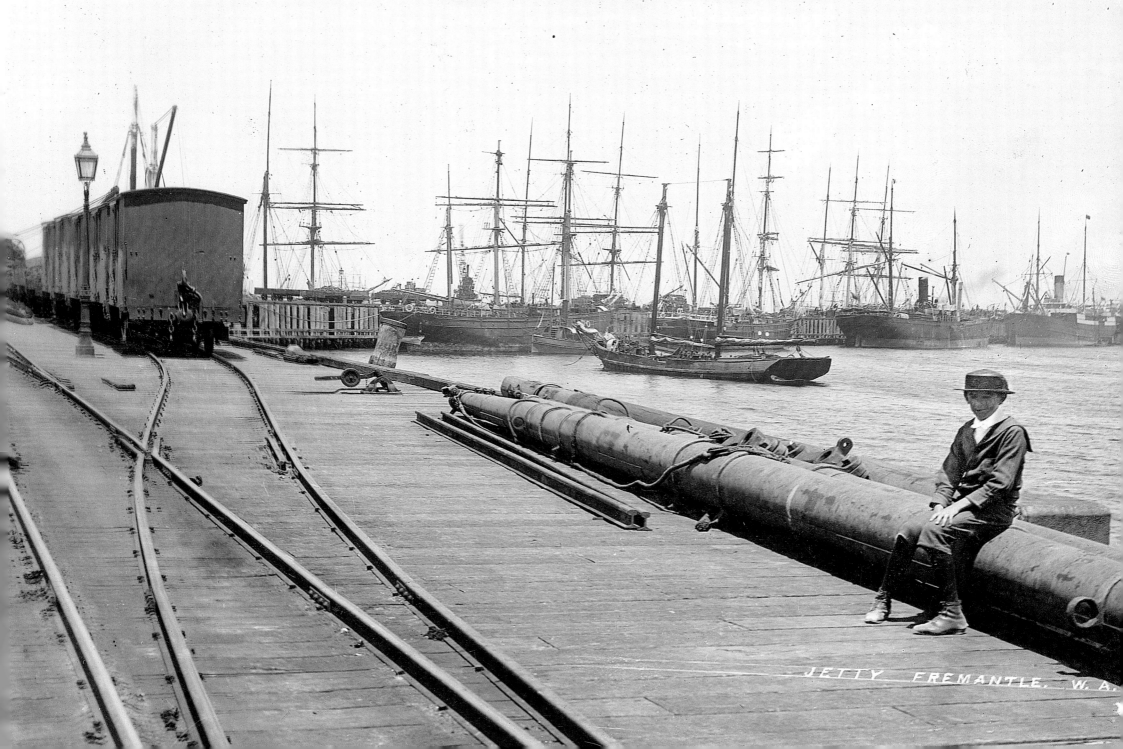

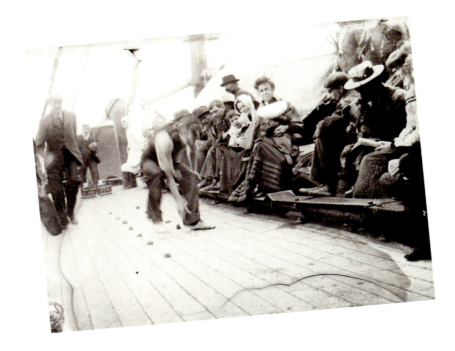

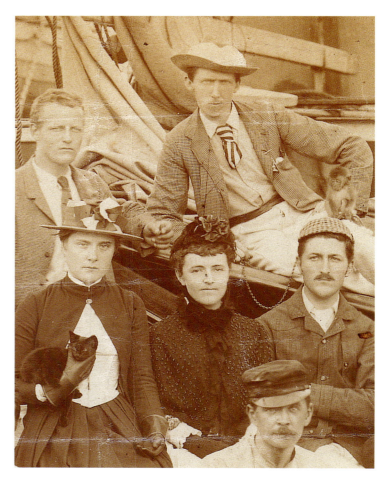

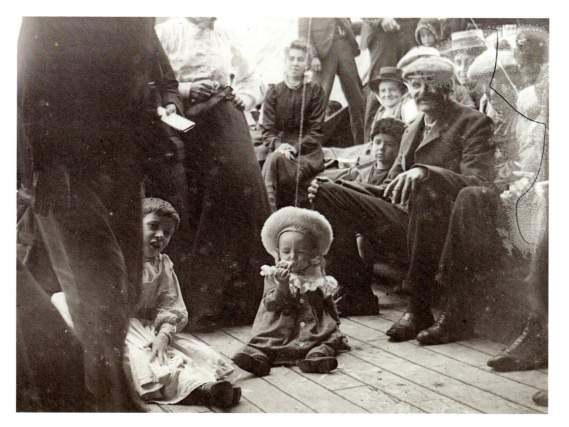

Above: Detail of photograph opposite, showing a monkey and cat as passengers' pets. It was not unusual for exotic animals to be purchased by travellers during their travels.

Left: Unposed shipboard recreation on the SS *Perth*, c1900, from a damaged glass plate.

Above left: Shipboard deck games on the SS *Perth*, c1900, from a damaged glass plate. Another photograph taken on the *Perth* on the same voyage is reproduced on the Contents page.

Opposite: Passengers and crew aboard the first ship at Fremantle boasting electric light, the *Australind*, in 1890.

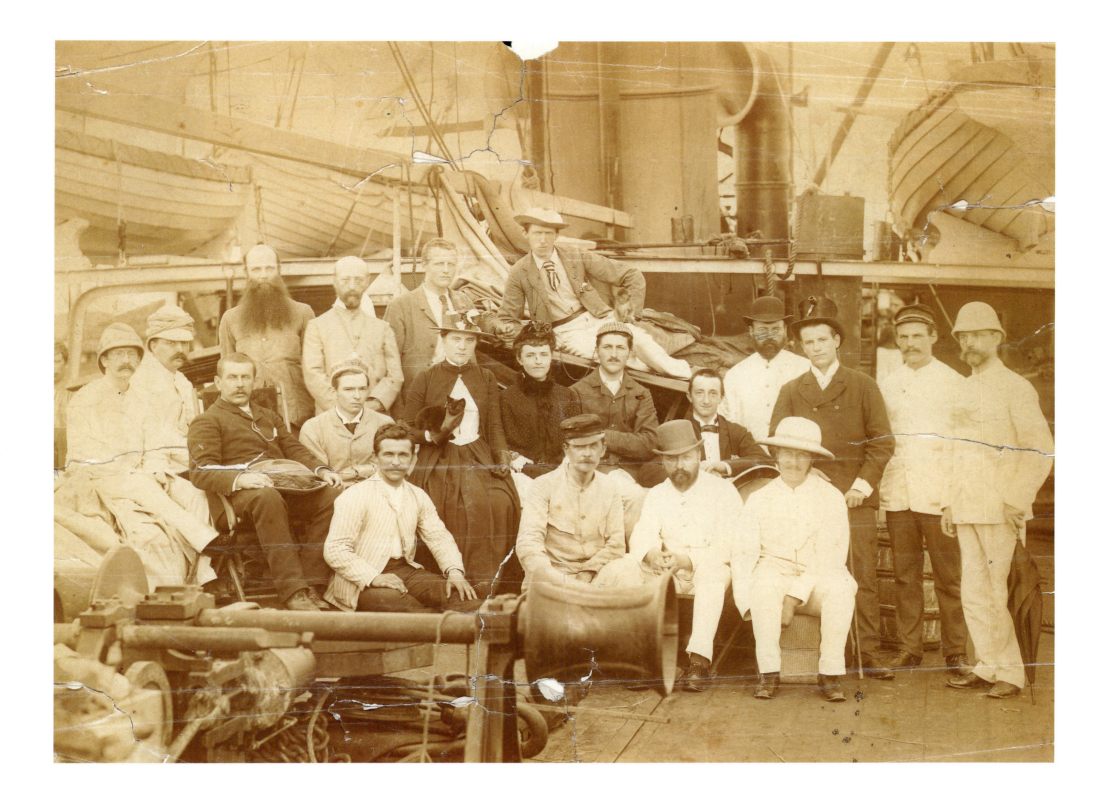

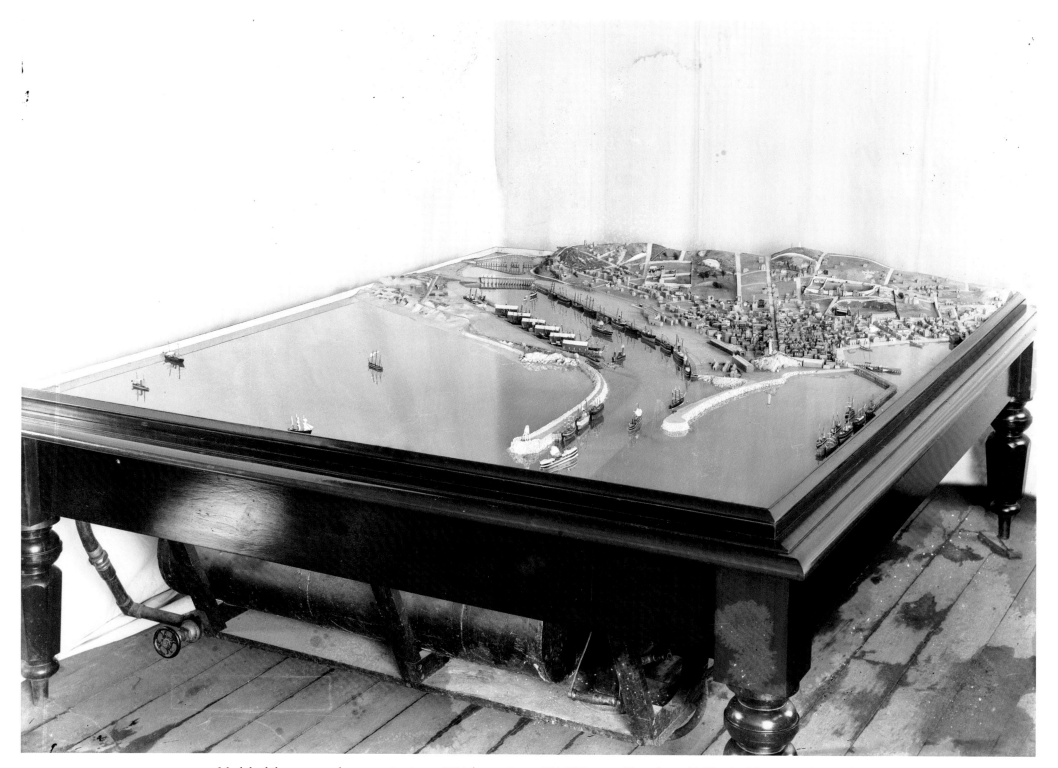

Model of the proposed new port set up c1894 for engineer C.Y. O'Connor. The adapted billiard table is complete with floating boats. Note the water tank underneath. The proposed finger wharves for North Quay seen here were never built.

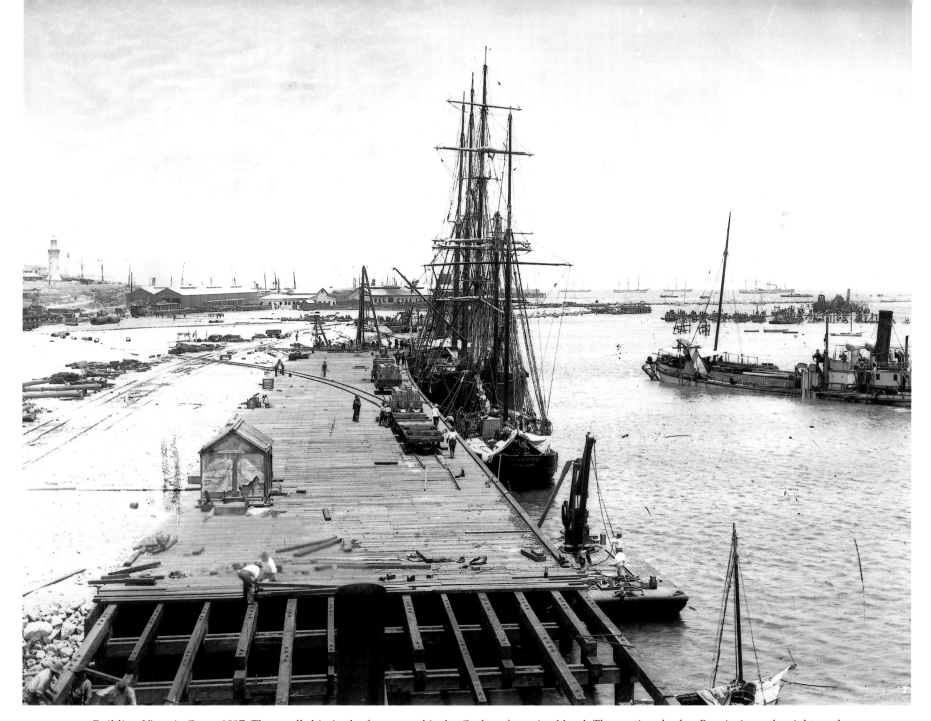

Building Victoria Quay, 1897. The small ship in the foreground is the *Orpheus* from Auckland. The suction dredge *Premier* is on the right, and beyond is the platform for blasting the limestone bar from across the mouth of the Swan River. The Arthur Head 1879 lighthouse is on the extreme left. Seaworms (*Teredo navalis*) feasted on the jarrah wharves, and within ten years some parts of the quay had collapsed, almost toppling cranes into the water. The government was promoting the use of jarrah, and pressured the port to keep using it instead of concrete. In 1923 the wharves again had to be replaced, though that work was not finished until 1938 on the south quay and 1943 on the north.

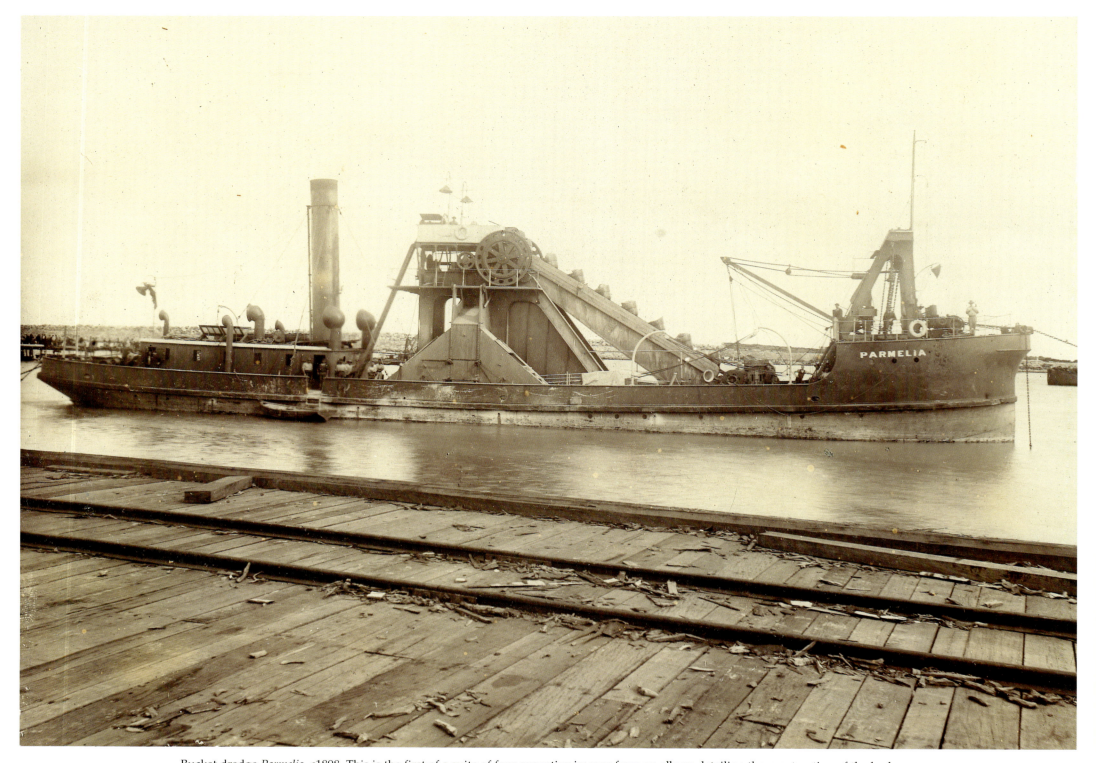

Bucket dredge *Parmelia*, c1898. This is the first of a suite of four evocative images from an album detailing the construction of the harbour.

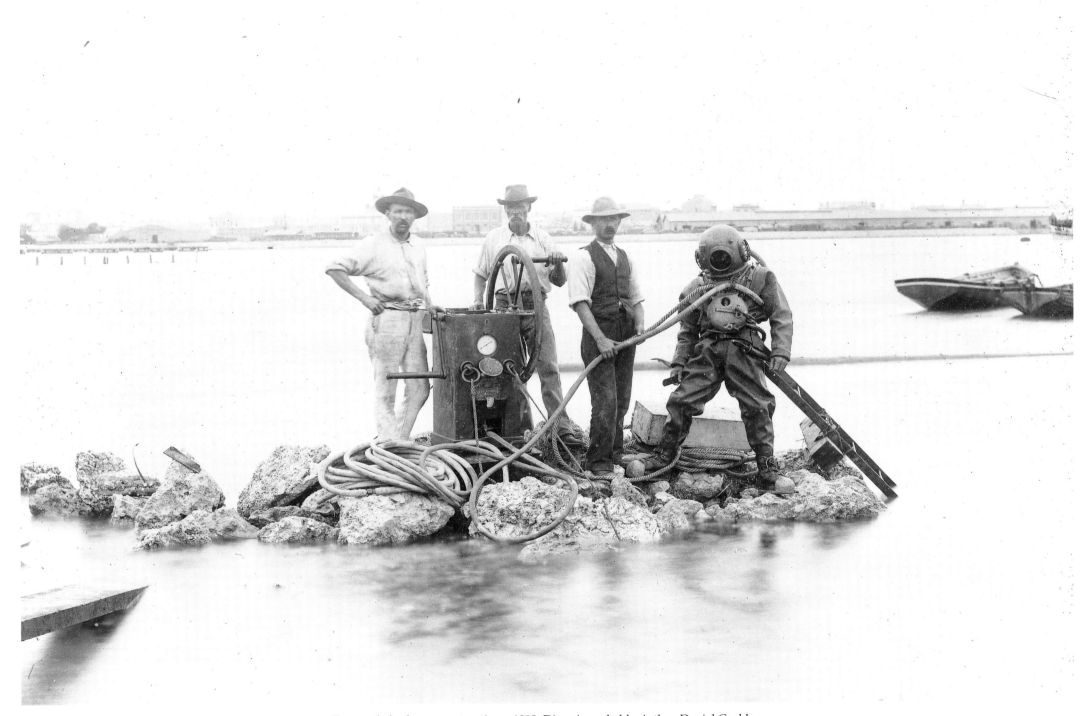

Fremantle harbour construction, c1898. Diver is probably Arthur Daniel Cockle.

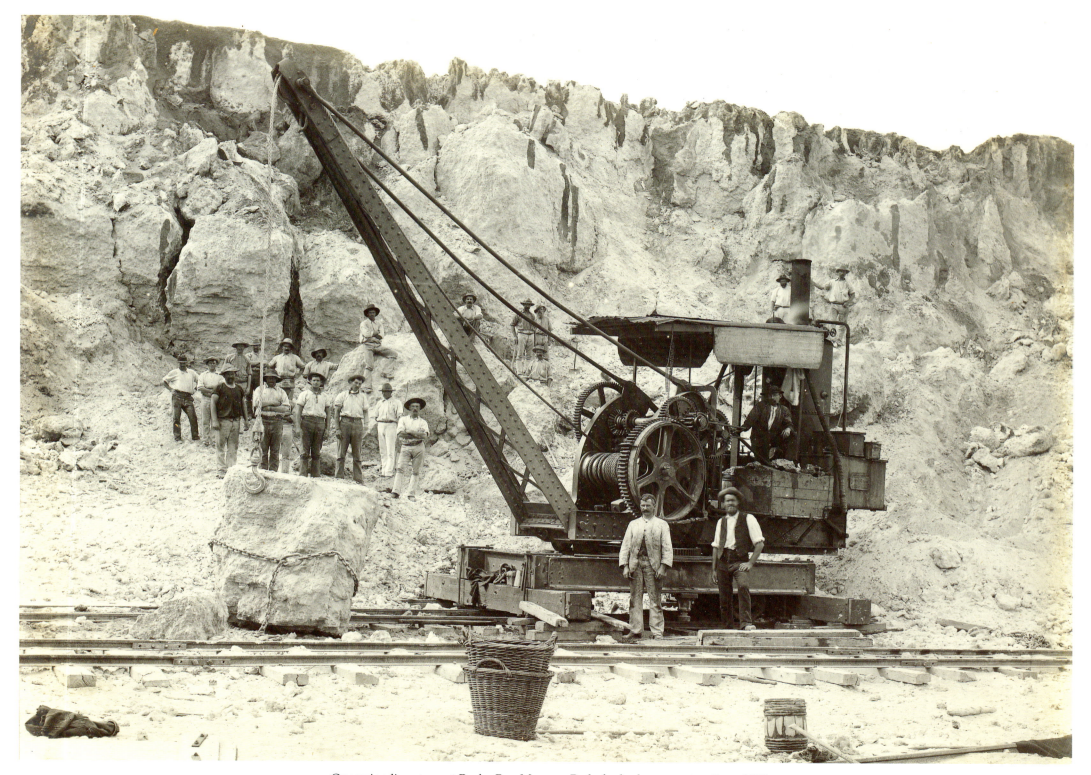
Quarrying limestone at Rocky Bay, Mosman Park, for harbour construction, c1898.

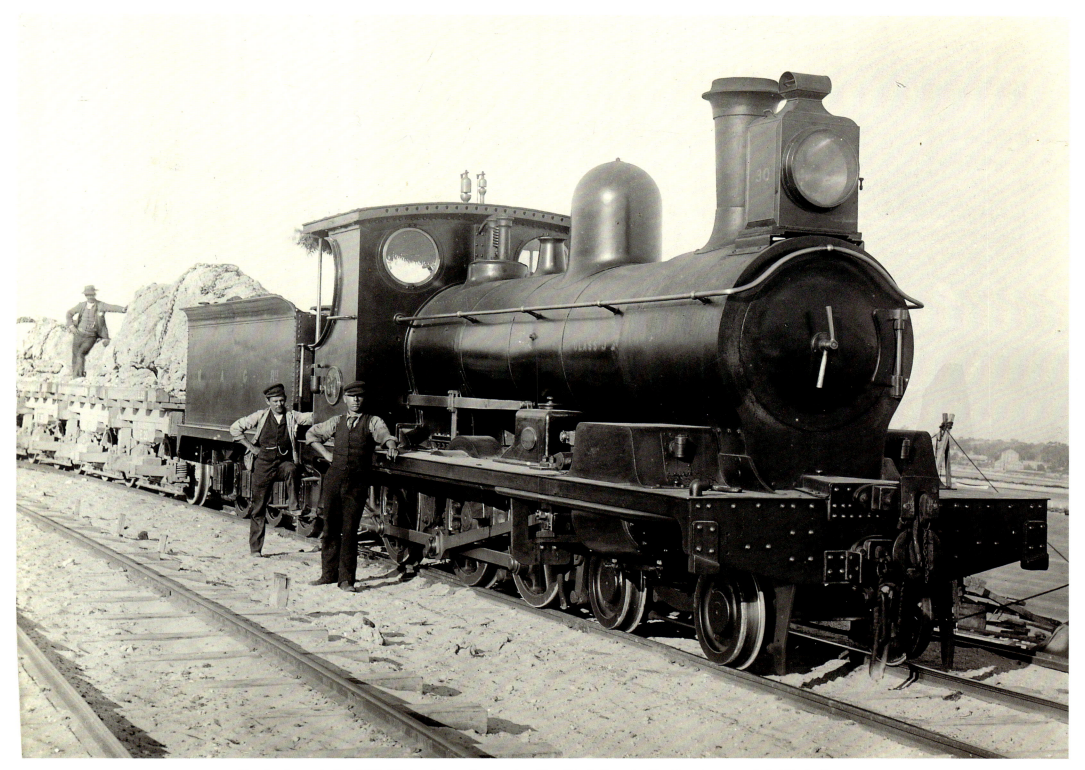
Pausing for posterity, c1898. "J" class locomotive number 30 on North Quay hauling limestone quarried at Rocky Bay.

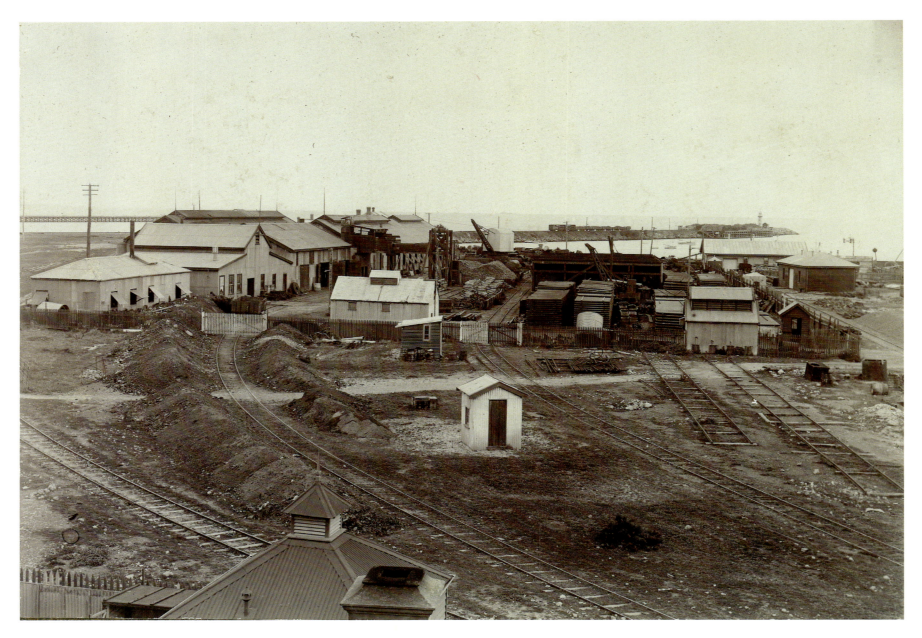

Port buildings, c1900, on the site of the 2002 Maritime Museum, looking west with the Long Jetty on the left and South Mole on the right. The Sydney *Bulletin* wrote some scathing comments about the new Harbour Trust in 1903: "The Fremantle harbor is now controlled by a trust formed by three shipping agents, a Perth hardware merchant, and a chairman who is principal stevedore of the Port. They don't seem to do much, and the port is in a scandalous condition. The Victoria Quay is sinking in places; there is no ferry service between one side of the river and the other; no proper system of handling cargo; and scarcely a week passes without some unfortunate sailor loses his life owing to the want of lights to guide him to his ship. There is no dock." The *Fremantle Mail* scoffed at such criticism, countering that perhaps the Trust should issue sailors with "a free life assurance policy and a few life belts."

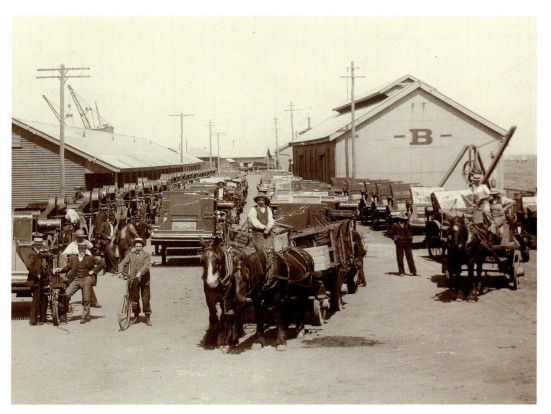

Fremantle Port – Conduit for Cargo

Above: Cargo cult – Sunshine harvesters heading for the wheatbelt, c1905. Invented by Hugh McKay when he was eighteen, this machine, named from an evangelist's sermon – "The Sunshine in Your Life" – revolutionized farming worldwide. The Sunshine Harvester Works in Victoria became Australia's largest industrial enterprise, with three thousand workers.

Right: South Quay (renamed Victoria Quay in 1901), c1898, looking east. The massive rail network is indicative of the importance of rail at this time. But the huge amount of rail traffic and shunting made access to the port difficult and dangerous. Even a passenger footbridge did little to quell complaints. In September 1900 the *Daily News* thundered: "Those passengers who come down to Fremantle by train do not want to walk around the slums of Fremantle in order to reach this bridge. The trouble of getting luggage to the wharf is dreadful, and about the whole business there is an air of fearful confusion." The removal of the railway workshops to Midland Junction by 1905 eased problems, but took hundreds of jobs out of Fremantle.

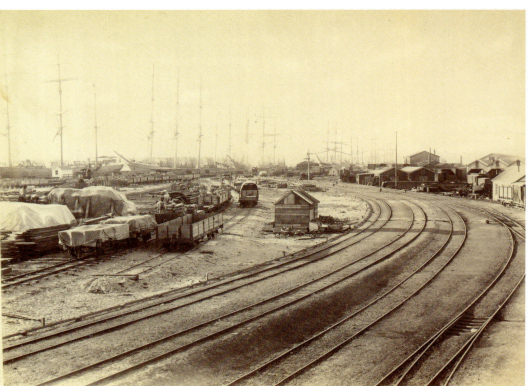

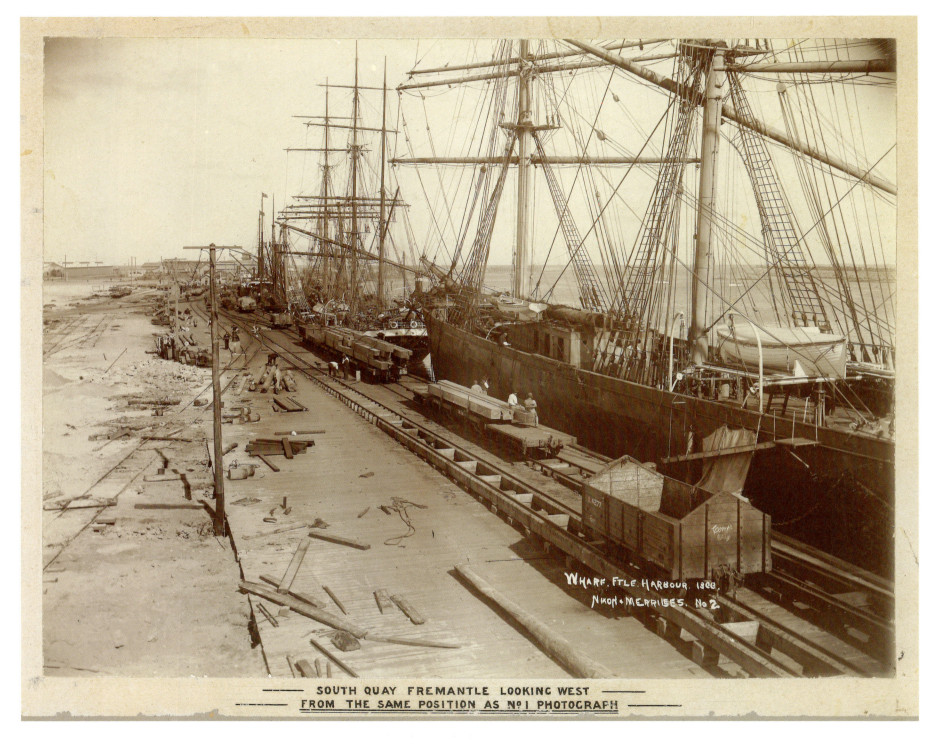

South Quay looking west, 1899.

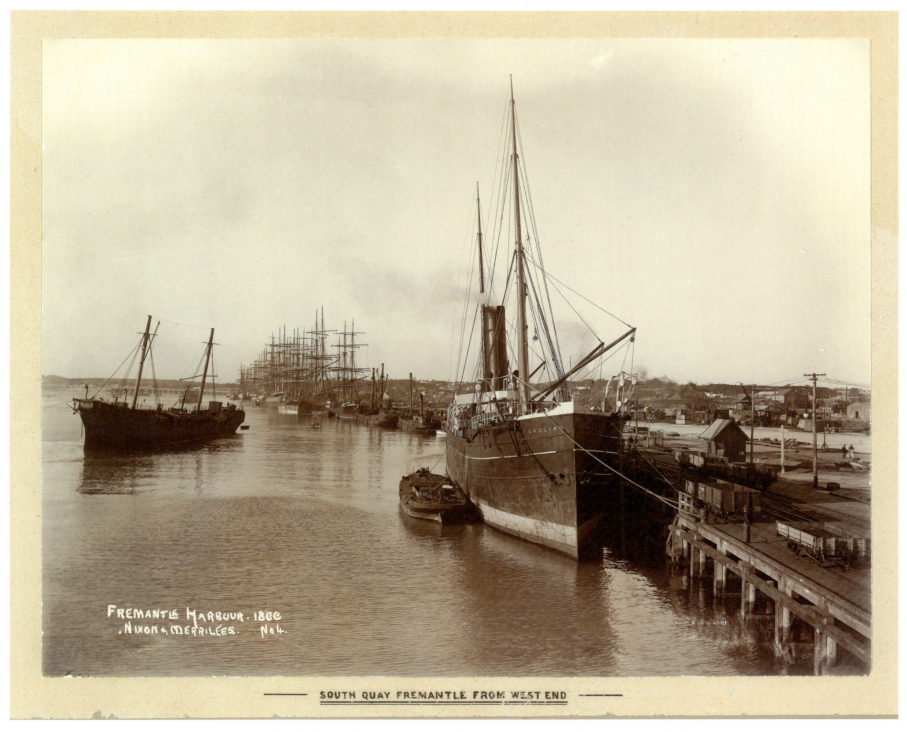

South Quay from West End, 1899. The sorry sight on the left is the once famous *Samuel Plimsoll*, now acting as a coal hulk. It remained here until it sank and was towed out to its grave.

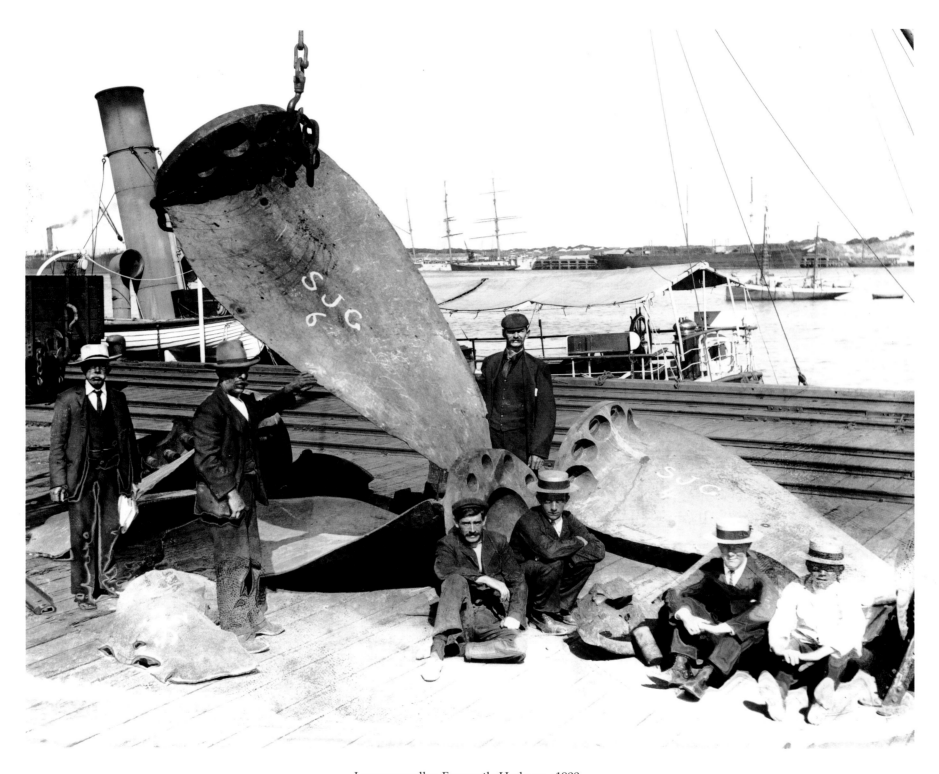

Large propeller, Fremantle Harbour, c1900.

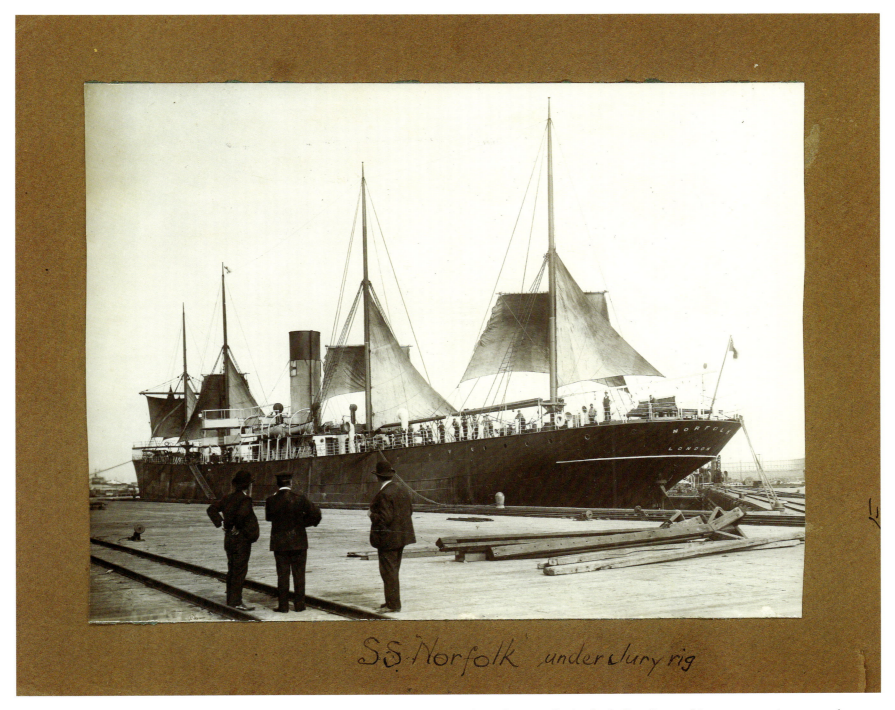

SS *Norfolk* under jury rig, 22 June 1906. When the ship was disabled by the loss of a propeller in the Indian Ocean, this emergency rig was used to get her to Fremantle, 950 miles away. Captain Corner rigged sails using every available tarpaulin and hatch cover, but: "When the sea got up she again failed to answer her helm. As it was impossible to set any more sail, I tried the effect of oil to smooth the water … A small amount of oil was kept continually trickling through a canvas hose long enough to reach the sea. This answered very well, and the ship began to steer again."

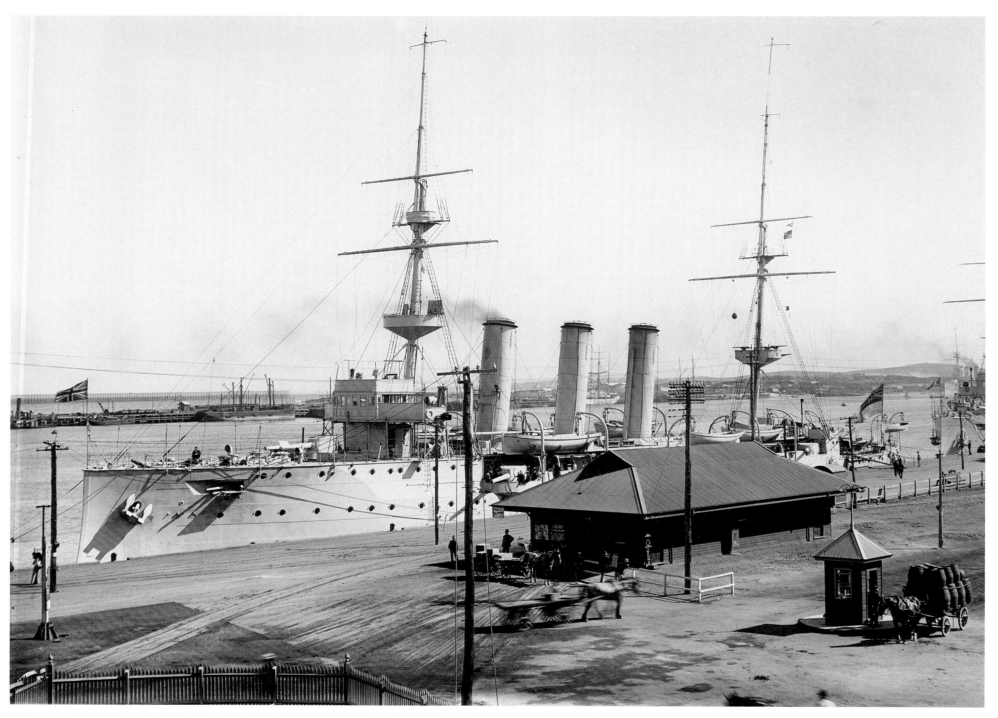
HMS *Encounter*, 1906. Australia did not have its own navy until 1911. From 1859 the country was established as a separate British naval station, the colonies paying the cost.

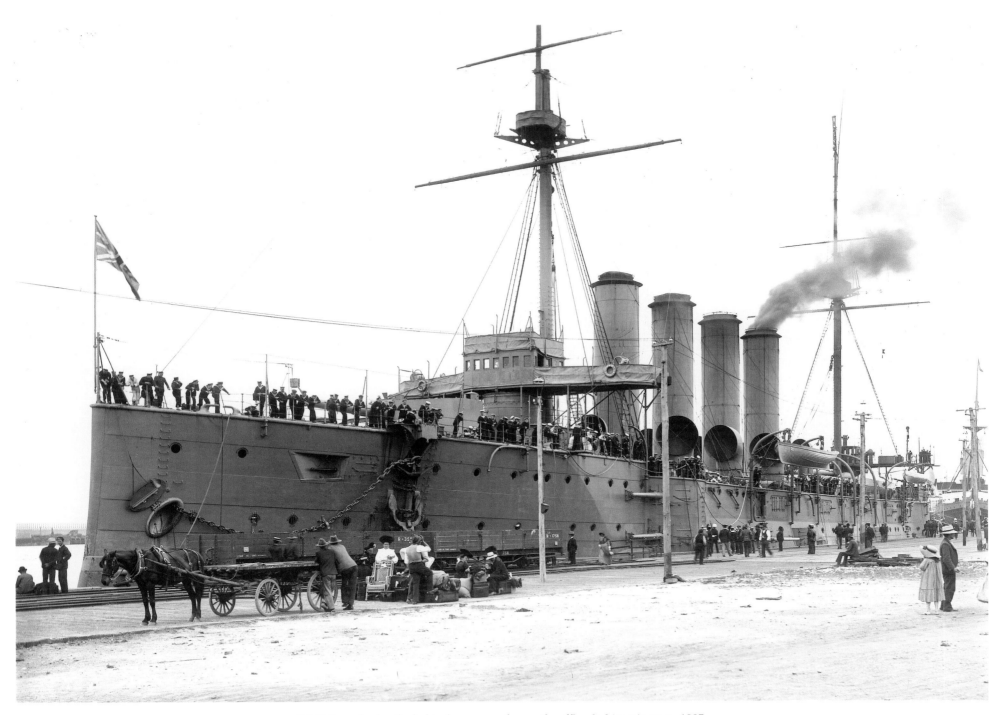
HMS *Euryalus* berths behind a group of recently offloaded immigrants, 1905.

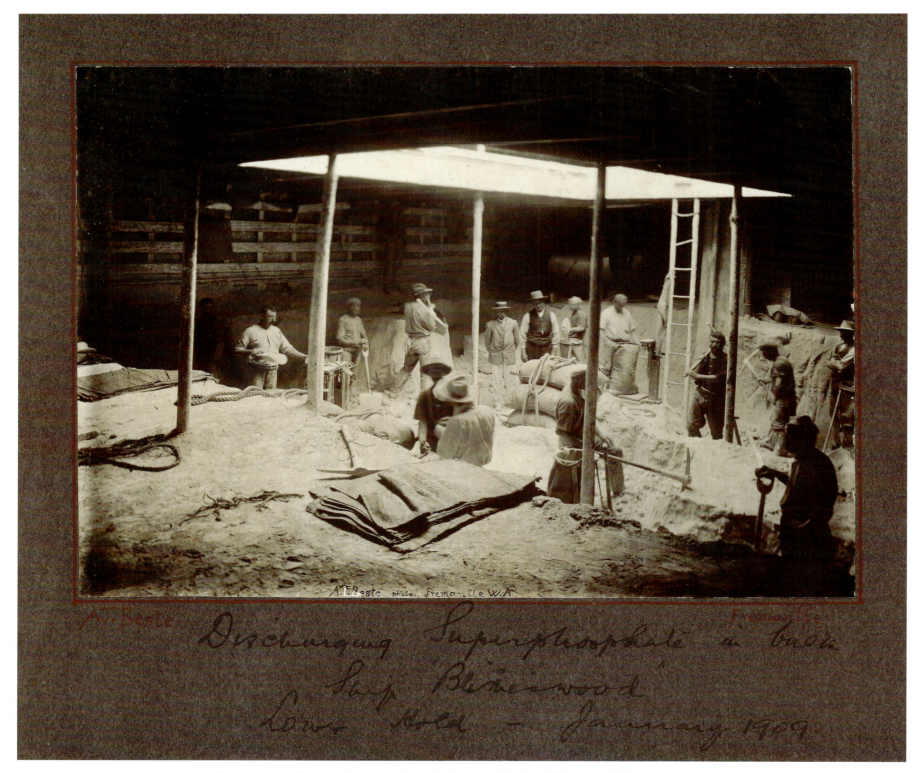

Discharging bulk superphosphate from the lower hold of the *Blithewood*, 1909. Rare glimpse of working life below decks, with workers here shovelling the superphosphate into sacks.

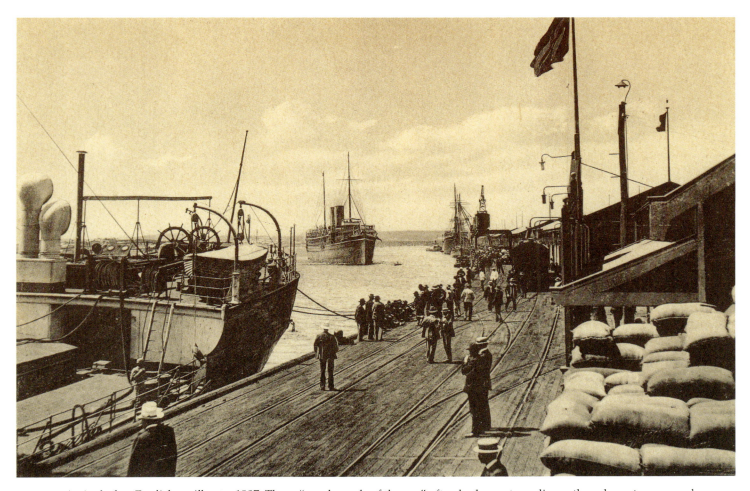

Arrival of an English mailboat, c1907. These "greyhounds of the sea" often had an extraordinary three-hour turnaround in port before leaving. This one is berthing between B and C sheds with a Royal Mail railway carriage waiting on the dock. Bags of wheat are piled up next to the immigration building. Known as the Immigration Office and Information Bureau, the building was in this location only between 1906 and 1912. It still exists in a much altered form, set back from the gap between C and D sheds. A new three-ton electric crane can be seen in the distance.

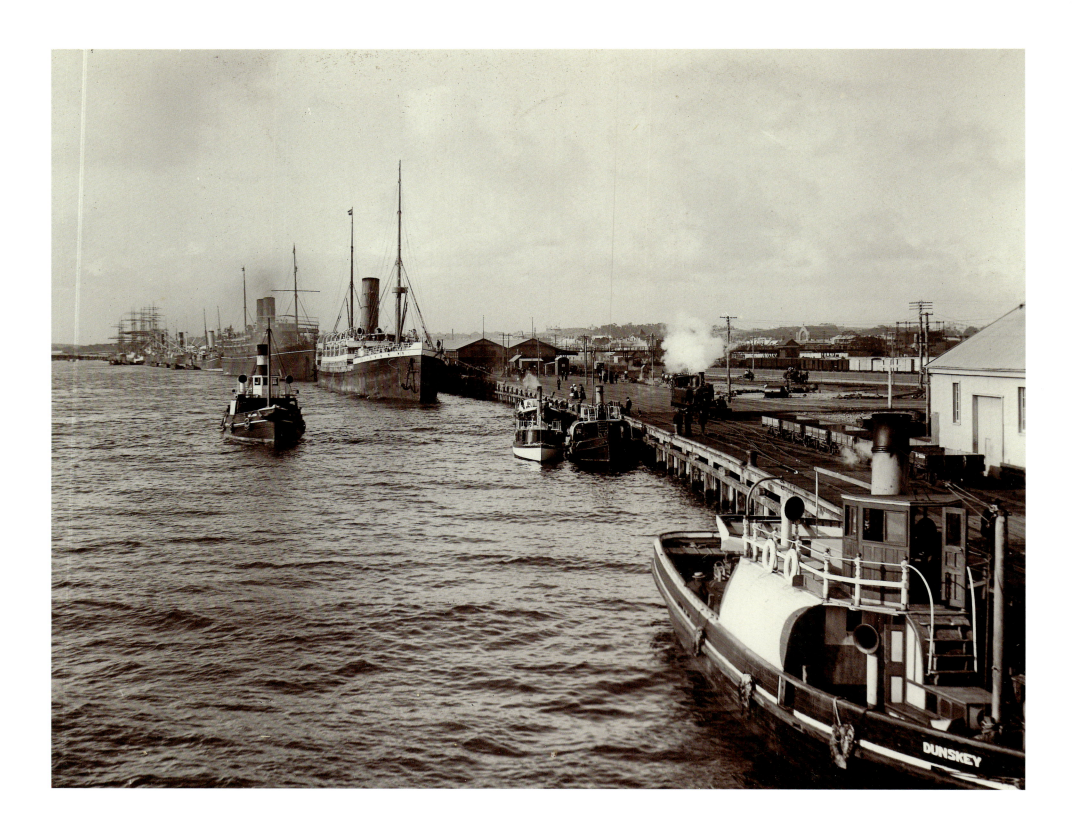

Right: Tilley's boat-building yards in East Fremantle, c1900.

Below: One of hundreds of pearling luggers built by A.E. Brown, the state's most prolific boat-builder. Brown is on the right in this 1910 portrait, taken in his Marine Terrace yards.

Opposite: The tug *Dunskey* sits in the foreground with cross-harbour ferries behind and a steam locomotive prowling the wharf, c1905.

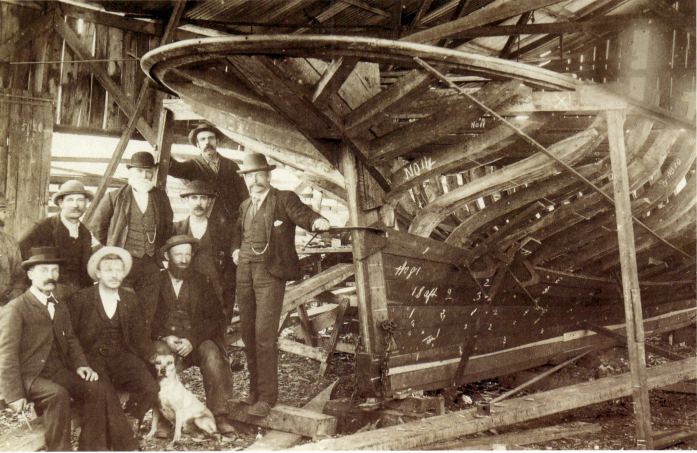

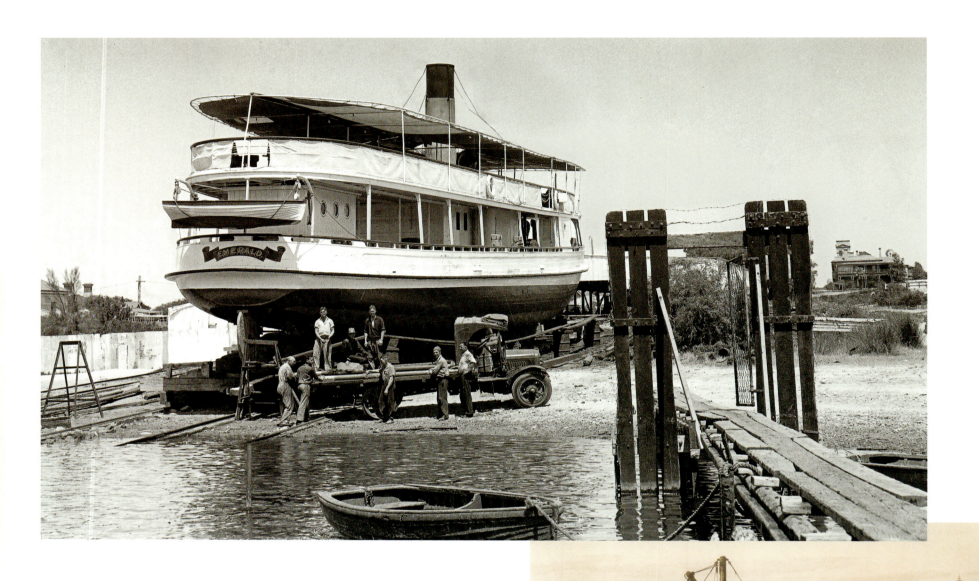

Above: The *Emerald* ferry, taking a spell on dry land.

Right: Unloading Rottnest salt along the East Fremantle foreshore from the former ferry *Duchess*, c1920.

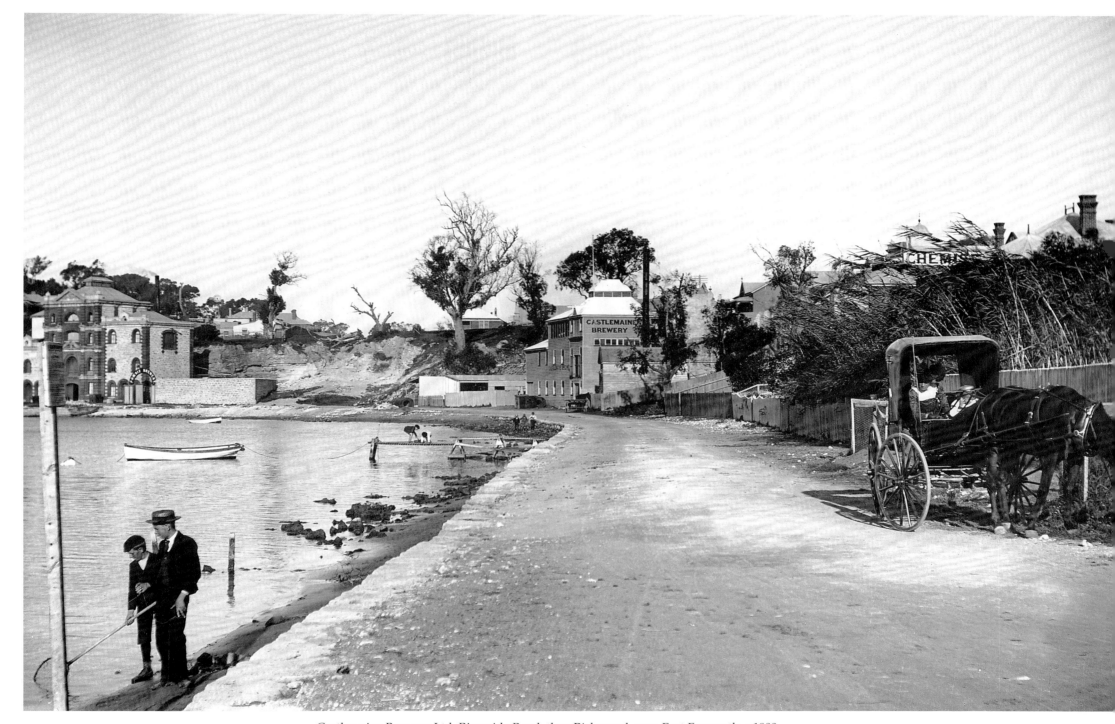
Castlemaine Brewery Ltd, Riverside Road, then Richmond, now East Fremantle, c1900.

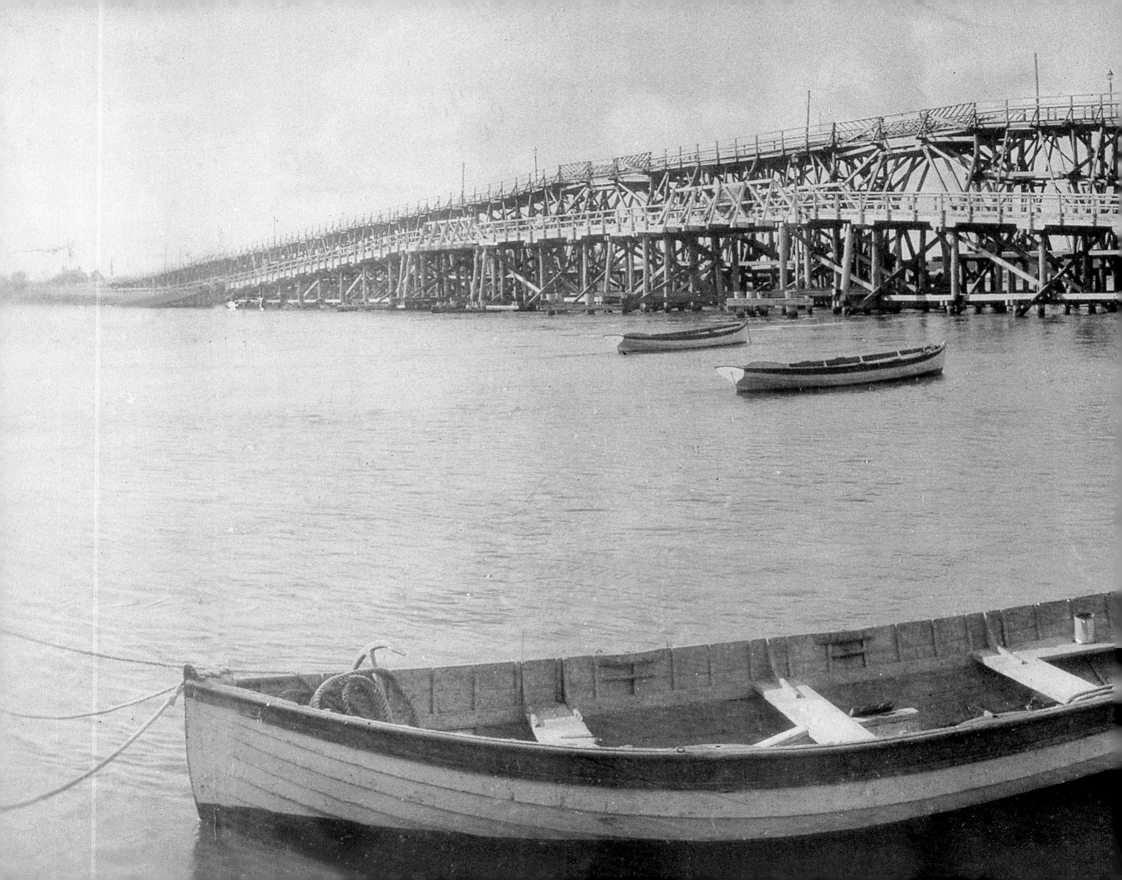

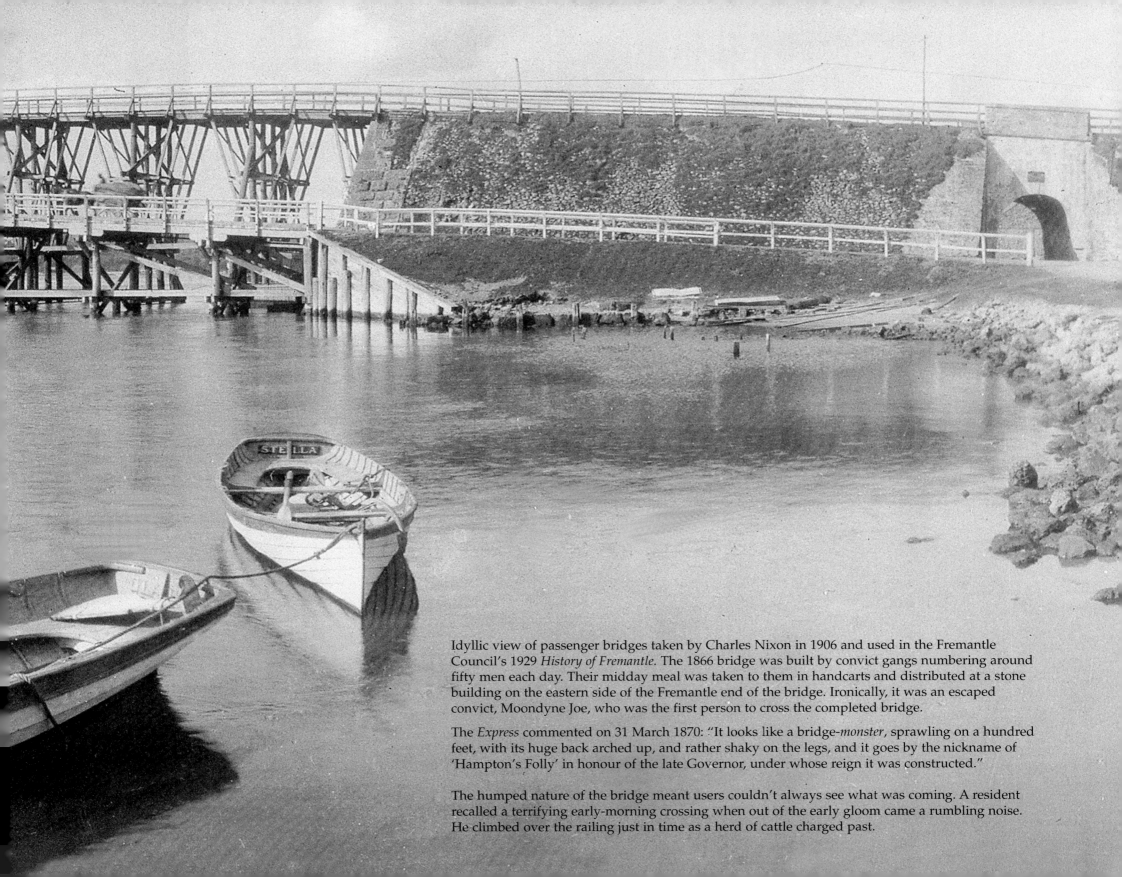

Idyllic view of passenger bridges taken by Charles Nixon in 1906 and used in the Fremantle Council's 1929 *History of Fremantle*. The 1866 bridge was built by convict gangs numbering around fifty men each day. Their midday meal was taken to them in handcarts and distributed at a stone building on the eastern side of the Fremantle end of the bridge. Ironically, it was an escaped convict, Moondyne Joe, who was the first person to cross the completed bridge.

The *Express* commented on 31 March 1870: "It looks like a bridge-*monster*, sprawling on a hundred feet, with its huge back arched up, and rather shaky on the legs, and it goes by the nickname of 'Hampton's Folly' in honour of the late Governor, under whose reign it was constructed."

The humped nature of the bridge meant users couldn't always see what was coming. A resident recalled a terrifying early-morning crossing when out of the early gloom came a rumbling noise. He climbed over the railing just in time as a herd of cattle charged past.

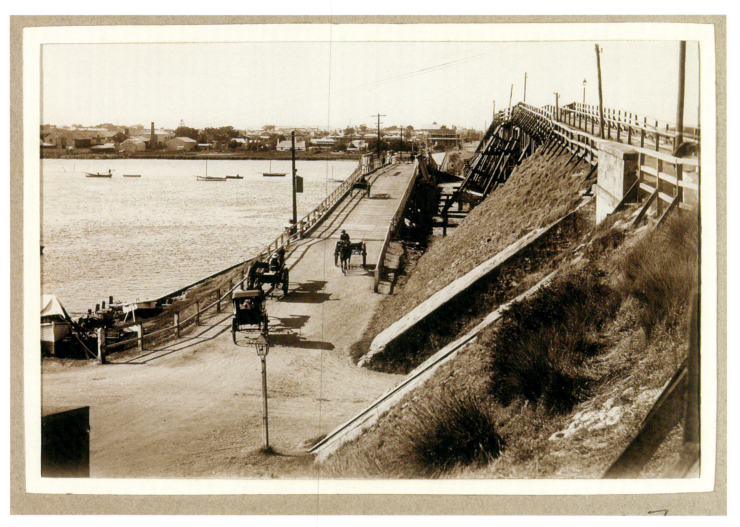

The two bridges, 1907.

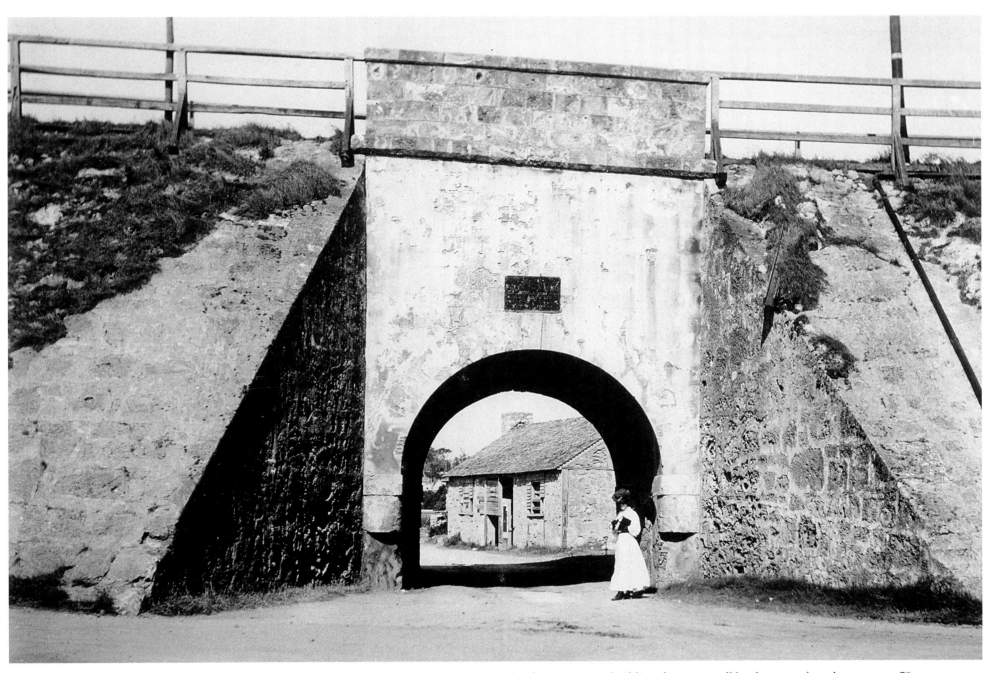

This passageway under the southern approach to the original 1866 passenger bridge frames a stone building that may well be the one referred to on page 59.

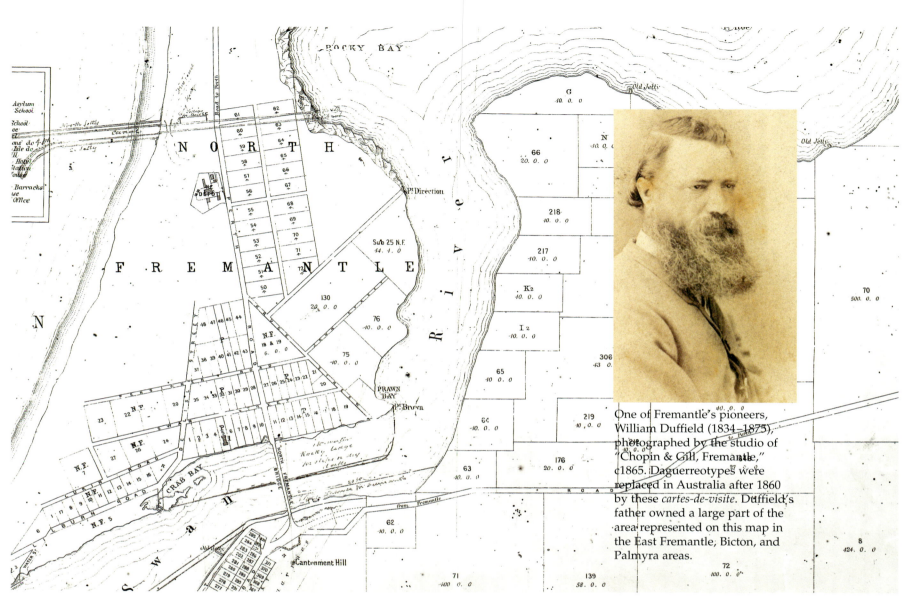

One of Fremantle's pioneers, William Duffield (1834–1875), photographed by the studio of "Chopin & Gill, Fremantle," c1865. Daguerreotypes were replaced in Australia after 1860 by these *cartes-de-visite*. Duffield's father owned a large part of the area represented on this map in the East Fremantle, Bicton, and Palmyra areas.

Above: 1877 map showing pencilled plans that were never realized for a canal from the ocean to Rocky Bay and wharves upriver of the passenger bridge, both of which would have destroyed the beauty of the river so well pictured opposite. The canal idea was raised at different times. World authority Sir John Coode had dismissed the canal plan, but then he had also dismissed the removal of the bar across the mouth of the Swan River because of sand-travel problems. C.Y. O'Connor saw no such difficulty and, with the strong support of his minister, Harry Venn – later sacked by Premier John Forrest – the latter's preferred plan for a harbour at Owen Anchorage, two miles south of Fremantle, was overturned in favour of the one we have today inside the mouth of the river.

Opposite: Quiet beauty: the Swan River at Fremantle, c1890, looking from the foot of East Street across to North Fremantle.

Thomas James Briggs, born in Fremantle in 1859, reflected on his days growing up along the river: "The Swan was teeming with fish. It was long before the Dago got a footing in Western Australia, and when fishing was really sport, and not the wholesale murder of fish by means of explosives, or the catching of all and sundry regardless of size. We are supposed to keep an eye on these fish poachers, but the dynamiting goes on all the same … One could make a selection from flathead, kingfish, tailor, schnapper, and skipjack. Crabs were so plentiful that one could walk along the shore and rake in a sackful in an hour." (*Life and Experiences of a Successful West Australian*, 1917)

In 1906 Leopoldo Zunini, Royal Consul of Italy, wrote: "The vistas along the river are really charming; for two or three miles the river flows between rather high rocky cliffs before it widens out near Claremont, about the half way point." (*Western Australia As It Is Today*, 1977)

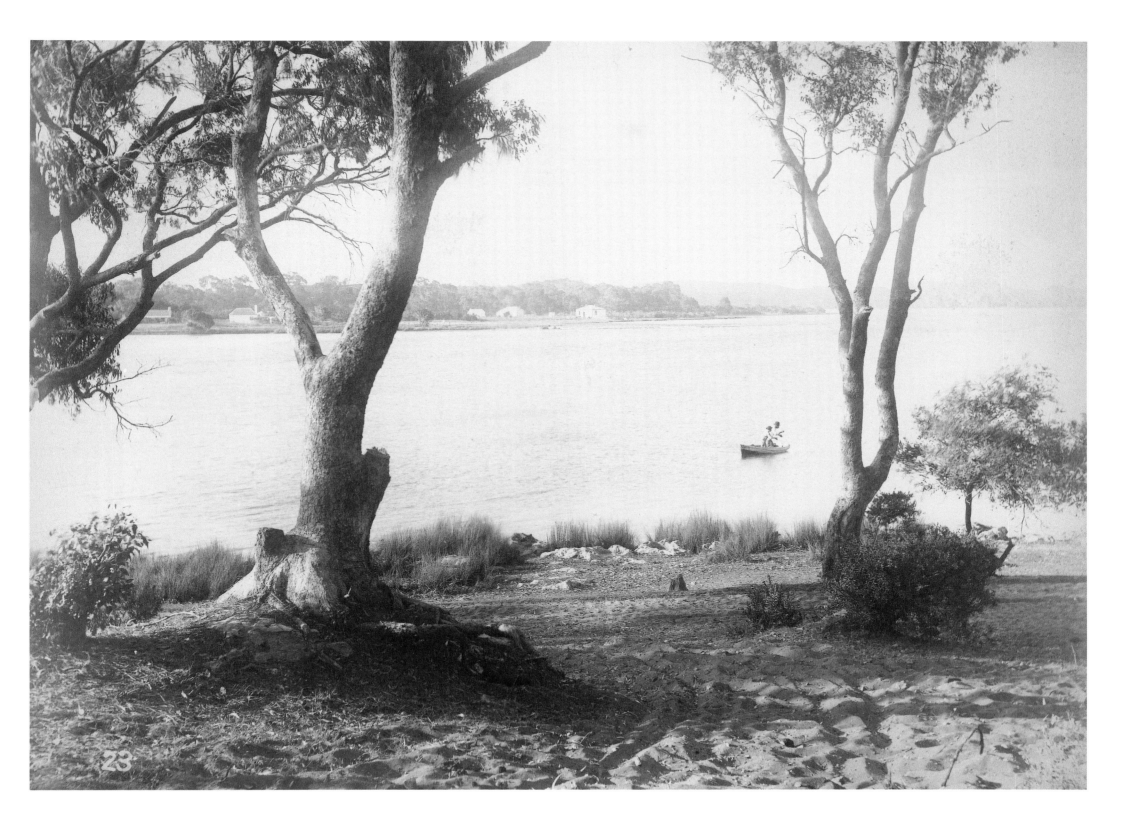

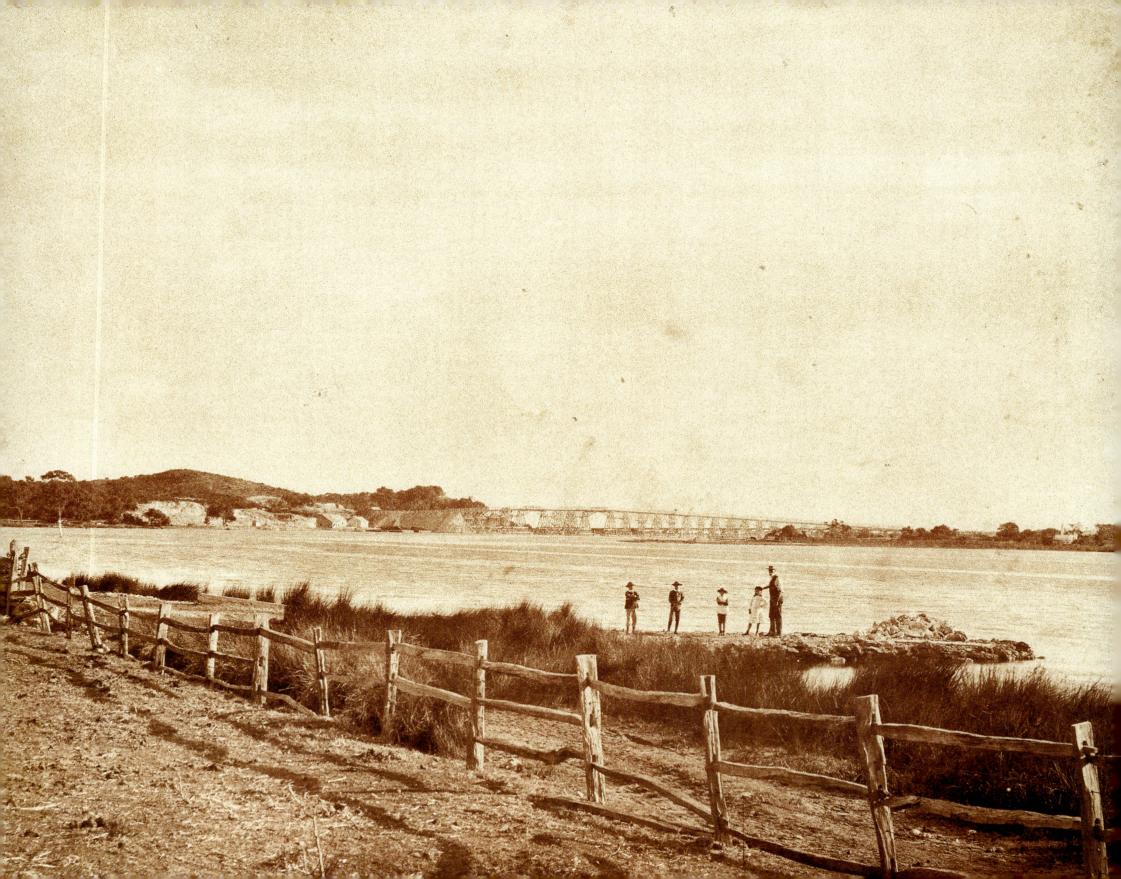

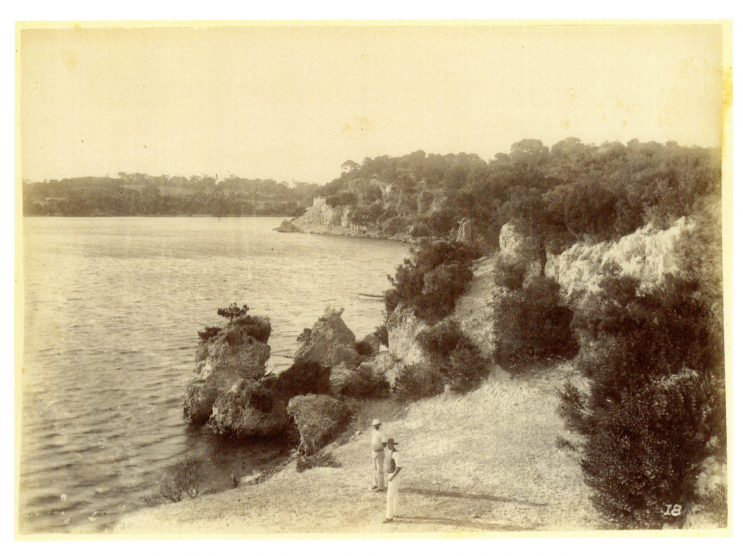

Above: Rocky Bay, North Fremantle, from the soapworks looking downriver, c1895.
Opposite: View from East Fremantle, c1890, looking back at Fremantle and the 1866 passenger bridge.

Along the River

The following account by a clergyman, Robert Lyon, who had befriended Yagan while spending time with him on Carnac Island, when he was sent there as punishment, occurred four years after white settlement began in 1829.

Instead of enmity and blood-shedding, the confidence, friendship, and good-will of the natives were gained; while their acquisition of English and a publication of a vocabulary of their language, led for a time to the most friendly intercourse between them and the settlers. This state of things would have been long lasting, had it not been interrupted by one of those wanton acts of cruelty which are ever sure to involve a community in ruin or endless trouble.

The settlers having taken possession of their fishing stations and hunting grounds, the fish and the game – the two great sources of their living – were gone. Starving for want of food, therefore, and unconscious of any moral wrong in helping themselves to the sustenance of human life, under such circumstances, wherever they could find it, a number of them attempted one morning to take a little flour from a store in the town of Fremantle to satisfy the cravings of hunger.

While in the act of doing so, two servants from a neighbouring house, without desiring them to desist, or giving them any warning, fired upon them and killed two, of whom the brother of Yagan was one – a most quiet inoffensive character, who occasionally put on clothing, worked for the settlers like a common labourer, and was much esteemed by all who knew him.

Yagan, in obedience to the immemorial usage of his country, felt that he was bound to avenge the death of his brother; and, joined by his father and the rest of the tribe, crossed the river for this purpose at Preston Point about nine o'clock, announcing his intention to the ferryman, but at the same time assuring him that he should not be touched. The whole of the natives had fallen into the error of supposing that the whites were, like themselves, divided into separate clans, and that the settlers on the Swan were a distinct tribe from those on the adjoining river. Remembering, therefore, after having fallen into the hands of the former, the kindness shown to him at Carnac, he determined to attack those on the Canning, whom he supposed to be part of the tribe that had slain his brother, and from whom he had besides received many provocations … He soon fell in with two men driving a team; and, in their death avenged that of those of his tribe who had been that morning slain at Fremantle.

Such frightful occurrences, happening one after another on the same day, threw the settlement into a state of consternation, dismay, and terror. Those in the Council who advocated hostilities, now resumed their influence; a price was again set on the head of Yagan; his father Midjegoorong was taken and shot in the midst of the capital; and others were doomed by proclamation to a similar fate.

From *Australia: An Appeal to the World on Behalf of the Younger Branch of the Family of Shem* (anonymous, but by Robert Lyon), Sydney 1839.

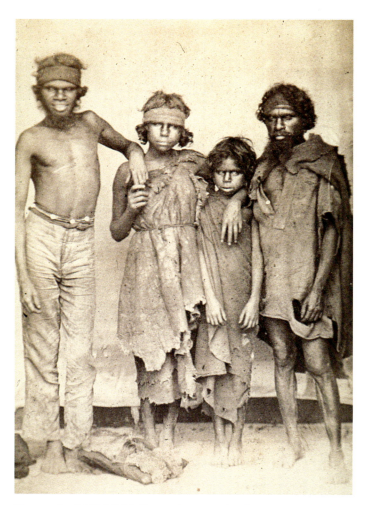

Very early (1860s) S.M. Stout photograph of South West Aborigines.

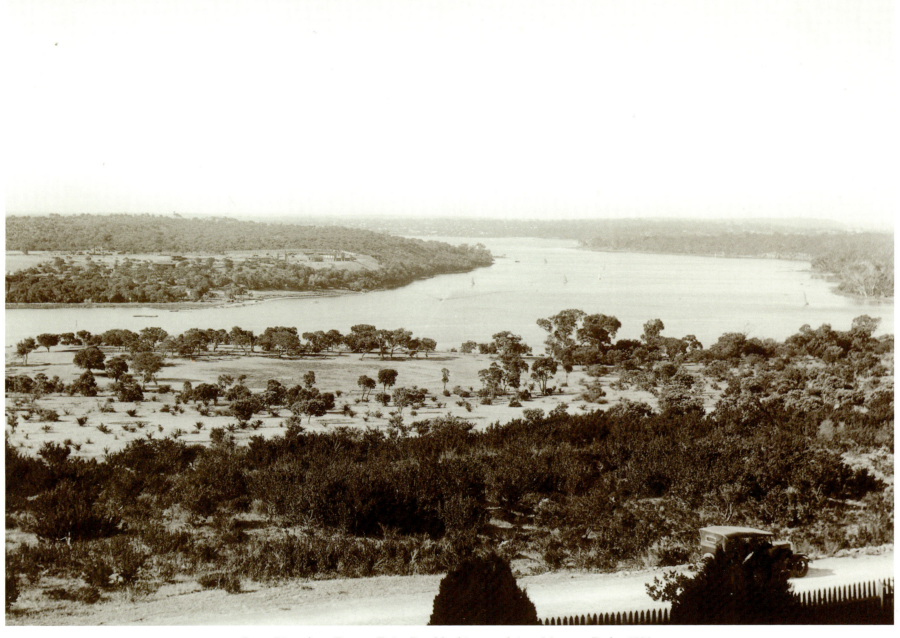
Swan River from Preston Point Road looking north into Mosman Park, c1920.

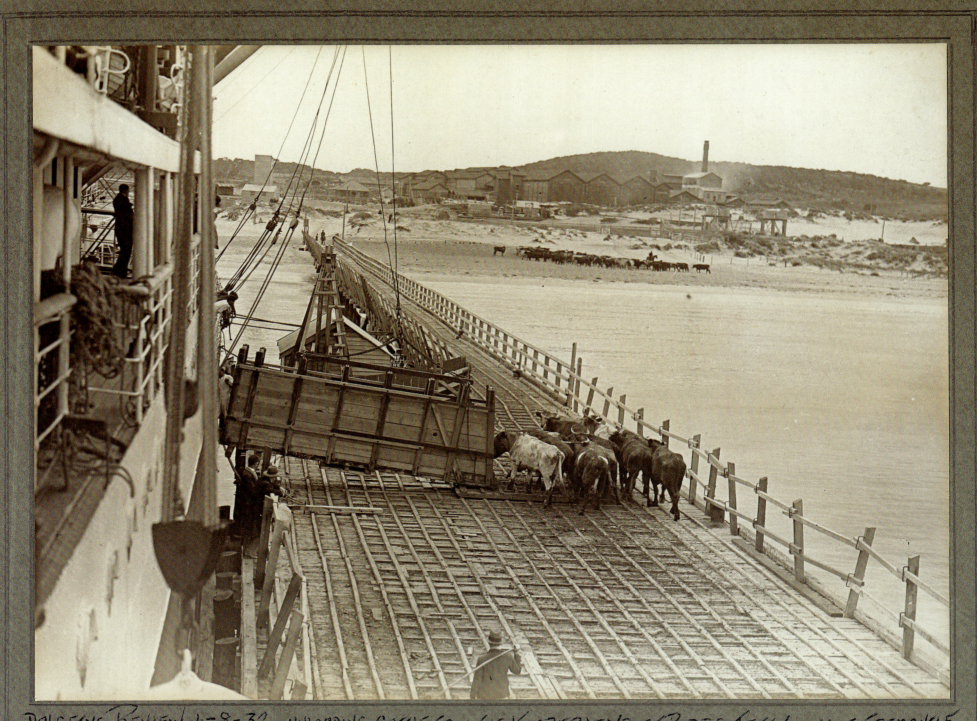

Dalgety's Review 4-8-32. Unloading cattle from the Kimberleys at Robbs Jetty south of Fremantle. W.A. Meat Works in background.

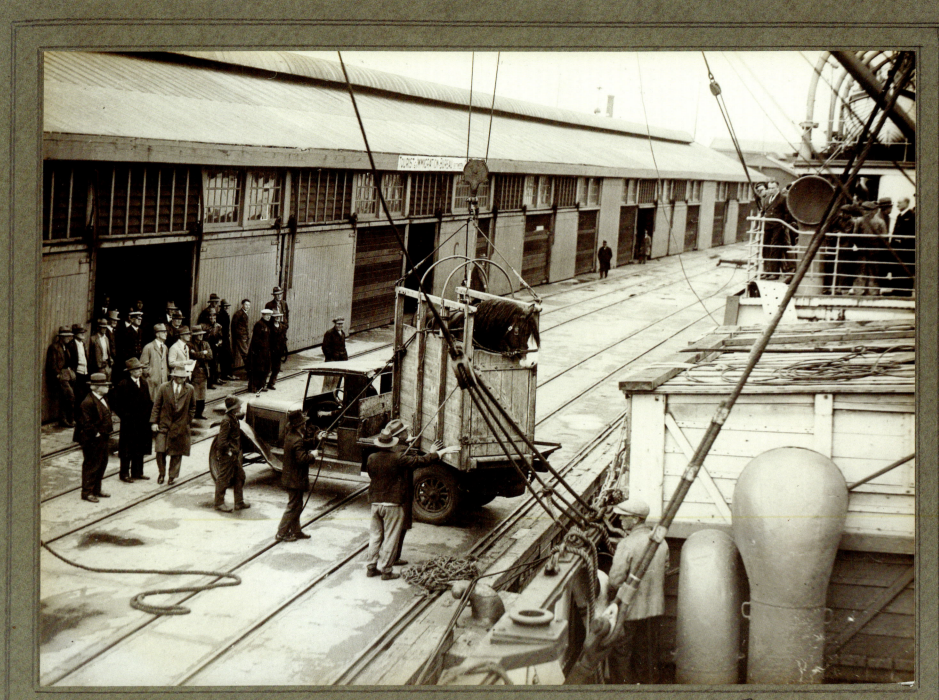

Unloading a (imported) famous stallion as shown by the large crowd of stock agents present on ship & wharf. George Booth and Sons the handling agents. C. Shed Victoria Quay. 1 ton Chevrolet truck

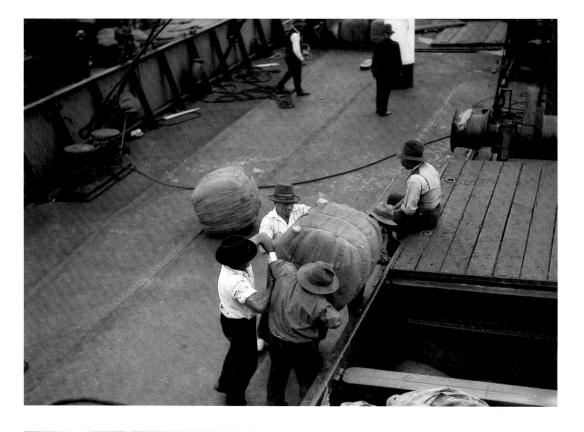

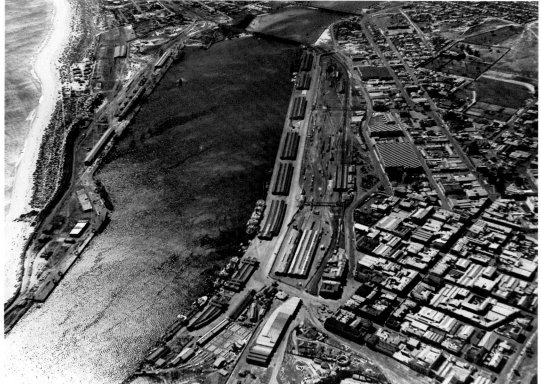

Upper left: Lumpers (well, most of them) loading bales.

Left: This 1930s aerial view highlights the heavy use of cargo sheds and rail for freight. Port Beach is here unaffected and Arthur Head, at the bottom of the photograph, still has its guns and much more of its headland than today.

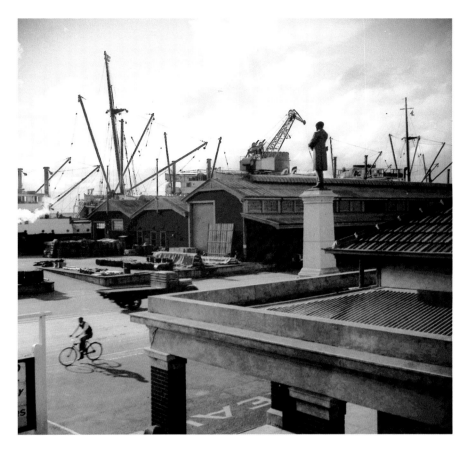

Above right: Looking from the footbridge, 1939, over the immigration and tourist building to the wharf area between "C" and "D" sheds. C.Y. O'Connor's statue gazed from the front of this immigration and tourism precinct for half a century before being moved in 1974 to the front of the new Port Authority building. This important precinct was created in 1928 and extended in 1945 with the addition of cafeteria facilities for wharfies – on orders from the Prime Minister during World War II to reduce industrial strife. The precinct linked directly into the heart of Fremantle via the footbridge to the railway station and Market Street.

Right: The main immigration and tourist building in 1933. The original "Government Immigration Office and Information Bureau" had been built in 1906 on the wharf between "B" and "C" sheds and was moved to this location in 1912. Much of the original building survives today within the above structure, which here has an added colonnade.

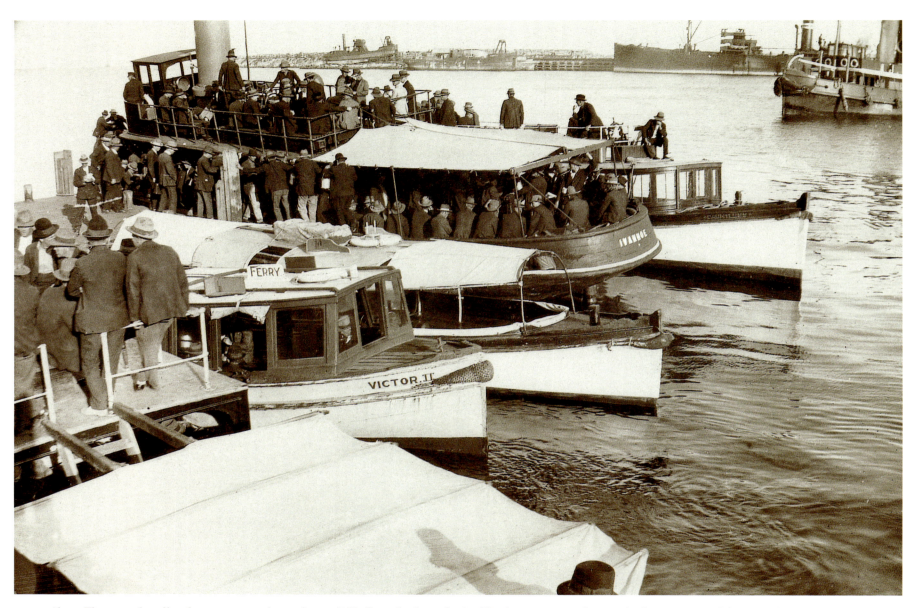

Above: The cargo handlers become cargo themselves, c1930. Cross-harbour ferries like these were used to get the lumpers to and from work on North Quay. *Victor II* and the *Ivanhoe* were Harbour Trust owned and the others privately chartered. The 1912 tug *Wyola*, in operation for fifty years, can be seen on the right. At the rear left the original slipway, abandoned in World War II, can be seen in use. A very effective snapshot by an amateur photographer, George Davidson (1892–1988), who worked nearby in a shipping office. *Opposite:* The Ferryman. A warm and empathetic human portrait by Saxon Fogarty, c1935.

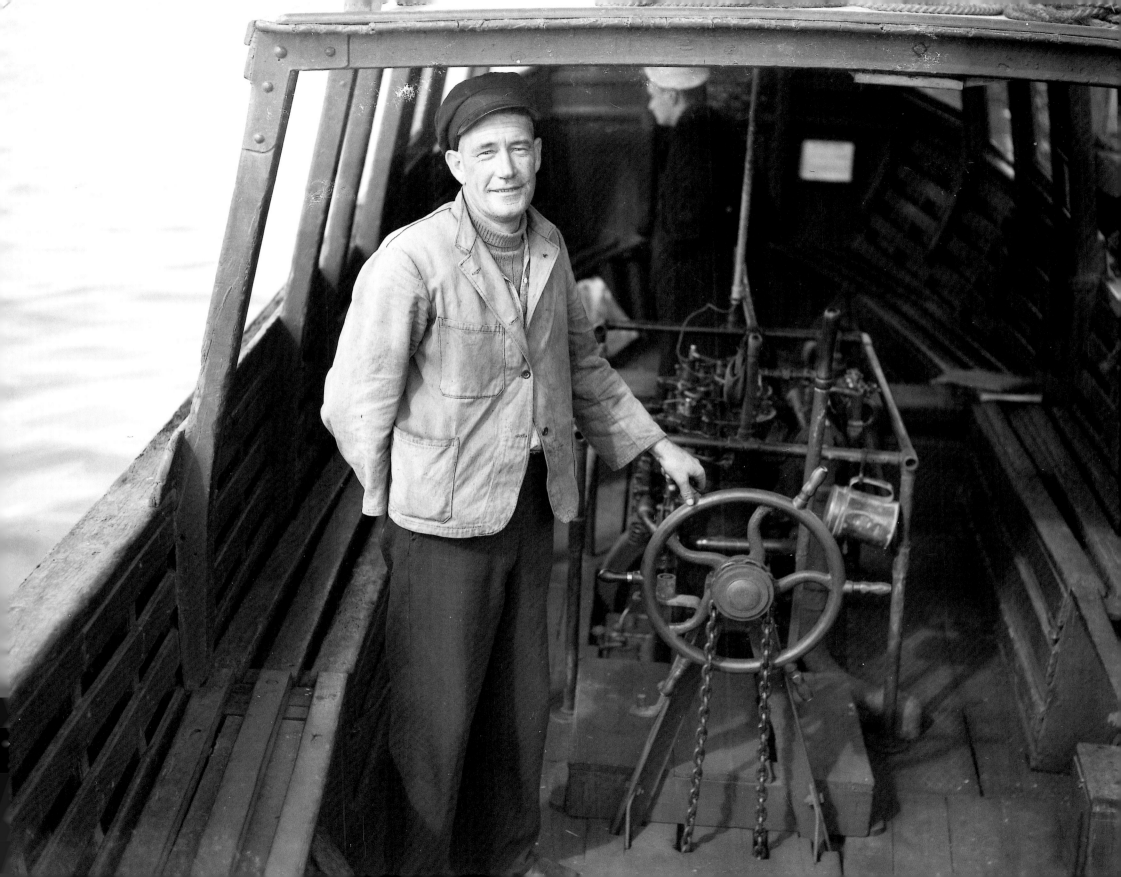

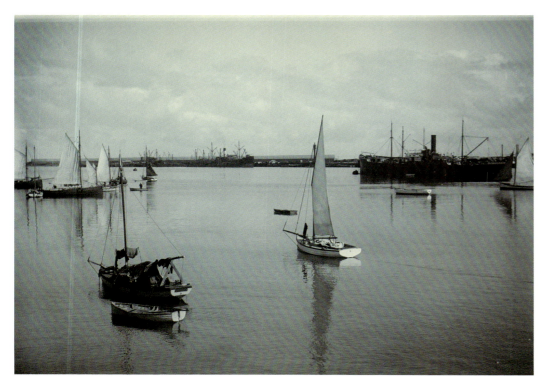

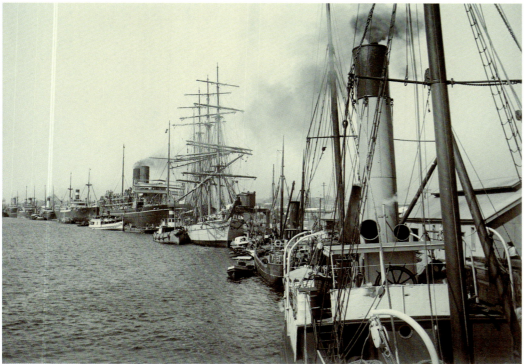

Above left: Fishing fleet inside harbour, c1905.

Left: Crowded harbour, c1905.

Opposite: Victoria Quay just after World War II – the tanker still has a gun on its bow. Behind the gun, profiled against the sky, is the 1942 "Hospital Silo," so named because it was used to treat infected grain. A secret communications base was run twenty-four hours a day during the war from the top of the silo by US and Australian military. Most of the trucks pictured are ex US World War II vehicles.

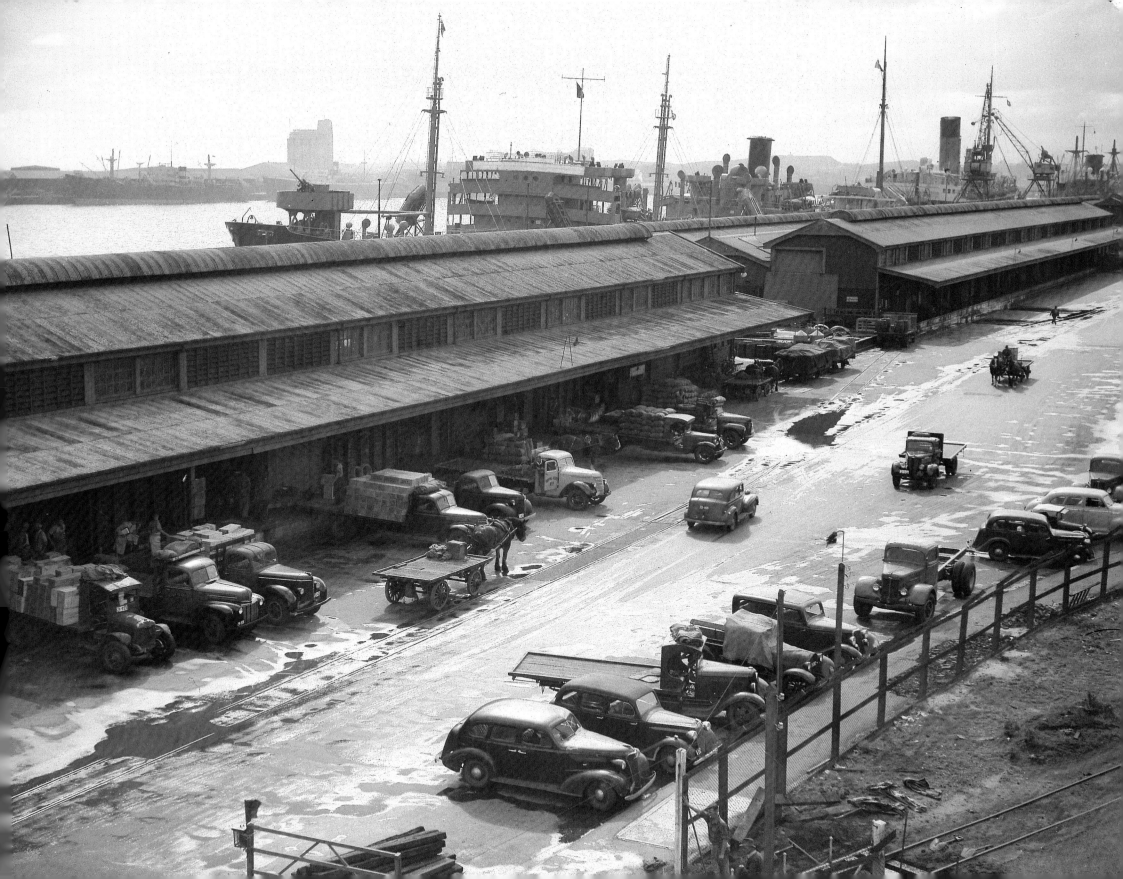

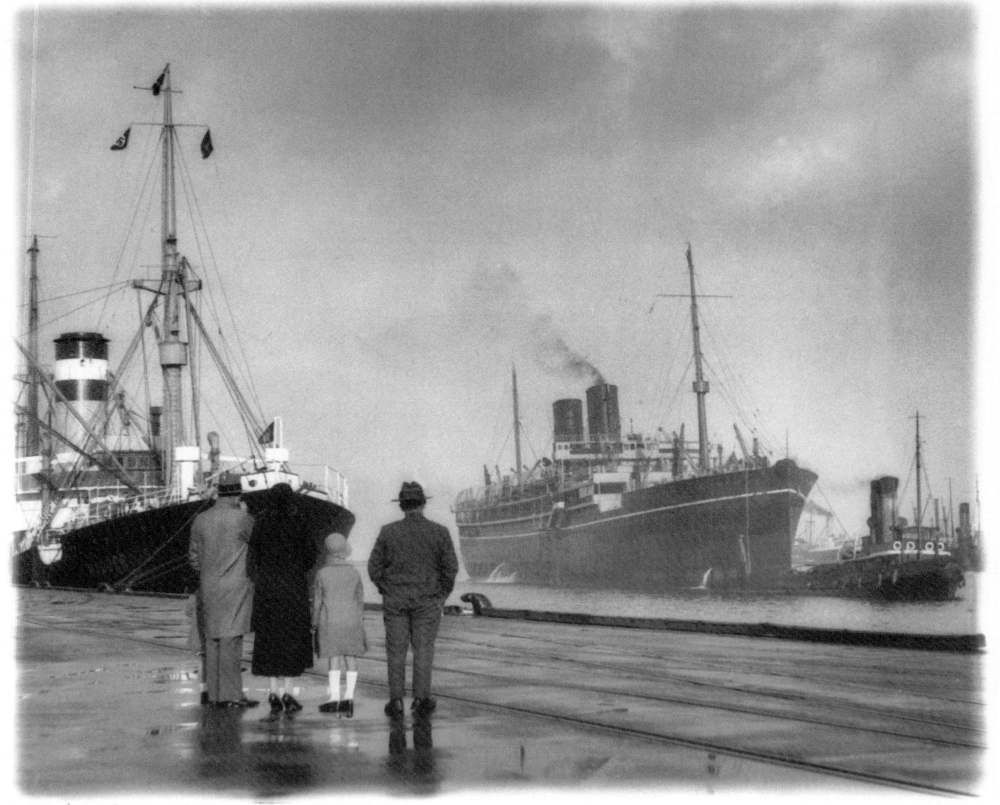

Early Arrivals — F.W. Flood

Frank Hurley in Fremantle. Between 1946 and 1956 the famous photographer covered 400,000 kilometres on a photographic odyssey around Australia. In the crowded harbour., foreground, are army boats near "H" Shed. *Maureen*, the closest one, later became the VIP boat *Challenger*. The floating crane is the *Pelican*.
Opposite: Another renowned photographer at work in Fremantle harbour. This is one of Fred Flood's most powerful compositions, showing the arrival of a P & O liner in the 1930s. Flood arrived in Fremantle as a migrant in 1912 and returned often to photograph the port. His photos of run-down buildings around Fremantle are in contrast to this strong image of a flourishing waterfront .

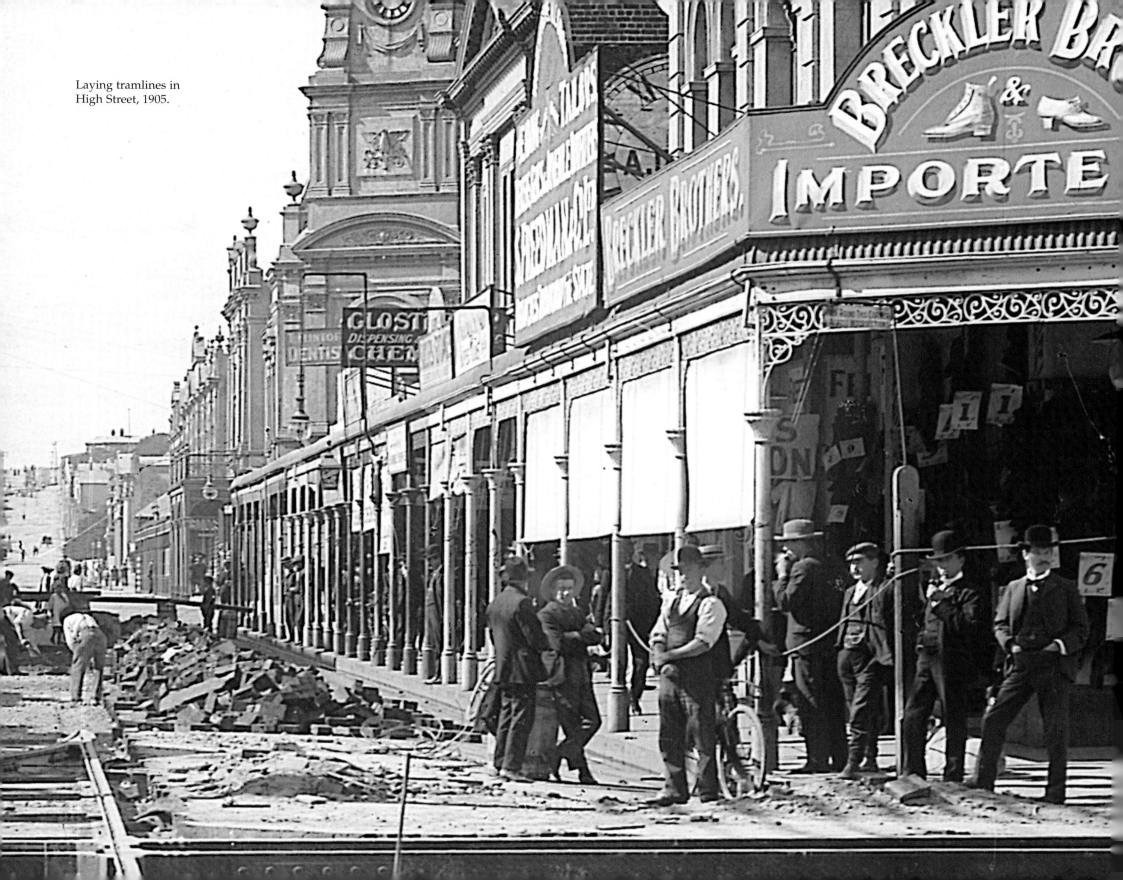

Laying tramlines in High Street, 1905.

City

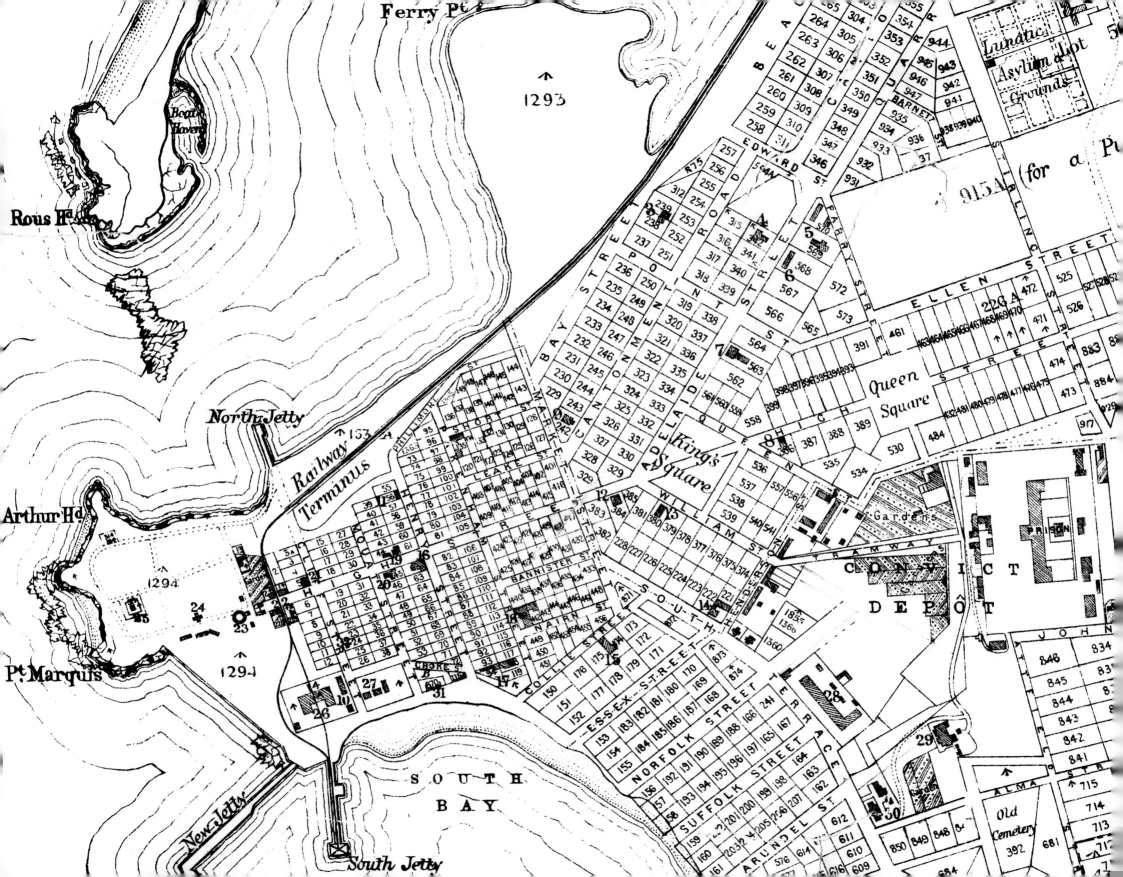

REFERENCE

1 Tannery	2 Lunatic Asylum
3 C.E. Parsonage	4 National School
5 R.C. Church	6 Convent
7 Ind.t Chapel	8 Infants' School
9 Wesleyan do.	10 Com. Office
11 Castle Hotel	12 Port Hotel
13 Odd Fellows' Hall	14 Freemasons' do
15 Port Flour Mill	16 Emerald Isle dc
17 Custom House	18 Flour Mill
19 Post & Tel.n Office	20 Victoria Hotel
21 Private Hotel	22 Police Station
23 Gaol	24 Light House
25 Powder Magazine	26 A Store
27 Water Police	28 Military Barracks
29 The Knowle	30 Gov.t House
31 Freemasons' Hall	32 "Herald" Office

Opposite: Plan of the Town of Fremantle. This is a c1885 updated version (ref. 24/7/16) of the August 1877 Surveyor General's map by C. Woodhouse. The main change is that the railways have taken away the Recreation Ground for their terminus, next to the North (or River) Jetty. This was the continent's westernmost railway station, and it handled the gold-rush traffic until a new station (the current one) was opened in 1907.

Page 79: Tourist guides like these encouraged travel to places like Fremantle. The Steamship Company Howard Smith's *Tourist's Handbook of Australia* of 1904 waxed lyrical: "The blue light on the Fremantle breakwater is the last thing the patriotic Australian watches as he leaves his land for Europe. The glittering white lights of the town itself, resting like a diamond diadem on the brow of Australia, are the first thing he sees when the engines of the homecoming mailboat stop … For twenty-four hours he has smelt the perfume of the bush, and Westerner or Easterner, he looks to Fremantle as home." Still, the guide called the Fremantle town hall a "stucco abomination."

Fremantle – What's Left?

Most of the thirty-two significant places listed on the adjoining map have disappeared. Money from the gold-rushes of the 1890s rebuilt the town.

What survives? From the left (23) remains, known now as the Round House; (26) is the former Commissariat, now the Maritime Museum's Shipwreck Galleries; the Freemasons' Hall (31) still exists; the Flour Mill (18) remains in part; the Wesleyan chapel (9), the 1841 chapel built over to make Wesley Hall, has gone, though the 1889 church built after this map was compiled remains alongside the site; the National School (4), originally built in 1854 and known to most as Fremantle Boys' School, continues to exist as the Film and Television Institute; the Lunatic Asylum (2) remains minus its forecourt; the Freemasons' Hotel (14) was remodelled as the Sail and Anchor Hotel; and the House for Comptroller General Henderson of the Convict Depot (29) is now swallowed up into Fremantle Hospital.

The Legibility of Fremantle

The map shows a compact and clearly legible layout with High Street as the spine of the city and strong connectivity between the city and the Convict Depot, which was seriously affected by the building of Parry Street in the 1970s.

Fremantle – An Outsider's View

Our Round House: "A stone gasometer."

In 1870, just after the following outdoor photographs of Fremantle were taken – the first ever – this unflattering report appeared in the Melbourne Argus *on 26 February.*

Many natural drawbacks combine to render Fremantle very objectionable as a port, and I should deem it hard to settle upon any situation which appears less promising. The town is built at the mouth of the Swan River which is here but a shallow stream, 500 yards across, sluggishly winding its way between banks of sand contiguous to a flat and desolate sea beach. The site is very low, and may probably at one time have formed the ancient channel of the river. It is partly sheltered to seaward by a mound of limestone rock, called Arthur's Head, upon which is built the lighthouse; at the back of the town rises a big sandhill, sparsely covered with stunted bushes and shrivelled grass, and surmounted by a limestone obelisk put there for a guide to the anchorage for ships.

The town is closely packed within a very small space; the streets are narrow, laid off at right angles, and thickly built in with houses and stone fences; the houses are constructed of a dingy colored limestone, that gives them a rough and bleached appearance; they stand in close rows with square fronts and naked walls, with nothing to relieve their distressing whiteness.

Fremantle is truly a queer-looking place, not young and growing like most colonial towns, but old and withered, already showing signs of premature decay … a blinding glare pervades the place … and the dazzled street walker stumbles blinking on his way, while looking for shade or relief in vain.

High Street, the busiest thoroughfare, is only about a quarter of a mile long. At one end of the town stands the church of England, a low stone building, with a truly pepper-box tower; at the other extremity the street runs straight against Arthur's Head, and ends in a tunnel through that promontory. Flights of stairs cut in the rock, lead up to an elevated terrace overlooking the town, crowned by a low round building, something like a stone gasometer, but which turns out on inspection to be the "lock-up." The outlying town allotments, at present mere mounds of sand and heaps of rubbish, are capable of growing the vine and the olive.

The population of Fremantle is reckoned at 3,000 out of which number, I should think, a very considerable proportion are still under the 'surveillance' of the police. Ticket-of-leave men are not allowed to be out after 10 o'clock at night, and at a quarter to ten a bell tolls, giving timely warning. At that awful sound, a general stampede of 'ticketers' takes place, and in a few minutes the streets are deserted, and the unrecognized stranger who indulges in an evening stroll may possibly be stopped by some inquisitive officer of the watch, and made to answer to the challenge "Bond or free?"

Another Whinger

At about the same time, a letter to the editor in the local press – "Cornstalk," The Express, 2 February 1870 – also carried some strong comment:

I think one reason why casual visitors imbibe such an unfavorable opinion of the colony, is to be found in the indolence of your people at Fremantle … What sort of an opinion of the fertility of the colony is likely to be formed by a stranger when he sees Fremantle? – a mere sandy waste, covered with a few good houses, a great number of wooden shanties, unfenced plots of drift sand, and a stray fig tree, or a scraggy vine scattered here and there … A man's misfortunes should entitle him to pity.

But you are not so situated; I have travelled much and never, during the whole course of my wanderings, have I seen such unpromising soil bear such luxuriant fruit. There is not a plot of ground in Fremantle but what might be made to carry fruit trees; and setting all considerations of profit on one side, just think how a number of trim well kept gardens would add to the beauty of your town. But what does he see now? A number of uncultivated plots of waste ground – covered with stones, broken bottles, empty jam pots, old rags, and a goodly quantity of bones!

You tell the man of means that there is plenty of good land for the asking; and the poor man, that by the exercise of industry he may soon grow a rich one. Neither one nor the other believe you. You have no books descriptive of the place; you possess no channel through which to transmit reliable information.

The Fremantle Recreation Ground

The recreation ground was highly valued by locals at the time the photograph opposite was taken, some ten years before the railways gobbled up the space for Fremantle's main terminus.

James Manning's daughter wrote: "Immediately opposite the jetty was the cricket-ground – a spot beloved of all the young people. Not only did its soft couch-grass sward provide a place for the sport, but, every evening, it was the social gathering place for all who wished to take the air and walk or talk with their friends. Every Friday evening, too, the newly formed Volunteer Band lit up the field and provided music for the strollers. Seats were there for those who wished to sit and listen."

Facing the field lived Mrs Agate. "Behind her glass-enclosed verandah all the ladies of Fremantle would congregate to watch the cricket matches and rejoice when Fremantle won. We did not 'barrack' in those days. The most one could then do to mark appreciation was to flutter a white handkerchief."

Charlotte Elizabeth Vigors Lochee was born in 1855 and married Edward Shenton, George's son, in 1876. At the time this photograph was taken she was a regular visitor to the Shentons' summer house. She reminisced about a visit in 1869 when she was fourteen:

"I was staying with Mrs Shenton and her daughters in their summer home; they went to Fremantle for all the summer months. In the evenings Mrs Shenton and her great friend Mrs Helmish would take us to sit on the river jetty to listen to the band playing on the green. On a cool, still, moonlight night it was like looking into Fairyland to sit on the edges of that river jetty and look down into the pale green water and see the moon and stars reflected in it; also fish and crabs swimming and floating about, and jelly fish and different coloured sea-weed, also small rowing and sailing boats floating gently on the water.

"In the afternoon we often went on the green to watch the cricketers practising. They had a beautiful cricket pitch and large grounds on that old green on the bank of the river where the railway station now is. Fremantle (I was always told by her people) had the best cricket players in any West Australian club. The only names of the players I can remember just now were Rosser, Newman, and Dr Attfield, who was their wicket-keeper. [Attfield had arrived in 1854 to be the medical officer at the Convict Establishment, where he remained until 1879. For most of that period he was the only doctor in Fremantle.]

"The Shentons' house was a large two-storied one with large rooms and very thick walls made of stone, which kept it beautifully cool. It was built by a Mr Humphrey, who only lived there a short time and then returned to England, as his wife did not like the life in Western Australia. It is now Dalgety's in Cliff Street. The ladies bathing place was beautiful, with a lovely hard white beach, below Arthur's Head, almost in line with High Street. Most days we bathed both morning and afternoon. We had great fun learning to swim and float. We wore a thick garment half way down to our ankles."

Opposite: At some time prior to 1868 Alfred Stone took this photograph of a group of buildings facing Cliff Street of which the centrepiece is the summer house of his friend George Shenton. The view is from across the Recreation Ground. S.M. Stout took a similar photograph around the same time, though a study of the vegetation in the images suggests that Stone's is earlier.

Because of its provenance, composition, and historical interest, it is possibly the most important early photograph of Fremantle. The foreground is a rare view of the Fremantle Recreation Ground, which the locals lost upon the arrival of the railways in the 1880s. With its unusual pillars, Shenton's house stood on lot 3a, Fremantle, which marks the corner of Cliff and Phillimore Streets. When Shenton, who became the richest man in the state, opted for year-round residence in Perth, the Adelaide Steamship Company used the building for its offices. The firm moved to Mouat Street in 1901, and the house and the stables to its right were demolished two years later and replaced by the Elder Building, which still stands.

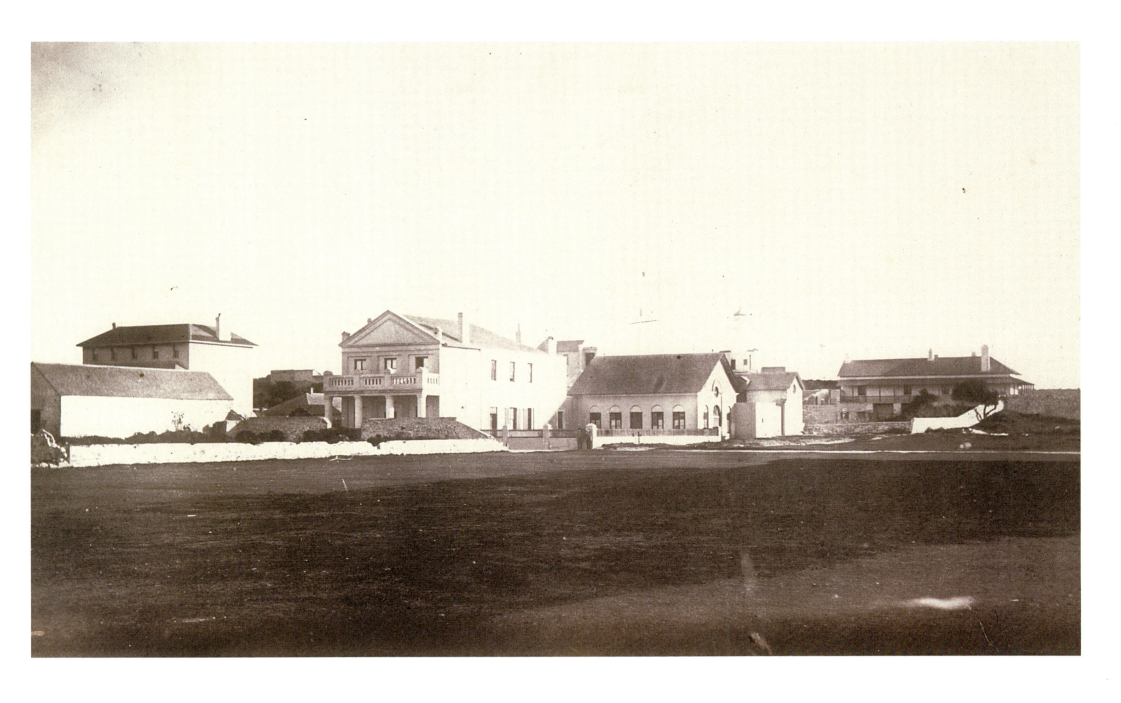

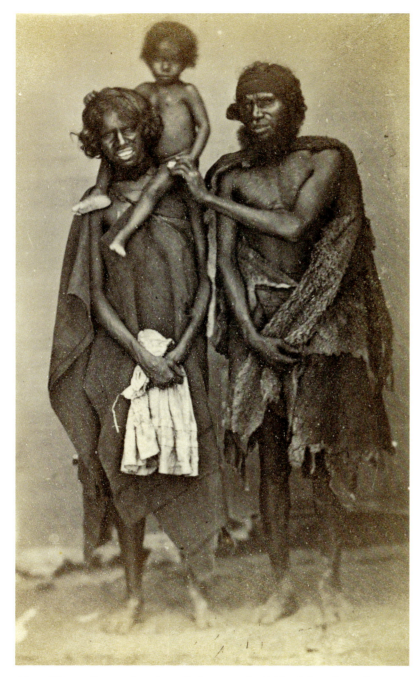

Above: The earliest authenticated photograph of Aborigines from the Fremantle area, taken by Stout around 1864. The adults wear kangaroo-skin cloaks, or *boukas*, made from several skins sewn together. These were worn in cool weather with the fur on the inside.

Opposite: The Lunatic Asylum, now the Fremantle Arts Centre, built 1861, photographed around 1865. According to the Fremantle *Express*, in its edition of 22 July 1870, "Our town has no public buildings with any pretensions to architectural beauty except perhaps the Lunatic Asylum."

Stephen Montague Stout
Fremantle's pioneering photographer

The following section of the book contains most of S.M. Stout's known photographs, which are, along with a couple by Alfred Stone, the earliest taken of Fremantle.

These images exist in what is known as the Clifton Album, the first half of which contains the earliest known photographs of New Norcia Aborigines, while the second half covers Fremantle. Stout had taught some of the Clifton children while in Australind, though how this album ended up with the Clifton family is a mystery. Who took the New Norcia photographs? The possibility that Stout was responsible is rather dashed by a stamp on one of them reading "Manning and Knight, Perth." The same problem does not exist for the scenes of Fremantle, as Stout's name appears on the reverse of many.

In 1856 Stout had been convicted of forgery in England. The London *Times* reported that, in passing sentence of fourteen years' transportation, the Recorder stated "that the prisoner was a most dangerous man to be allowed to remain in this country, and that it was his duty to remove him from it." Aboard the convict ship, Stout edited a weekly paper called "Life Boat" and gave lectures. His interests in journalism and teaching formed a prominent part of his subsequent life.

Despite his lengthy sentence, he was granted a ticket of leave in the year following his arrival, and went to teach in Australind. In about 1861–1863 he ran the Fremantle Academy in High Street, with twenty-five boys, and gave public lectures. The *Perth Gazette* reported on 15 November 1861 that, with the band of the Royal Engineers in attendance at the W.A. Rummer's Assembly Rooms in Fremantle, he lectured on "The discovery of gold," Arthur Shenton having found some at Northam.

In 1864 he opened a photographic studio in Henry Street "opposite the late Castle Hotel." It was probably around this time that he took the following photographs, because by 1868 he had returned to Australind to get married and work as a photographer. In 1872 he opened a studio in Perth, though by the following year he was back in the classroom. In 1876 he combined his lecturing and photography to give a magic lantern show in the Perth Town Hall, and in 1878 he headed north to teach in Geraldton before becoming embroiled in another embezzlement controversy. The 1884 *Almanack* lists him as a journalist in Fremantle, but it was in Perth in 1886 that he dropped dead while walking past the hospital.

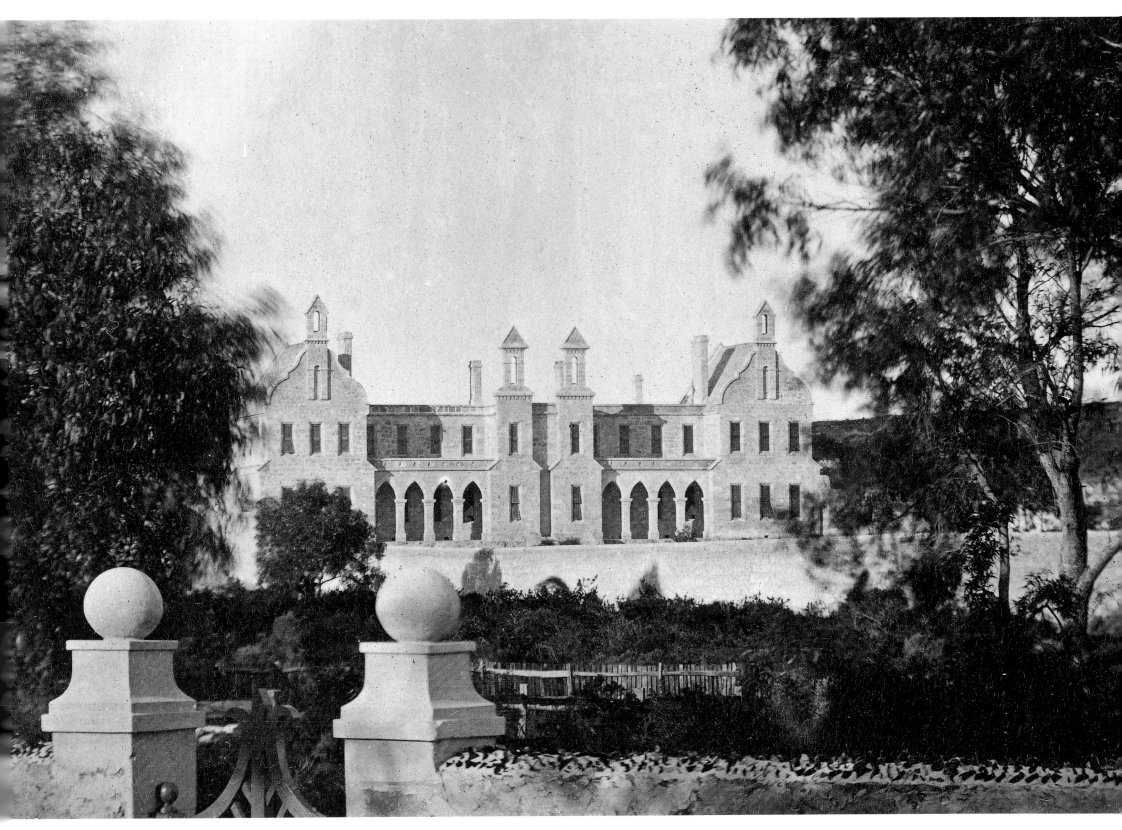

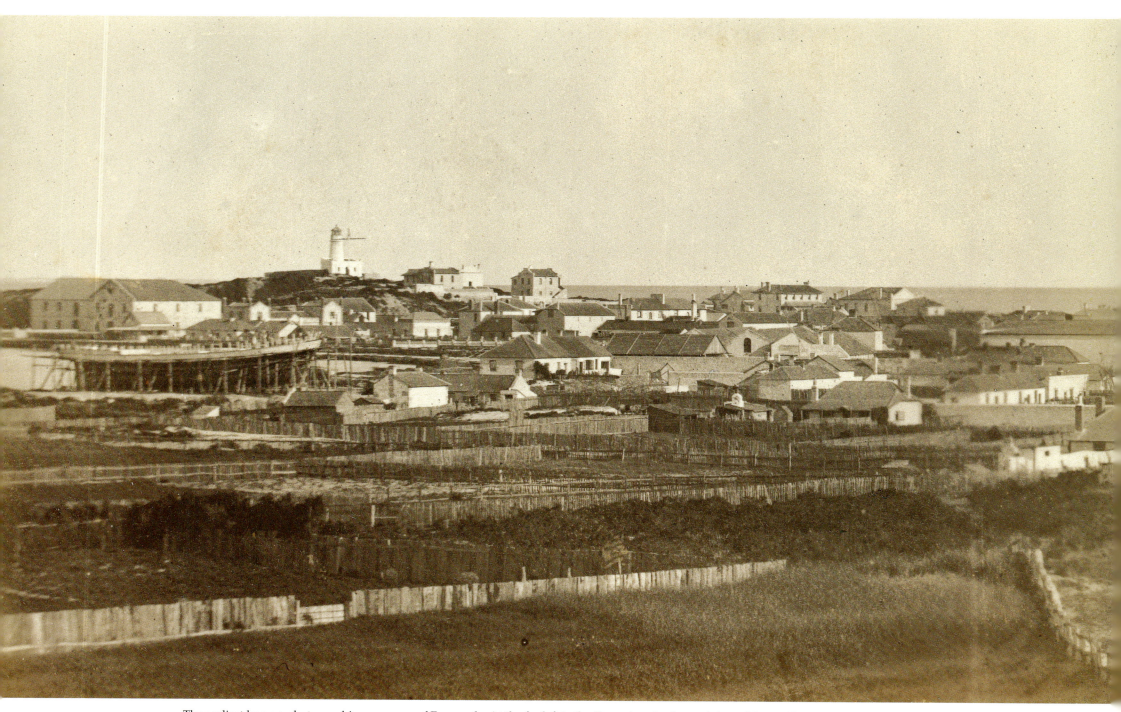

The earliest known photographic panorama of Fremantle. At the far left is the Commissariat; beneath it, on Marine Terrace, stands a boat-building cradle. The highest feature is the first lighthouse, on Arthur Head; to the right the first and second courthouses straddle the Round House.

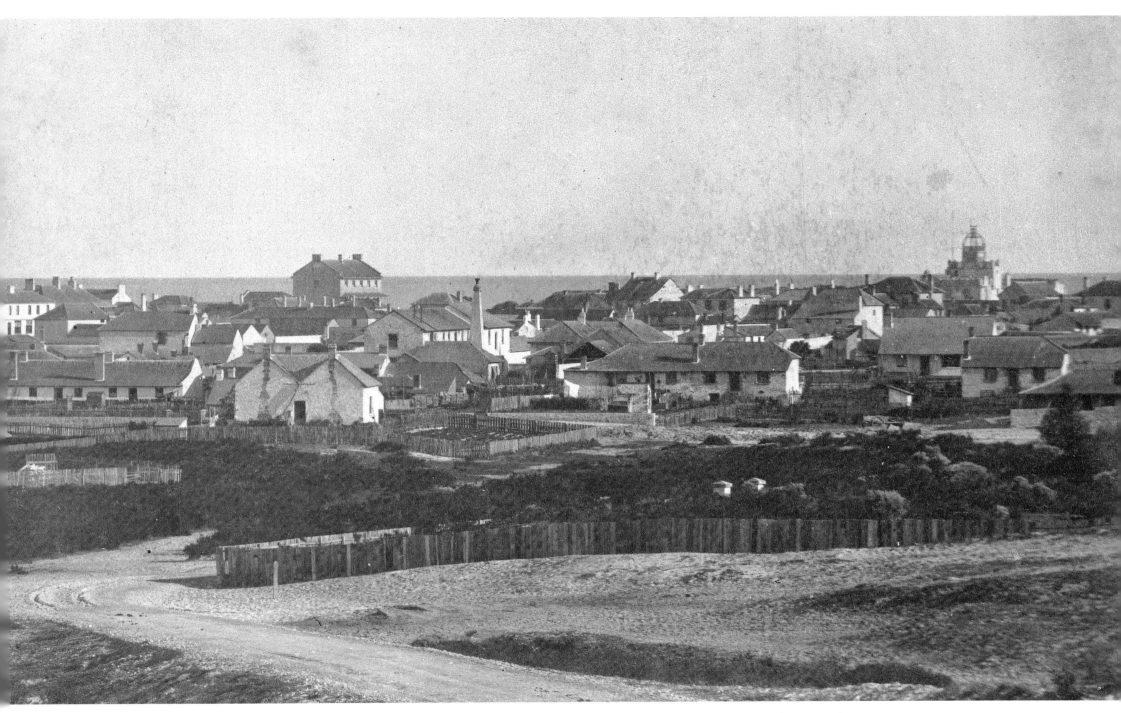

In this second photograph of Stout's panorama the two dominant buildings are the Castle Hotel in Henry Street – which was across the street from the photographer's studio – and, further right, Manning's Folly (see page 95).

Stout's *Cartes-de-Visite*

In 1854 Frenchman André Adolphe Disderi patented a way of taking a number of photographs on one plate, usually eight, thus greatly reducing production costs. Stout used this technique. The *cartes-de-visite*, as they were called, measuring 4 x 2½ inches (about 10 x 6 centimetres), became phenomenally popular. Introduced as visiting cards, they soon filled family albums, where they were protected from the light. The egg whites and common salt used in these albumen prints imparted a lustre and warmth that ushered in a new era of glossy photographs.

The Stout image on the right – a view east over Cliff Street to the prison warders' cottages – is printed in the original *carte-de-visite* size. Beneath it are "thumbnails" of six others featured in the following pages, while the bottom two appear only here. Altogether the photographs reproduced on pages 84–94 are nearly all the Fremantle *cartes* in the Clifton Album, each of which appears to have been taken around 1865. All of Stout's pictures, bar the ones at the top and bottom adjacent, are reproduced, like many others in the book, at a greater size than the original because they are worth looking at in more detail. The six on the following pages are presented as rare items without the intrusion of captions.

Page 89: When Governor Hutt rode his horse from Perth in 1843 to open Fremantle's first Church of England church, the whole of Western Australia was part of the diocese of Adelaide. Fremantle's first rector, George King, also rode his horse long distances, and he established a mission for Aboriginal children in Fremantle. The church was positioned to face down High Street to the Round House on "Gaol Hill," thus positioning "God" at one end and "the Devil" at the other. The Revd John Wollaston, asked his opinion of St John's, said: "The style, I suppose, must be called Western Australian."

Page 90: Arthur Head. At the centre is the Round House, built as a prison in 1831. Beneath it is the 1837 whalers' tunnel, on either side of which are police buildings, and Lionel Samson's house is left front. Charlotte Shenton recalled: "Fremantle should have been called White Town, for everything was white; the roads were made of white limestone, the houses and walls round them were built of the same stone or whitewashed, the steps up to the Round House were white, everywhere you looked it seemed to be white, except for Arthur's Head, which was green." (*The West Australian*, 21 December, 1935)

Page 91: The Convict Establishment, later known as the Fremantle Prison, dominated the town when it was completed in 1859.

Page 92: Original 1853 Congregational chapel and the Revd Joseph Johnston's manse in Adelaide Street.

Page 93: Roman Catholic presbytery (left), church, and convent.

Page 94: High Street. Left to right - the Albert Hotel, Leach's store, and a vegetable stall. Charlotte Shenton recollected Leach's store from the 1870s: "Miss Leach had a fancy shop. Hers was in High Street, and it was a very fashionable resort for children and their elders of both sexes. She was just as nice to children as to grown-ups. We all loved her China ornaments, which were not beyond our purses." (*West Australian*, 21 December 1935)

Bottom left: High Street looking west. Misattributed by the Battye Library to Nixon, and also misdated.

Bottom right: The Government Cottage, also known as the Residency. Eagle-eyed viewers comparing this with a similar view (page 26) taken a few years later, around 1870, will note that the building on the left, the first courthouse, does not have the verandahs that were added when it became the residence of the Harbour Master. Other minor differences in gates and growth of vegetation help reveal the date of the photograph.

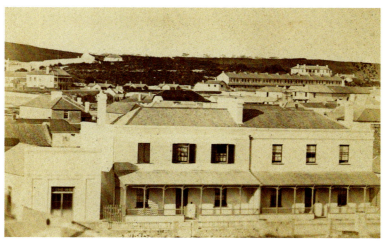

 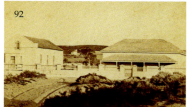

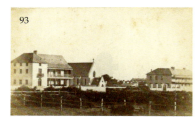 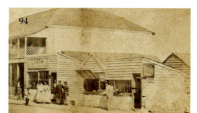

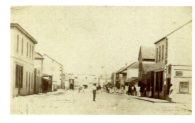 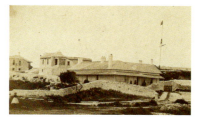

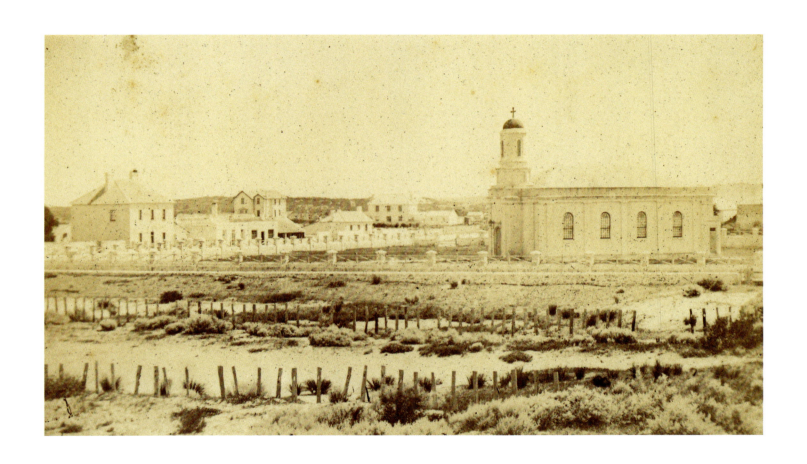

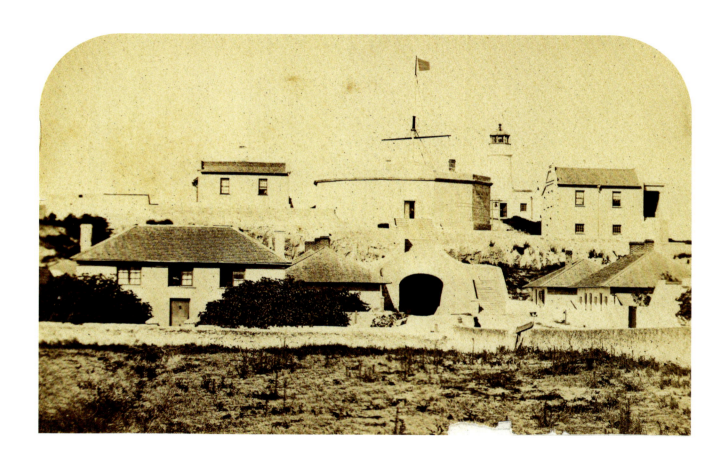

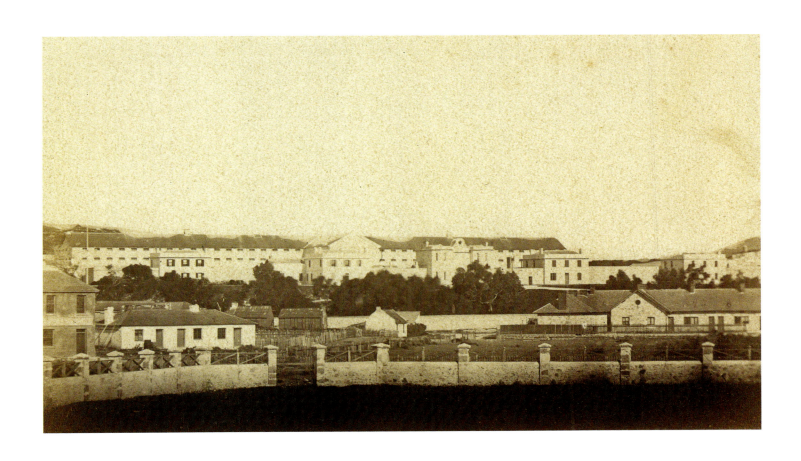

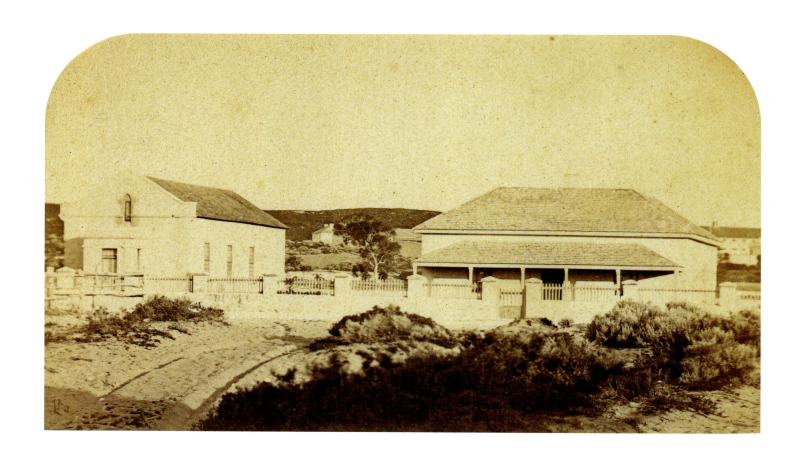

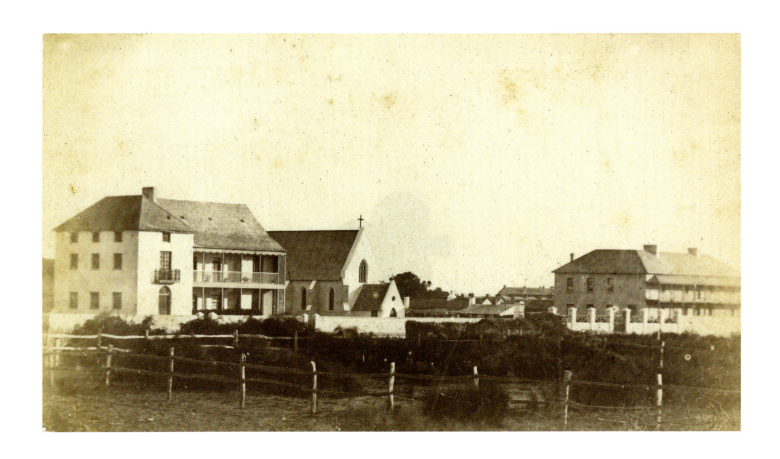

Alfred Hawes Stone was Registrar of the Supreme Court in Perth when he took this photograph around 1865. An unsightly structure that dominated the Fremantle skyline for many years, it was built in 1858 by Charles Alexander Manning on the corner of Pakenham and Short Streets. It was intended as a sanatorium, or health resort, for Indian officers, who had the good sense to stay away. Manning, who became the largest landowner in Fremantle and established "Davilak" south of Fremantle on 700 acres, spent so much money on this that it became known as "Manning's Folly." It had a private observatory on the roof, and was intended to have extensive quarters for his large family. Manning was Chairman of the Fremantle Town Trust 1859–1867, and thus the town's first rate-collector and record-keeper. He promoted decimal currency a hundred years before its adoption, and acted as Consul for France. He originated the Fremantle Volunteer Defence Force in 1861 and, because he held a liquor licence, was able to dispense free rum to entice volunteers. After Manning's death in 1869, his wife went off to the local asylum to spend the rest of her days. The building was a liquor warehouse for Tolley's during the gold-rushes. It was demolished in 1928.

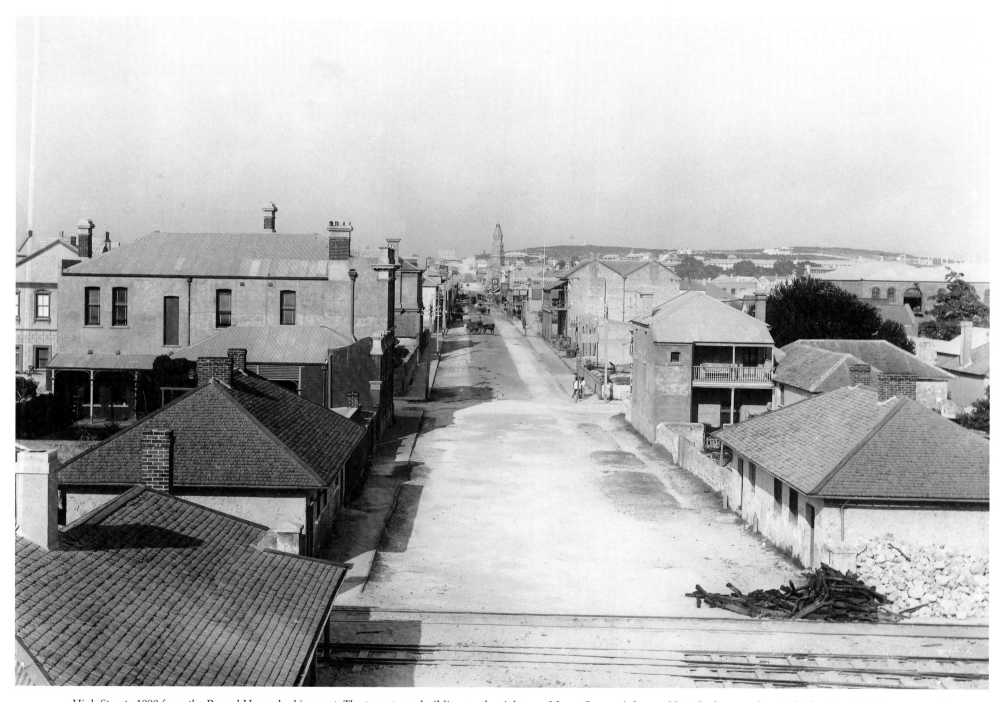

High Street c1890 from the Round House looking east. The two-storey building on the right was Mayor Samson's house. Note the large anchor in the front yard of the next premises.

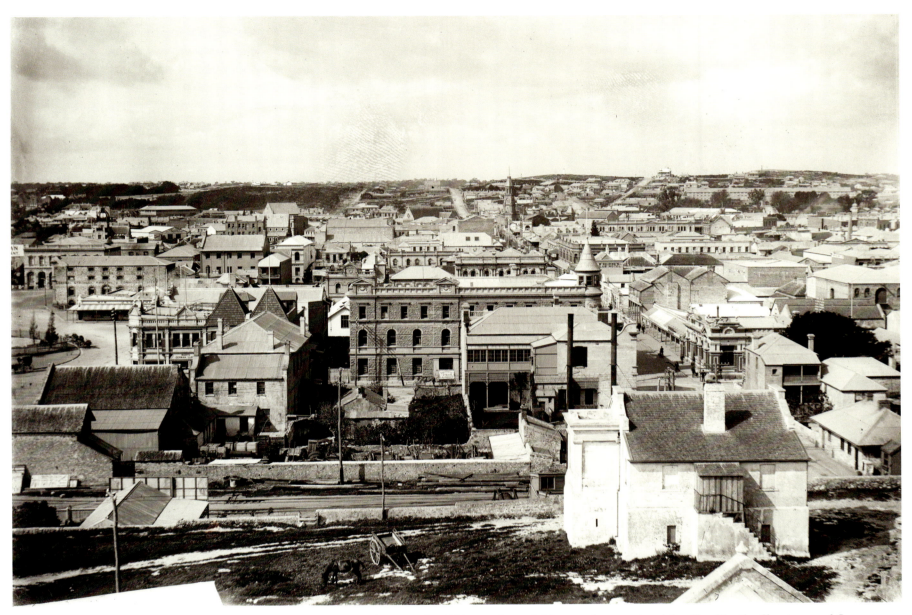

Above: Looking east from the second lighthouse on Arthur Head, c1896. Gold-rush money flooding back from the fields had sparked a virtual rebuilding of the Fremantle business area. In the foreground can be seen a section of the roof of the lighthouse-keeper's quarters, beyond which is Fremantle's second courthouse. High Street runs diagonally from the right. The large three-storeyed building in the centre with the Fremantle Steam Laundry cart in front is the Fremantle Hotel, located on the corner of Cliff and High Streets. Most of the buildings this side of Cliff Street, formerly substantial houses for prominent families like the Shentons and Samsons, were soon to be razed to make way for substantial commercial buildings.

Overleaf: View from Arthur Head, c1900, looking across the since demolished railway sheds to the former Commissariat – now the Maritime Museum's Shipwreck Galleries – to South Bay. The Arundel Street Baths can be seen adjacent to where Esplanade Park is now located. This photograph features a dramatic and brooding sky; most early photographs had empty skies due to the limitations of the photographic processes of the time.

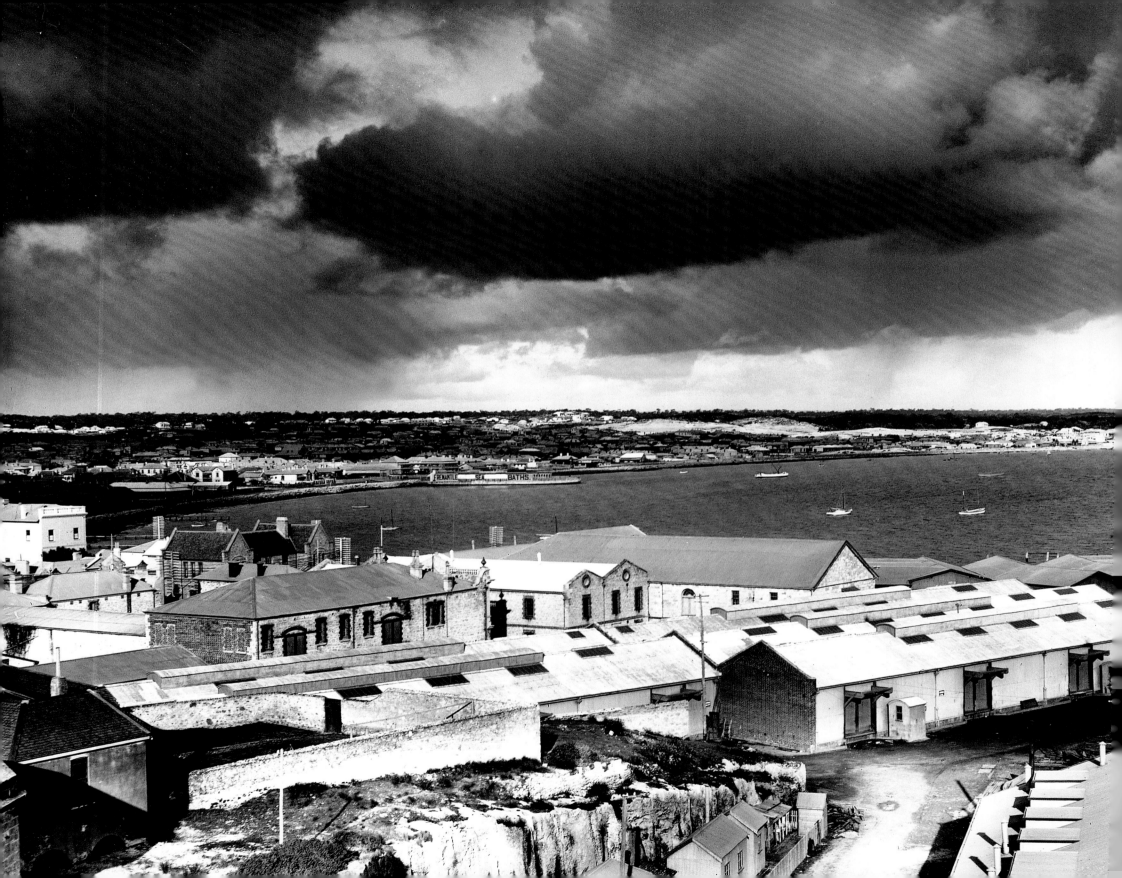

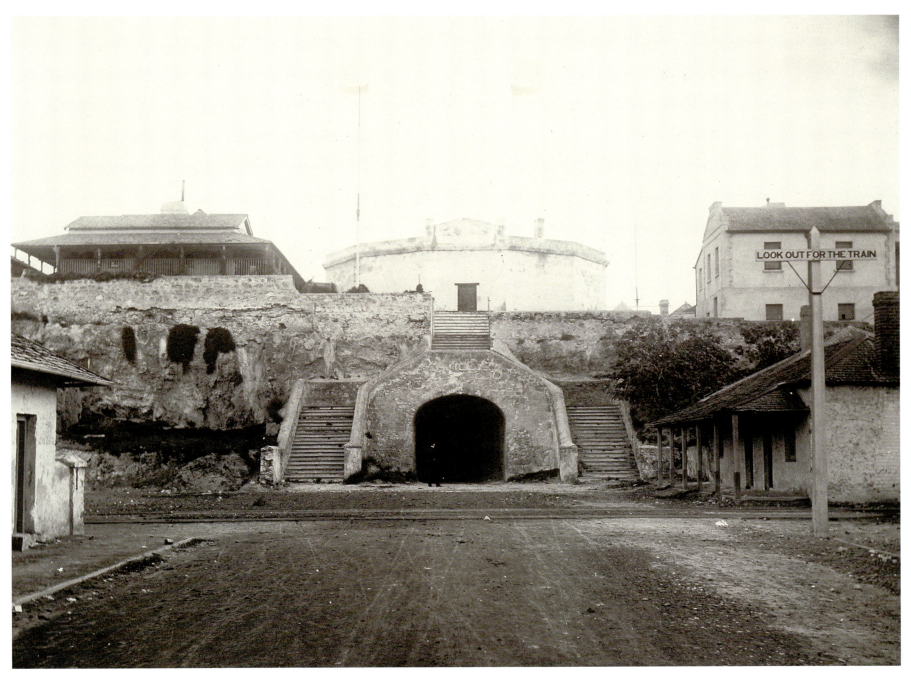

Western Australia's oldest public building, the 1831 Round House. Fremantle's first courthouse of 1835, to the left, had been much added to when this photograph was taken. Underneath the Round House is the whalers' tunnel, constructed in 1837 to facilitate the movement of goods between Bathers Beach and the town, the cliff having been a formidable barrier before much of it was blasted away. In the left foreground is the police station, which included stables and quarters for Aboriginal trackers. Of the many original structures on Arthur Head only the Round House survives, though some newer cottages remain. The old building has not always been appreciated: a writer for the Melbourne *Argus* expressed the opinion in 1870 that it looked "something like a stone gasometer." (c1900)

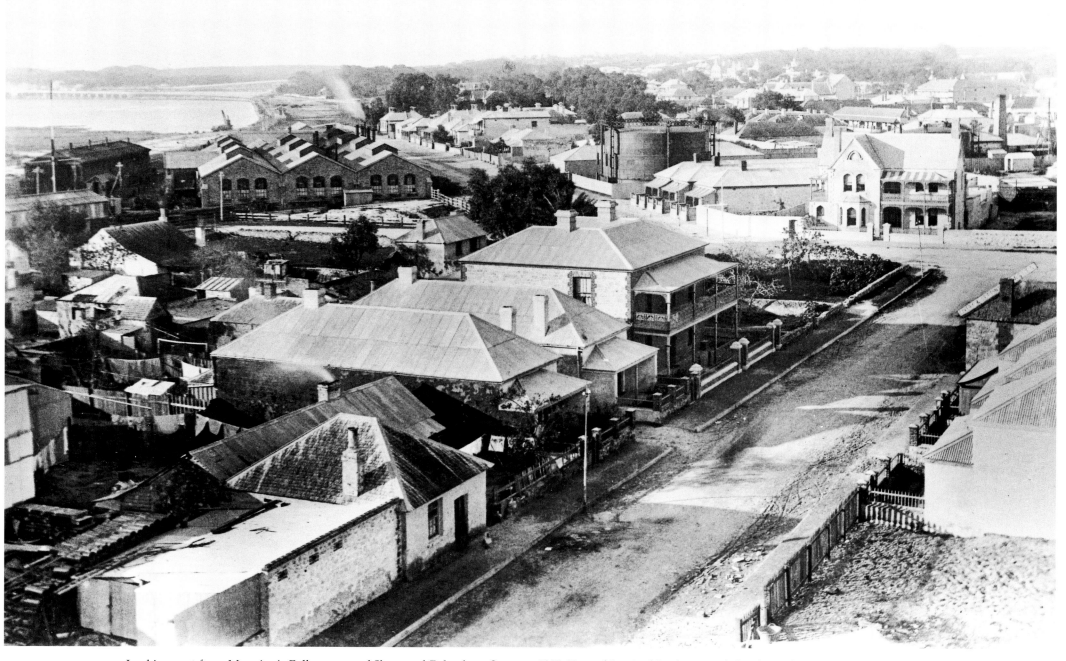

Looking east from Manning's Folly, corner of Short and Pakenham Streets, c1895. Everything in this photograph has been demolished except the old Lunatic Asylum, now the Fremantle Arts Centre, in the distance. It has lost only its forecourt and finials. Running diagonally to the right and meeting Market Street is Short Street. The area on the left of Short Street is now Pioneer Park. The railway workshops are in the left middle distance.

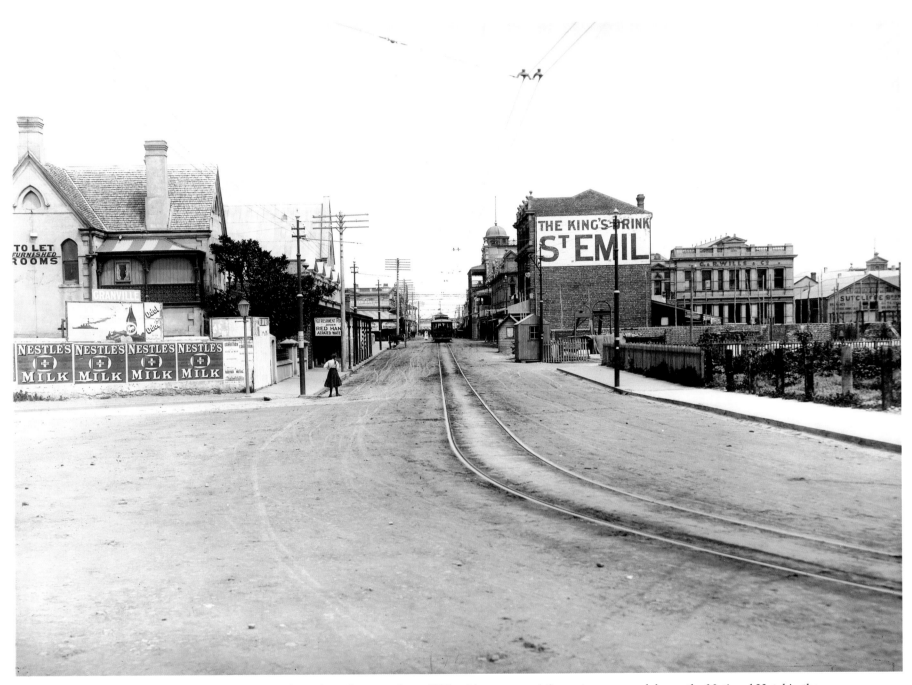

Looking south down Market Street from the railway station, c1906, with a tram and three-storey verandahs on the National Hotel in the distance. The post office building of 1907 was built on this side of the St Emil sign. On the right is the area that became Pioneer Park.

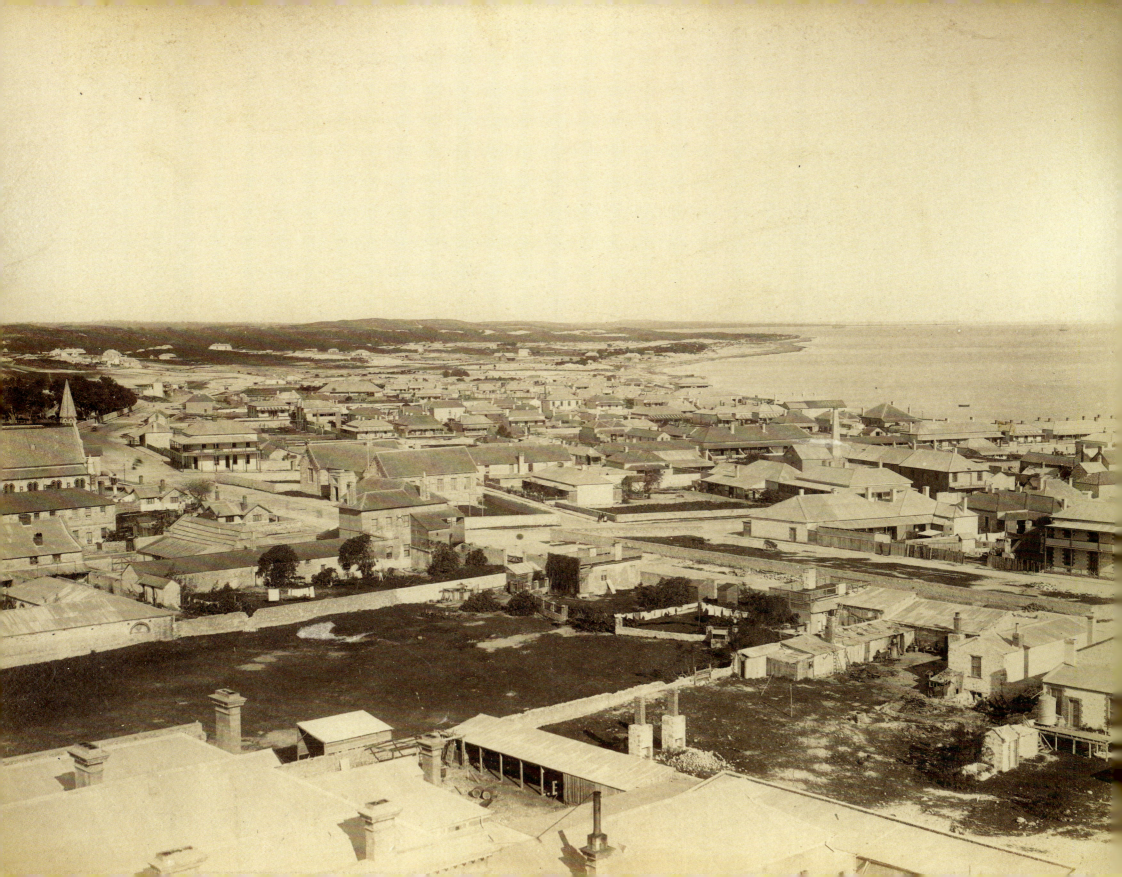

Below: Looking west across Market and Bannister Streets to the Short and Long Jetties, c1890.
Opposite: Panorama looking south from the Town Hall across South Terrace, c1890.

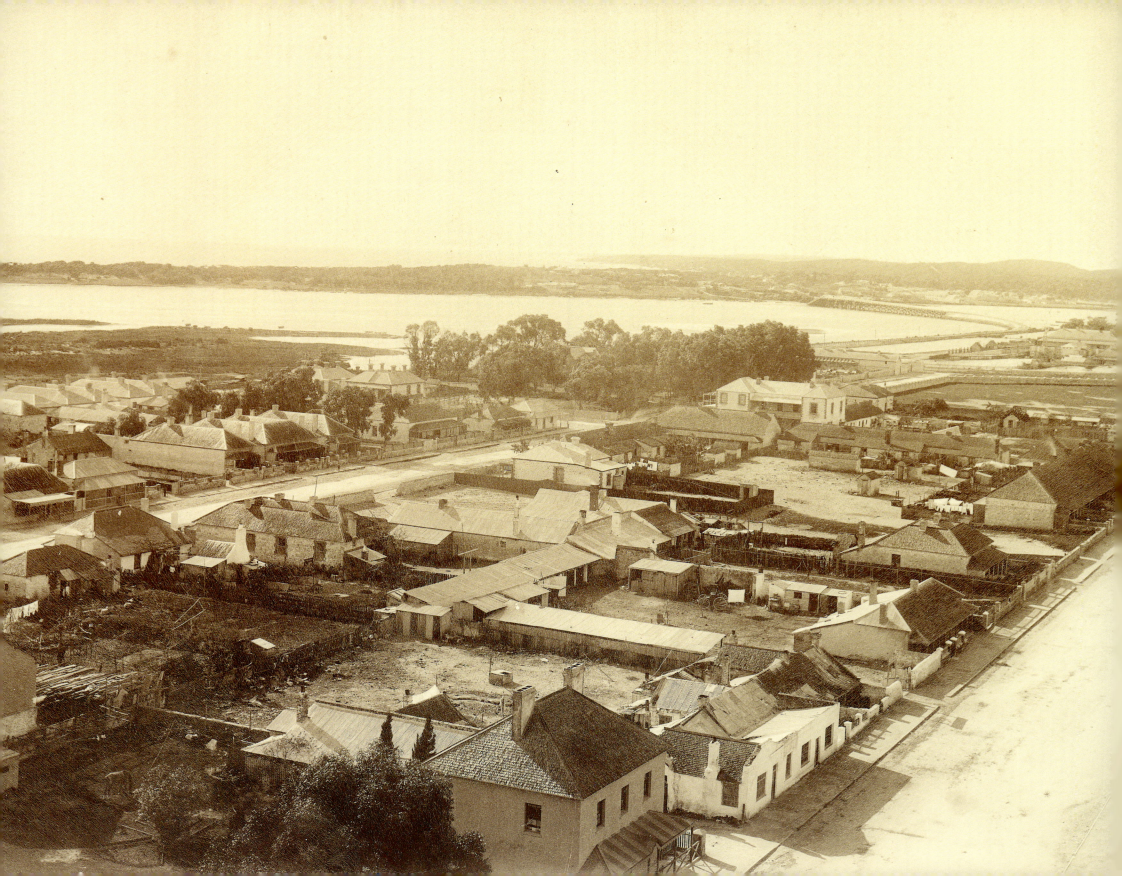

Opposite: Looking north from the Town Hall, c1890.

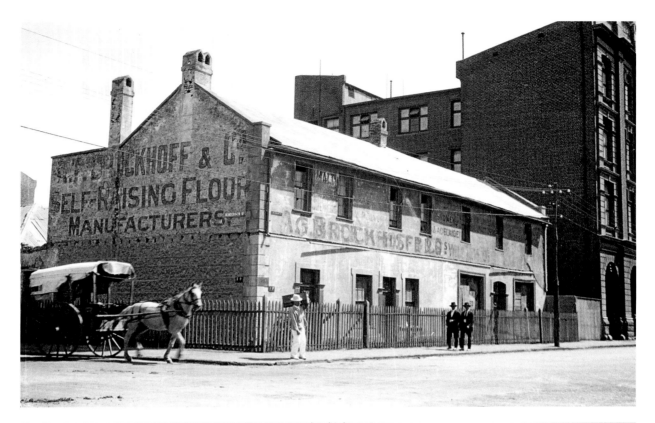

A pair of *West Australian* press photographs taken by famous staff photographer Fred Flood, showing none of the glamour or romance of his idyllic country images.

Above: Corner of Henderson and William Streets, c1925, currently a car park. The large building belonged to Spicers.

Lower: The tattered remains of Charles Manning's 1858 residence at the corner of Short and Pakenham Streets, photographed a few years before it was demolished in 1928 – see page 95. The verandahed building on the right is the Terminus Hotel.

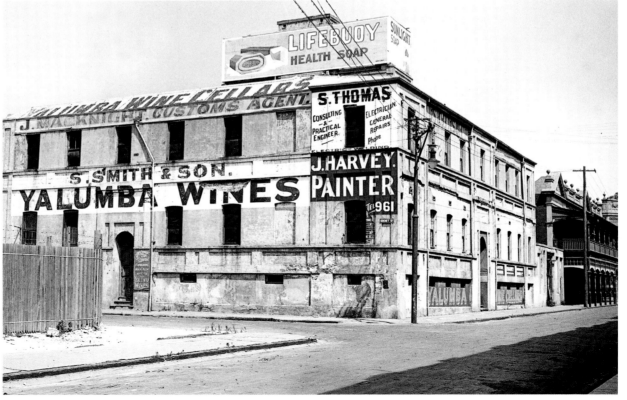

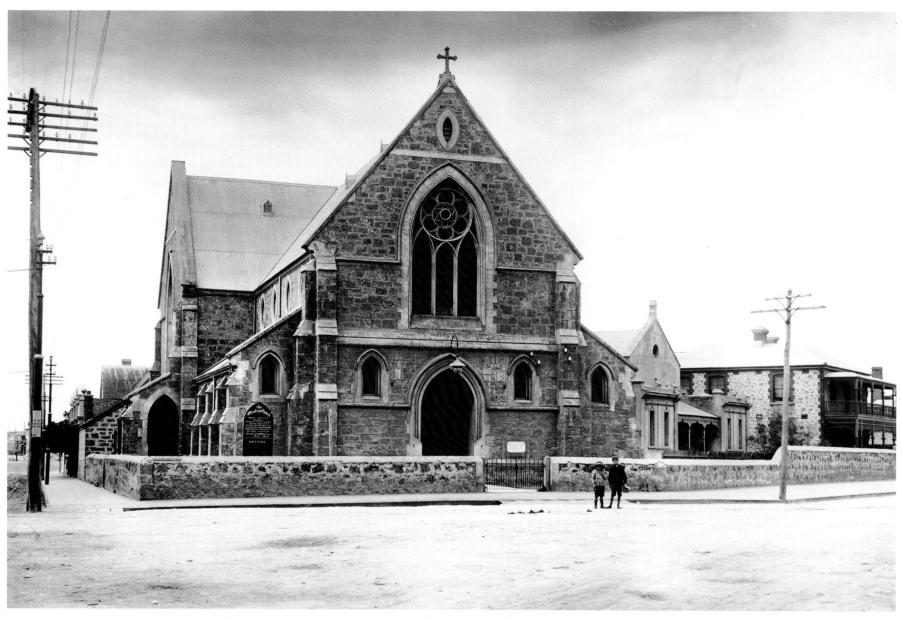

Wesley Church, corner of Market and Cantonment Streets, c1900. Built in 1889, the building was extended in 1898. The low wall was removed in 1928. The small building on the right is Wesley Hall, which incorporated the original 1841 chapel. This was demolished in 1928 to make way for Wesley Chambers, which itself was replaced by Wesley Way in 1974. On the far right is the 1893 Wesleyan manse.

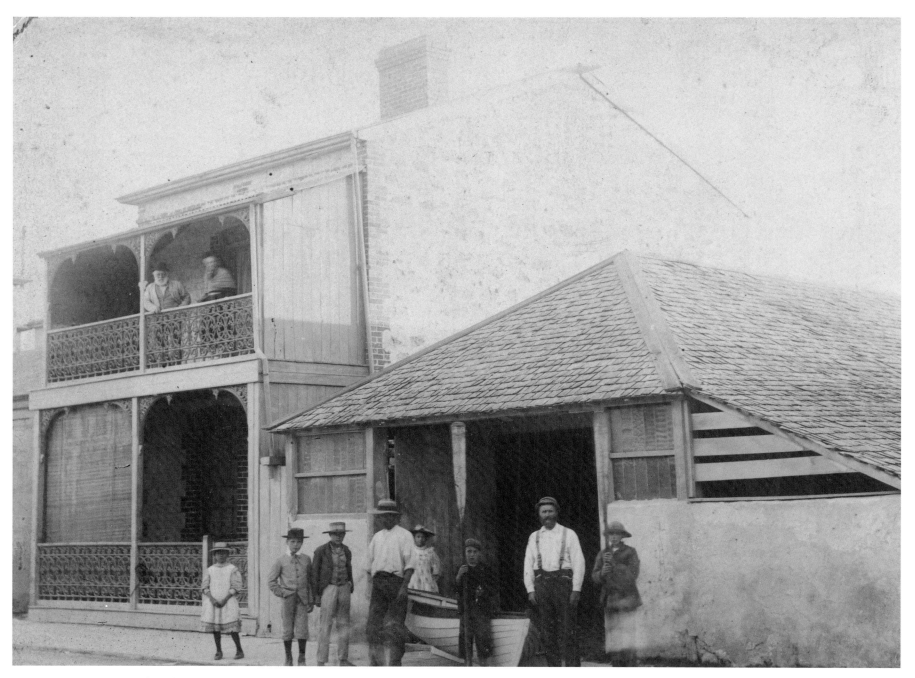

Mews boat-builders in Henry Street, c1885. Thomas Mews Jnr, leaning on the verandah rail, arrived in Fremantle in 1830 when he was fourteen and, like his father, became a prominent boat-builder. These lots, 59 (right) and 60 (left), were purchased in 1870 and the boatshed was built in 1873, then just a few metres from the river. Son Robert lived at lot 59 while son James, who married fourteen-year-old Adelaide Caporn and went on to sire a total of twelve children, lived for a while at lot 60. In 1890 James Leake is recorded as living in the two-storey terrace, and Thomas and James Mews and family apparently moved in with Robert next door.

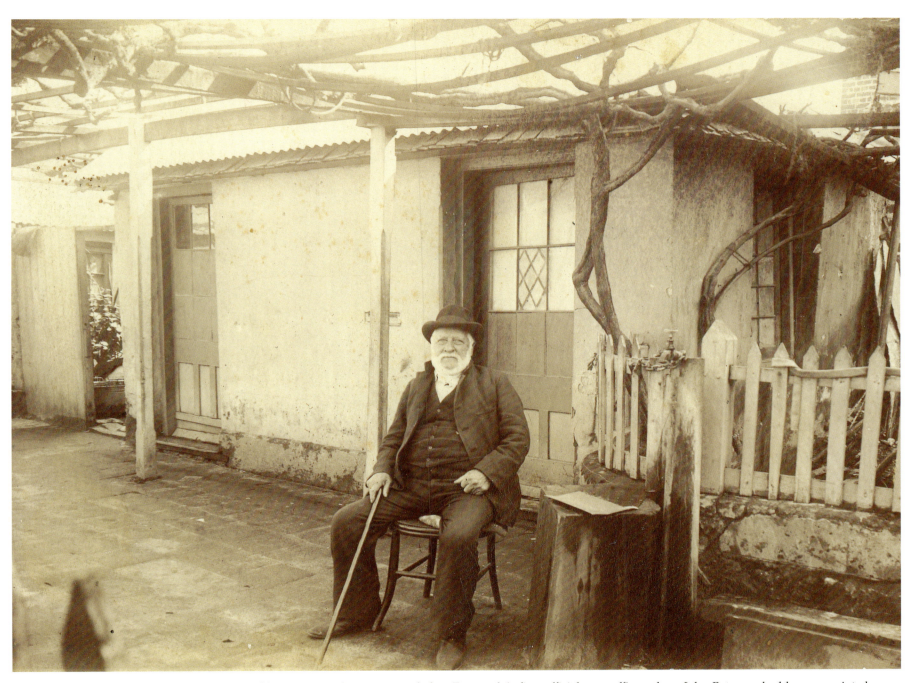

This vine-clad cottage at the rear of lot 59 Henry Street is regarded as Fremantle's first official post office, where John Bateman had been appointed postmaster in 1835. Before that, for the first six years of the Swan River Colony's existence, from 1829, the wreck of *The Marquis of Anglesea* had acted as a post office, and Lionel Samson worked voluntarily until 1835. The amount of business transacted can be seen in the fact that, even in Bateman's time, the details of every letter posted were recorded in a book. Thomas Mews Jnr (pictured) bought the property from Bateman in 1870.

Below: View west from the prison: Scots Church on the left, then rear of warders' cottages – still existing, but Fremantle Markets now obscure this view. The Town Hall is on the right.

Left: Looking back at the same view from South Terrace past Scots Church.

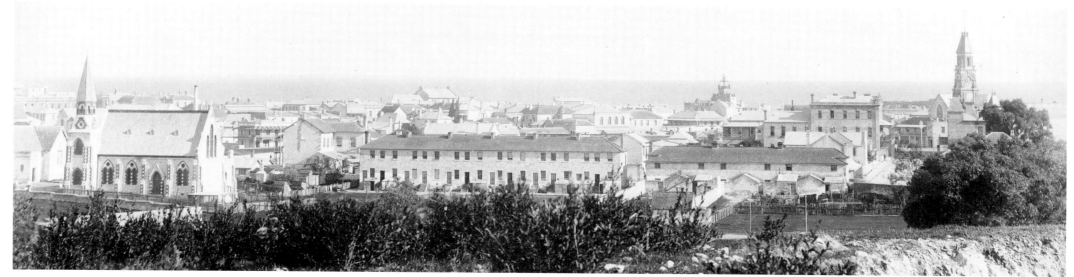

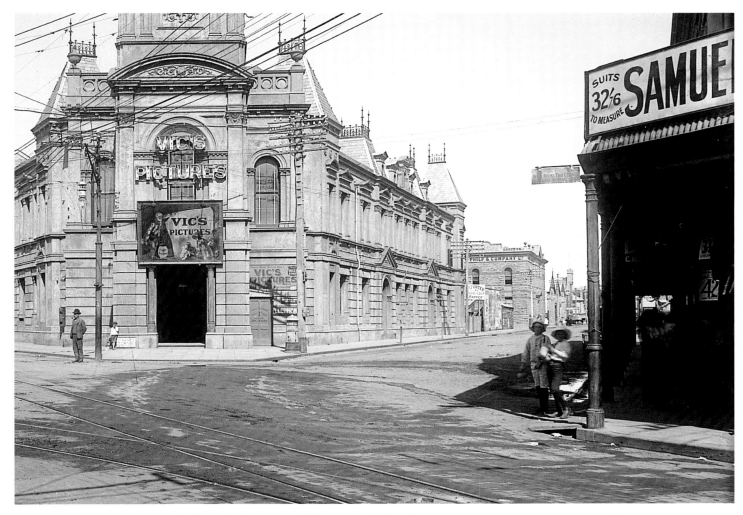

Fremantle Town Hall just after 1910 (cropped). Vic's Pictures was operating there, paying £15 per week rent. Vic Newton and Jack Coulter were directors of the Victor Picture Co. Ltd, which each Friday gave two free tickets per class to the nearby Fremantle Boys' School.

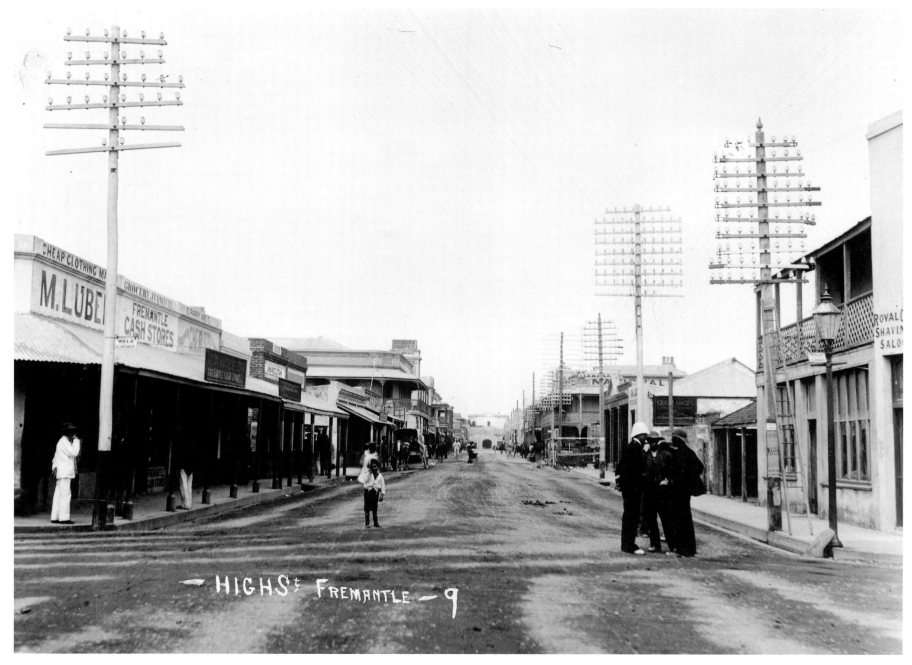

High Street looking west towards the Round House from the front of the Town Hall. Nearly all buildings here were rebuilt during the gold-rush boom a few years later. Note the pith-helmetted policeman. This 1894 High Street scene was copyrighted by Charles Nixon, whose studio was only a few metres from where this photograph was taken.

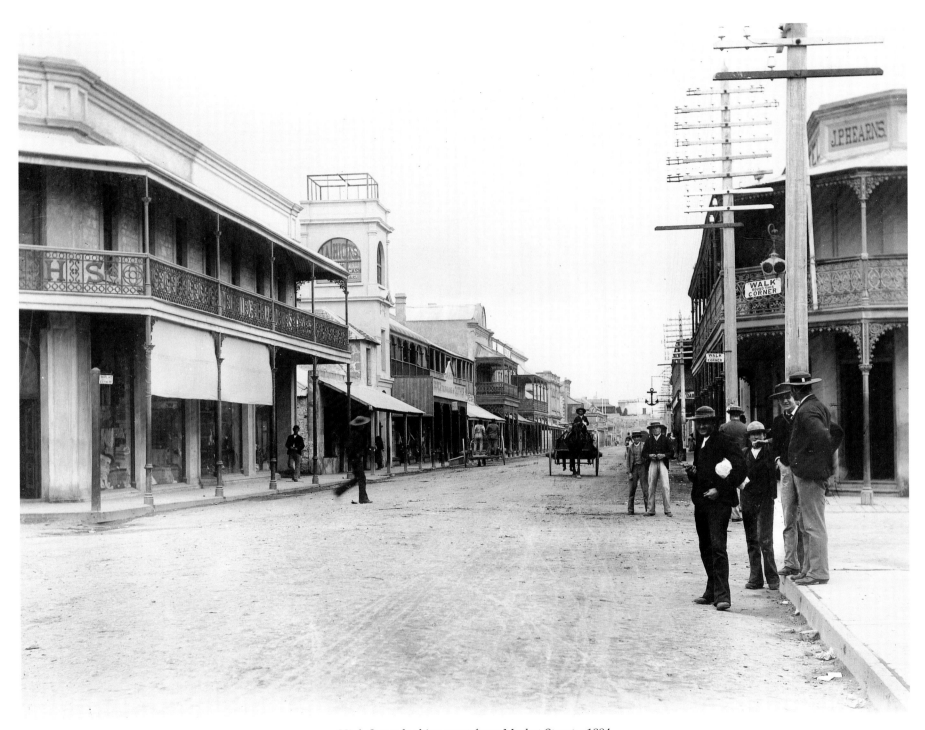
High Street looking west from Market Street, c1894.

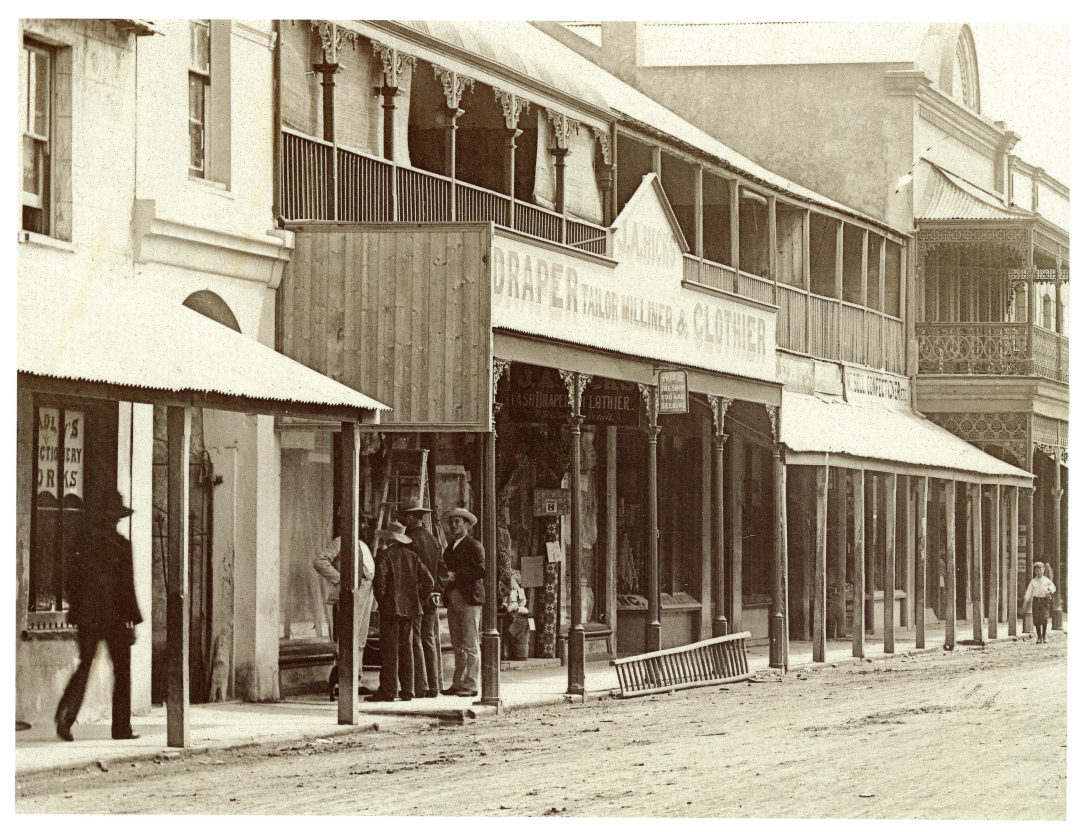

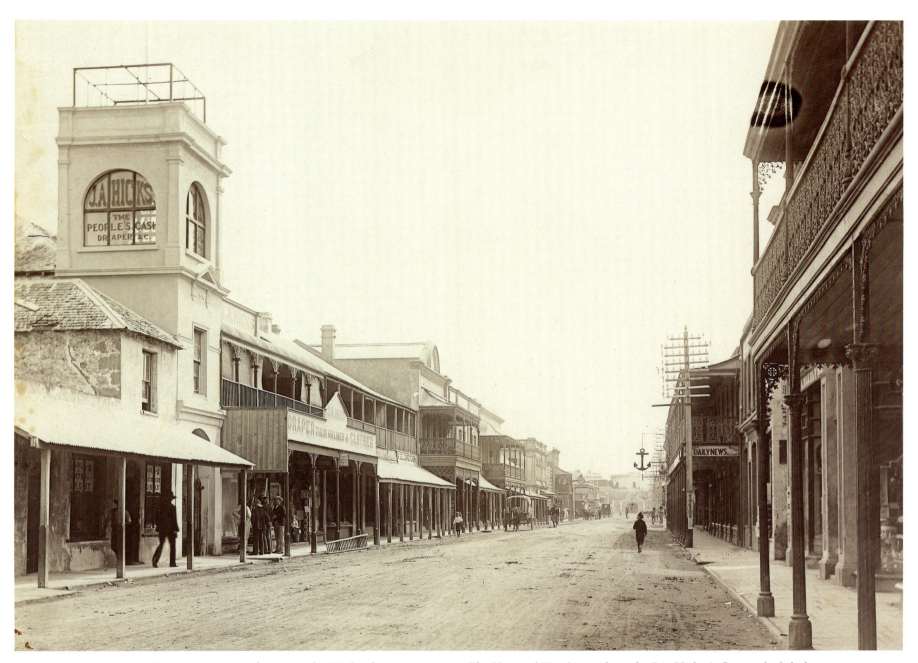

Above: High Street looking west from near the Market Street intersection. The National Hotel is on the right. J.A. Hicks & Co., on the left, figures prominently in the townscape. Advertising themselves as "The White House," they catered for all from "the merest mites of humanity." As drapers, clothiers, and mercers, they operated on "the latest and most approved American plan," with the "Catapult Cash" system. They advertised progressive practices for their staff as well, giving each of their seventy employees a week's holiday each year on full pay. *Opposite:* Detail (c1894).

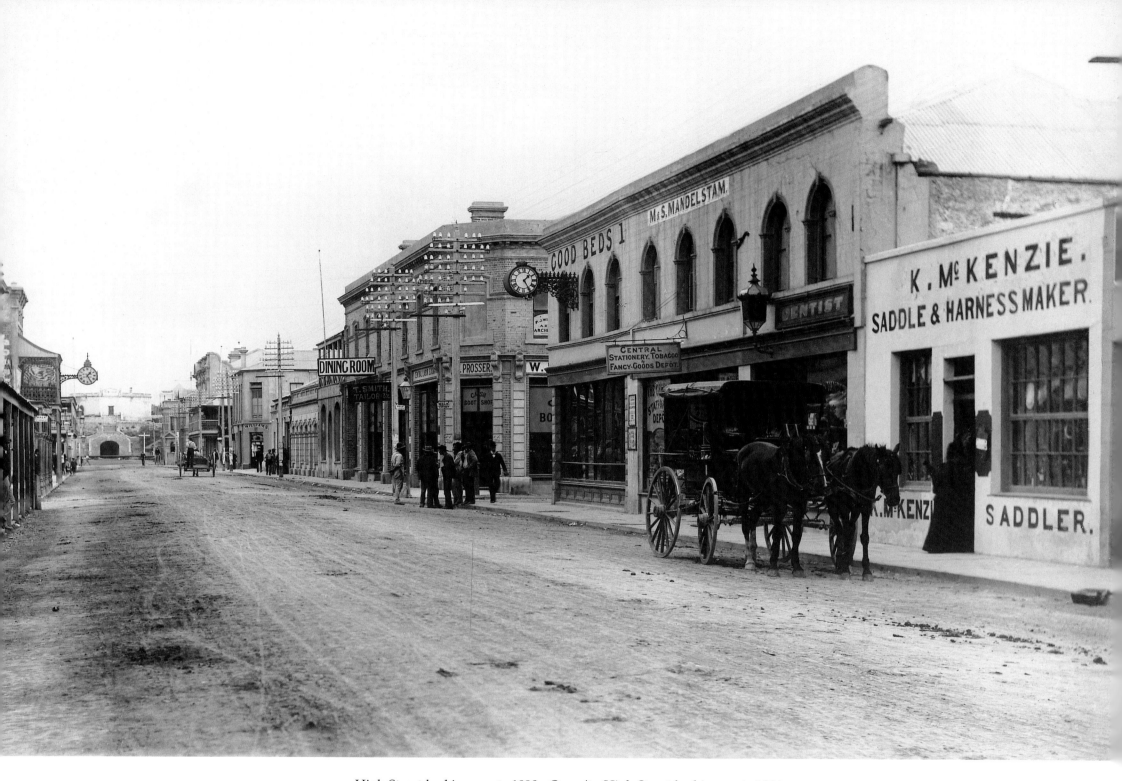

High Street looking west c1890. *Opposite:* High Street looking east c1894.

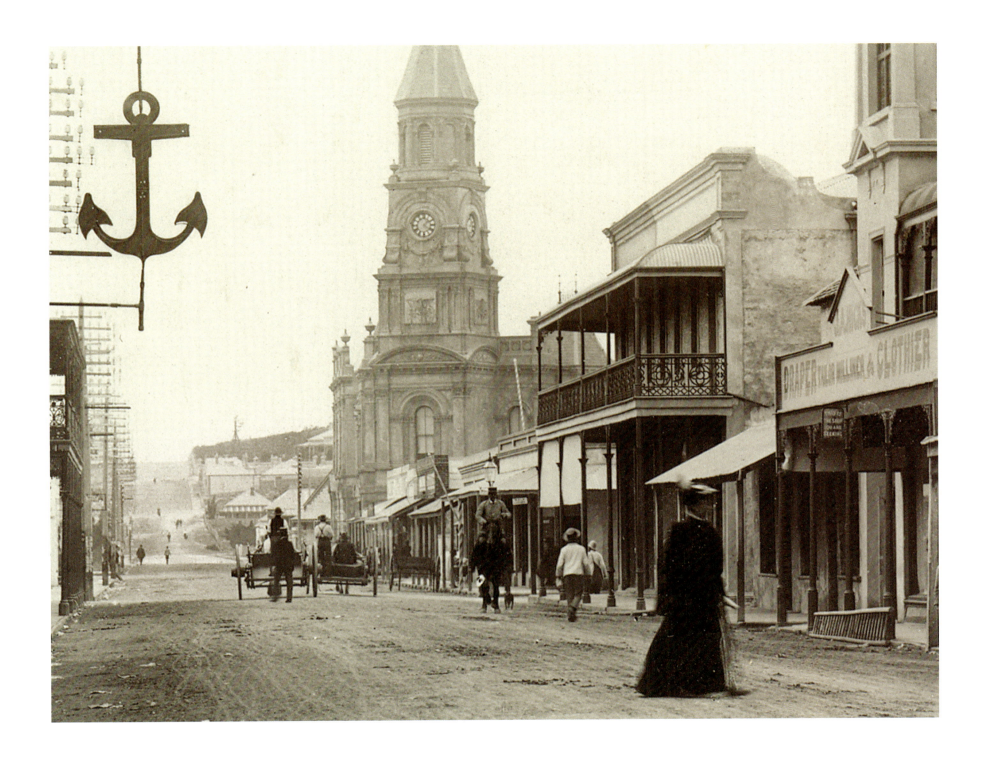

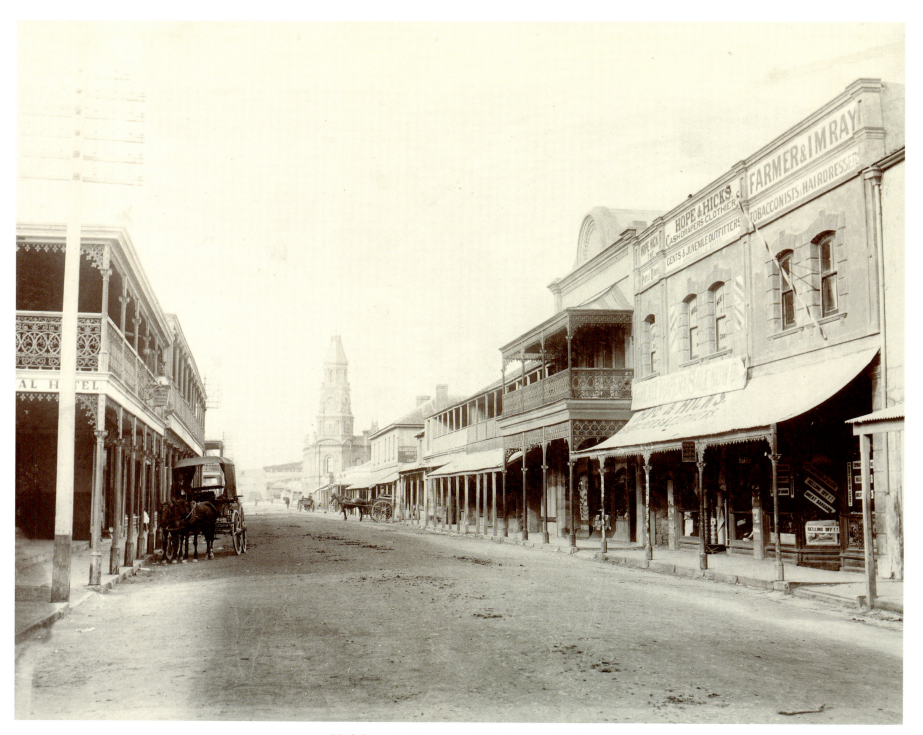

High Street looking east, c1890. *Opposite:* Detail.

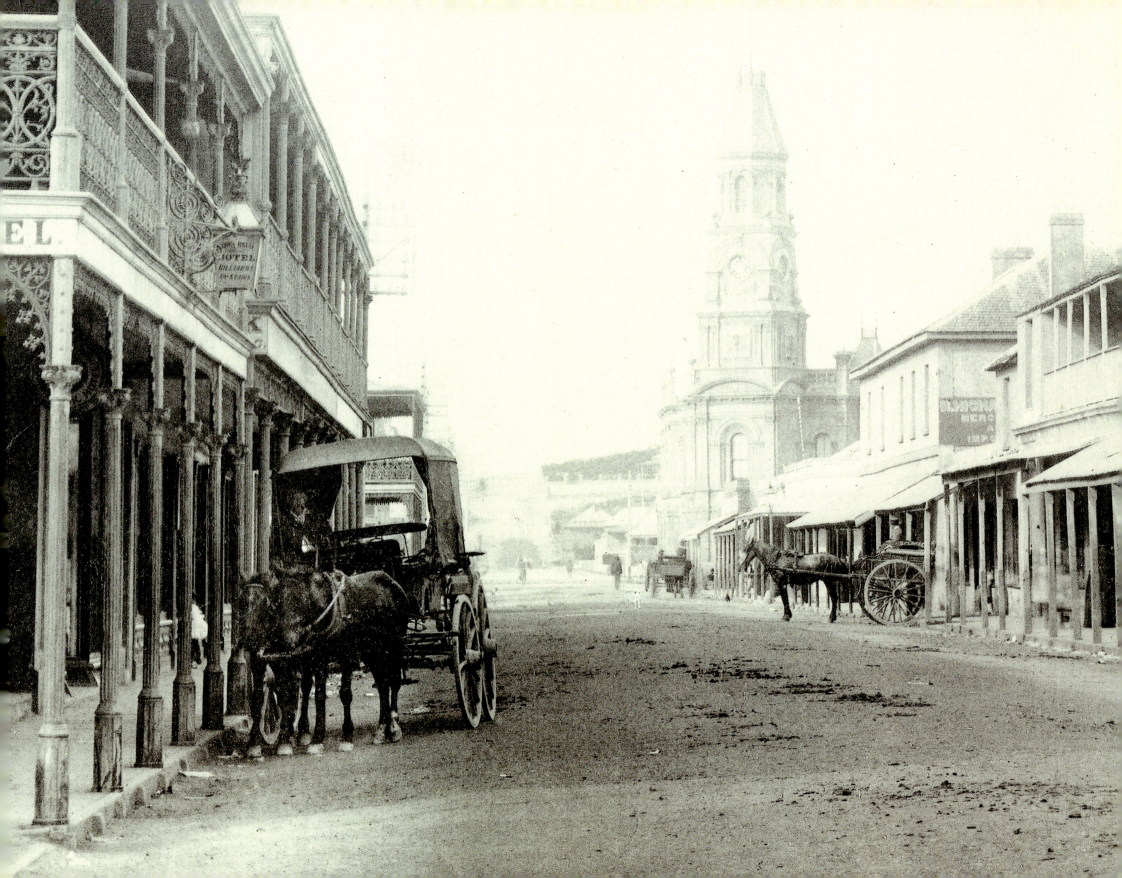

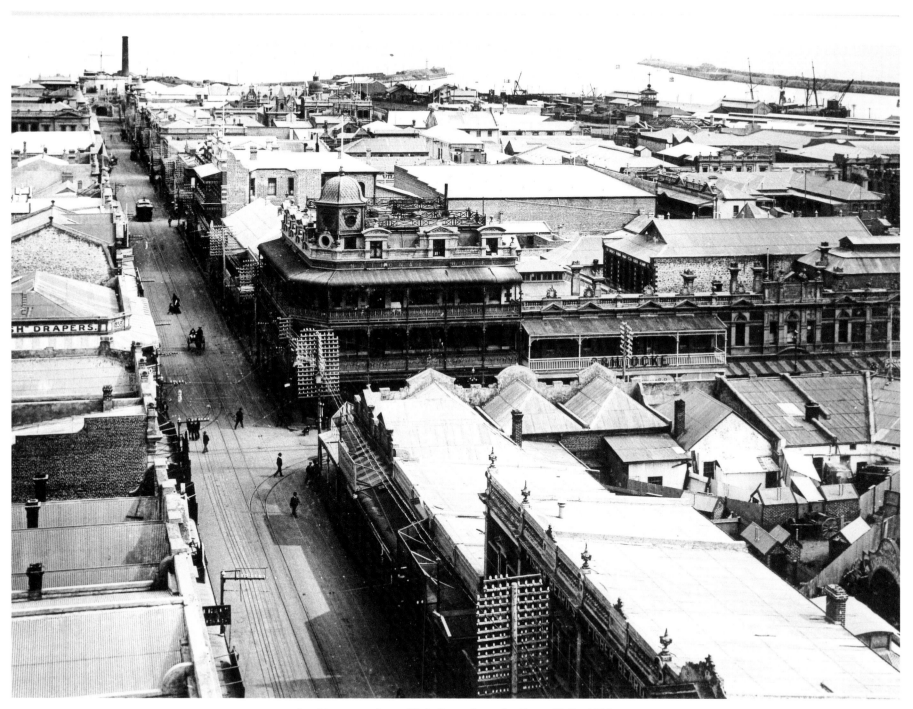
Looking west down High Street from the Town Hall, c1910.

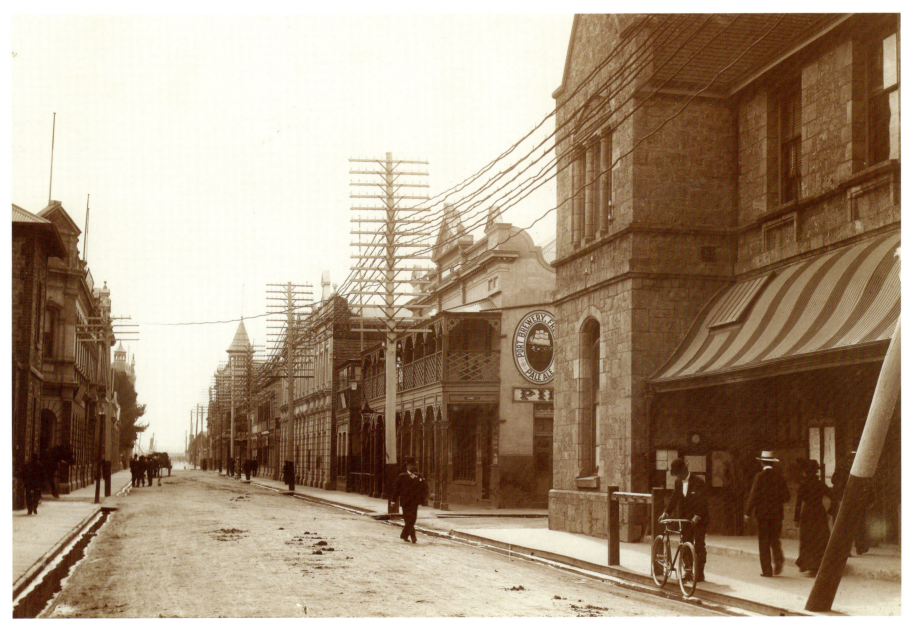

Cliff Street looking north, c1903. The building in the right foreground, which housed the post office until it moved to Market Street in 1907, was demolished in 1965 and is now a car park. Though it was lauded by many as a finely detailed and attractive structure, at about the time this photograph was taken the *Fremantle Mail* whined: "The present abortion of a building is out of the way, small, unsightly and a disgrace to a large go-ahead seaport like Fremantle" (3 October 1903). The next building is the Pier Hotel, which opened in 1873 and later hosted an outdoor cinema at the rear. Demolished in 1955, it too is now a car park. Before the opening of the new harbour in 1897, Cliff Street was an important conduit between the ocean (South Jetty and later Long Jetty) and the river (North or River Jetty) and the first railway station (1881), 200 metres past the spire of the Fremantle Hotel, in the distance.

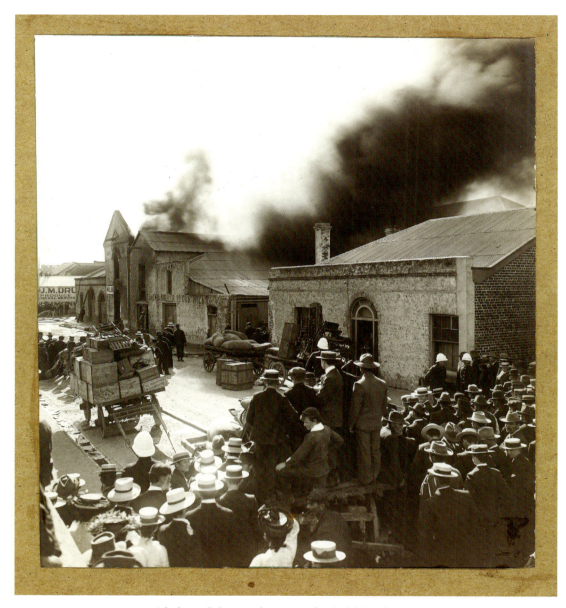

A behatted throng observes a fire in Nairn Street at the Vacuum Oil Co. premises, 1904.

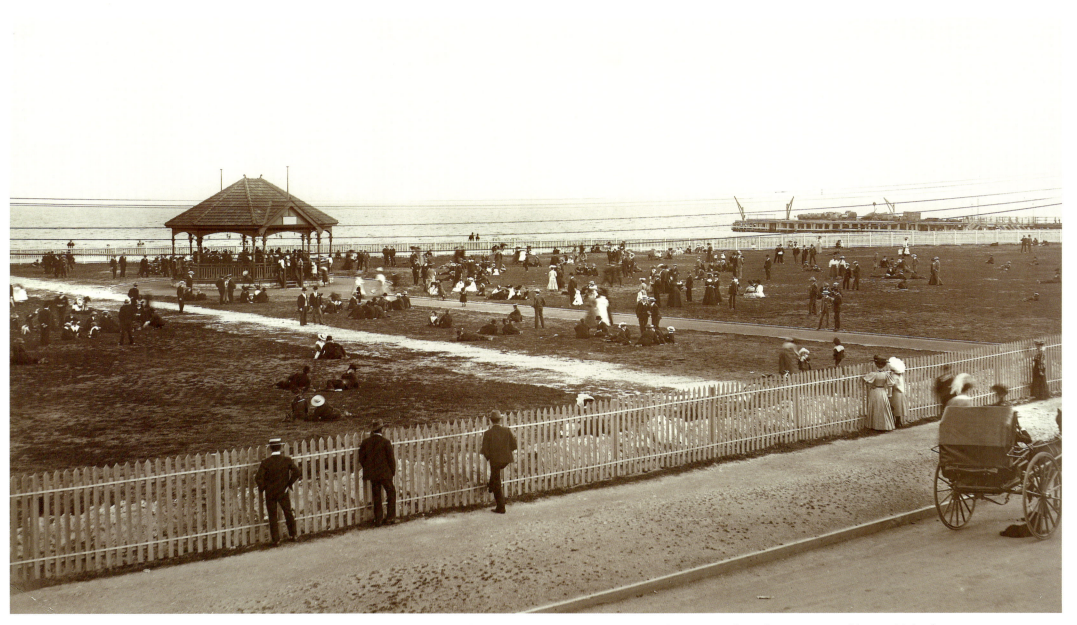

Fremantle Esplanade, c1905. In 1903 the short-lived *Fremantle Mail* (18 September 1903 – 2 April 1904) grumbled: "Instead of improving the foreshore, it is a debatable point as to whether The Esplanade has not been rendered even worse than it was before. Instead of being provided with a decent promenade resort, we have been made the present of a stinking and unsightly sewage pond. No-one in his sober senses would ever think of walking along the Esplanade for pleasure." Meanwhile the foreshore buildings were improving, with the newly constructed Water Police buildings (now residences), the Esplanade Hotel (now vastly extended), the Trades Hall, and the savings bank (now restored and used as a pearl showroom).

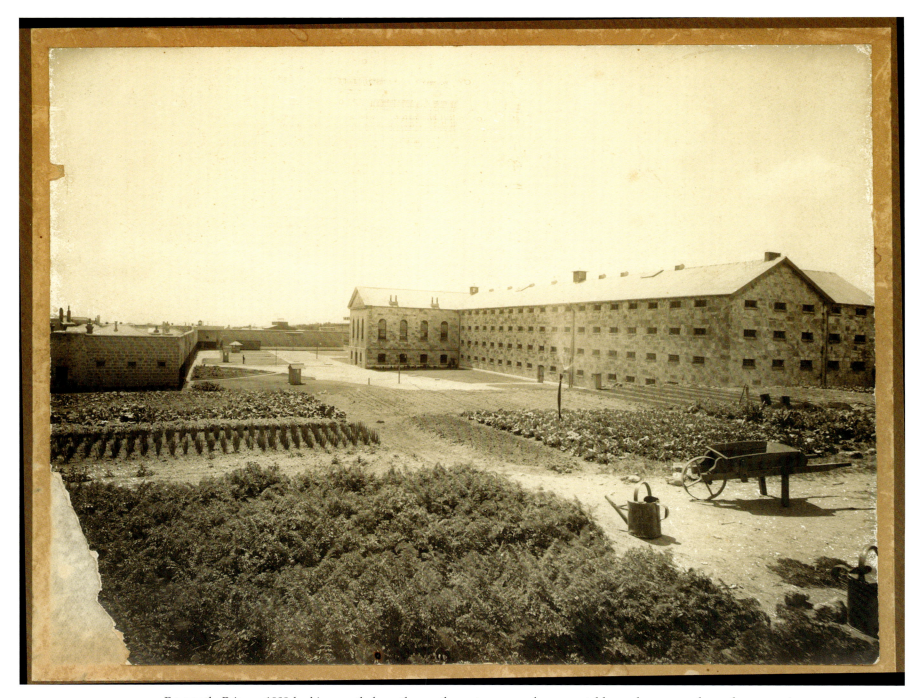

Fremantle Prison c1909 looking north from the south-west corner, where vegetable gardens grew above the reservoir. Photographs of the inside of the prison from before the 1970s are very rare. It was allowable to photograph the wheelbarrow and watering-can, but not the inmates. The only human visible is a distant sentry facing the chapel.

Crime Time

William Lyons is typical of the thousands of people, mainly men, who spent a considerable part of their lives locked up inside Fremantle Prison. A habitual drunkard, Lyons was gaoled many times over a long period from 1899. This battered and wasted life is a grim reminder of the enormous human misery that existed, largely unseen, right in the centre of Fremantle from the time of the arrival of convicts in 1850 until the closure of the prison in 1991.

The convict period ran from 1850 to 1868, when almost 10,000 men were transported to Western Australia from Britain. After the Imperial Convict Establishment was handed over by the British in 1886, by which time there were only 75 prisoners in cells built to hold 587, prisoner number one in the new system was W. Wolfenden, who scored three months for vagrancy in 1888. Common offences of the time were drunkenness and the use of obscene and profane language.

Robert Fairbairn, a Fremantle magistrate between 1886 and 1908, imposed punishments such as the following: deserting ship, three weeks in gaol; vagrancy, three months hard labour; drunkenness, five shillings or three days, more for regulars. Giving a false name to the police was worth forty shillings or fourteen days, assault fifty shillings or a month, obscene language £1 or fourteen days. Even swearing in your own home could land you in court. The *Fremantle Mail* on 28 January 1904 reported: "James and Mary Thompson were summoned to the Fremantle court this morning with the use of indecent language. Constable Clark stated that the two were inside their house in Lord Street on the night of 22nd inst., having a row, and made use of the language complained of, which could be heard from the street. People were living all round. The woman was the worse. The female defendant was fined 40s and the male 20s, Mr Fairbairn, R.M., stating that he had never heard worse language."

Fairbairn also kept Fremantle youngsters in line. He awarded fourteen-year-old Harold Grose twelve strokes of the birch and sent him to the reformatory school on Rottnest for stealing grapes. Ten-year-old S. Goddard received twenty-four strokes for stealing.

Fremantle Prison has dominated the town's skyline for more than 150 years. For most of that time it has been a town within a town, and a hidden world largely unrecorded by the camera.

Above: Nurse Bottle standing outside the isolation block of Fremantle Hospital in 1910. The building was close up to the walls of Fremantle Prison.

Below: Prisoner William Lyons.

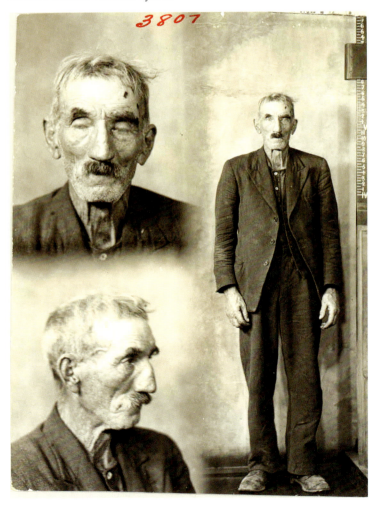

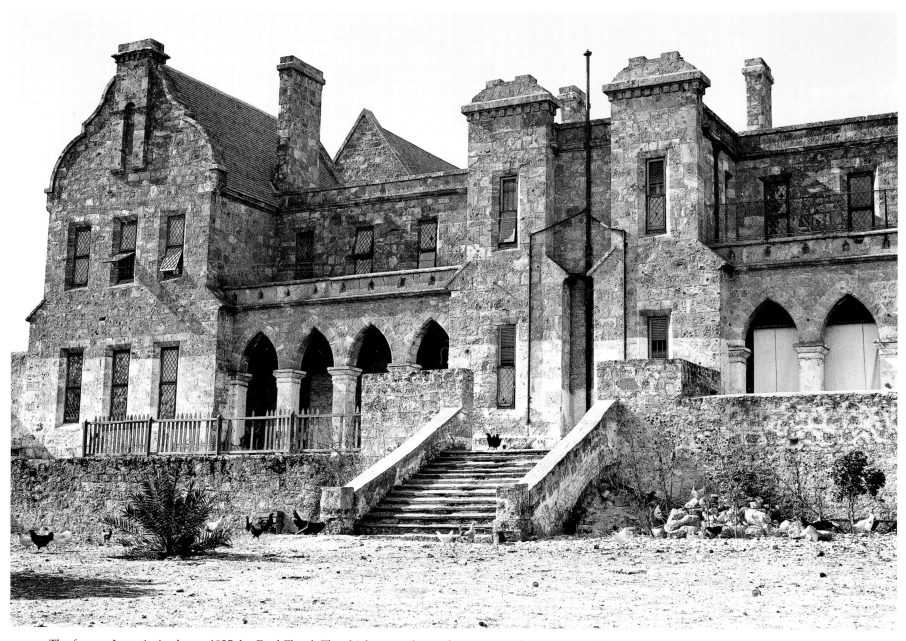

The former Lunatic Asylum, c1925, by Fred Flood. The chickens are home, but no sign of anyone else. The chimney-like finials are now missing – compare Stout photograph on page 85 – and the inmates are no longer lunatics but elderly women. During World War II American military personnel moved in.

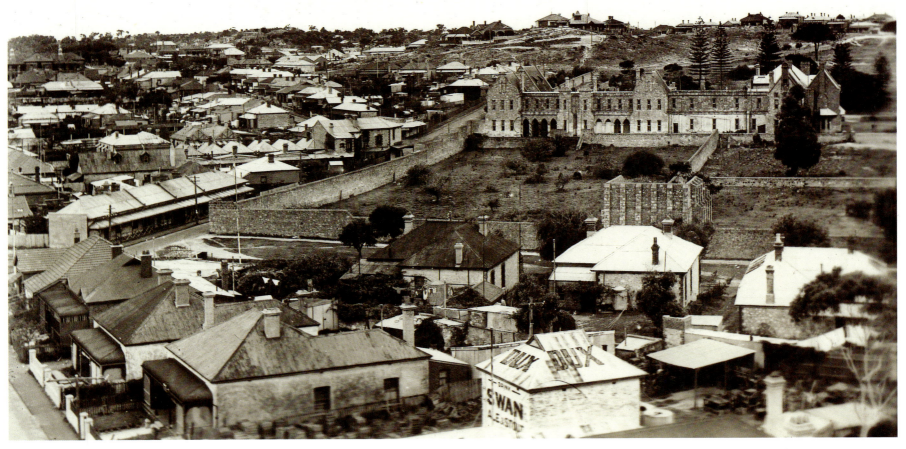

The 1861 Lunatic Asylum, now the Fremantle Arts Centre, seen here before the Ord Street extension was brutally rammed through its front yard, just centimetres from the original steps – at least a better outcome than the Education Department's earlier intention to demolish the whole place to give the new John Curtin High School more playing fields. Isaac Norman Branson took this photograph around 1930 while working as a train driver in Fremantle. He regularly sold his images to the newspapers for ten shillings each.

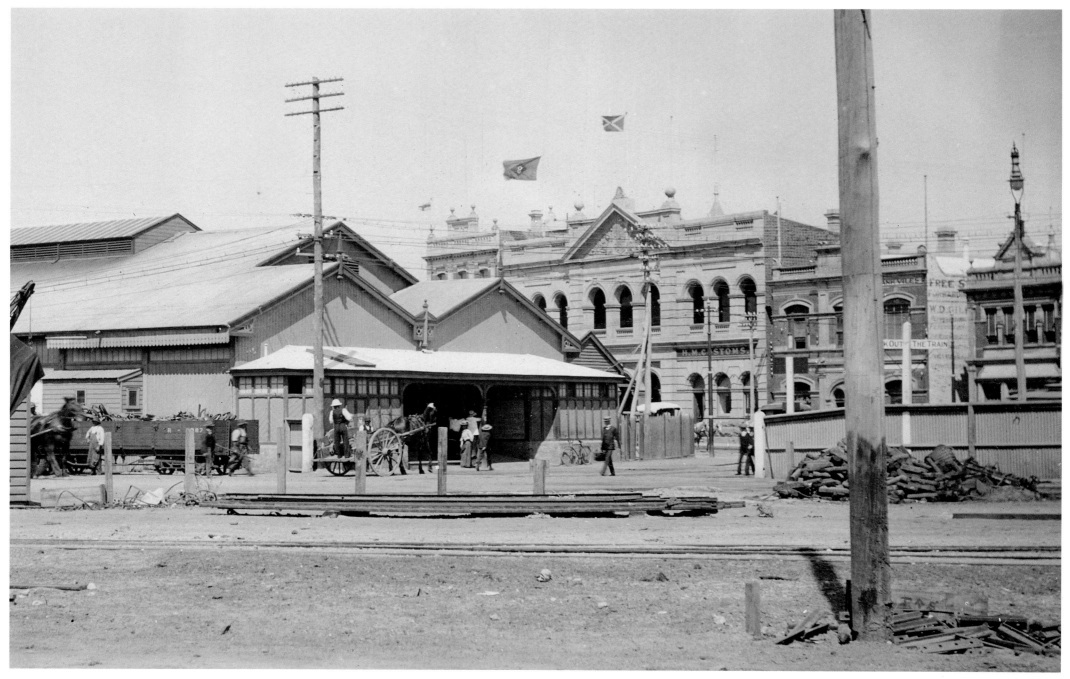

Above: A horse and cart pause in Cliff Street outside Fremantle's first railway station. Built on the corner of Phillimore Street in 1881, it was then the westernmost railhead in Australia. The current station, near Market Street, replaced it in 1907. After 1897 this area was the busy main entrance to the new harbour and, conversely, the main entrance to the city from the wharf. Even in the early years of the colony Cliff Street, which then extended right to the harbour, was one of the busiest thoroughfares in Western Australia, as goods flowed along it from the South Jetty and later the Long Jetty to the River Jetty until the opening of the harbour. Beyond the railway station can be seen the premises that some of the shipping companies raced to have constructed near the wharf entrance after 1897. The large balconied building is known to most as the P&O shipping offices, purchased in 2003 by the University of Notre Dame. At the time of this photograph it also housed HM Customs, which began in Henry Street and by 1907 occupied a handsome sandstone building where this railway station stands. *Opposite:* Former Fremantle Literary Institute, c1900, on South Terrace, now renovated with double-storey verandahs and accommodating the Dôme cafe and, upstairs, Kulcha – Multicultural Arts of WA.

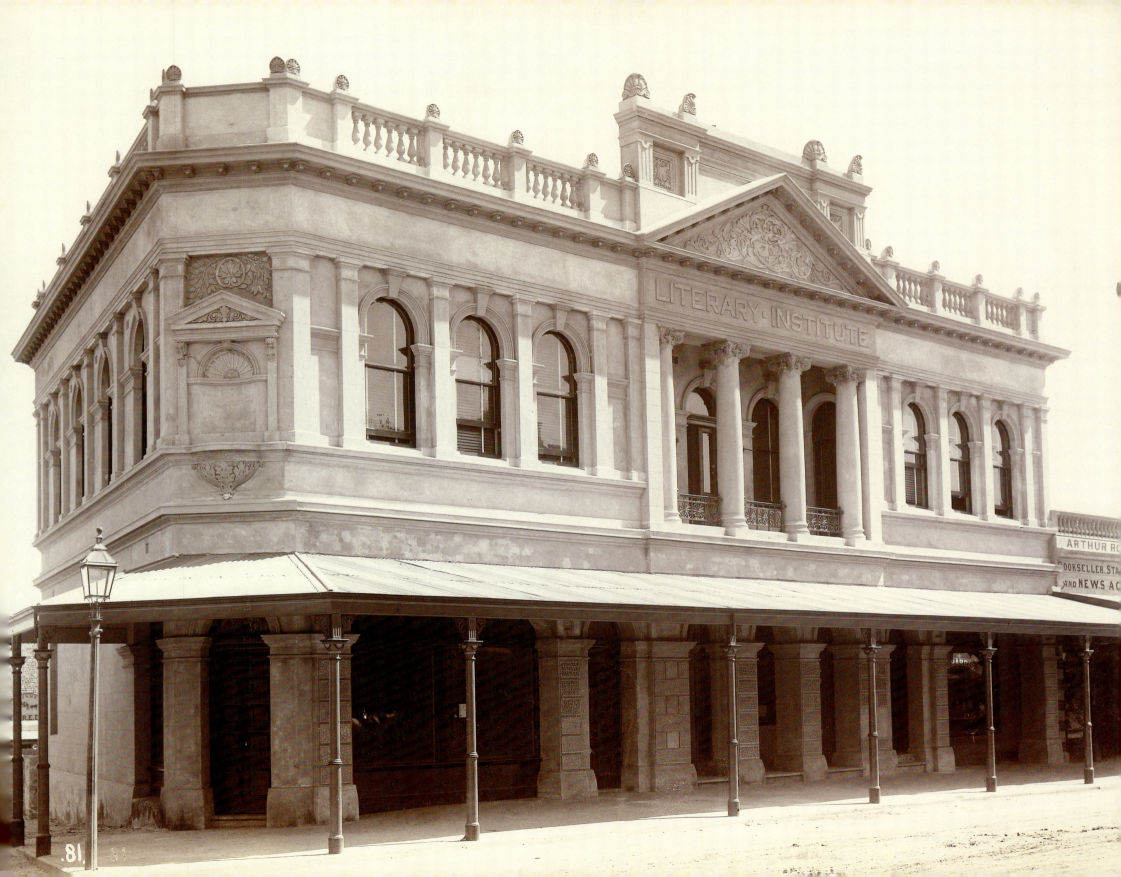

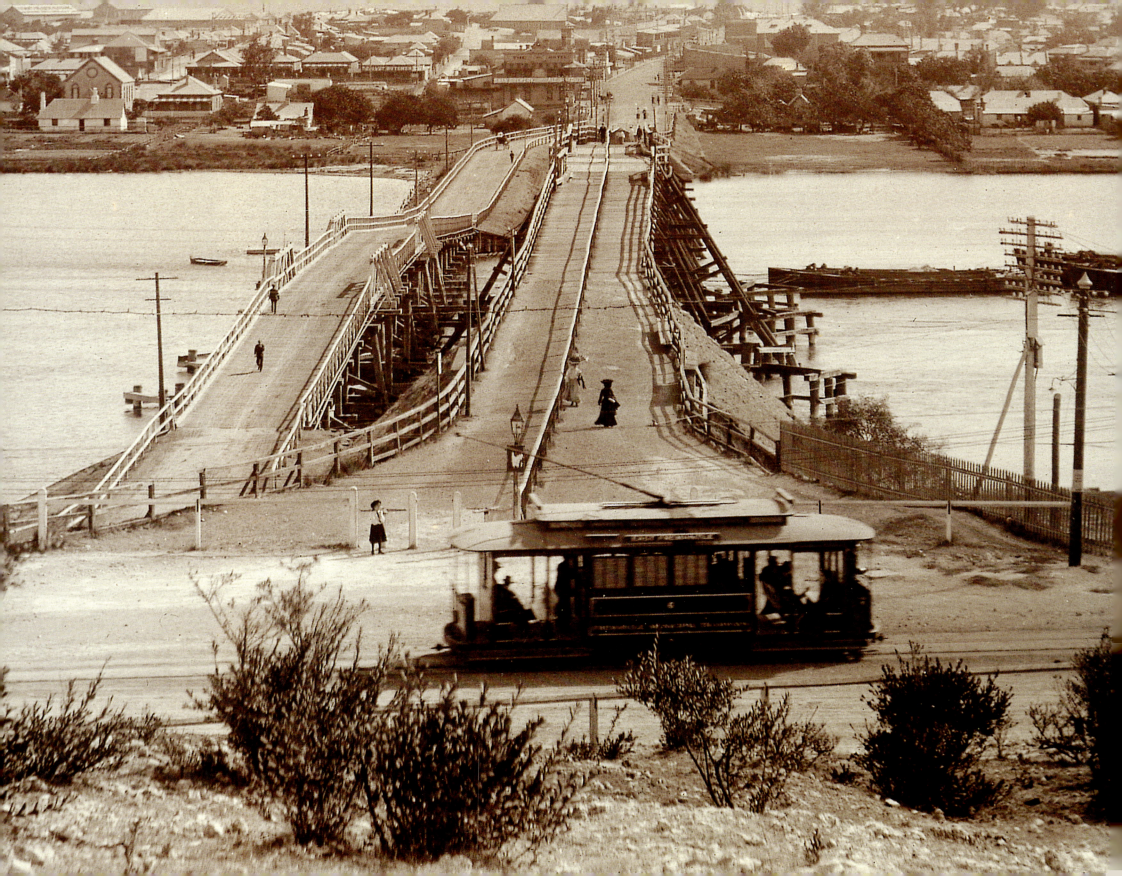

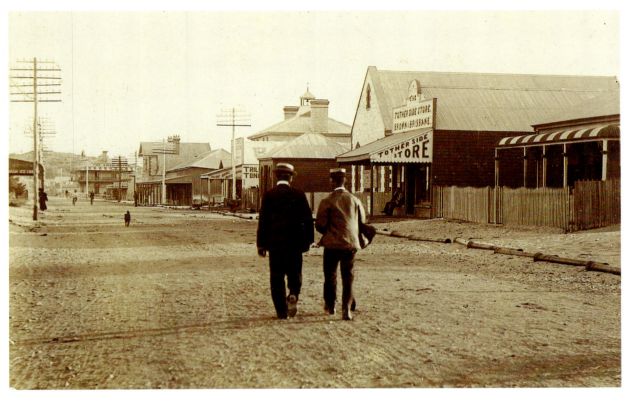

North Fremantle Images

Above: Victoria Road, North Fremantle, c1900. Brown and Brisbane ran the Tother Side Store and the Swan Hotel is in the distance.

Right: Alfred Road, North Fremantle. The North Fremantle School, at the end of the road, was built in 1894 on the site of a former convict depot.

Opposite: The East Fremantle tram passes the two traffic bridges in a blur in 1906. North Fremantle, originally settled by Pensioner Guards, became a separate municipality in 1895 and its population doubled in the following ten years to almost four thousand.

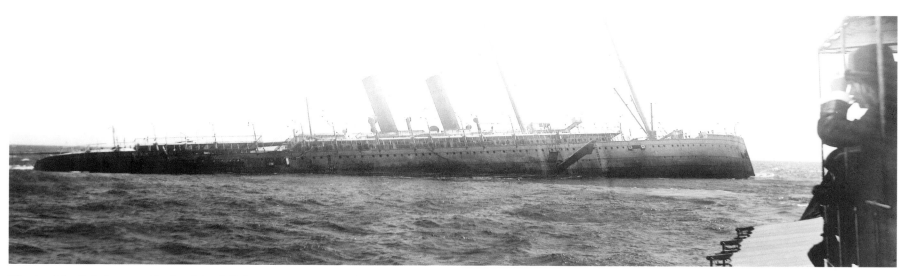

Wreck of the *Orizaba*, near Garden Island, February 1905, as seen from the *Manx* ferry, packed with day-tripping sightseers. The Orient Line mail steamer went aground on "five fathom bank" in the midst of dense haze caused by a bushfire. A *Daily News* reporter based at Fremantle, E.H. Brewer, recollects receiving the dramatic news:

"We pressmen tried to get out at once, but, as usual, were blocked by officialdom. I conceived the idea of beating the officials by taking out a basket of carrier pigeons. It seemed simple enough. All I had to do was write the copy, tie it to the legs of the birds, and I had arranged for a friend in Fremantle to send the 'scoops' on to the Perth *Daily News*. I stowed away on a coal hulk belonging to the Adelaide Steamship Company, which was the first craft, outside the pilot boat, to approach the *Orizaba*. On arrival there, I gathered the news, tied the messages to the carriers, and let them loose. To my consternation they refused (although we pelted them with coal) to leave the masts of the ship, and I shall never forget the raucous laughter of the stevedores when they realised the position. I can still remember the *Orizaba* as she looked that morning – pitifully inept as she lay like a wounded swan." (*The Golden West*, 1926–27)

Opposite: Auction of salvage material from the wreck of the *Orizaba* at the Cleopatra Hotel in High Street. A public house for travellers and locals operated at these premises from 1845 until the property was bought by the University of Notre Dame in 2002.

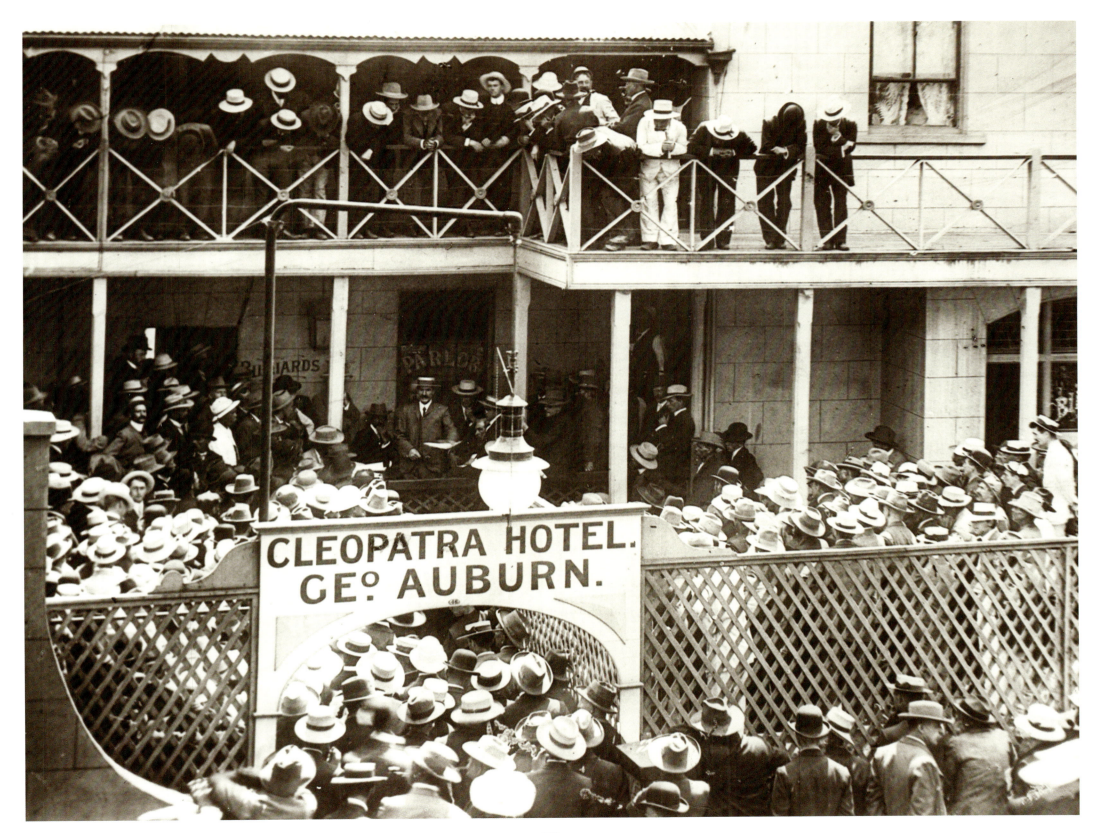

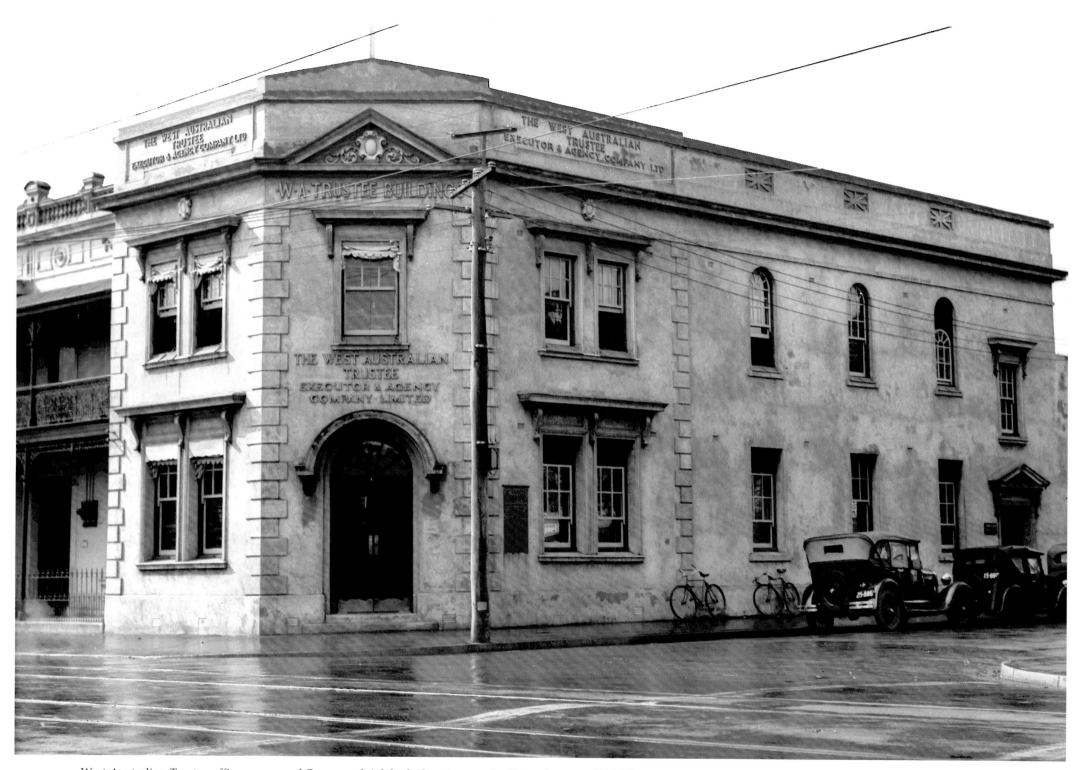

West Australian Trustee offices, corner of Queen and Adelaide Streets opposite Kings Square, c1930. The site was proposed for a six-storey building by disgraced developer Alan Bond, but the Fremantle Society successfully fought the plan. Unfortunately this handsome building, and the terrace houses on the left, have since all been demolished.

Companion photograph to the one opposite: view down Queen Street past the rear of the WA Trustee building on the left and the taxi rank mid-picture.

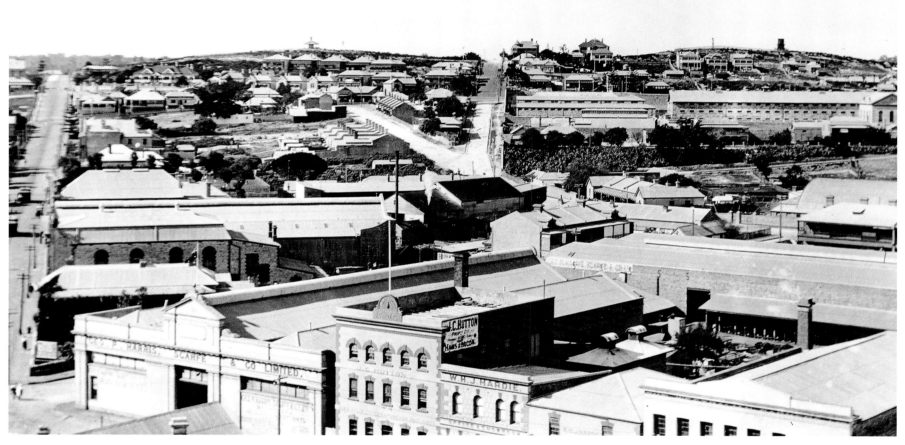

View East from the Town Hall, c1924, with High Street on the left and the obelisk on Monument Hill (erected 1867, demolished 1924). The warehouse buildings in the foreground, on the former Newman Street, were demolished to make way for the totally out of scale Myer building of 1972 and later Queensgate. The low building on the left behind the Harris, Scarfe warehouse, at the intersection of High and Queen Streets and just this side of Victoria Hall, was Marlborough House, a boarding house for country students. Built as the Rose and Crown Hotel in 1849, it was demolished in 1937 to make way for the Art Deco Oriana Theatre, itself now demolished and replaced with a row of unimpressive shops.

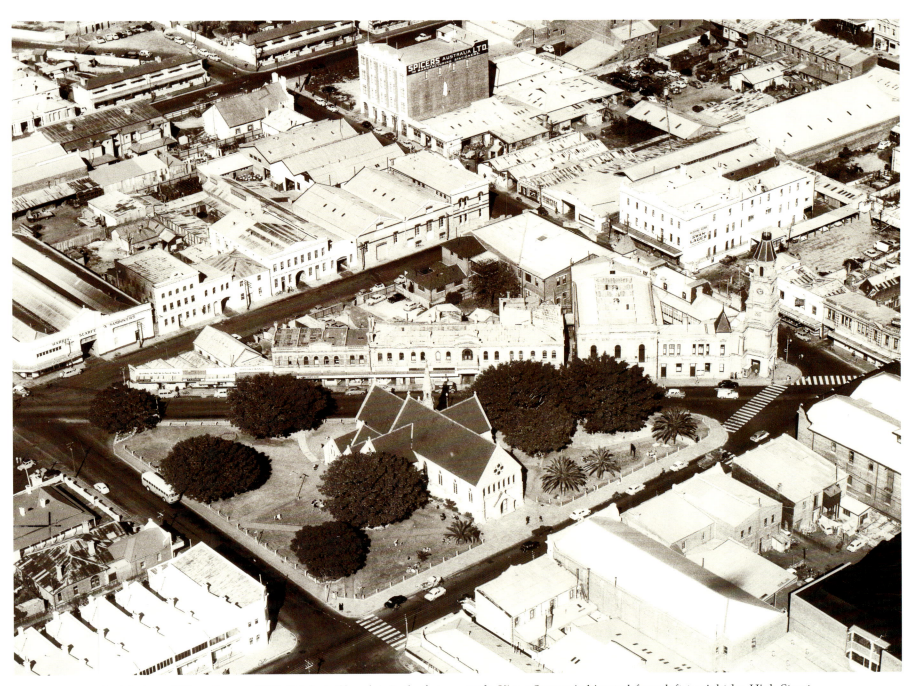

Aerial view of Kings Square, 1957. St John's Church is in the foreground, with the Town Hall and 1929 Centenary additions behind. To the left of the Town Hall tower is the Federal Hotel and the four-storey building to the left of that is the Spicer Building, now a car park. Kings Square is bisected from left to right by High Street, with trams and traffic flowing through it. All the buildings on the far side of the square in former Newman Street were demolished to make way for the oversized Myer and Queensgate buildings.

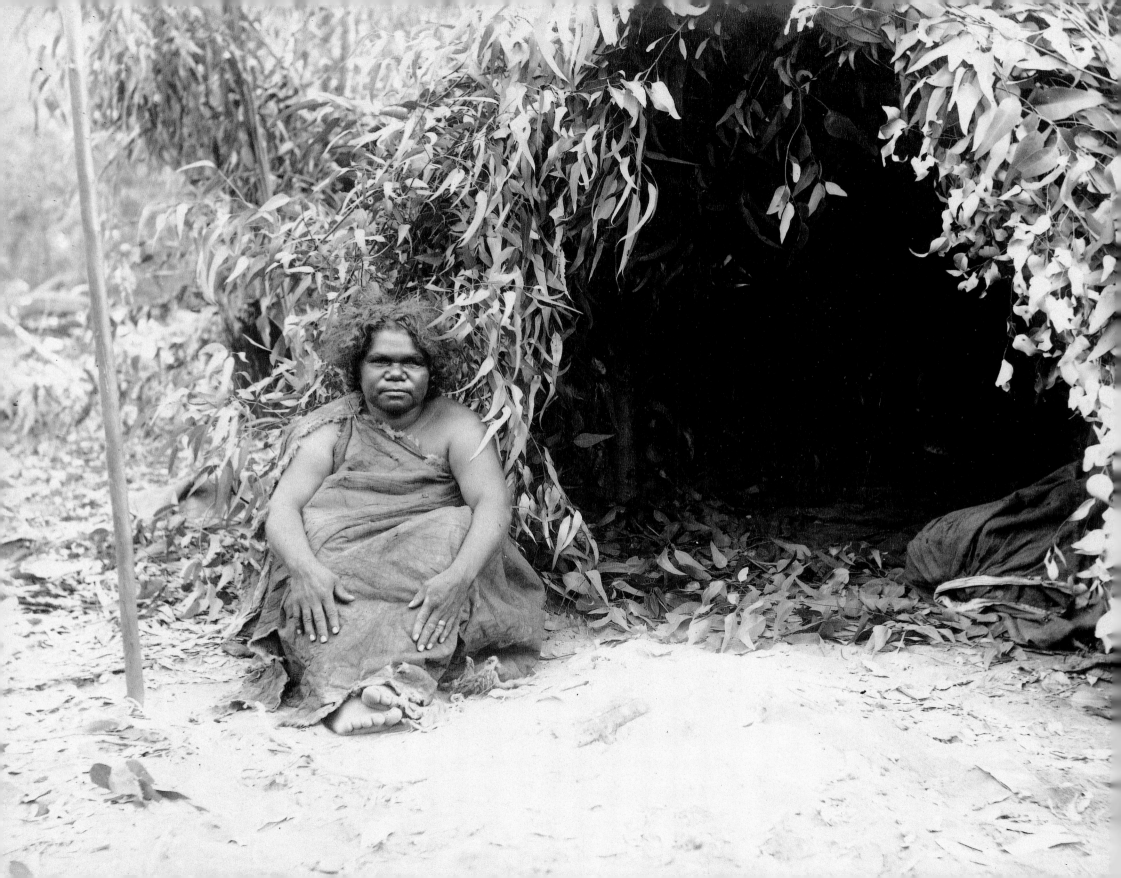

Home

Aborigines traversed the Fremantle area for thousands of years, but to date no evidence has been found of their residence in the area. No sites have been recorded for the Fremantle district. It is likely that, from early summer to late autumn, Aborigines fished and hunted in this area, crossing the river not at the dangerous river mouth but by swimming across a narrow part upstream. The Aboriginal woman pictured opposite features in a published album entitled *Fremantle Views*, but the only authenticated early photograph of Aborigines taken in Fremantle is the one by S.M. Stout reproduced on page 84.

Early letters provide an insight into the first encounters with Aborigines in the Fremantle area when white settlement began in 1829. It was unusual for workers to send letters, but a carpenter wrote on 1 November 1829:

"There are no natives to be seen within thirty or forty miles from the sea, and what have been seen (about forty) are very civil, but great thieves ... We had six of our sheep killed one night, which we expect was done by the native dogs ... The timber in general is seasoned, being burnt and killed by the natives ..."

"Give my bst respects to Mr –, and tell him I have not seen any black fellows yet."

Both quotes: *Extracts of Letters*, Battye Library monograph on reel. Original: Mitchell Library.

A letter written by the wife of a settler on 12 December 1829 was published in London as "for the first time, some account of the natives." It read:

"The natives have visited us several times. They are in a state of perfect nudity, of a dark copper colour. The chief of the clan has a large hook through the nose, and a band of feathers round his head. In general they are oiled all over their bodies. Their females we have never seen. The native men bring their children down frequently; they are very civil and harmless. They will not intrude into any of our tents, where they conceive they are not desired; for instance I never wish for them in mine; so I always send them something to eat, and then they go off quietly. They have no dwellings, but wander from place to place, leaving their females and young children behind them in the woods. They are easily intimidated; very fearful of dogs and goats. Yesterday there were about twenty natives in this place; they observed a horse and cart coming towards them, when they immediately to a man ran off, and shouting in the most frantic manner, never before, it appears, having seen a thing of the kind!"

It is ironic that it was white settlement of the area that led some Aborigines to make Fremantle their home. By 1857 there were sixty-five living in Fremantle, the same number as in Perth. In 1912 the number was only fifteen, and in 1927 laws excluded Aborigines from the metropolitan area unless they were employed. That law remained until 1954.

Above: "Riverview," the residence built in 1889 at 75 Tuckfield Street for Edward Mayhew. He had purchased the land from William Sandover, a friend and business neighbour in Newman Street. The prominent position of the house is reflected in the *Daily News* account of an explosion in a powder store connected with the harbour works, about a kilometre away: "Mr E.W. Mayhew's residence at Plympton was shaken to such an extent that the ceiling collapsed, and Mr Mayhew sustained a severe cut on the knee from the falling debris." Mayhew, a chemist who also acted as the United States Consul, sold "Riverview" in 1902 to the Oblate Fathers of Fremantle as Sacred Heart Girls' School. During World War II pupils and boarders were dispersed to the country and the building was used as a military hospital. The school re-opened in 1946 and the building was savagely altered before being demolished in 1988 to make a playground. The land has since been used again for housing. *Opposite:* The home of well-known merchant W.D. Moore, from Canning Road near Fremantle, 1908.

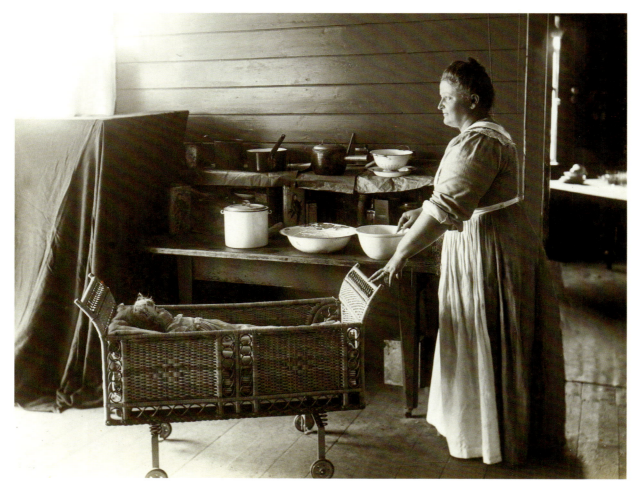

Left: Early indoor domestic photographs are rare; this is one of the best. A suite of indoor photographs was taken by Charles Nixon for the Brown family around 1909 when they lived in Grey Street. Lillian Brown and her boat-building husband, Alfred, had two daughters, May and Violet, but lost twelve other children. The mobile bassinette, a patented invention of Alfred's that could be secured in place, has a doll as substitute for her lost children. Lillian was dead two years after this photograph was taken, and Alfred moved to Elizabeth Street, North Fremantle.

Opposite: "Villa Maria," L. Ratazzi's home in Queen Victoria Street between James and Burt Streets, demolished in 1965 to build the Flying Angel Club. Similar limestone architecture can be seen on the office building he had built at 5 Mouat Street, still existing and probably the most photographed commercial building in Western Australia. Ratazzi helped, as German Consul, to found the German Club in 1901, which closed in 1914 when World War I broke out. Several merchants acted as voluntary consuls. Ratazzi was also the Italian Consul.

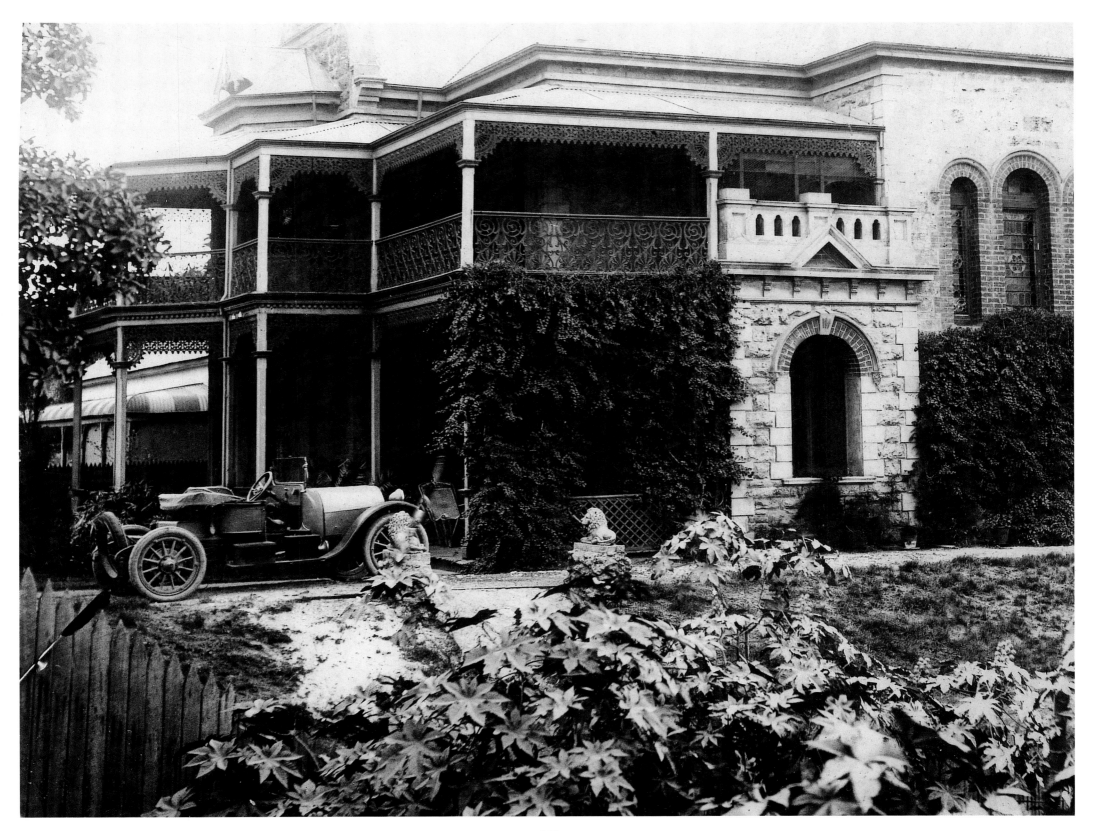

Left: East Fremantle Gothic, c1920.

Right: The Revd Mr Gunning, Church of England minister, stands outside his rectory ready for a game of tennis.

Opposite: Church of England rectory, Cantonment Street (lots 238, 239, 252, 253). Built pre-1908, this two-storey limestone house was situated in extensive grounds with tennis court and stables. It was sold to Goldsborough Mort in 1925 for £13,000 and demolished the following year. A brick woolstore, known as the Northern Woolstore, was built on the property in 1927.

Above: Unusual rear view of a family home from around 1910, on the corner of Grey Street and Marine Terrace. The Brown girls are seen with their dog Flora. The cat wishes to remain anonymous – note the large aviary. The girls were the two survivors from fourteen children of Alfred E. Brown and his wife, Lillian. Mr Brown features on page 55 as the builder of hundreds of pearling luggers and other craft. Mrs Brown can be seen on page 142, while Mr Brown's residence in North Fremantle around 1913 is opposite, his wife having died a year after the picture above was taken. *Opposite:* Mr Brown is standing alone in the yard of his large riverfront residence watching the 450-passenger *Zephyr* glide by. The Sydney-built *Zephyr* arrived in 1906 to compete with the *Decoy* and *Westralian* on the Swan River. Brown's boat-building yard was next door to his home.

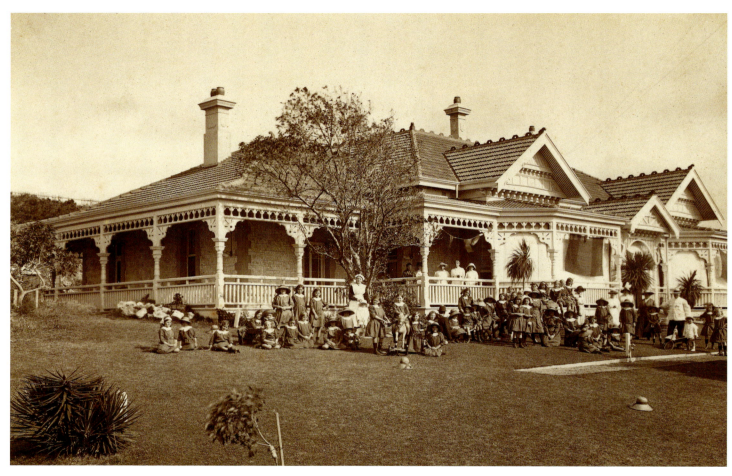

Above: "Ivanhoe," built in 1889 for James Lilly on the corner of High and Ord Streets. Known as the "Father of WA shipping," Lilly was state manager for the Adelaide Steamship Company. In 1905 he committed suicide and his widow continued to live here until the place was sold in 1914 to Frank and Blanche Biddles, seen here on 18 November 1916, when fifty orphan girls visited from the Perth Girls' Orphanage. It was demolished in 1966 to make way for a block of flats and a petrol station.
Opposite: Looking across Fremantle Park, formerly Victoria Park, to "Ivanhoe" in the distance, the occasion being a citizen defence bivouac c1914, possibly 86th infantry camp. Council minutes for 18 January 1915 complained that "some person or persons connected with the military encampment have been destroying the park fence and using it for firewood."

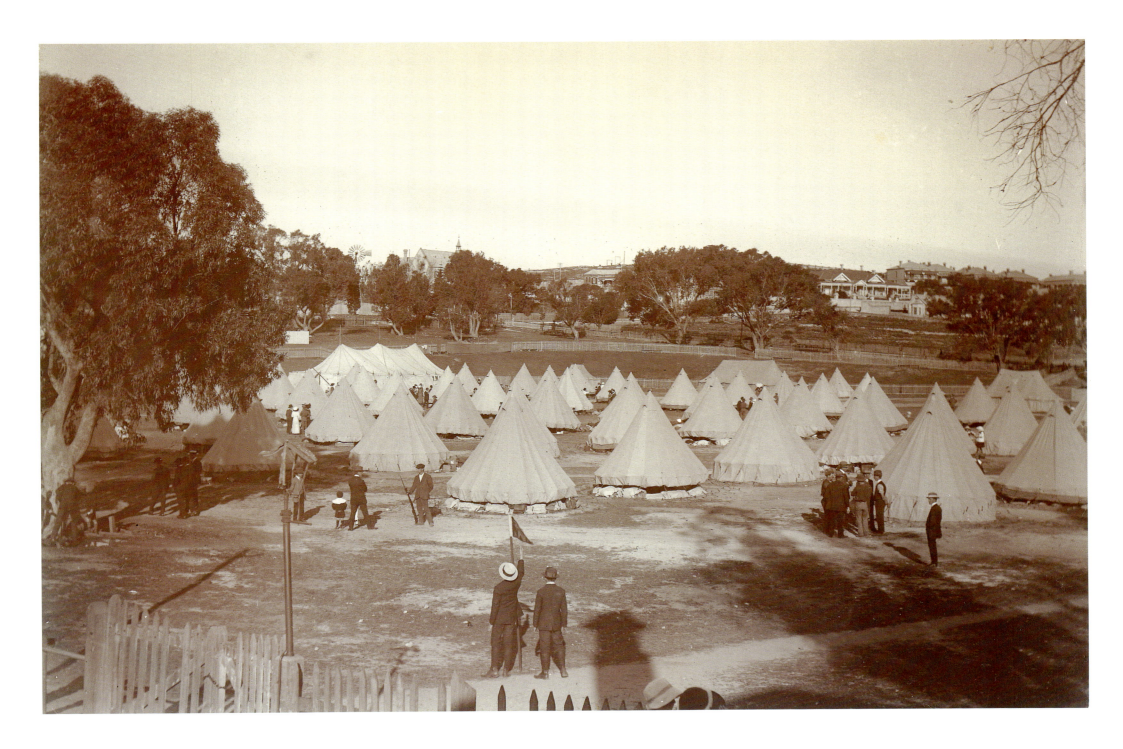

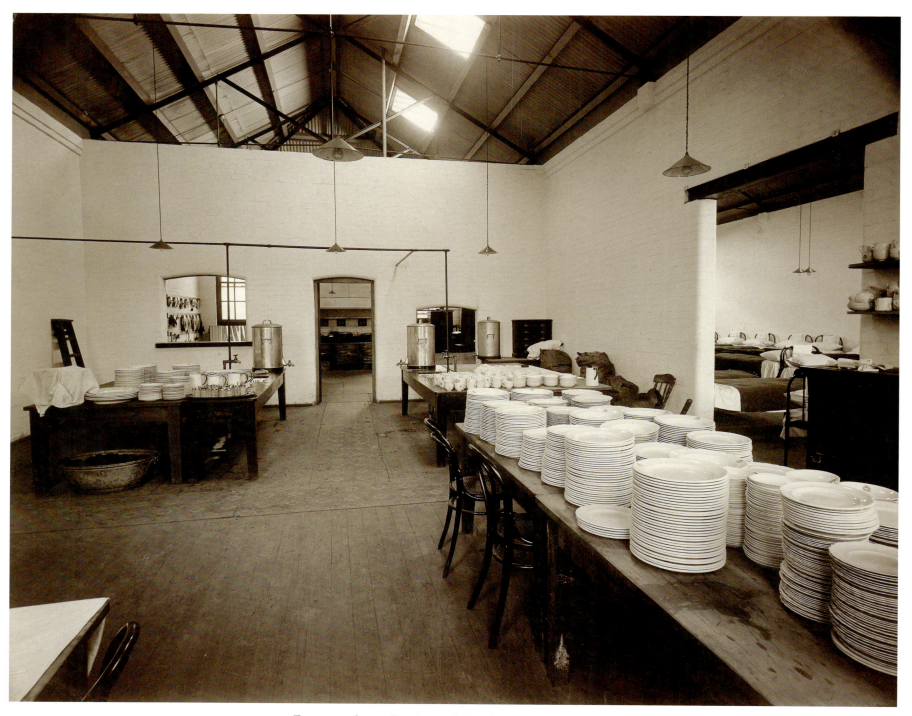
Temporary home: Immigrants' Hostel, South Terrace, c1920.

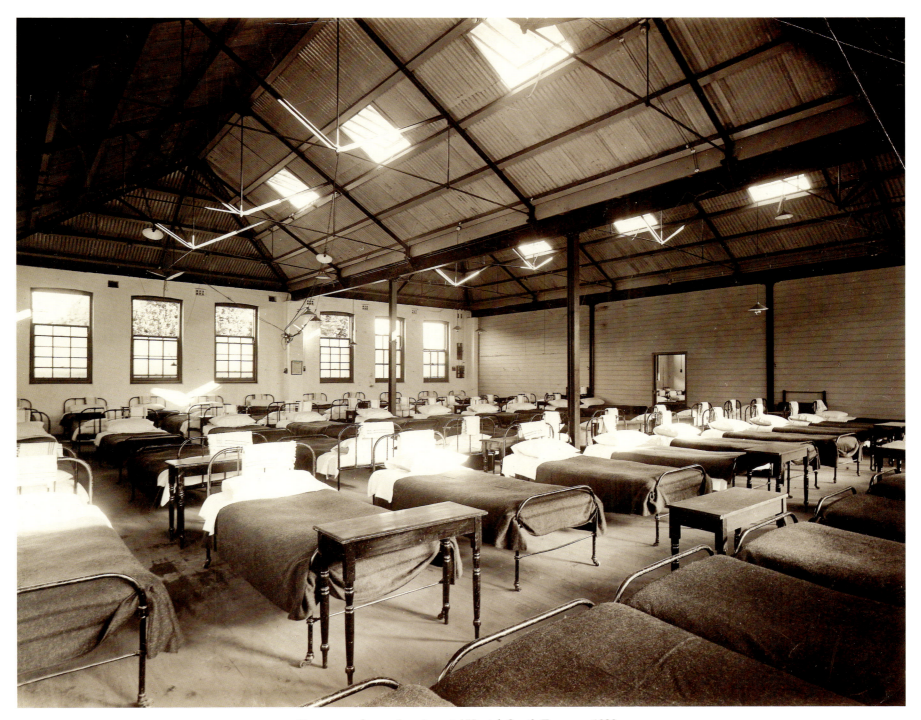

Temporary home: Immigrants' Hostel, South Terrace, c1920.

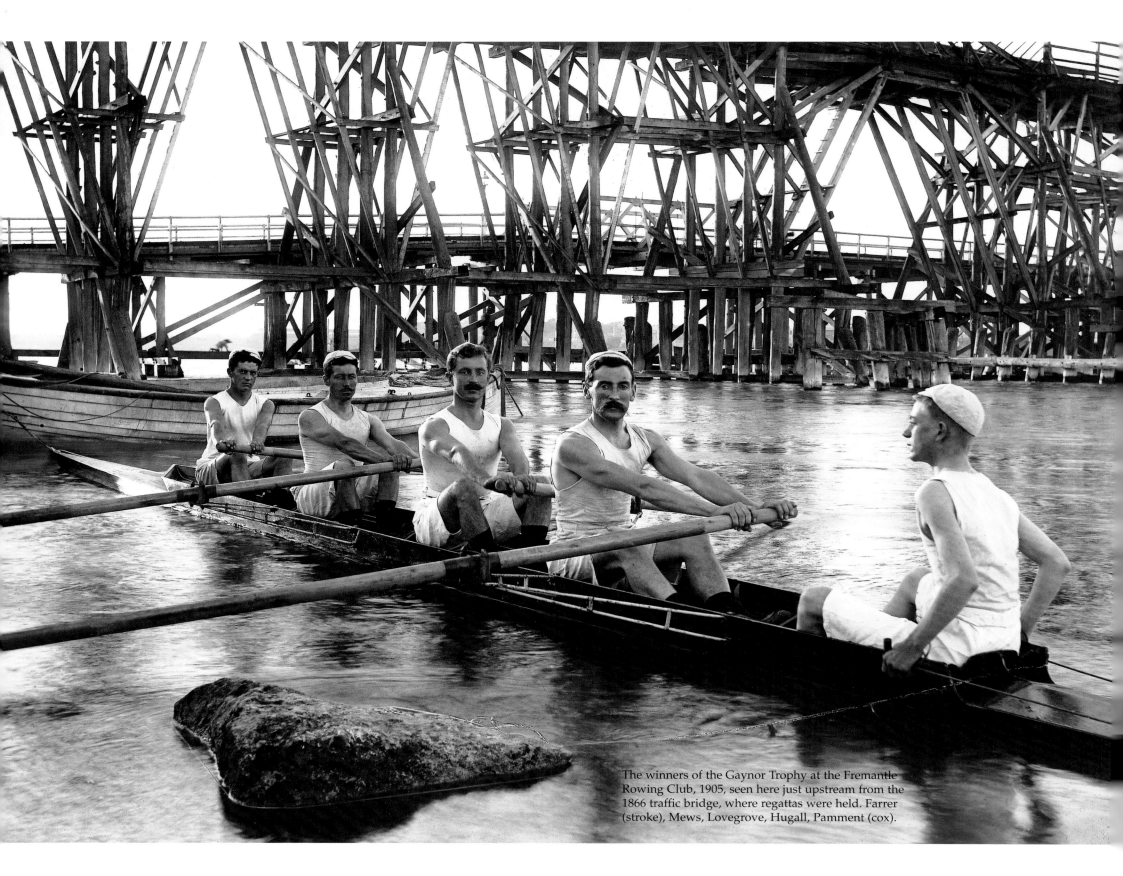

The winners of the Gaynor Trophy at the Fremantle Rowing Club, 1905, seen here just upstream from the 1866 traffic bridge, where regattas were held. Farrer (stroke), Mews, Lovegrove, Hugall, Pamment (cox).

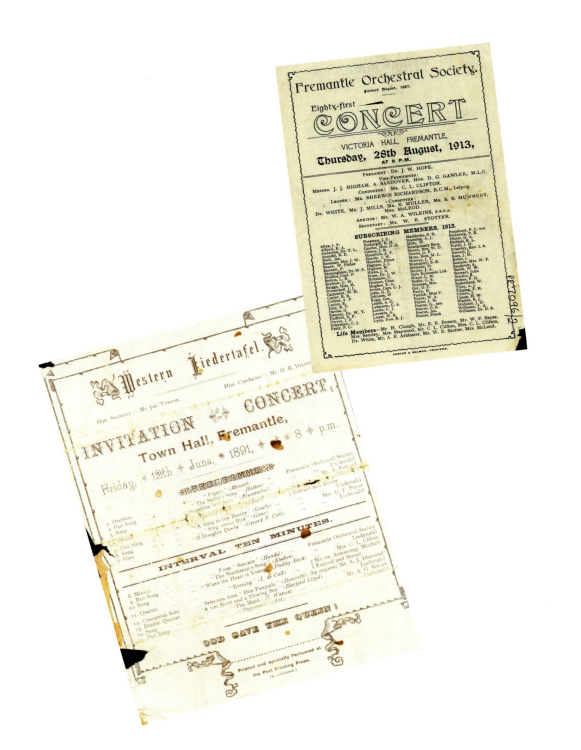

People and Pleasure

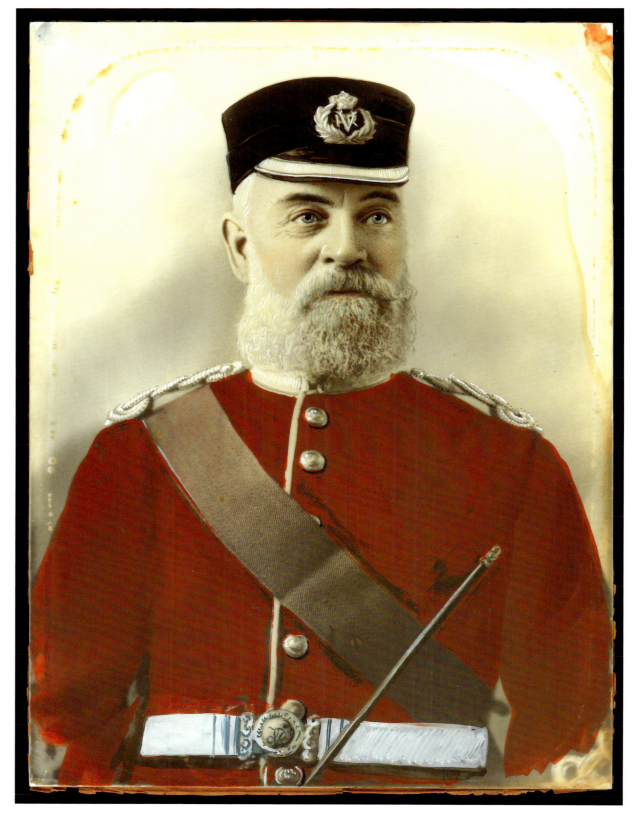

Right: Bandmaster Patrick Henry Fay, c1895, in a rare hand-coloured photograph on glass called an opalotype or milk glass photograph. The first opalotypes were advertised in Australia in 1882 and were most popular between 1890 and 1900.

Opposite: Fremantle Infantry Volunteer Band, May 1896, Lawrence Fay on left. The Infantry Volunteers formed in 1861 in response to fears of a convict uprising. They drilled on Barracks Field, now Fremantle Oval.

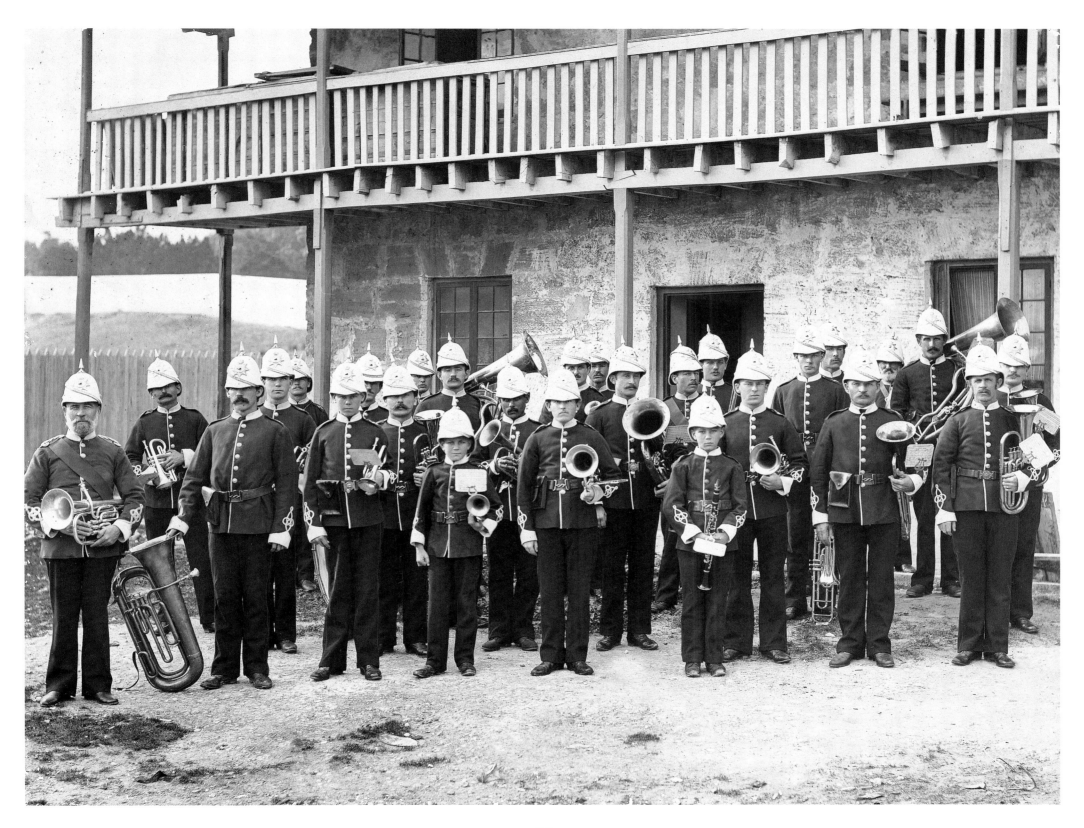

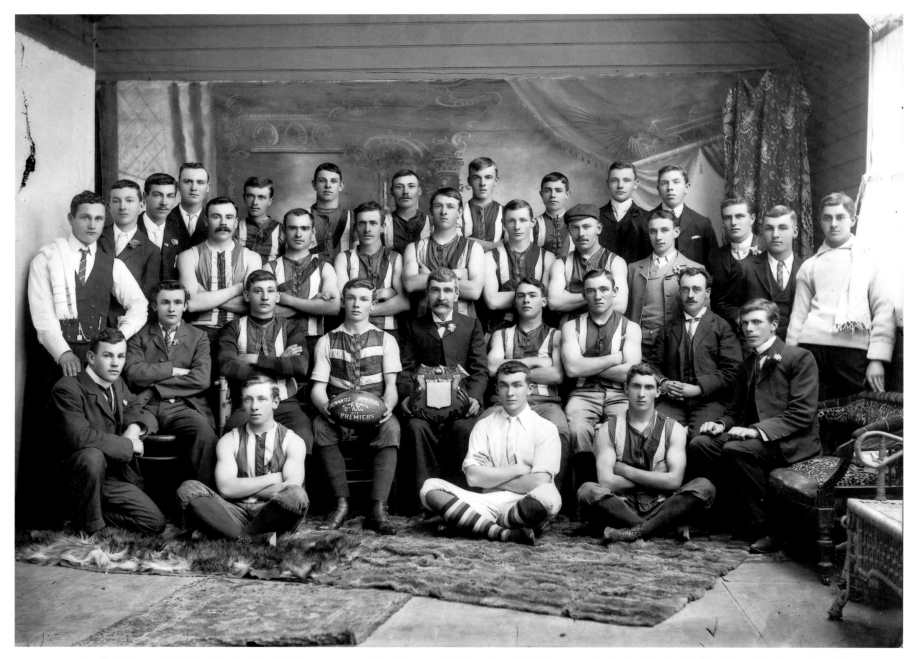

Football team, 2nd Rates Junior Football (home ground East Fremantle), Premiers 1903. The team included Medwell, Orr, Sharp, Matison, Bovell, Saunders, Jones, Hoare, Hindricks, Wilcox, Byrne, Howson, Watson, Crighton, Bell, Rowlands, Lewis, Smellie, Garvey, Milne, and Hicks.

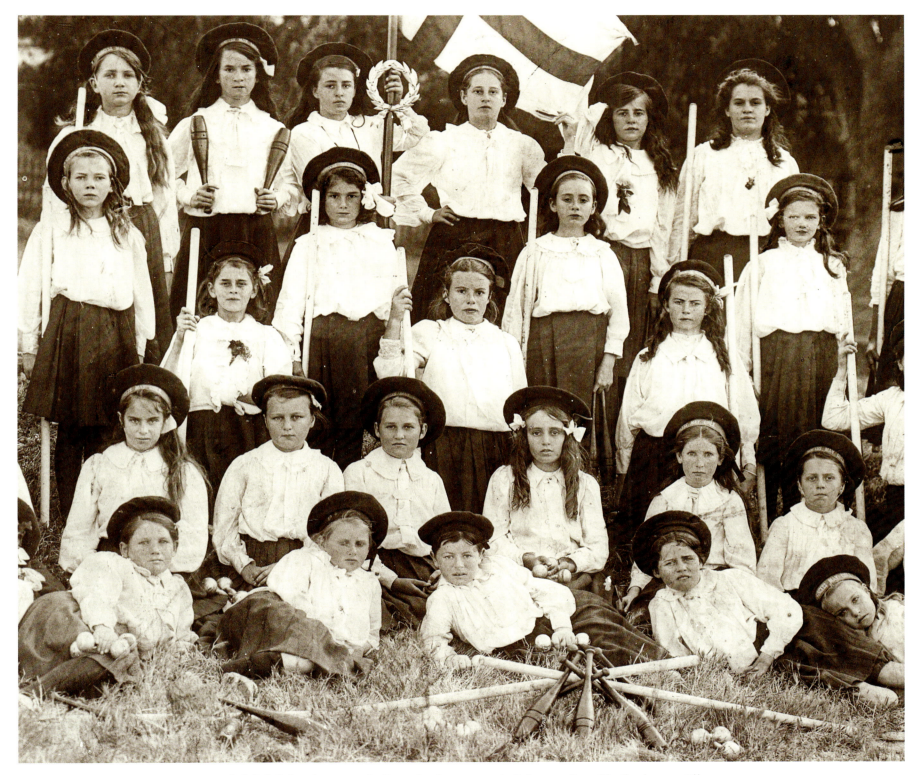

A delightful and communicative school group portrait (cropped), unlike the dreary, stiff, and robotic ones often seen today. Princess May Girls' School 1910 Competition Squad.

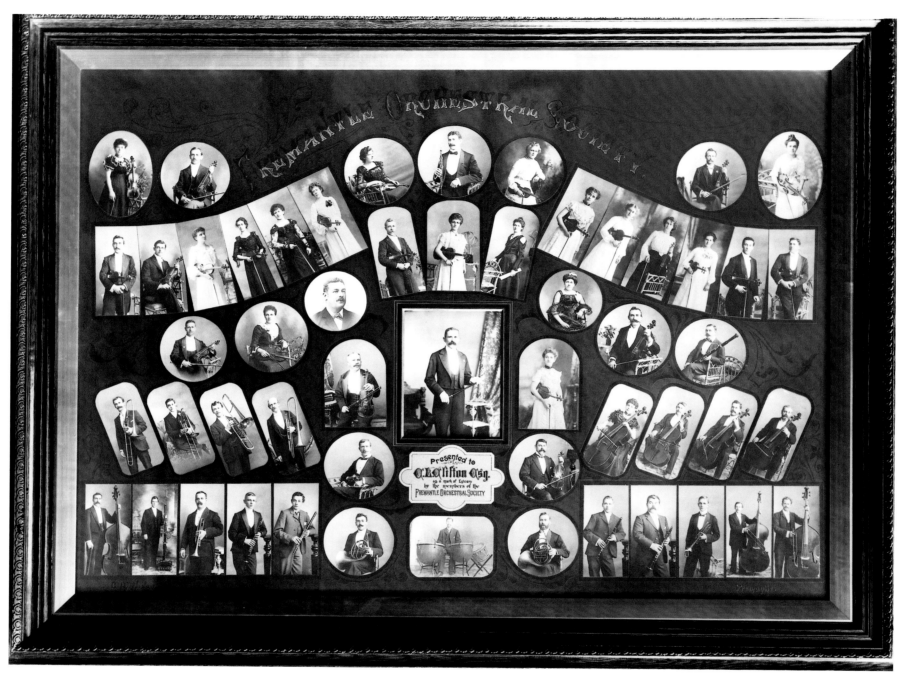

The Fremantle Orchestral Society was formed in 1887 by Charles Clifton (1854–1928). Having arrived in Western Australia as a teenager in 1867, Clifton went on to become manager of the WA Bank in Fremantle. He also had musical interests, his instrument being the cornet. His wife, a pianist as well as mother of his eight children, was also a foundation member of the society. As represented here in this carefully executed composite, presented to Clifton after many years as leader, the orchestra has fifty-four players. The last member signed up in 1922.

Residents of the Old Women's Home, former Lunatic Asylum, Finnerty Street, c1924, now the Fremantle Arts Centre.

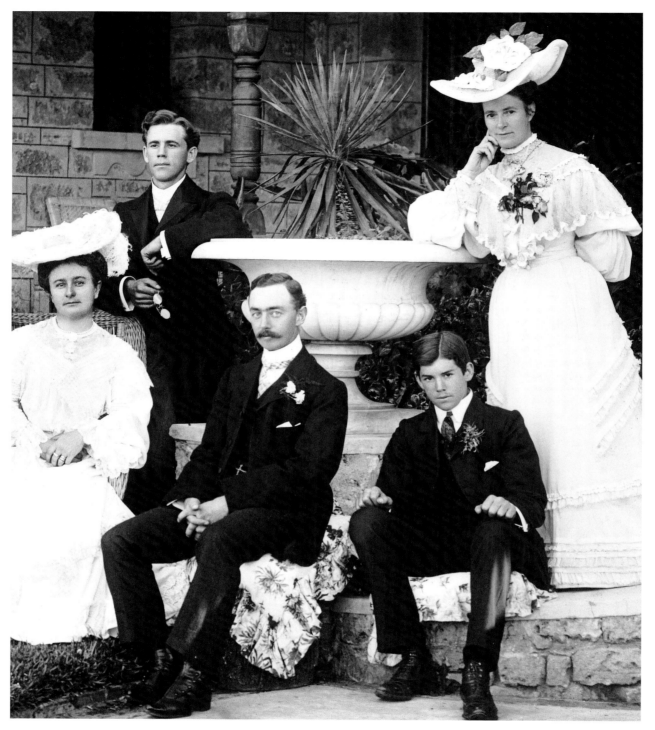

Wedding of Ross and Louisa Harwood at the home of John Harwood (uncle of Ross), 11 Point Street, on 16 November 1904 (photograph cropped). The bride and groom are on the left. Standing right is Jean Richardson and the seated men are Oliver Gravden (left) and Leopold Harwood.

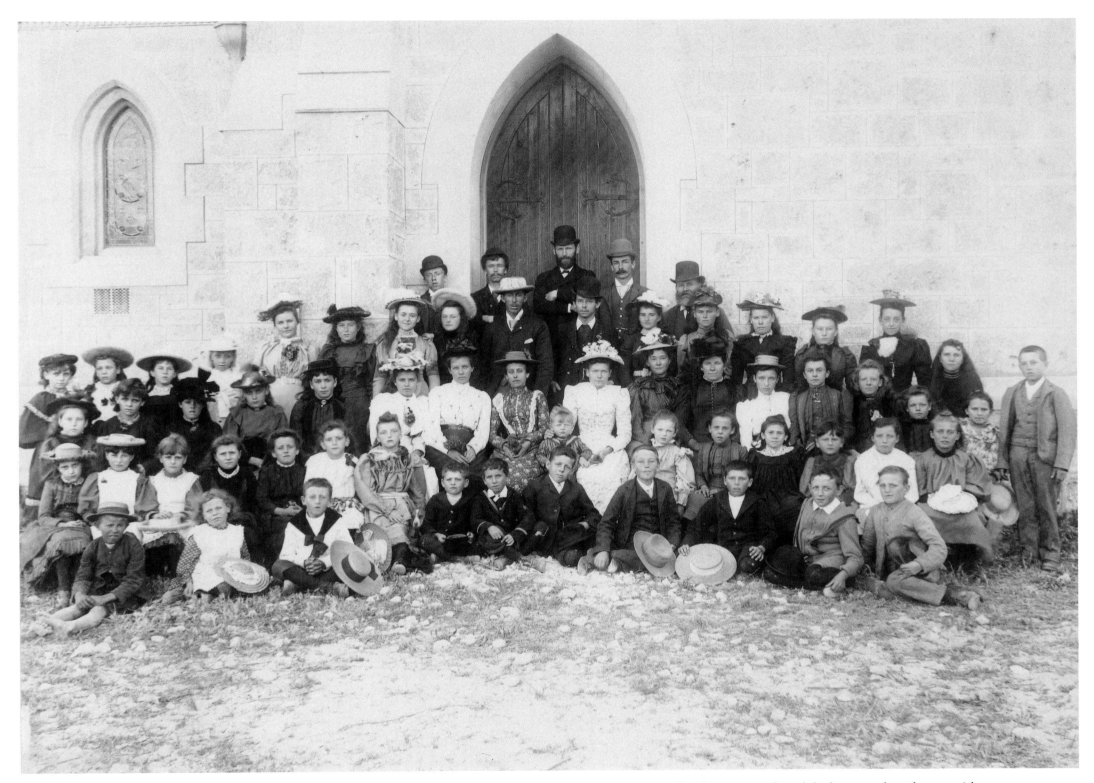
Sunday school group outside an unknown Fremantle church, c1900. Of note are the ratio of almost three females to one male and the large number of young girls.

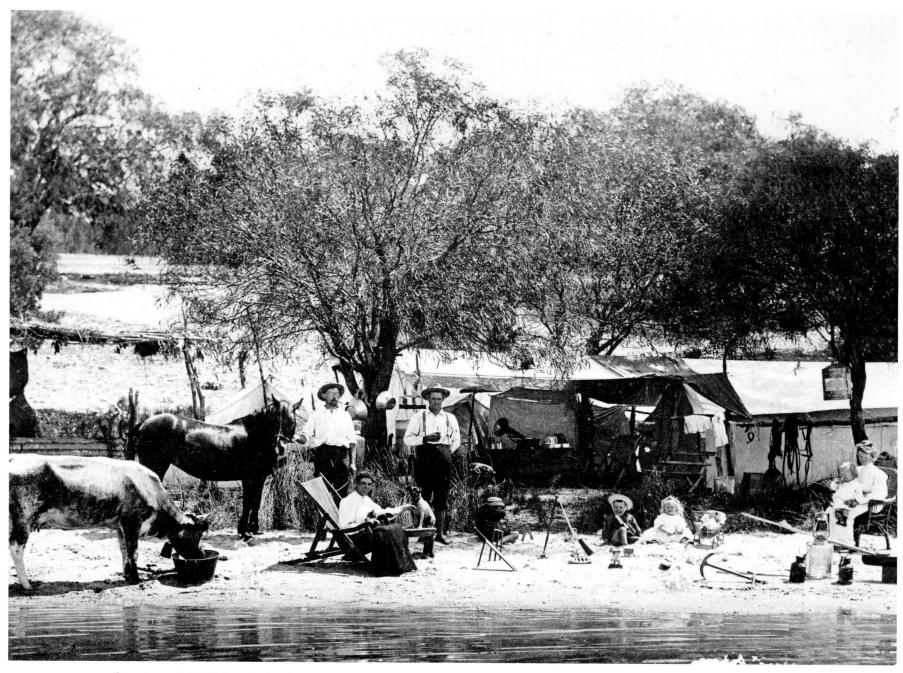

Camping at Point Walter: the family of Lewis Benningfield Bateman (1868–1914), from Northam, c1909. Bateman is standing second from left, the crying child fourth from left is Master Aubrey J. Bateman, and seated is Amy Kathleen Bateman (née Cook).

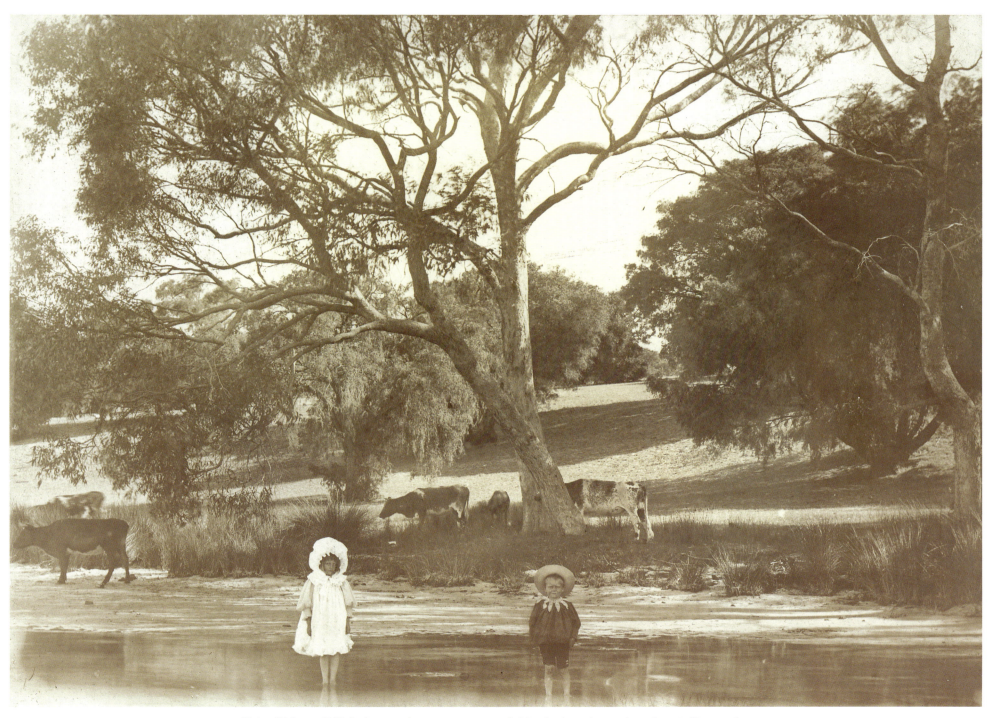

Point Walter, c1900, before road or tram connected this picnic and camping place to Fremantle.

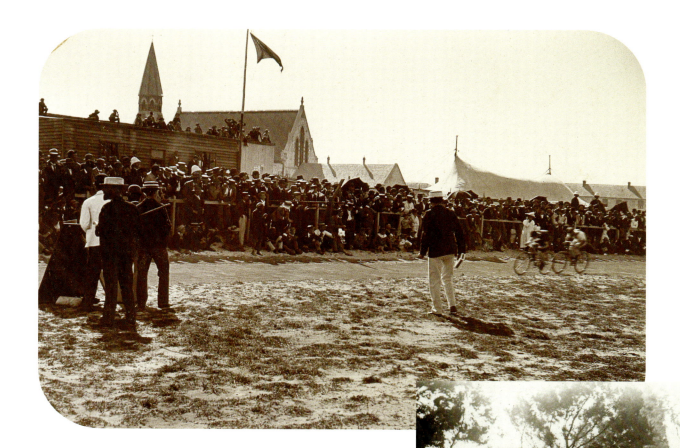

Above: Cycle racing at Fremantle Oval, c1905.

Right: 1913 Sister Kate's children's camp at Elizabeth Street, North Fremantle, where the camp benefactor, boat-builder Alfred Brown, lived and worked. He is the tall man in the back row. Few Asians then lived in Australia, and the Asian girl on the left looks rather isolated from the group.

"Opening Day" of the season, South Beach, 8 March 1909. The event reportedly attracted 25,000 people. Even allowing for wild exaggeration, this makes South Beach by far the most popular tourist destination at that time in Western Australia. By comparison, the government had spent a large amount at Caves House and the caves in the Margaret River district, but attracted a total of only 191 tourists for the whole of 1909. Pictured here are Percy Wright's swings and merry-go-rounds.

A little bit of fishing, c1945. The current Fremantle Traffic Bridge, behind, had opened in 1939 in time for World War II.

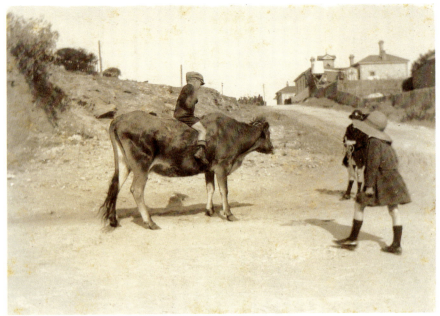

Above, above right: The Mulcahy girls of "Knockagow" in Bolton Street, East Fremantle, with the family cow, c1920.

Right: Three young ladies going crabbing, 1930.

Fremantle Sea Baths. Located between the Short and Long Jetties in South Bay, near where Cicerello's now stands, the facility was opened in January 1907 by Mayor Michael Samson. One and a half acres were set aside for gentlemen and three-quarters of an acre for ladies. Thursday nights were "Continental Nights," when mixed bathing was allowed. They were known as the "New Baths" to distinguish them from the earlier facility at the end of Arundel Street. A financial disaster brought about by storm damage combined with the development of South Beach led to the baths' closure in 1917.

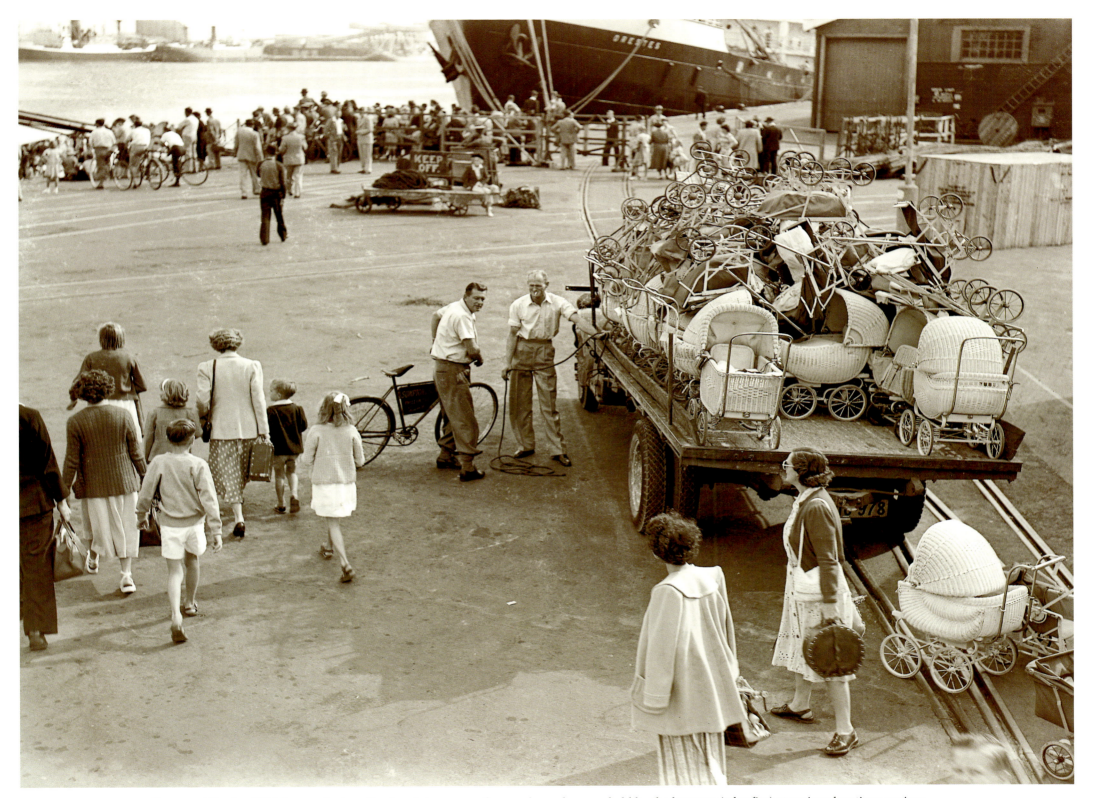
Lumpers' Picnic, c1946. Large picnics, often involving over a thousand people, were held by the lumpers (wharfies) at various locations upriver.

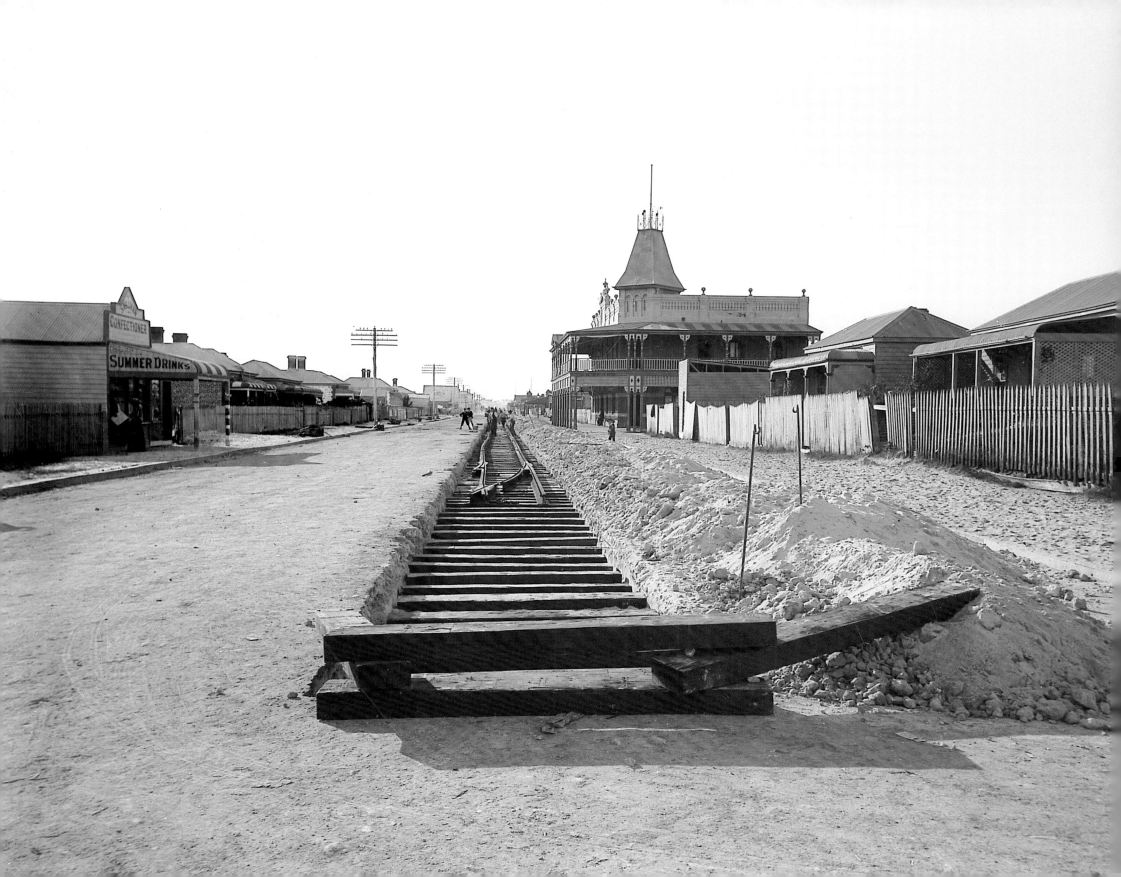

Trains and Trams

The advent of trains in 1881 got people in and out of Fremantle, and the coming of trams in 1905 got people around Fremantle, ushering in the new phenomenon of public transport. For 3d one way, a passenger could ride in one of fourteen 40-seater tram cars that ran nineteen hours a day on weekdays. The system was wildly successful, carrying over two million passengers in its first year, and also selling – one of its core activities – electricity to 203 customers. The network expanded rapidly, and the impact of the Fremantle Municipal Tramways was significant in developing outer suburbs. A service to North Fremantle opened in 1908. By 1911 the East Fremantle Council had introduced a speed limit of 12 miles per hour. The last trams ran in 1952.

Right: Bus services provided competition for trams and trains. These timetables from the 1930s show that initially every copy of the timetable was hand-typed for passengers.

Above: Tram tickets, one showing advertising on reverse side.

Opposite: End of the line: tram terminus in South Terrace at South Beach, 15 June 1905.

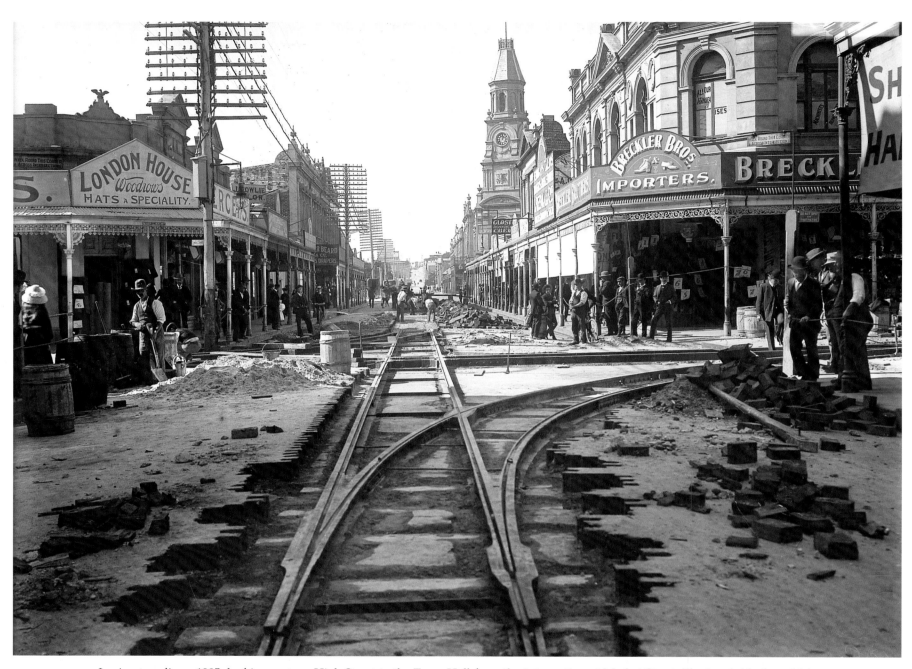

Laying tramlines, 1905, looking east up High Street to the Town Hall from the intersection at Market Street. The jarrah blocks, which had been laid only in 1898, are here being temporarily removed. Vast quantities of this Western Australian timber were used to pave city streets in Australia and overseas. Later, there were problems with water getting between the tram lines and the wooden blocks.

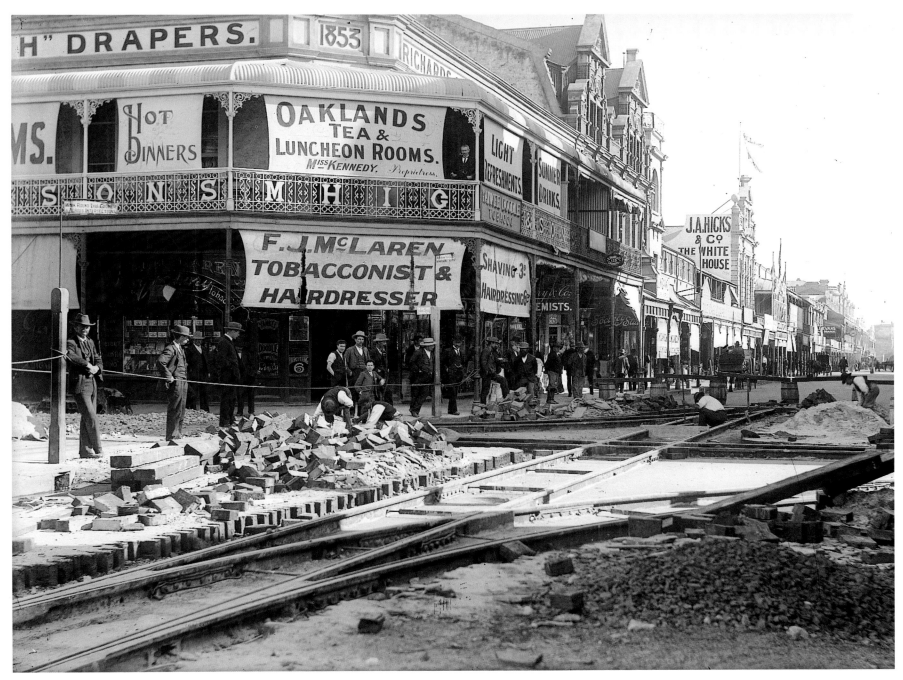

Tram track construction in High Street at the Market Street intersection, 1905, looking west towards the Round House.
The J.A. Hicks building further down High Street is now the Wyola Club.

Cleaning jarrah street blocks for re-use in September 1905, just months after tramlines began to be laid throughout Fremantle. The photograph was taken in what is now known as Pioneer Park, opposite the railway station. The building on the left is the 1858 Manning Building, so big and with so many windows it was known as Manning's Folly (demolished 1928). The Tolley Building is still standing, though occupied by Tolleys only from 1901 to 1911.

Installation of electric cabling, 23 September 1905, for the new tramways showing 33–37 High Street. The Baird's building is sited between the Orient Hotel (verandahs recently partly reconstructed) and the P&O Hotel (verandahs recently reconstructed, though the finials are still missing).

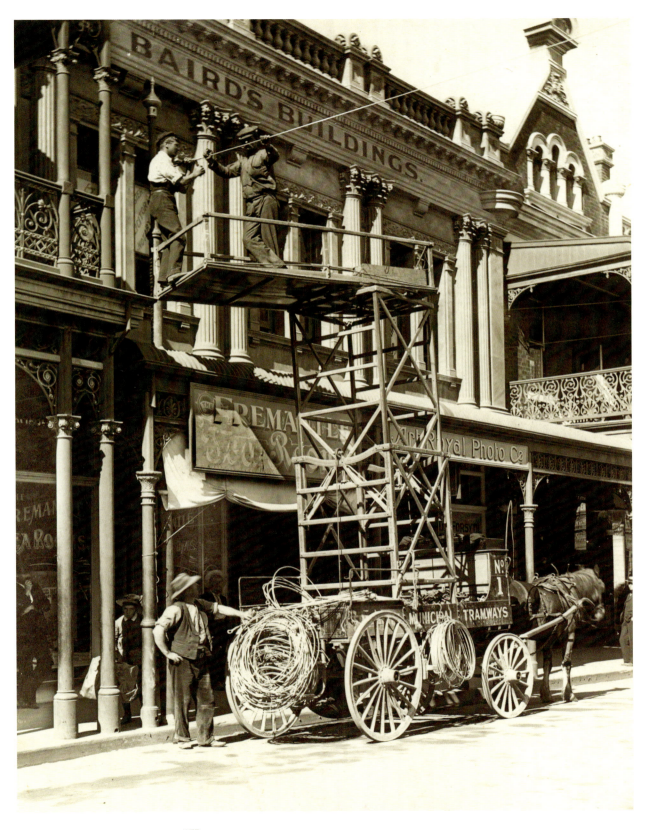

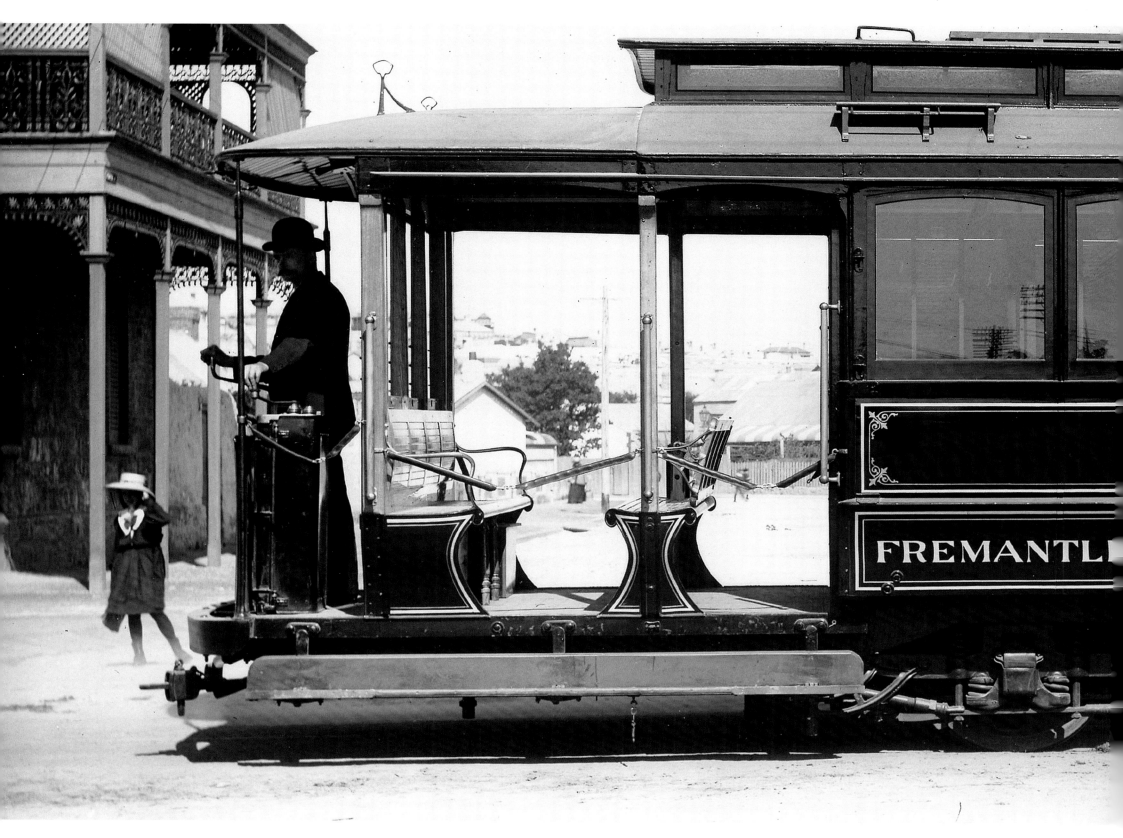

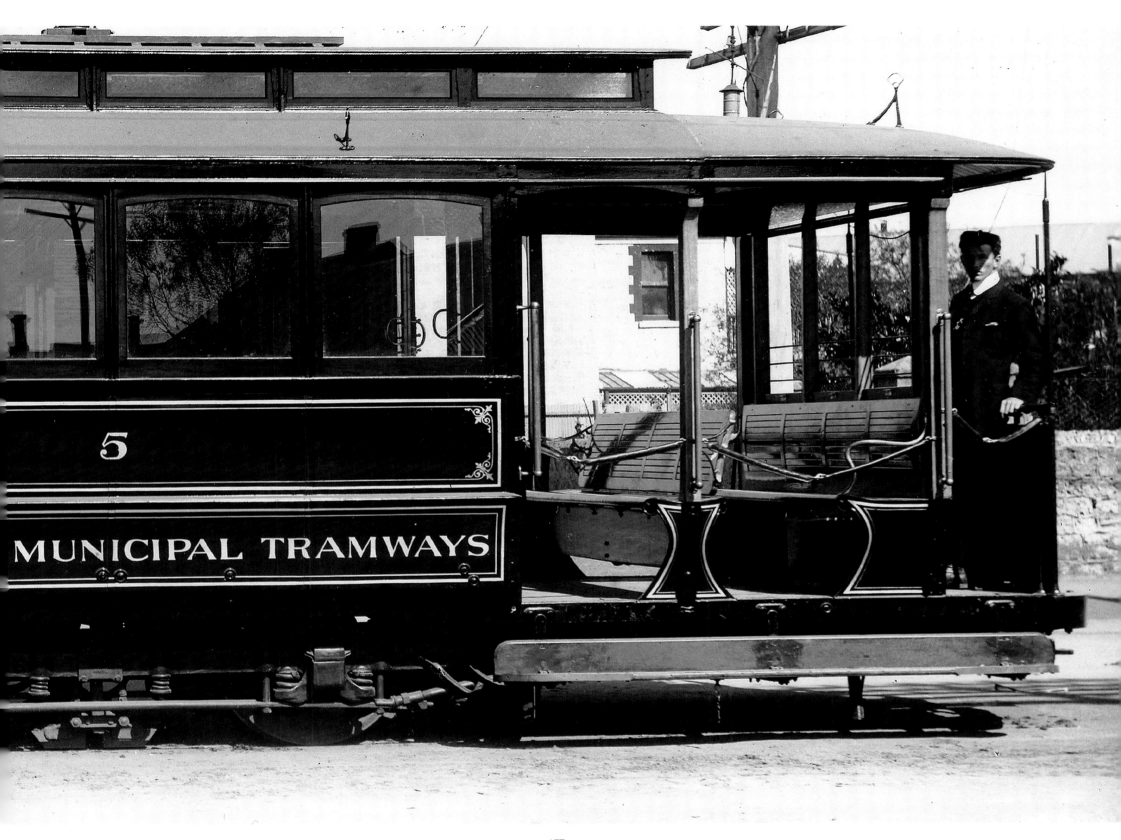

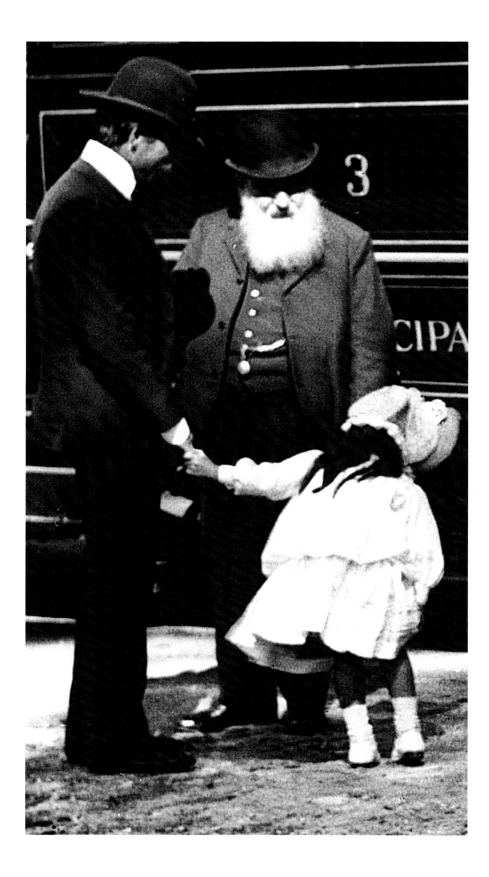

Opposite: East Fremantle tram, c1908.
Left: Detail.

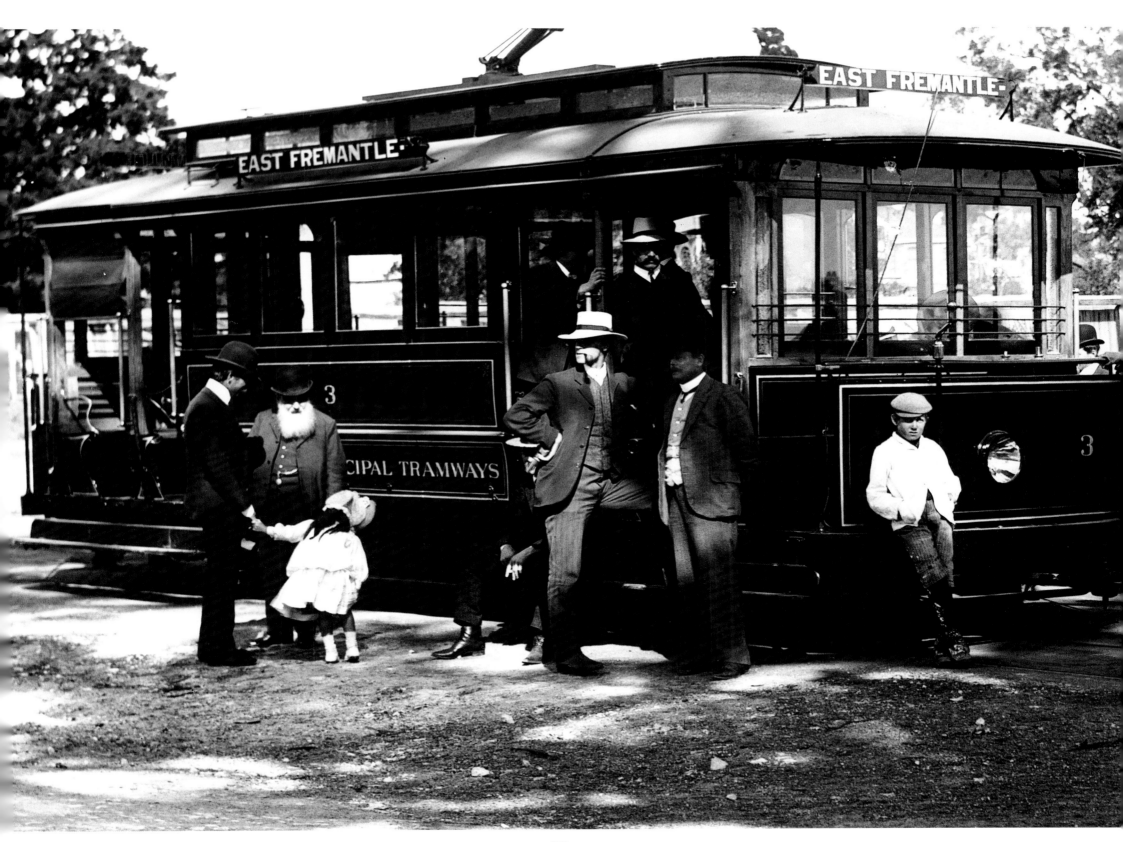

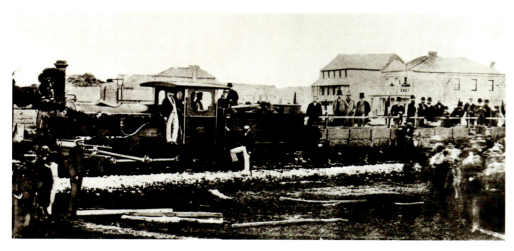

Above: Fremantle's first train, photographed on 31 August 1880 in anticipation of its run across the railway bridge, officially opened that day, to the North Fremantle depot. The view is across what once was the Recreation Ground to Cliff Street and George Shenton's house.

Below: Motor bodies arriving in 1920 after a record trip over the Trans Australian Railway.

"The interesting ceremony of starting the first train on the Eastern Railway was performed by His Excellency the Governor on Tuesday last. Four brand new trucks accommodated with benches, and gaily decorated with flags, were in readiness on the Fremantle 'Green' at 12 o'clock, and shortly before his Excellency's arrival, the contractor's engine, garlanded with flowers, steamed down from the depot and hooked on." (*West Australian*, 3 September 1880) Charlotte Shenton recollected: "In 1880 when I was staying at Fremantle with my young children in the same old Shenton house, the railway to Perth was being built. It amused mother and the children for many hours in the day watching the men at their work and the engine passing backward and forward all day long and sometimes at night. It made me sad to see the cricket ground cut up and rails all over the green, but it had to be." (*West Australian*, 21 December 1935)

The official opening of the Fremantle-to-Guildford railway occurred on 1 March 1881: "At 5 minutes past 10, His Excellency and party left for Fremantle. It was a pretty ride, the train passing through timbered country all the way till it emerged near Fremantle in sight of the blue sea; and crossing the broad placid river with the picturesque bridge of sticks on the left, and the mouth of the river and the shipping on its right, reached the platform 28 minutes after leaving Perth." (*Herald*, 5 March 1881) The ride today is not as picturesque and not much faster.

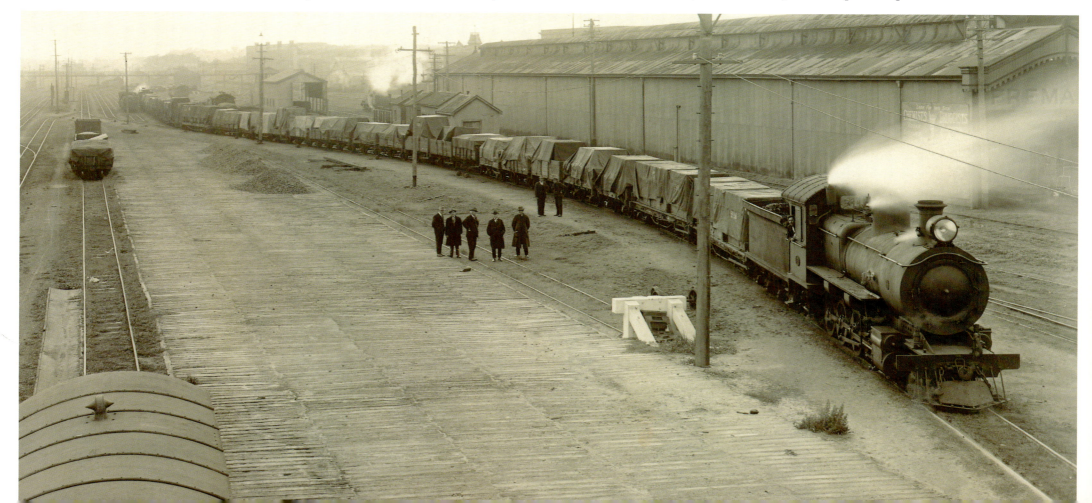

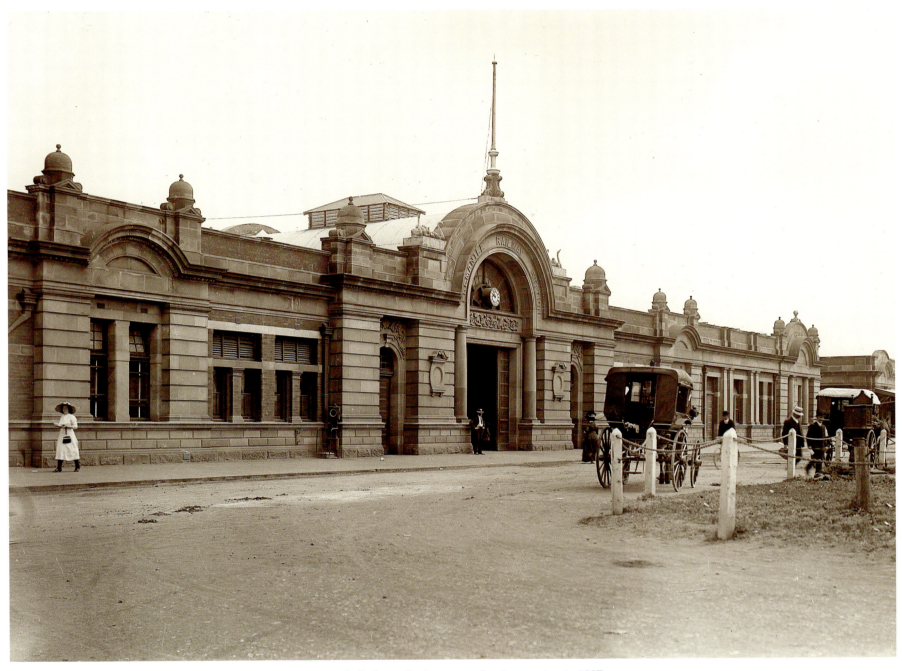

Fremantle Railway Station soon after its opening in 1907.

This page: Unknown boat launch.
Opposite left: 1919 Business guide.
Opposite right: Lionel Samson's copy of the 1870 Almanack and Directory.

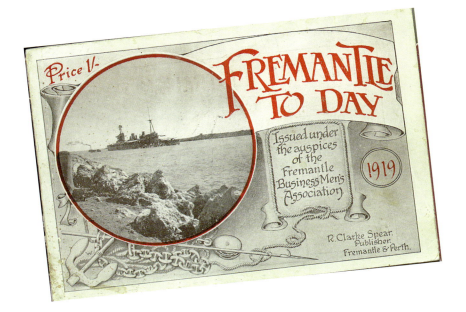

Business

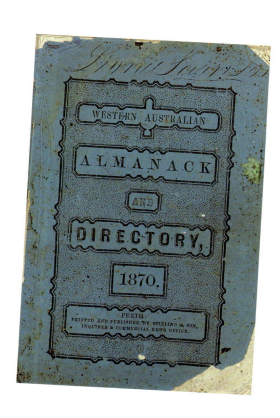

Collector of Customs

Rare and very early Fremantle photographs:
Below: Leonard Worsley Clifton (1830–1895), Collector of Customs (1862–1891), outside his offices in 1864 at the corner of Henry Street and Marine Terrace, the first official Customs House in Western Australia, which had opened in 1862.
Left: This 1864 daguerreotype of Clifton is, even by today's standards, a superb quality portrait.
Far left: Clifton signed the certificate because, long after transportation of convicts to Western Australia ceased in 1868, other colonies refused to receive passengers from Western Australia unless they carried such a document. These were supposed to be retained in South Australia, but Connor was the owner of the ship and the certificate returned with him.

Clifton, born in Somerset House, London, in 1830, was one of eleven children who arrived with his parents, Marshall Waller and Elinor Clifton, in 1841. Marshall Clifton was Chief Commissioner for the settlement at Australind, which failed. When Comptroller General of the Convict Establishment Edmund Henderson left in 1863, Clifton moved into his large house near the prison, called "The Knowle," where he remained until 1892. He had moved from one of the most famous places in London to the best house in Fremantle.

Posts and Telegraphs

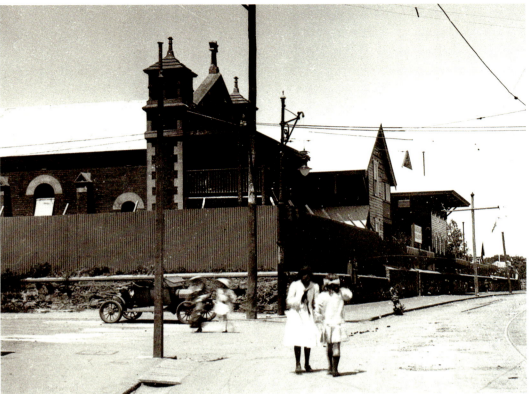

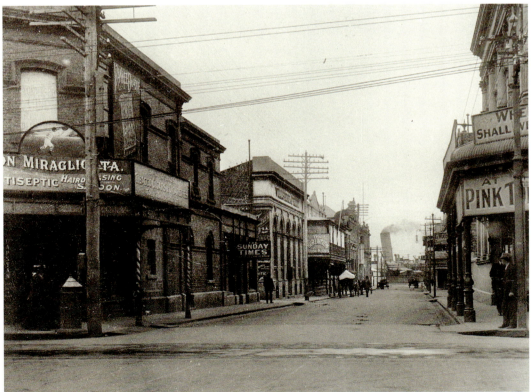

Above right: One of a number of photographs taken by the Posts and Telegraph Department of their public works. This view, c1912, is of South Terrace looking past the synagogue on the corner of Parry Street to the immigration centre. This photograph features the dismantling of telegraph wires rather than their installation. The same parked car appears in other images in this series, suggesting that the photographer had a love affair with his own vehicle, a model T Ford.

Right (cropped): A rare view of Pakenham Street – rare because, unlike High Street for example, side streets like this one were not heavily photographed.

Above: An early Fremantle telegram. The first telegram in Western Australia was sent on 21 June 1869 from Perth to Fremantle. This was a private venture by Edmund Stirling, who wrote: "So little interest was taken at the first establishment of the telegraph in the Colony that only five persons were present when the first post was erected … This line was seldom used for the first few months, but was soon afterwards appreciated, and made available for both business and social purposes (especially the latter), which had not always been the most friendly between the two centres of population." (*Souvenir of the Postal Telegraph and Telephone Departments of Western Australia*, 1898). By 1880 the post office was open seven days a week for receipt and dispatch by this new means of rapid communication.

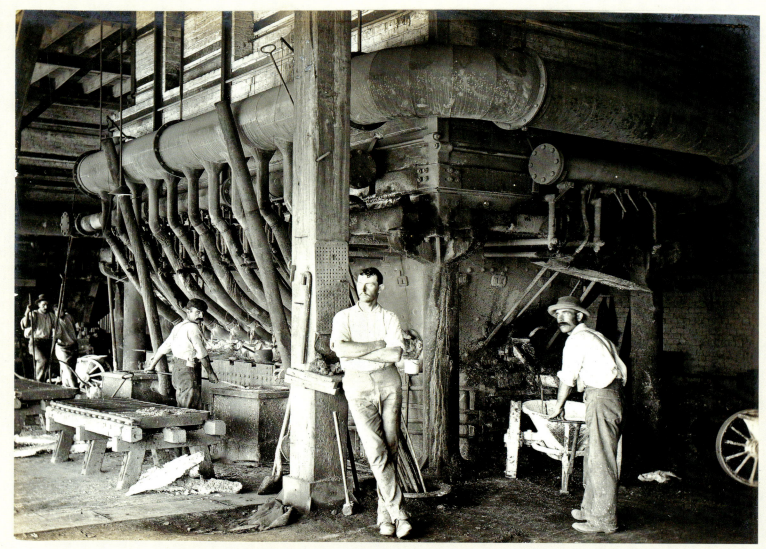

Smelting Ores at Fremantle.

The Fremantle Smelting Works, built 1898 just south of South Beach, initially ran on coke brought from Wales in windjammers. Later it became the largest user of Collie coal after the railways. Three water-jacketed furnaces could treat 85 tons of gold and of lead ore each 24 hours. In 1904 Fremantle Council was cajoled into using some of the slag dump for road material in a trial outside St John's Church, but the sharp material did not agree with the horses' hooves. This image is from a fabulous and extensive photographic album of eighty-nine Western Australian images presented to Harry Whittall Venn, MLA, as Chairman of the Paris Exhibition Commission by the Perth photographic company Greenham & Evans. After being sacked by John Forrest in 1896 while serving as the first Commissioner for Railways and Public Works, when the lack of railway rolling stock caused freight blockages in Fremantle and bitter arguments between Venn and Forrest, he was appointed by the government in 1899 to "undertake the collection of the products of industry and agriculture" for the 1900 Paris Exhibition, which also included the fine arts. Some of the photographs, though not this one, were used in the official Western Australian catalogue published in Paris.

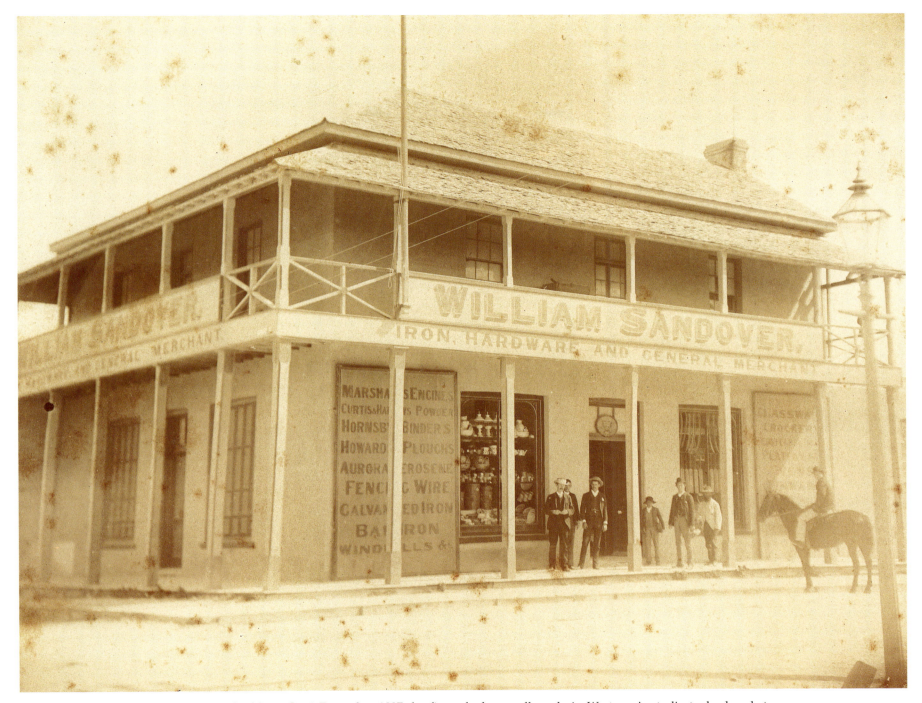

William Sandover building. On 1 December 1887 the first telephone call made in Western Australia took place between Sandover and his friend William Mayhew. When the first telephone numbers in WA were allocated, the numbers 1 to 100 were set aside for Perth, the number 1 being assigned to Government House. Fremantle was initially allocated numbers 101–200.

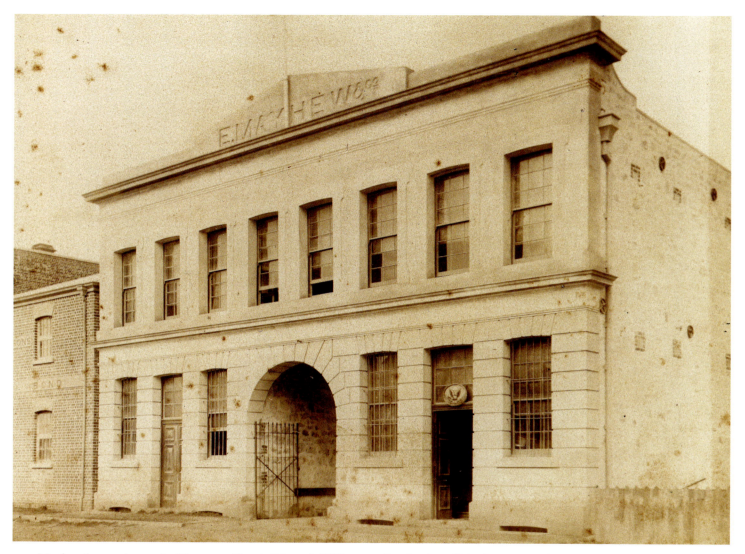

Mayhew's warehouse in Newman Street. Edward William Alfred Austin Augustin Pendlebury Mayhew (1855–1933) had his first job in WA at Fremantle Prison, followed by several years with the Western Australian bank from 1878. While there he met another twenty-three year old, William Sandover, and they went into business together in Henry Street in 1881, their first stock being ten kegs of butter from Adelaide. Having become manufacturing wholesale chemists as well as grocers, they moved to larger premises at the corner of High and Mouat Streets. The partnership was dissolved, and Mayhew set up the Pelican Confectionery and a soap works. He was the first chemist in WA to distil sandalwood oil. By marriage to Agnes Jewell, Mayhew became a brother-in-law to his former partner. He was given command of the Fremantle Battery, which had dangerously old guns including two six-pounder howitzers used by Wellington's army at Waterloo. In 1899 Mayhew retired with the rank of captain. For almost twenty years he was the United States Consul General, and in 1892 he founded and became founding president of the Pharmaceutical Society.

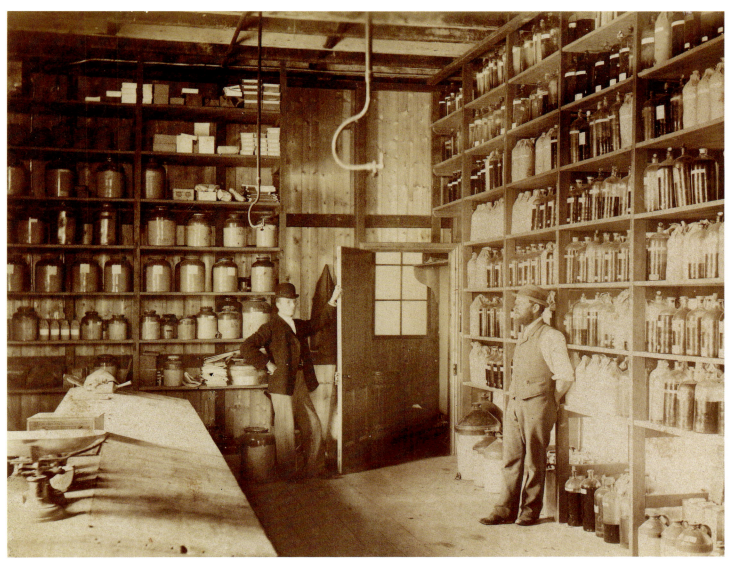

Drug department inside Mayhew's warehouse in Newman Street, where Queensgate now stands. Soap was also manufactured and sold here.

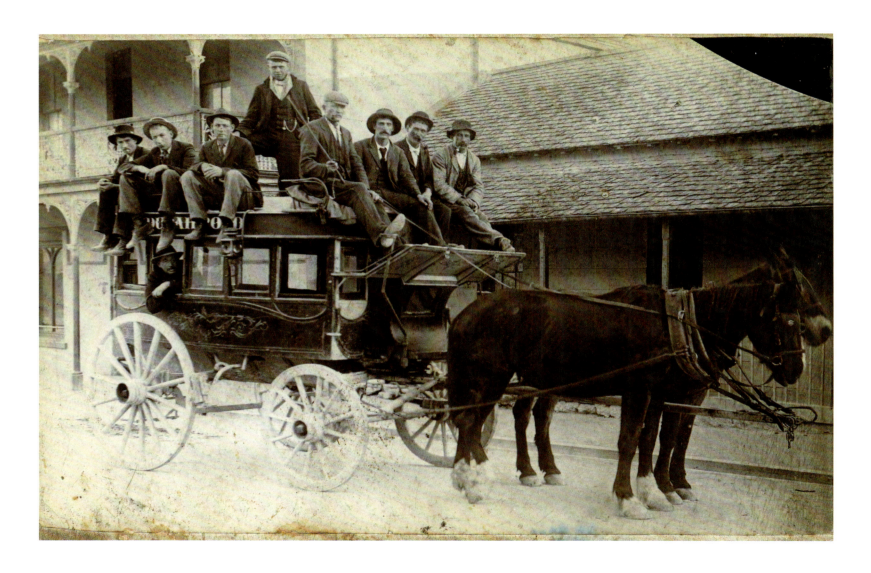

Early transportation business relied heavily on the horse. Here two of them wait in Collie Street before heading to the outskirts of Fremantle along Mandurah Road (now South Terrace). c1895.

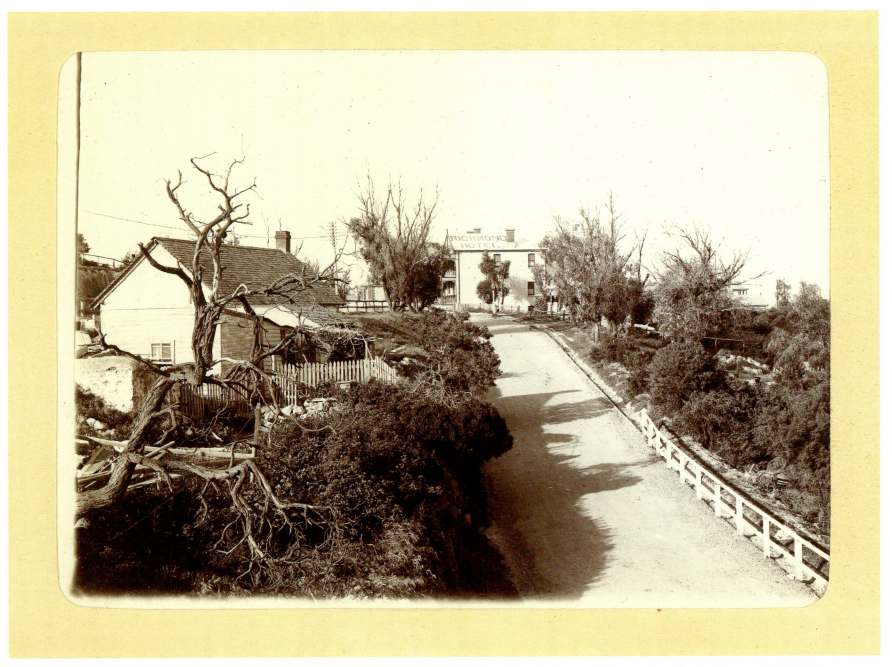

Rural scene between Cantonment Hill and the river, c1900. At the top of the rise is the Richmond Hotel, later the Bridge Hotel, originally a single-storey building built by convict labour. The hotel opened in 1866, the same year as the passenger bridge nearby. In 1884 the hotel obtained a wayside liquor licence, after which it became the hub of social and sporting activities, in particular as a meeting-place for horse-riding parties. The hotel was at 193–197 Queen Victoria Street, until 1922 known as Victoria Road, and before that Cantonment Street. In 1937 the name was changed to Bridge Hotel to avoid confusion with Richmond Beer, which was by then being sold in Western Australia. The first beer garden in Fremantle with a commanding view of the river, it closed on 31 December 1964.

Above: Alderman brand products were appropriately available from the Fremantle Town Hall. (Advertisement, *Western Mail*, 1902)

Below: Detail from a magnificent chromolithographic panorama of Fremantle almost one metre wide issued in 1892 as a supplement to the *West Australian* and now extremely rare. Such illustrations were often based on photographs at this time, when photographs were being used much more in the mass media in their own right.

Fishy Business

The photograph opposite shows the Italian fishing fleet in South Bay, c1910, with the recently completed breakwater at the end of the jetty. These fishermen had moved from the calmer waters of the river because the new harbour had opened and an outbreak of bubonic plague had led to the burning of the fish landing on the river wharf. The breakwater did little to shelter boats moored in South Bay, nor did it help larger vessels to berth. Many of the fishermen pictured lived on their boats, but later many rented or bought houses nearby.

The first Italian fisherman in Fremantle may have been Guiseppe Marselli, who arrived in 1863 from Tuscany. Italians had been in the Swan River Colony since 1846, but even by 1901 there were only 139, all men bar three. While some Italians were accused of using dynamite to catch fish in the Swan River in the 1870s (see page 62), by 1881 there was a group of at least twelve Sicilian fishermen living at Point Peron. A fishing industry of sorts evolved, with fish being sold directly to customers on the beach and on the quays. There were two groups of Italian fishermen – the Sicilians and the Apulians – the latter living on their boats. Although a 1906 report on fishing recorded 542 registered fishermen in the state, with 275 being "British" and 183 being "Italian," the trade was regarded as being in the hands of "foreigners," with the Italians doing the fishing and the Greeks the buying. "Protected by their boats, their life style and their traditions, the fishermen of Fremantle, in the first decade of this [20th] century, remained far more citizens of the Italies (but not of Italy) than they were of Western Australia." (R. and M. Bosworth, *Fremantle's Italy*, 1993) While the middlemen flourished, the fisherman suffered meagre profits and poor facilities. The earnings per boat, each with two men, totalled only around £100 a year.

Leopoldo Zunini, the first Italian resident vice-consul in Western Australia, saw huge potential for trade and migration between Italy and Australia, and at this time hailed Fremantle as the "new Brindisi, the key to Western Australia." But he noted the difficulties and recalled one trader who imported a crate of pasta from Naples to find that it contained only lava from Mt Vesuvius.

In 1922 the Select Committee appointed to inquire into "The Fishing Industry and the Operations of the Fremantle Fish Markets" was scathing about the Fremantle Council's management of the Fish Markets and lamented the primitive state of the fishing industry: "An extraordinary lack of knowledge at present prevails with regard to the fish life in our waters." Fish were a luxury, and the consumption per head of population in Britain was five times higher than in Western Australia. The report recommended government control of the markets and the erection of cold-storage facilities.

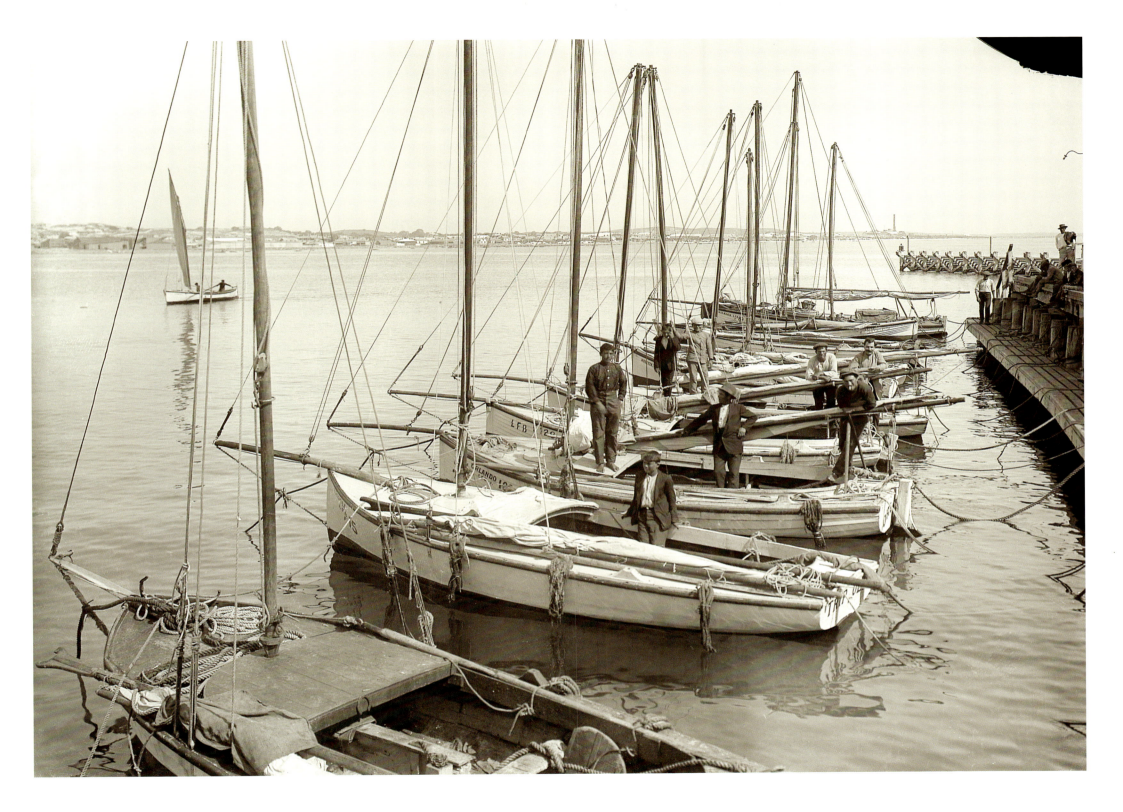

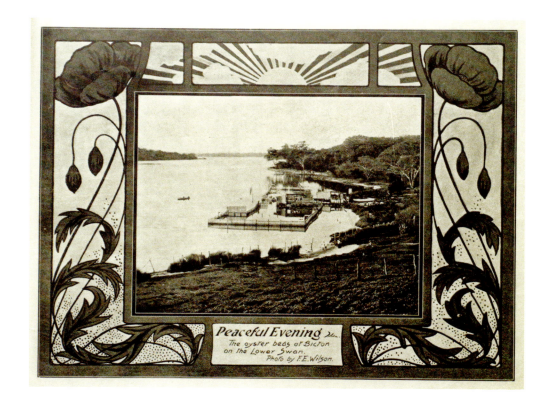

Left: Greek immigrant George Falangas set up these oyster beds at Bicton in 1904. A few years earlier, famous marine biologist Saville Kent had promoted oyster farming for this area, especially along the new north and south moles then being constructed for C.Y. O'Connor's new harbour: "The most sanguine prospects of success relating to the establishment of oyster fisheries in the Swan River estuary, are, in my opinion, associated with the fine breakwater now in course of construction … [This] would add considerably to the strength of that structure, it being the habit of these oysters to, as it were, cement all contiguous rock-surfaces into a solid mass by the amalgamation of their calcarious shells." (Francis Hart, *Western Australia in 1893*, London 1893) Falangas was successful, but he does not appear to have had many competitors along the newly flushed Swan River.

Western Mail Images

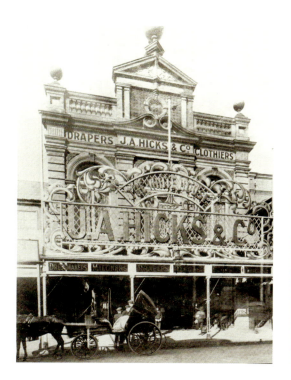
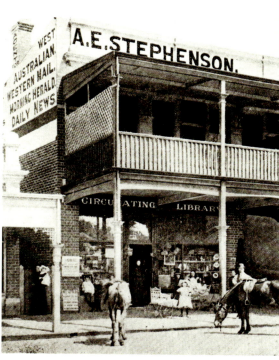

Far left: Prominent drapers Hicks of High Street overdid the advertising on their building, albeit rather stylishly.

Left: In 1903 you could tie your horse up in Victoria Avenue, North Fremantle, and buy a wider choice of local papers at a newsagency like Stephenson's than you can today.

Inside Business

Early interior photographs are rare, and the best ones appeared in the *Western Mail*, begun in 1885 by Charles Harper of the *West Australian*. The *Western Mail* annuals, which ran from 1897 until 1955, are a prime source of photographic images. Pictured are, top to bottom, the showroom of D.J. Fowler in Henry Street (1900), candle-making at W.H. Burford's (1904), and the men's hats department at J.A. Hicks & Co. "Drapers and Clothiers" (1904).

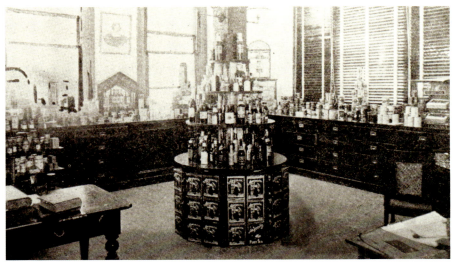

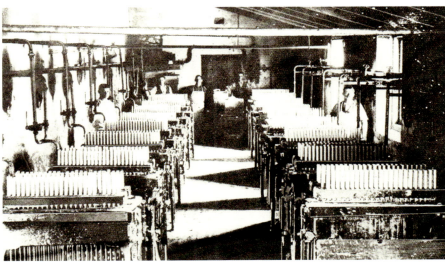

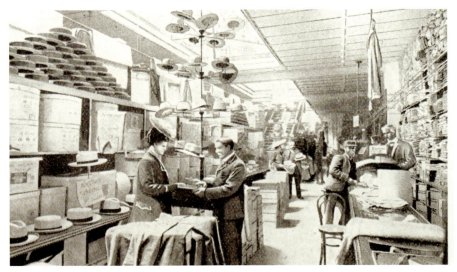

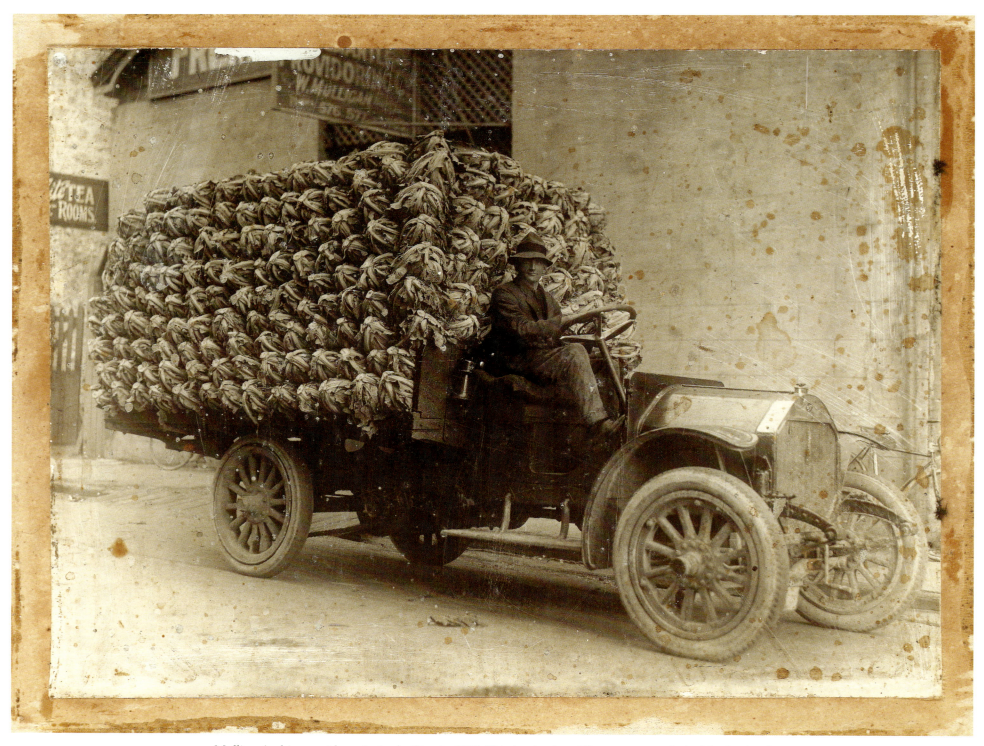

Mulligan's ship providores in Leake Street, c1919. This truck of cauliflowers was typical of the loads of produce brought into Fremantle from suburbs like Spearwood on rough roads and solid rubber tyres.

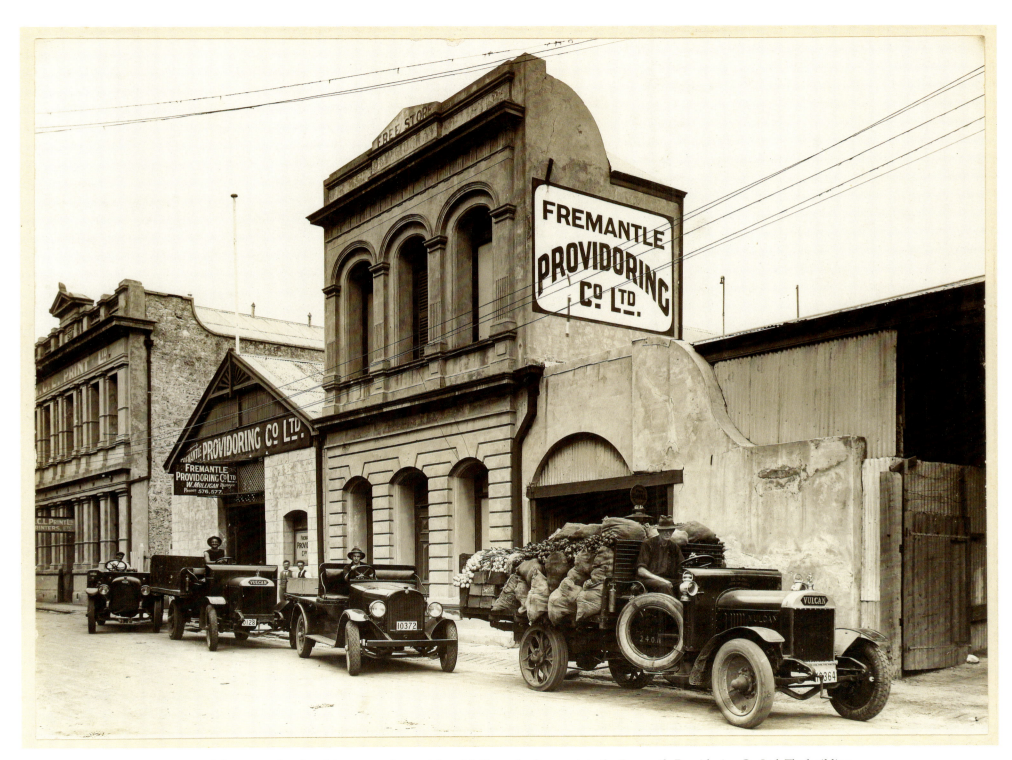

A few years after the picture opposite was taken, Mulligans had grown into the Fremantle Providoring Co. Ltd. The building on the far left, that of G. & R. Wills, has been demolished, but the two-storey building in the middle remains today.

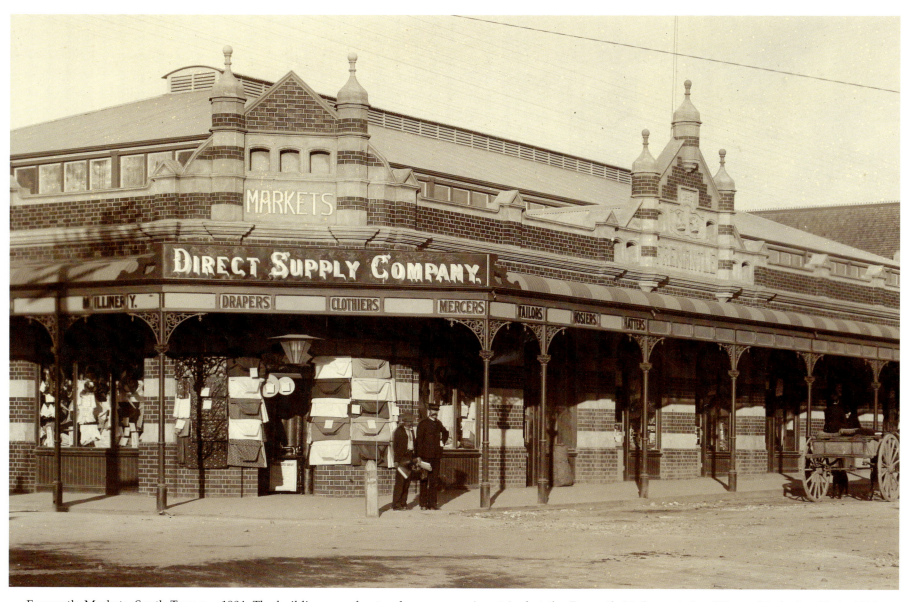

Fremantle Markets, South Terrace, c1904. The building now fronts a busy cappuccino strip, but the *Fremantle Mail* reported a different kind of traffic in 1904: "William Brogan and James Butler were charged at Fremantle Court with driving horned cattle along South Terrace during prohibited hours and fined 5 shillings."

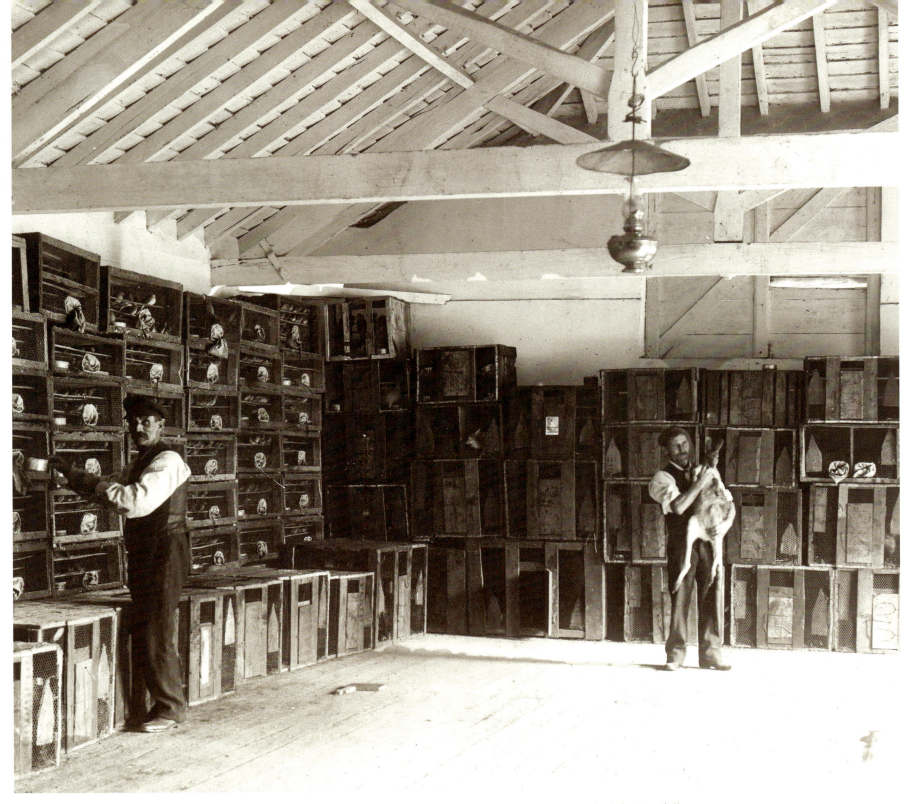

Pet shop, c1900, unknown location in Fremantle. Caged birds are on the left. Hopefully the kangaroo wasn't confined to the small box on the floor with its door open.

pply Coy Ltd

MILLS & WARE,

BISCUITS & CAKES.

AGENTS FOR
S.C.A.T.
ITALA
SUNBEAM
CROSSLEY
OVERLAND

SHOW ROOMS

BOLTON & SONS BUILDERS FREMANTLE

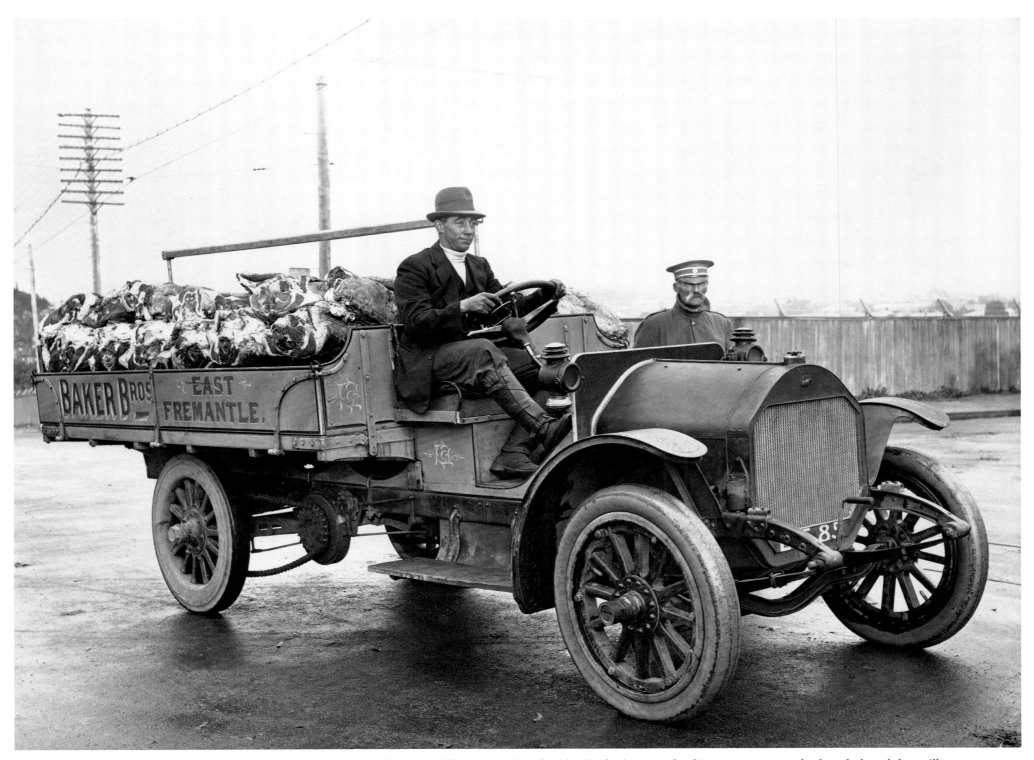

Above: East Fremantle butchers, Baker Bros, with their c1920 flatbed Willys' truck. Note, besides the fresh meat, the distance counter on the front hub and the artillery style wooden wheels with treadless tyres. *Left:* Bolton & Sons of 61-63 Henry Street built this truck for Mills & Ware, a legendary Fremantle company that grew from the takeover of Ross & Co biscuit factory on corner of Wardie and Mandurah Road (South Terrace) in 1898.

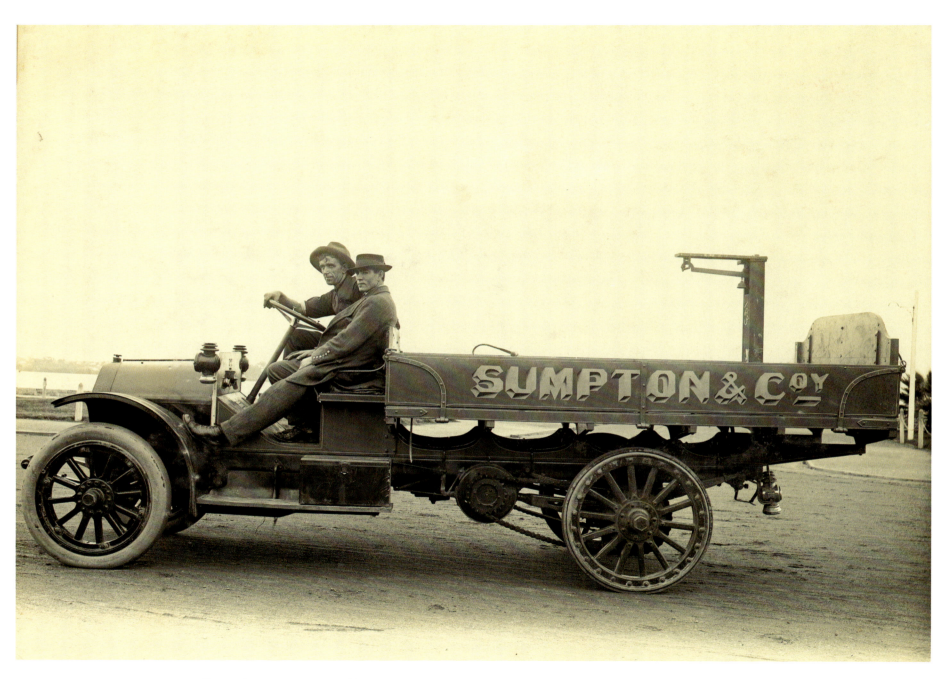

Above: Sumpton & Coy staff on one of their motor transport and shipping agency vehicles c1920. They had an office at the entrance to the wharf in Phillimore Street. *Right:* Detail.

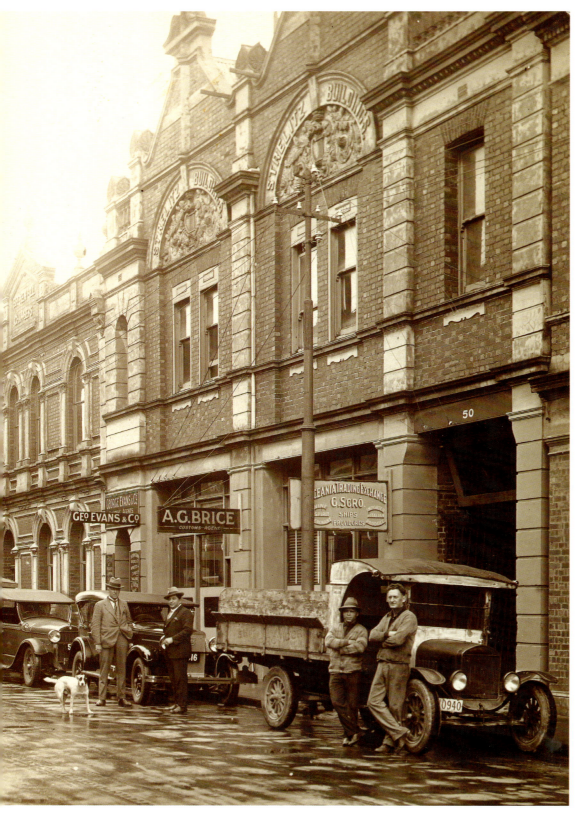

Left: Oceania Trading Exchange in Mouat Street, c1925. Ships' providores at this address from 1922 to 1928, the company also imported Italian macaroni and olive oil. Standing on the left beside the dog is George Evans, next are Con Sgro and Ernie Minciullo, with the fourth man unknown. The building, now clumsily renovated at the front, still exists. It has international significance because of its connection with USA President Herbert Hoover, whose company Bewick Moreing ran its office from here in 1904–05 when Hoover was mining manager and financier, and made five trips to Western Australia.

Right: George Shenton's agency, c1900. The building still stands at 39 Cliff Street, but not with the handsome panelled doors and the interesting signs detailing P&O shipping movements and advertising Shenton's agency for Nobel's explosives, much used in gold-mining and in the construction of the harbour.

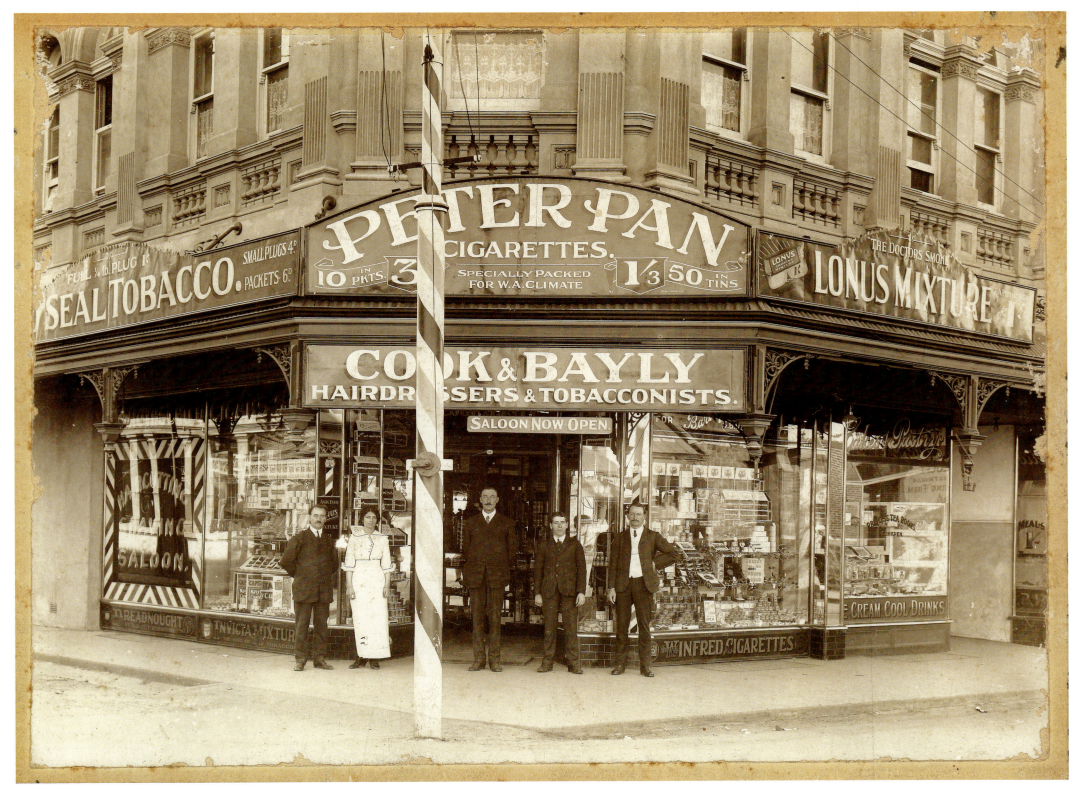

Still in existence, Fremantle's famous barbershop on the corner of Market and Leake Streets.
Left to right: Harry Bayly, Mrs. Dwyer, Walter Cook, Ollie Jenkins, and Bill Stanmore, c1915.

Buyer valuing sheepskins stacked for weekly sale in the Dalgety Building, Queen Victoria Street, c1930.

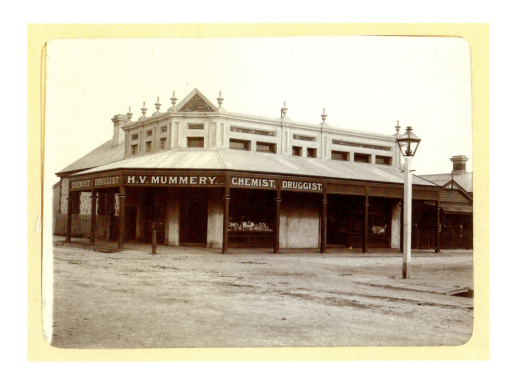

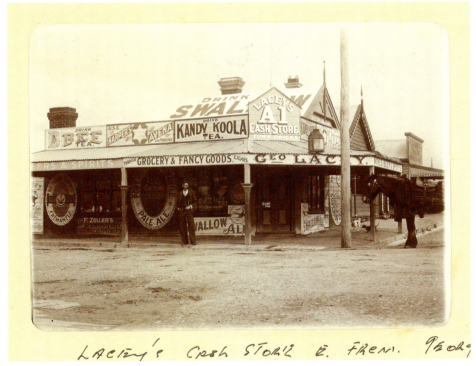

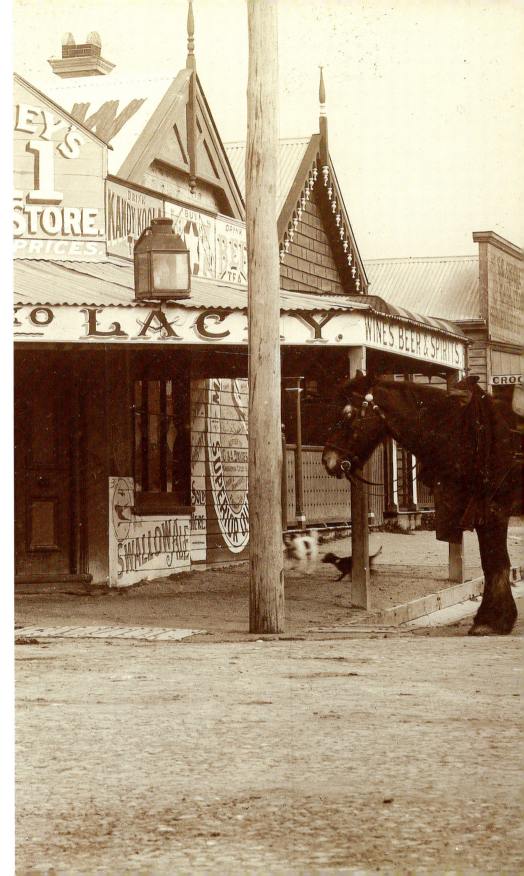

Top: Mummery's chemists, East Fremantle.

Above: Lacey's Cash Store in George Street, East Fremantle, c1910.

Right: Lacey's store *(detail)*.

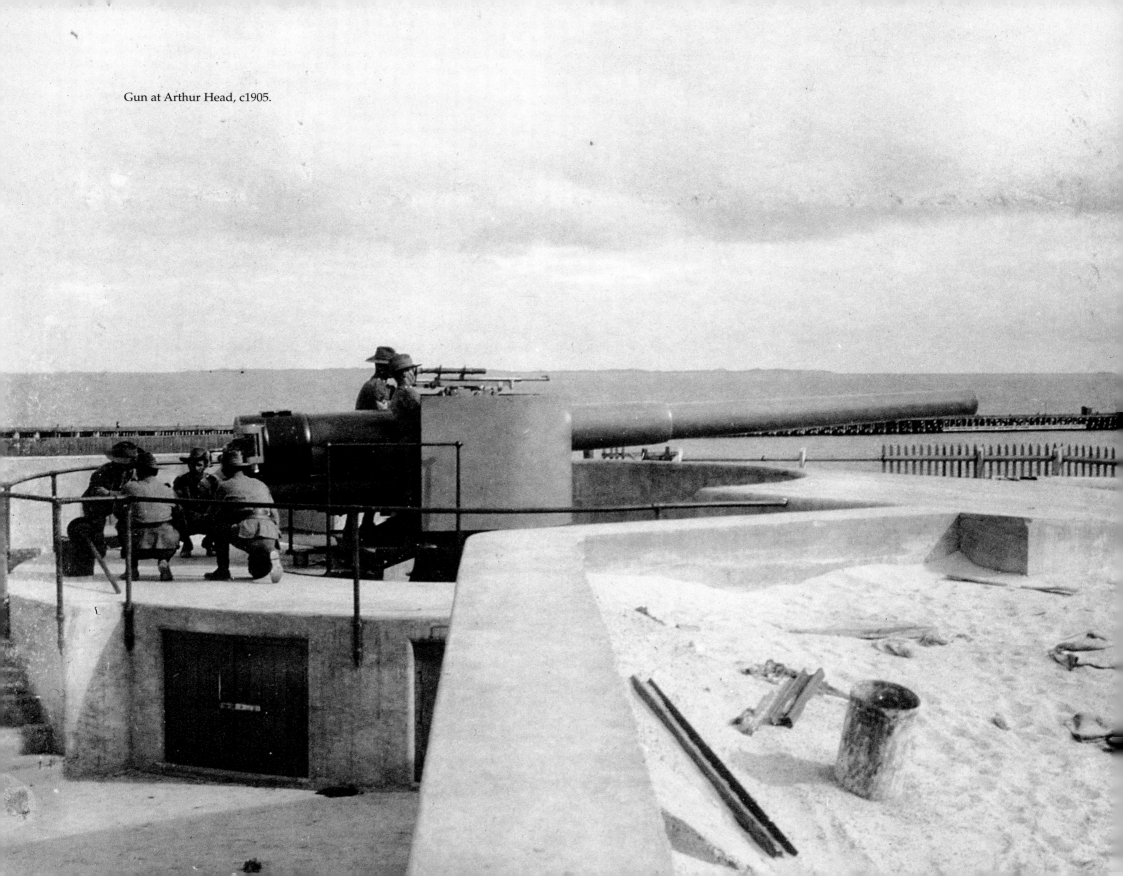
Gun at Arthur Head, c1905.

War

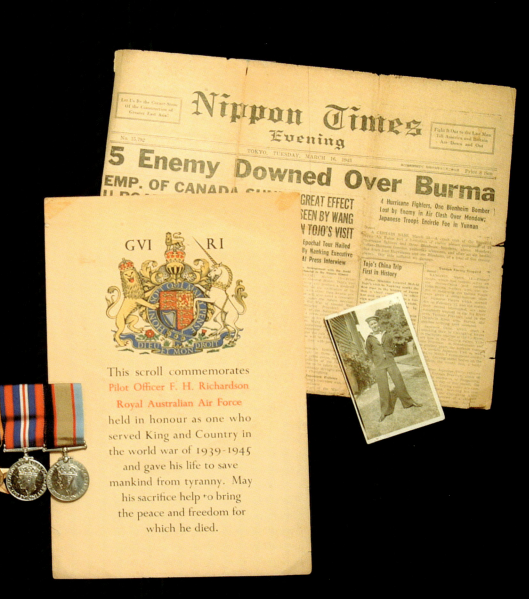

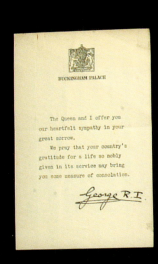

Frank Richardson was a member of the Royal Australian Naval Reserve in Fremantle (above right) before leaving Fremantle on the *Queen Mary* in 1941 during World War II to serve as a pilot with the Royal Australian Air Force. Like thousands of other Australians, he never returned. Frank, the author's uncle, was shot down by the Japanese over Burma in the Blenheim mentioned above right in the *Nippon Times*.

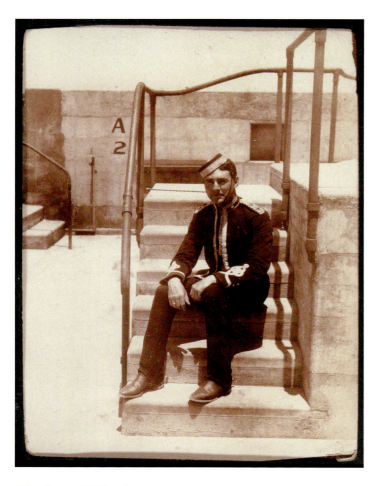

Federal Defence

Upon Federation in 1901, defence became a higher national priority, and the lighthouses and associated buildings on Arthur Head were demolished to make way for the Fort Arthur's Head Battery.

Above: Dixon Hearder on steps at Arthur's Head Battery. Born in 1878, he was a solicitor in High Street and a town councillor. In 1905 he was given command of the Fremantle Artillery with the rank of captain, which he held until 1908. Note spurs on boots and pill-box cap.

Above right: Gunnery practice, Arthur Head, c1905: turntable dial clock.

Right: No. 2 Battery Field Artillery, Fremantle Parade Ground, c1905. Twenty-seven man battery wearing Boer War khaki uniforms.

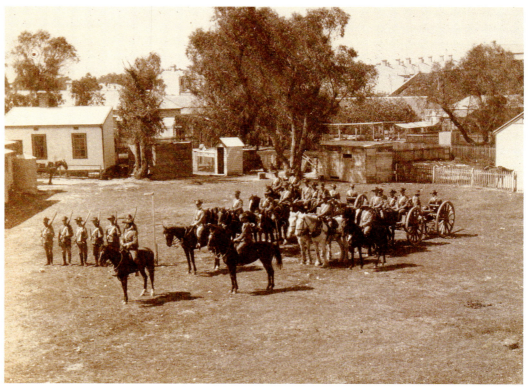

Above: Thomas Blamey (1884-1951) with his 1903 prize winning shooting team at Fremantle Boys' School. Employed by his cousin Henry Wheeler, who was headmaster, Blamey asked to take the toughest class in the school. He sorted the pupils out and thereafter they were known as "Blamey's lambs." After three years he left when he won a commission in the Australian Corps. In World War I he served as Chief of Staff to Sir John Monash and for most of World War II he was Australia's top soldier. He is the only Australian to have attained the rank of Field Marshal.

Right: Embarkation for World War I (detail).

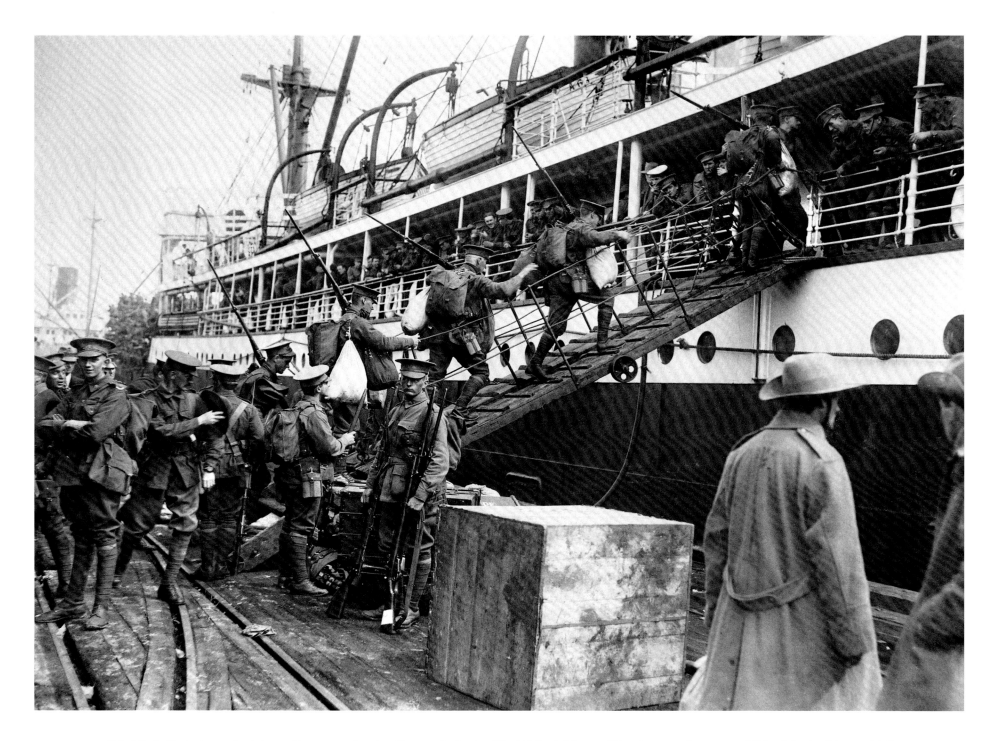

E.L. Mitchell photographed Australian troops leaving Fremantle during World War I. Many of his photographs were published in the *Western Mail*.

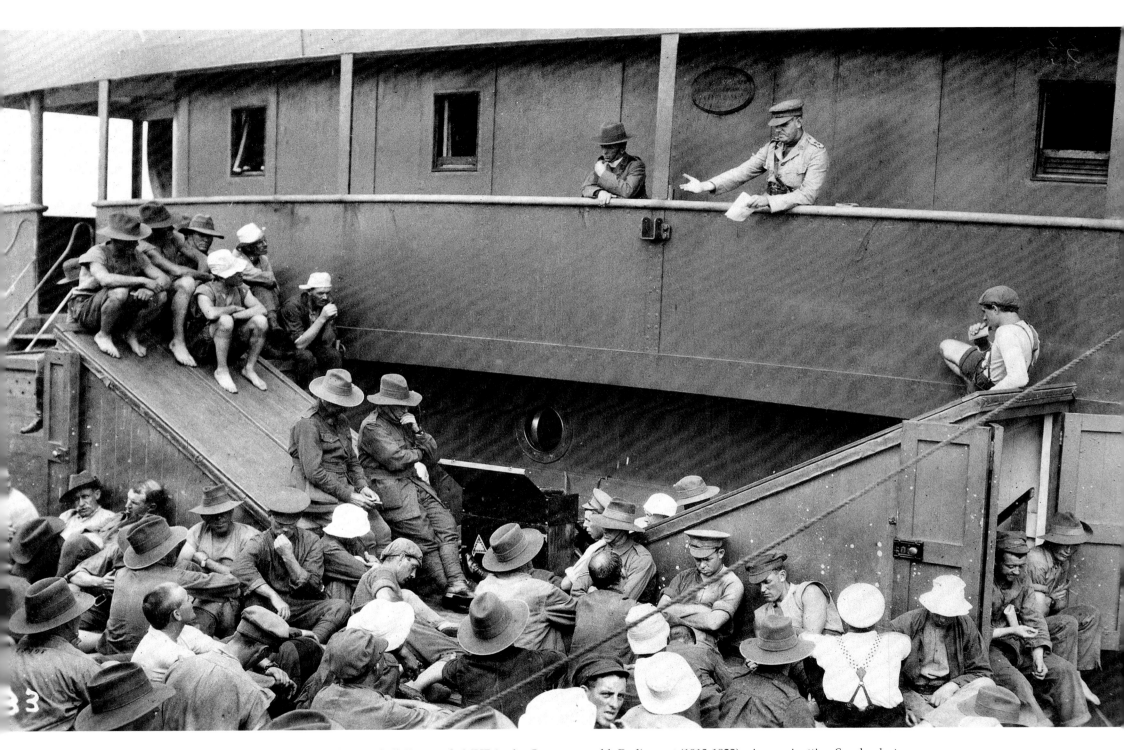

Lieutenant Reginald John Burchell, Fremantle MHR in the Commonwealth Parliament (1913-1922), gives a rivetting Sunday lecture to troops aboard the HMAT *Shropshire* (A9) in Fremantle during May 1917, awaiting departure for the Western Front. Burchell, a former railwayman, joined the AIF in 1917 and went on to win the Military Cross. The subject of his lecture was Canada.

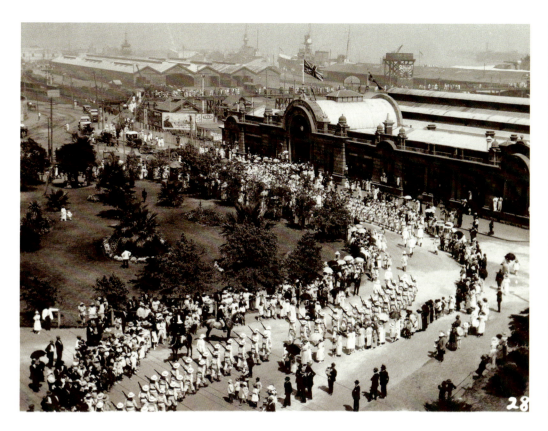

From 23 November 1923 until 24 September 1924, HMS *Hood* and the First Light Cruiser Squadron made a 38,152-mile Empire Cruise to remind both friend and foe that Britannia still ruled the waves. Ironically, it was on Empire Day 1941 that the *Hood* exploded and sank immediately in its battle with the *Bismarck* and *Prinz Eugen*. There were only three survivors out of a complement of 1415 men. The *Bismarck*, a vessel the same size as the *Hood*, was hunted down and sunk, with 2131 lives lost.

Above: Sailors from HMS *Hood* march past the railway station, 28 February 1924.

Right: Front page of special edition of the *Western Mail*, 1924.

Opposite: HMS *Hood* at Fremantle. The 48,400-ton warship, the longest ever built for the Royal Navy, hammered along at 32 knots. It was built in 1920 at the John Brown shipyards, where the *Queen Mary*, the *Queen Elizabeth*, and the *QEII* were built.

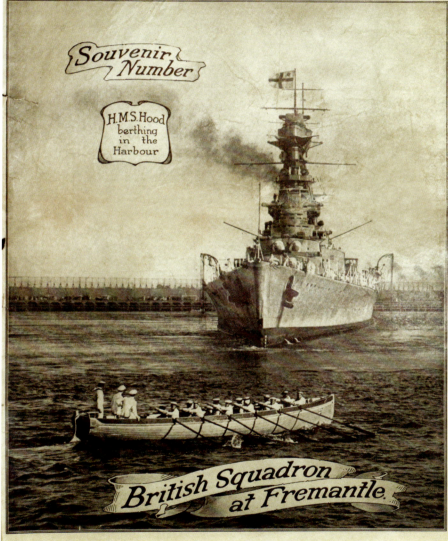

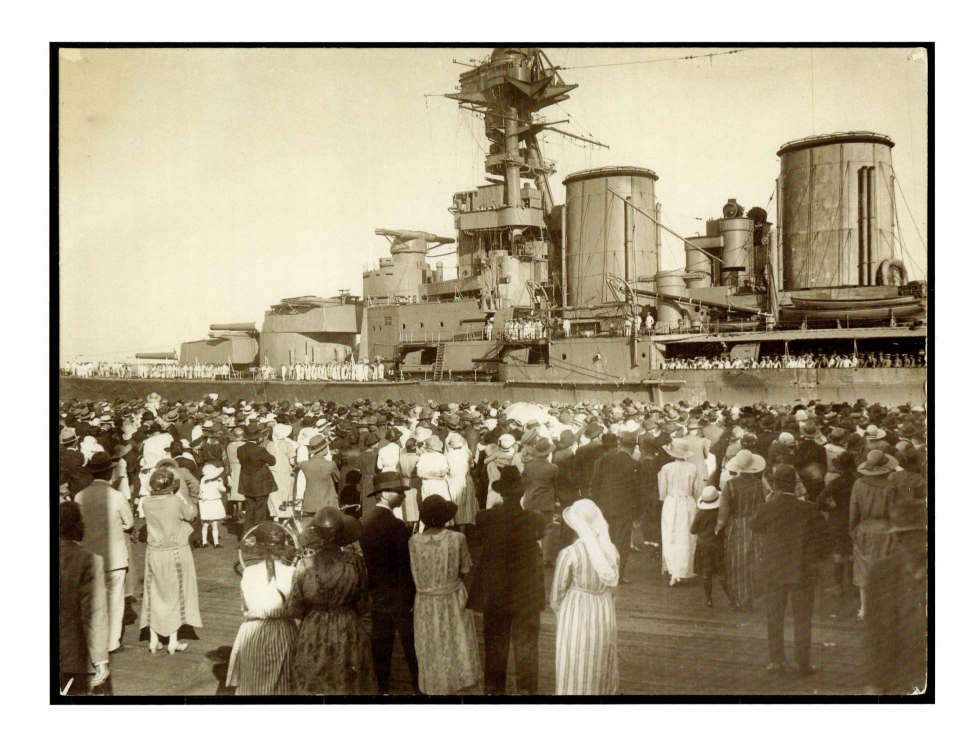

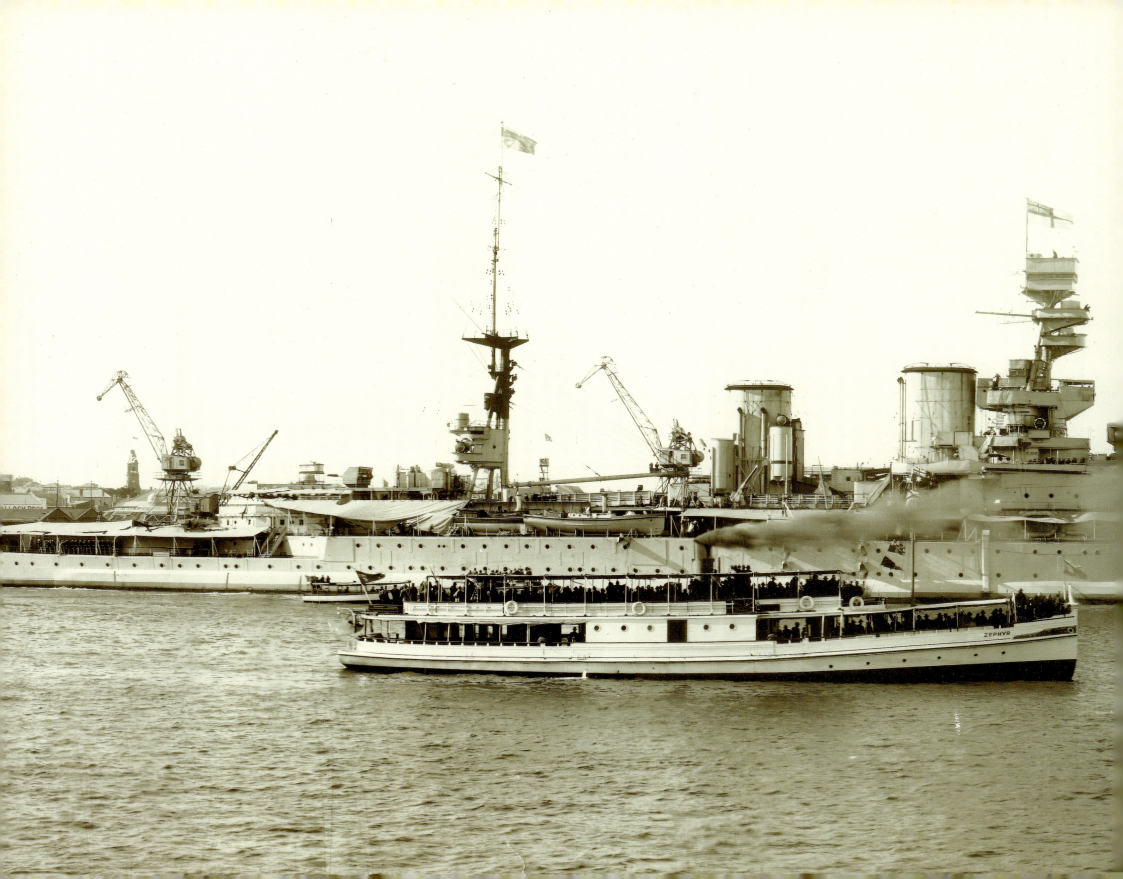

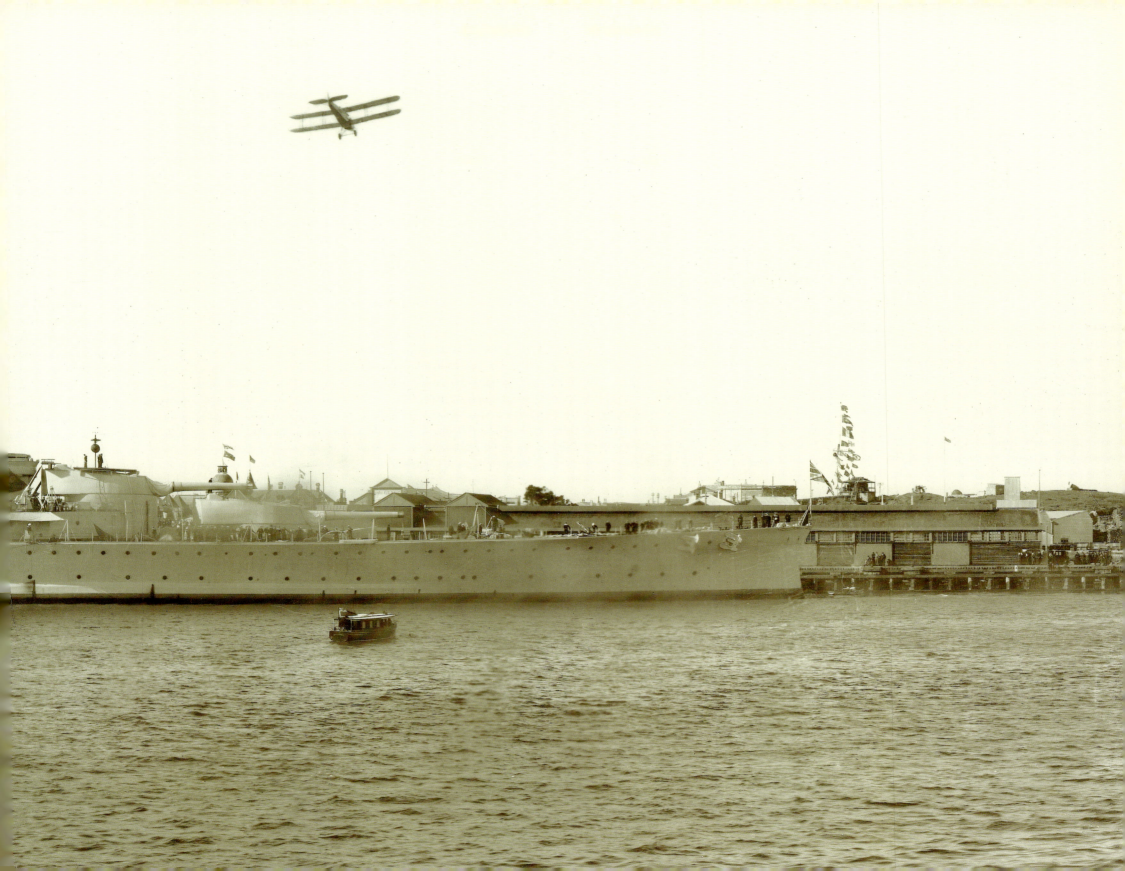

Above left: John Spanton, US Navy, was awarded this card for three successful patrols out of Fremantle in 1945, the last year of World War II. The reverse reads: "This card to be carried at all times by the wearer of the Submarine Combat Insignia."

Above: German prisoners of war, (ex *Ramses*), come ashore at Fremantle off HMAS *Adelaide* on 4 December 1942.

Previous pages: The *Zephyr* glides past HMS *Renown* during a Royal visit 1927.

Lieutenant General Gordon Bennett reviewing troops, 17 August 1942, outside the Fremantle Town Hall. Bennett (1887–1962) was at the time in charge of III Corps, responsible for the defence of Western Australia. The previous year he had escaped from Singapore when it fell to the Japanese, and, though at the time he was defended by Prime Minister Curtin as having acted in "complete conformity with his duty," after the war Prime Minister Chifley ordered a Royal Commission, which found he had been under orders in Singapore to surrender. The controversy overshadowed his courageous World War I career: having landed at Anzac on 25 April 1915, he was shot twice and, when evacuated to a hospital ship, jumped ship and rejoined his troops on the front line the next day. After Gallipoli, he continued his strong leadership in France and at the age of twenty-nine became the youngest ever general in the Australian army.

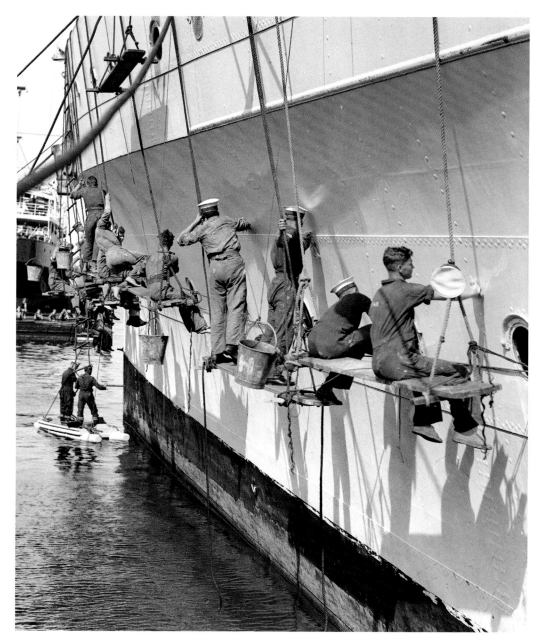

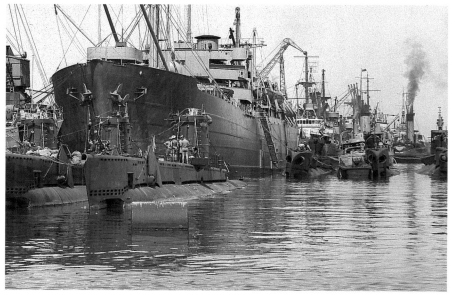

Above: Cleaning duty.

Above right: Submarine tenders *Adamant*, *Maidstone*, and *Anthedon* at Berth 4, North Quay on 30 September 1945.

Lower right: Submarines in harbour.

Two of the World War II images on this page – above and top right – are from the archives of the *West Australian*.

Opposite: Mother ship HMS *Adamant* with six of her submarines. In late February 1942 Japanese submarines were active off Fremantle and the port was vulnerable. In 1943 a Japanese reconnaissance plane was spotted at Swanbourne in broad daylight. Australia had no submarines of its own, the last two – the *Oxley* and the *Otway* – having been transferred to the Royal Navy in 1931. US, British, and Dutch submarines were stationed here between 1942 and 1945. One of the first US submarines to arrive in Fremantle, the *Sargo*, was bombed by an Australian Lockhead Hudson, which mistook it for a Japanese vessel. Both periscopes were wrecked and the conning tower damaged. Fremantle hosted 170 submarines, which made 416 war patrols, 353 of them by US vessels. By 1944 two hundred civilian workers were directly employed in US facilities.

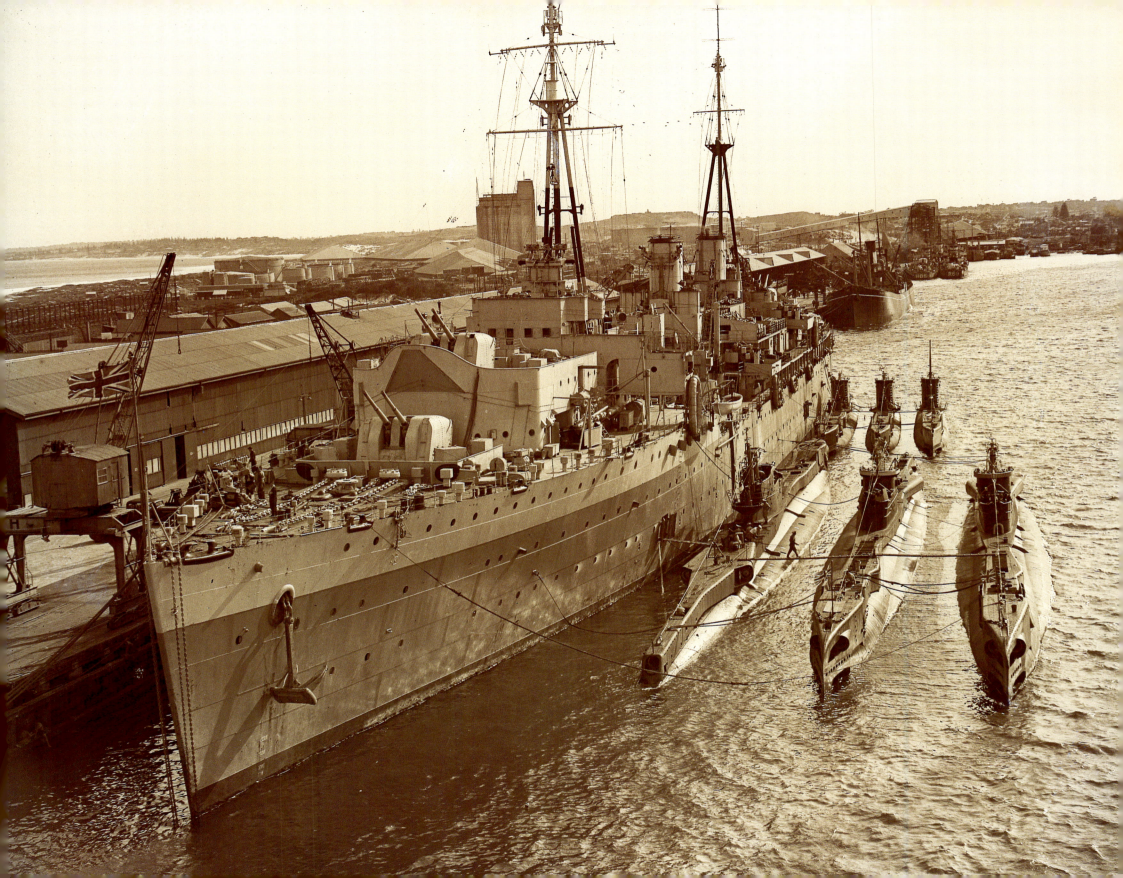

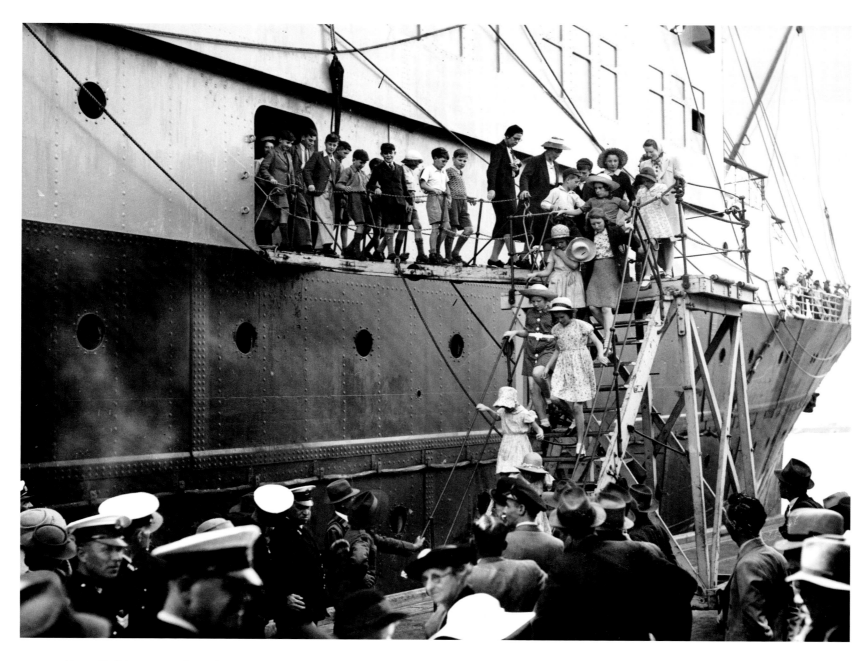

Above: Child evacuees from Great Britain arriving at Fremantle, October 1940.
Opposite: Secret file G 13/4/50 from November 1943 shows smoke screen trials over Fremantle with fears of impending Japanese attacks, ironically just a couple of years after the children above had travelled half way around the world to escape the horrors of war in Britain. The smoke screen trials used US Navy Besler generators and imported fog oil. Each generator used 88 gallons of fog oil, 15 gallons of fuel oil, and 17.6 gallons of water each hour. The report concluded: "The net result of the trial is to prove that we have a great deal more to learn about the behaviour of large screens, and that further work is most desirable."

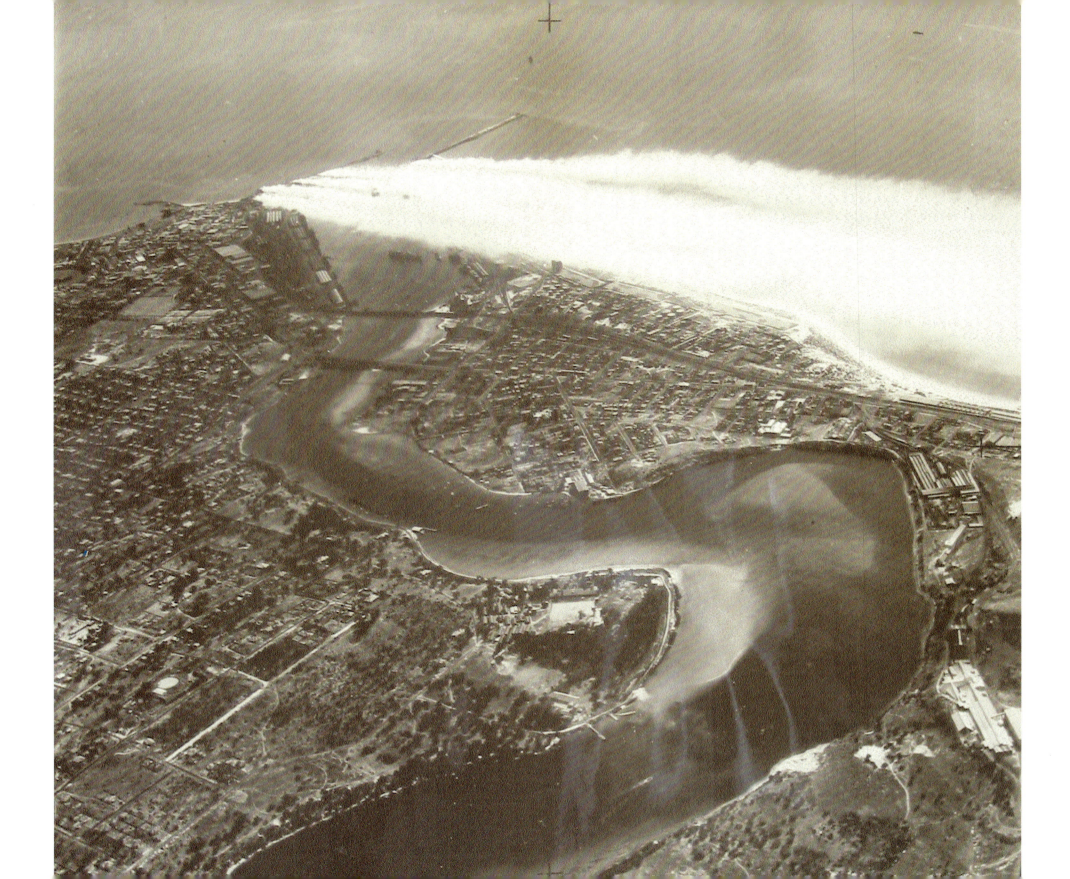

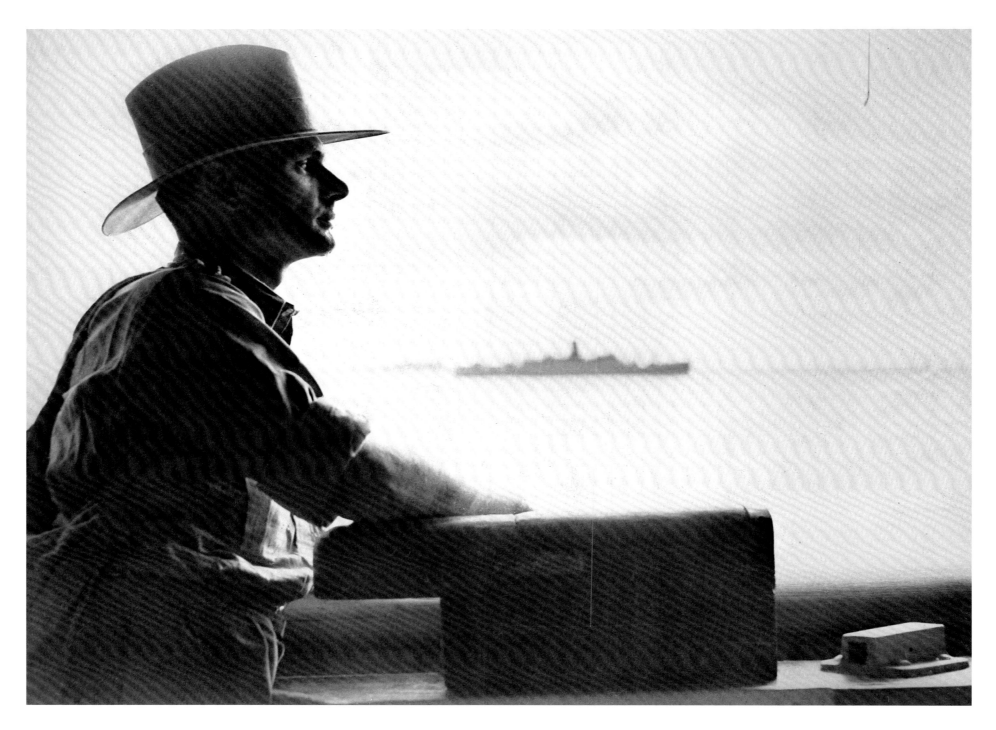

Damien Parer passed through Fremantle in 1940 on his way to war as official movie photographer to the AIF. At sea from Fremantle he composed this very deliberate 'heroic' image of Lt. R. Vial, using the convoy's battleship escort, the composition showing influence from Russians like Eisenstein and Nilsen.

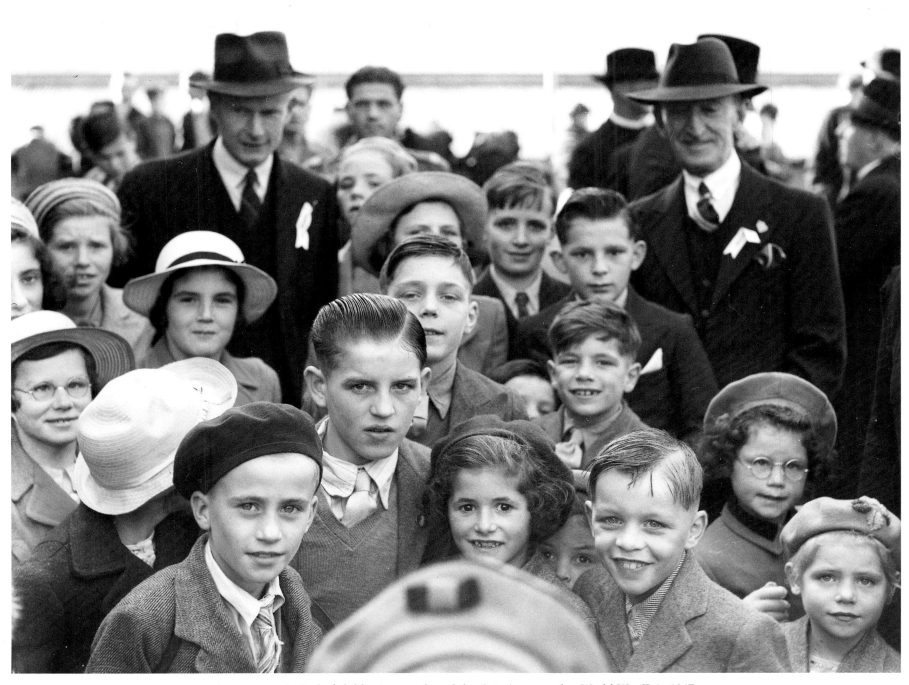

A new start. Arrival of child migrants aboard the *Asturias* soon after World War II, in 1947.

The Photographs

Page number is given first, followed by name of photograph, then owner. Following is the catalogue number if any and, finally, the photographer's name, where known, in brackets. Abbreviations: RWAHS (Royal West Australian Historical Society), FREO (Fremantle Library Local History Collection), WAN (West Australian Newspapers), NAA (National Archives of Australia, East Victoria Park), NLA (National Library of Australia, Canberra), Museum (Western Australian Museum, Perth), AWM (Australian War Memorial), and Battye (Battye Library, Perth).

Cover: Panorama, RWAHS UNCR3361 (Bartletto Studios) Inside cover: Signwriters, Hedgeland- daughter of John Lyons; girl, Hedgeland (Jack Howe)
1. Panorama, RWAHS UNCR3361 (Bartletto Studios)
2. Building wharf (detail), RWAHS R1766
4. Alisa Dowson, (John Dowson)
5. East Street, Dudding
7. SS *Perth*, Coward
8. Mews (detail), RWAHS R5755
9. Lighter, Wordsworth (Greenham & Evans)
10. Daguerreotype and case, Lionel Samson & Son Pty Ltd
11. Samson family, Reece; ladies, FREO (Jenkins)
12. Stout, Reece (Stout); hut, FREO Wise album (Nixon)
13. Nixon & Merrilees Studio, Wise (Nixon); Charlton family, Hearn (Charlton); Peterson Kodak cover, FREO ephemera collection
14. Orloff farewell, Stratton (Fogarty)
16. High Street (detail), RWAHS UNCR2223
17. Tram (detail), Battye 10124P
18. Seddon house, NAA: SX119; port panorama, FREO (R. Vere Scott)
20. Building wharf, RWAHS R1766
21. Invitations, FREO (ephemera collection)
22. Harbour map, Fremantle Ports
23. 1877 Plan of the Town of Fremantle (detail), State Records Office 24/4/9
24. River jetty, Battye BA 1341/28
25. Troops depart to Boer War, FREO 1797
26. Government Cottage, RWAHS R2775 (Rae Bros)
27. Government Cottage (detail), RWAHS R2775 (Rae Bros)
28. Lighthouse, RWAHS B1203; heliograph, author (*Souvenir of the Postal Telegraph and Telephone Departments of Western Australia*, 1898)
29. Lighthouse 1900, Perth Mint
30. Lighthouse, Museum PH96-0214
31. Lighthouse (detail), Museum PH96-0214
32. Rous Head, RWAHS R3013
33. Bathers' Bay, RWAHS UN731
34. South Jetty 1870, Wordsworth; South Jetty 1900, RWAHS UNCR2222
35. Long Jetty, Robinson
36. Shipboard (2), Coward; *Australind* (detail), RWAHS UNCR2958
37. *Australind*, RWAHS UNCR2958
38. Harbour model, Museum PH 9006-18
39. Building wharf, FREO 97
40. Dredge *Parmelia*, RWAHS Album R1764
41. Divers, RWAHS Album R1764
42. Rocky Bay, RWAHS Album R1764
43. Locomotive, RWAHS Album R1764
44. Port buildings 1900 (new Museum site), Appleyard
45. Rails, author; harvesters, Rocke
46. South Quay looking west, Appleyard (Nixon & Merrilees)
47. South Quay looking east, Appleyard (Nixon & Merrilees)
48. Propeller, Battye 17560P Passey Collection
49. SS *Norfolk*, Dudding
50. HMS *Encounter*, Rocke
51. HMS *Euryalus*, Battye 9618P
52. Superphosphate unloading 1909, Appleyard (Beste)
53. Mailboats c1907, RWAHS UN1020 Pictorial Souvenir
54. *Dunskey*, RWAHS R1841 (Charles Walker)
55. Tilley's, RWAHS R5380 (Cynthia Mummery); Brown's boatyard, Brown family
56. *Emerald*, WAN COM132; barge, Battye 3009B1
57. East Fremantle foreshore, Battye 6700P
58–59. Bridge panorama, Battye BA1116/5 (Nixon)
60. Two bridges, Battye BA292/4
61. Tunnel through bridge, Battye BA292/3
62. Plan of the Town of Fremantle 1877 (detail), State Records Office 24/4/9; Duffield, Humble (Chopin & Gill)
63. Boat on river, RWAHS R3039
64. Looking back at bridge, Battye BA 1341/30
65. Rocky Bay, RWAHS R3009
66. SW Aborigines, Chaney (Stout)
67. Preston Point Road, FREO Wise album (Nixon)
68. Robb's Jetty, RWAHS UNR2994/8 Dalgety album
69. Unloading horse, RWAHS UNR2994/11 Dalgety album
70. Lumpers (wharfies), WAN 163i, aerial, WAN 197
71. Immigration buildings, WAN 179; immigration buildings WAN 296
72. Cross-harbour ferries FREO 2379 (George Davidson)
73. Ferryman, Stratton (Fogarty)
74. Fishing fleet, Rocke; crowded harbour, Rocke
75. Wharf scene, Stratton (Fogarty)
76. Early Arrivals, author (Flood)
77. Wharf, NLA 23197613 (Hurley)
78. Laying tramlines (detail), RWAHS R1773
79. Three books, author
80. Map, State Records Office 24/7/16
83. Shenton's house, WAN Hist 821 (Stone)
84. S.M. Stout's logo on reverse of photograph, Chaney (Stout); Fremantle Aborigines, Chaney (Stout)
85. Asylum, Chaney (Stout)
86–87. Panorama of Fremantle, Chaney (Stout)
88. Cliff Street plus eight others, Chaney (Stout)
89. St John's, Chaney (Stout)
90. Round House, Chaney (Stout)
91. Convict Establishment, Chaney (Stout)
92. Congregational chapel and manse, Chaney (Stout)
93. Roman Catholic church, Chaney (Stout)
94. Mrs Leach's store, Chaney (Stout)
95. Manning's Folly, WAN Hist 821 (Stone)
96. High Street, RWAHS R2225
97. From lighthouse, Museum PH96-0217
98. Looking over South Bay, Battye 6437P
99. Round House, Battye 4651B/8
100. Pioneer Park, Battye 26678P
101. Market Street, Battye 17555P
102. Panorama part 1, RWAHS Album E/4
103. Panorama part 2, RWAHS Album E/5
104. Panorama part 3, RWAHS Album E/7
105. Henderson and William Streets, WAN Flood 94 (Flood), Short and Pakenham Streets, WAN Flood 105a (Flood)
106. Wesley Church, Battye 9213P
107. Wesley Church (detail), Battye 9213P
108. Mews boatshed, RWAHS R5755
109. T.F. Mews, RWAHS R5754
110. Looking west over Fremantle, RWAHS album E/3; Scots Church, RWAHS R4158
111. Town Hall, RWAHS 74/22
112. 1894 High Street, FREO Wise album (Nixon)
113. High Street, RWAHS UNCR2223
114. High Street (detail), RWAHS R1785
115. High Street, RWAHS R1785
116. High Street (cropped), RWAHS UNCR2227
117. High Street (detail), RWAHS UNCR2224
118. High Street, RWAHS R3037
119. High Street (detail), RWAHS R3037
120. West from Town Hall, Battye 42P
121. Cliff Street, FREO 604
122. Fire in Nairn Street, FREO 715
123. Esplanade, FREO 577a
124. Prison, Fremantle Prison
125. Isolation ward, RWAHS B1458; prisoner Lyons, State Records Office 4286/3807
126. Asylum c1920, WAN Flood 106 (Flood)
127. Asylum c1930, Branson (Branson)
128. Cliff Street station, Rocke
129. Literary Institute, FREO Wise album (Gray Williams & Co., Royal Studio)
130. Tram near Bridge, Rocke
131. Alfred Street School, RWAHS R1299; Victoria Avenue, RWAHS R1298
132. *Orizaba* wreck, FREO 549
133. *Orizaba* auction, Battye 3050B/126
134. Queen Street corner, WAN neg 10
135. Queen Street, WAN neg 11
136. View to prison, Battye P112245 (Orloff)

137. King's Square, FREO unnumbered
138. Aboriginal woman, RWAHS R3008
140. "Riverview," RWAHS R3021
141. Moore's house, Battye P10540
142. Lillian Brown, Brown (Nixon)
143. Ratazzi Home, FREO 3170
144. Revd Mr Gunning FREO 3569; East Fremantle gothic, Battye 352/105 (Gore)
145. Manse, FREO Fremantle Society Collection 9-9
146. Brown home, Brown
147. Brown home, North Fremantle, Brown
148. "Ivanhoe," Ferguson
149. Camp on oval, Rocke
150. Immigration building, RWAHS UN814
151. Immigration building, RWAHS UN815
152. Rowing, FREO 617
153. Ephemera (l to r): author; FREO ephemera collection
154. Bandmaster Fay, FREO glass negative 1337
155. 1896 band, FREO 1335
156. Football team, FREO 951
157. Princess May team, FREO 1437
158. Orchestra, FREO 1984
159. Old Women's Home, FREO 2919
160. Wedding (cropped), FREO 676
161. Sunday school group, FREO Wise album (Nixon)
162. Point Walter, Fremantle Society (Beste)
163. Point Walter, two girls, RWAHS 1491
164. Cycling, RWAHS R3299; Sister Kate's camp, Brown
165. South Beach, Rocke
166. Shark, Stratton (Fogarty)
167. Mulcahy girls, Dudding; crabbing, Dudding
168. Swimming baths, RWAHS Box 74 glass plate
169. Lumpers' picnic, Stratton (Fogarty)
170. Tram terminus, RWAHS glass plate
171. Ephemera, FREO ephemera collection
172. Laying tramlines, RWAHS R1770
173. Laying tramlines, RWAHS R1773
174. Wood-blocks, East Fremantle Council (George Keane)
175. Cabling, East Fremantle Council
176–177. Tram panorama, Battye 10124P
178. East Fremantle tram (detail), Battye 9532P
179. East Fremantle tram, Battye 9532P
180. First train, WAN Hist 3780; 1920 train, NAA: 4294126
181. Railway station, RWAHS Box 74 glass plate
182. Boat launch, RWAHS Box 74 glass plate
183. Ephemera, author
184. Ephemera, FREO ephemera collection; daguerreotype, Chapman; Customs house, NAA: WA 00188B15
185. Ephemera, FREO ephemera collection; South Terrace, NAA: SX136; Pakenham Street, NAA: SX139
186. Smelting ore, Wordsworth (Greenham & Evans)
187. Sandover building, RWAHS R3031
188. Mayhew warehouse, RWAHS R3032
189. Mayhew warehouse interior, RWAHS R 3033
190. Horse bus, Rigg
191. Richmond Hotel, RWAHS R5372
192. Turtle soup advertisement, RWAHS *Western Mail* Christmas 1900; detail from 1892 *West Australian* supplement entitled *Views of Fremantle*, RWAHS map drawer
193. Italian fishing fleet, RWAHS Box 74/20 glass plate
194. Oyster beds, *Western Mail* Christmas 1906, RWAHS (F.E. Wilson); Hicks drapers, *Western Mail* Christmas 1904, RWAHS (Nixon); Stephenson's newsagency, *Western Mail* Christmas 1903, RWAHS
195. D.J. Fowler showroom, *Western Mail* Christmas 1900, RWAHS; candle-making at Burford's, *Western Mail* Christmas 1904, RWAHS; hat department at Hicks & Co. *Western Mail* Christmas 1904, RWAHS (Nixon)
196. Cauliflowers on truck, Poore (Harrison Studios)
197. Fremantle Providoring, Poore
198. Fremantle Markets, FREO 532
199. Pet shop interior, FREO 545
200. Mills & Ware, Fremantle Motor Museum
201. Baker Bros, Fremantle Motor Museum
202. Sumpton & Coy, Fremantle Motor Museum
203. as above (detail), Fremantle Motor Museum
204. Oceanic Trading, Sgro; Shenton's Office, Cliff Street, RWAHS R1769
205. Hairdressers' shop, Ferguson
206. Woolstores, RWAHS UNR2994/3
207. Lacey's Store, RWAHS R5386; Mummery's chemists, RWAHS R5369 (both Cynthia Mummery album)
208. Arthur Head gun, Battye BA1092/12
209. Memorabilia, Joan Dowson MBE OAM
210. Dixon Hearder, Battye BA1092/1; artillery target practice, Battye BA1092/10; No. 2 Battery, Australian Field Artillery, Battye BA1092/3
211. Blamey, AWM: A04074; troops (detail), AWM: H16166
212. Embarkation, AWM: H16166
213. Lecture, AWM PO1843.004
214. Railway station 1924, Battye (Orloff); *Western Mail* cover 1924, RWAHS (E.L. Mitchell)
215. HMS *Hood*, RWAHS UNCR2620
216–217. Panorama with HMS *Renown*, FREO 1754 (Lambert)
218. Ephemera, FREO ephemera; POWs, WAN W3010
219. Bennett takes salute, WAN W656
220. Cleaning ship, WAN Navy 145; submarine tenders docking, WAN Navy N4039; submarines, Stratton (Fogarty)
221. HMS *Adamant*, Stratton (Fogarty)
222. Evacuees disembarking, WAN NOW48
223. Smoke screen, NAA: MP729/6, 71/401/127217.
224. Lt. Vial, AWM 007232
225. Immigrant children 1947, Stratton (Fogarty)
Inside Rear Cover: First railway station, Battye 10008P

Photographic Sources

The largest source of Western Australian photographs is the Battye Library in Perth. There are more than 250,000 images in the collection, with over 200,000 awaiting accession. The earliest Western Australian photograph in the collection is one from 1853 of Captain and Mrs John Septimus Roe and family. A highlight of the holding is the Passey Collection, comprising 2048 negatives, mainly from 1900–1910 and chiefly from the Perth studio Rome. The Government Print Collection has over 88,000 images covering 1920 to 1984. The Battye also holds more than 1000 negatives by Izzy Orloff, 1700 by Stuart Gore, and 6000 glass plates by Dease (1890–1959), mainly portraits and yet to be listed.

The *West Australian* has an extensive archive, while the Royal Western Australian Historical Society and the Local History Collection of the Fremantle Library also have excellent material. Famous libraries such as the National Library of Australia in Canberra and the Mitchell Library in Sydney hold surprisingly few unique or interesting photographs of Western Australia. However, the National War Memorial, Canberra, has extensive World War II related photographs available on the internet.

Many well-known photographs are repeated in different collections, and reproduction charges vary wildly between them. Increasingly, the images are being made available through the internet.

It is remarkable how few collectors of photographs there are in Western Australia compared to collectors of books, stamps, and other collectibles. Extensive research was carried out to locate notable photographs in private hands, and generally those who did have material were simply acting as custodians for the next generation, a laudable concept.

Select Bibliography

The Local History Collection of the City of Fremantle Library holds a wide range of material on the history of Fremantle.

Appleyard, R.T. & Toby Manford *The Beginning: European Discovery and Early Settlement of Swan River Western Australia*, UWA Press, Nedlands, 1979
Barrie, Sandy *Australians Behind the Camera: Directory of Early Australian Photographers 1841–1945*, S. Barrie, Booval, Qld, 2002
Brown, Patricia M. *The Merchant Princes of Fremantle: The Rise and Decline of a Colonial Elite 1970–1900*, UWA Press, Nedlands, 1996
Bursill, H.O. *Souvenir of the Postal, Telegraph and Telephone Departments of Western Australia*, GPO, Perth, 1898
Burton, Craig "North Fremantle Heritage Study," Fremantle City Council, Fremantle, 1994
Cato, Jack *The Story of the Camera in Australia*, 2nd ed., Institute of Australian Photography, Melbourne, 1977
Chalmers, John *A Ticket to Ride: A History of the Fremantle Municipal Tramways*, rev. ed., Perth Electric Tramway Society, Mt Lawley, 2001
Charlesworth, Helene *Small But Strong: A Pictorial History of the Town of East Fremantle 1897–1997*, Town of East Fremantle, East Fremantle, 1997
Crawford, I., A. Delroy & L. Stevenson *A History of the Commissariat in Fremantle 1851–1981*, Western Australian Museum, Perth, 1981
Davies, Alan & Peter Stanbury *The Mechanical Eye in Australia: Photography 1841–1900*, Oxford University Press, Melbourne, 1985
Dickson, Rod *They Kept the State Afloat: Shipbuilders, Boatbuilders and Shipwrights of WA 1829–1929*, Hesperian Press, Victoria Park, 1998
Dowson, John *Fremantle: The Immigration Story*, The Fremantle Society, Fremantle, 2001
Erickson, Rica *The Bicentennial Dictionary of Western Australians pre 1829–1888*, UWA Press, Nedlands, 1988
Ewers, John K. *The Western Gateway: A History of Fremantle*, rev. ed., UWA Press, Nedlands, 1971
Fremantle Studies, vols 1 and 2, Fremantle History Society, Fremantle, 1999, 2001
Gamba, Charles *A Report on the Italian Fishermen of Fremantle: A Preliminary Study in Sociology and Economics*, University of Western Australia, Nedlands, 1952
Gibbs, Martin "Report on an Ethnohistorical Investigation into Aboriginal Heritage of the Fremantle Area," Centre for Prehistory, University of Western Australia, Nedlands, 1988
Hammond, Jesse *Western Pioneers: The Battle Well Fought*, Imperial Print Co., Perth, 1936
Hayes, Leigh *Worth Telling, Worth Keeping: A Guide to the Collections of the J.S. Battye Library of West Australian History*, Library Board of Western Australia, Perth, 2002
Hitchcock, J.K. *The History of Fremantle: The Front Gate of Australia, 1829–1929*, Fremantle City Council, Fremantle, 1929
Hoffman, Louise and Chris Jeffery *Izzy Orloff, Photographer: Images 1917–1935*, Fremantle Arts Centre Press, Fremantle, 1989
Holden, Robert *Photography in Colonial Australia: The Mechanical Eye and the Illustrated Book*, Hordern House, Potts Point, 1988
Kimberly, W.B. *History of West Australia: A Narrative of Her Past, Together with Biographies of Her Leading Men*, F.W. Niven, Melbourne, 1897
Minchin, R.S. & G.J. Higham *Robb's Railway: Fremantle to Guildford Railway Centenary 1881–1981*, Australian Railway Historical Society (WA Division), Bassendean, 1981
Morison, Margaret Pitt & John White (eds) *Western Towns and Buildings*, UWA Press, Nedlands, 1979
Moynihan, John *All the News in a Flash, Rottnest Communications 1829–1979*, Telecom Australia and Institution of Engineers Australia (WA Division), Perth, 1988
Newton, Gael *Shades of Light: Photography and Australia 1839–1988*, Australian National Gallery and Collins Australia, Sydney, 1988
O'Connor Susan & Rachel Thomson "Report on an Investigation into the Aboriginal Heritage of the Arthur Head Area, Fremantle," Fremantle City Council, Fremantle, 1984
Reece, R. & R. Pascoe *A Place of Consequence: A Pictorial History of Fremantle*, Fremantle Arts Centre Press, Fremantle, 1983
Seddon, G. *Sense of Place*, UWA Press, Nedlands, 1972
Tanre, Con *The Mechanical Eye: A Historical Guide to Australian Photography and Photographers*, The Macleay Museum, University of Sydney, Sydney, 1977
Tull, Malcolm "The Development of the Port of Fremantle, Australia's Western Gateway, 1903–1939" (unpublished Murdoch University thesis), 1985
Tull, Malcolm *A Community Enterprise: The History of the Port of Fremantle 1897–1997*, International Maritime Economic History Association, St Johns, Newfoundland, 1997
Twentieth Century Impressions of Western Australia, P.W.H. Thiel & Co., Perth 1901
Willis, Anne-Marie *Picturing Australia: A History of Photography*, Angus & Robertson, North Ryde, 1988
Zunini, Leopoldo, Royal Consul of Italy *Western Australia as It Is Today, 1906*, ed. R. Bosworth and M. Melia, UWA Press, Nedlands, 1977

Index

Aborigines, 66, 84, 138, 139
Acknowledgments, 4
Adamant, HMS, 221
Adelaide Steamship Company, 148, dust jacket
Adelaide Street, 134
Aerial photographs, 70, 137, 223
Albert's Hotel, 94
Alfred Road School, 131
Almanack, 12, 84, 183
Argus, The, 82, 99
Arthur Head, 24, 26, 28, 30, 32, 39, 70, 86, 90, 97–9, 208
Arthur's Head Battery, 28, 30, 208, 210
Asturias, 225
Auburn, G., 133
Australind, SS, 36, 37
Bairds, 175
Baker Bros., 201
Bannister Street, 103
Bartletto, front cover
Bateman, John, 109
Bateman picnic, 162
Bathers' Bay, 33
Baths, 97, 168
Bennett, Lt General Gordon, 219
Beste, Arnold, 52, 162
Blamey, T.A., 211
Briggs, Thomas, 62
"Blithewood," 52
Boat-building, 55, 86, 108, 146
Boat launch, 182
Boer War, 25, 206
Bolton & Sons, 200
Bottle, Nurse, 125
Boys' Reformatory Rottnest, 12
Branson, 127
Breckler Brothers, 172
Bridge Hotel, 191
Bridge, traffic, 58, 59, 60, 61
Brogan, William, 196
Brown family, 146
Brown's boatshed, 55
Brown, Alfred, 147
Brown, Jean, 11
Brown, Lillian, 142
Burchell, Reginald John, 213
Butler, James, 198
Cantonment Street, 144
Castle Hotel, 12, 87

Castlemaine Brewery, 57
Cattle, 59, 68, 198
Challenger, 76
Charlton, Alfred Osborne, 13
Child evacuees, 222
Child migrants, 225
Chopin & Gill, 62
Church of England, 89, 137
Church of England rectory, 144, 145
Cleopatra Hotel, 132, 133
Cliff Street, 121, 204
Clifton, Charles, 158
Clifton, Worsley, 184
Commissariat, 34, 80, 86, 98
Concert, 153
Congdon, D.K., 12
Convict Establishment, 91, 124, 125
Cook & Bayly, 205
Corner, Captain, 49
Coulter, Jack, 111
Courthouses, 26, 86, 97, 99
Crane, floating, 76
Customs Department, 128, 184
Cycling, 164
Daguerreotype, 10
Daily News, 45, 132, 140
Dalgety album, 68, 69
Dalgety's, 206
Davidson, George, 72
Divers, 41
Donkey engines, 2, 20
Dowson, Alisa, 4
Duchess, 56
Duffield, 62
Duke and Duchess of York, 216-217
Dunskey (tug), 54
East Fremantle Football Club, 153
East Fremantle tram, 130, 179
East Fremantle, 5, 55, 56, 57, 62, 64, 141, 144, 147, 167, 201, 207, 223
East Street, 5, 62
Emerald, 56
Encounter, HMS, 50
Esplanade, 123
Euryalus, HMS, 51
Evans, George, 204
Evans, Samuel Scriven, 12
Express newspaper (Perth), 12
Express newspaper (Fremantle), 85
Farrer, 152
Fay, Patrick Henry, 154

Ferries, cross-harbour, 72, 73
Ferry Point, 23
Ferryman, 73
First Light Cruiser Squadron, 214
Fish Markets, 193
Fishing fleet, 193
Fishing, 62, 193
Flood, Fred, 13, 77, 105, 126
Fogarty, Saxon, 14, 73, 75, 166, 169, 220, 221, 225
Football, 156
Forrest, John, 186
Fort Arthur's Head Battery, 28, 30, 208, 210
Fremantle Artillery, 210
Fremantle Boys' School, 211
Fremantle Harbour Trust, 21, 44
Fremantle Hospital, 81, 124
Fremantle Infantry Volunteer Band, 154, 155
Fremantle Literary Institute, 129
Fremantle Mail, 121, 123, 196
Fremantle Markets, 110, 196
Fremantle Orchestral Society, 153, 158
Fremantle Parade Ground, 210
Fremantle Oval, 164
Fremantle Park, 149
Fremantle Providoring, 195
Fremantle Railway Station, 128, 180, 181, 214
Fremantle Sea Baths, 168
Fremantle Today, 79
Fremantle Town Hall, 111, 117, 219
Fremantle Views, 139
Fremantle, map, 22, 23, 62, 80
George Street, 207
German Club, 142
German Consul, 142
Gold smelting, 186
Gore, S., 13, 144
Government Cottage, 24, 25, 26
Greek fishermen, 193
Greenham & Evans, 186
Grey Street, 146
Gunning, Revd Mr, 144
Harbour, 18, 19, 70, 77
Harbour building, 40–43
Harbour, map, 22
Harbour, model, 38
Harbour, shipping, 2, 9, 18-19, 25, 39, 46-47, 53, 54
Harbour Trust, 21, 44
Hardie, W.H., 136
Hairdresser, 205
Harris, Scarfe, 136
Harrison Studios, 196

Harvesters, 45
Harwood wedding, 160
Hearder, Dixon, 210
Henderson Street, 105
Henry Street, 8, 108, 109
Hicks, J.A., 114, 115, 116, 117, 173
High Street, 17, 18, 78, 94, 96, 97, 112, 113, 114, 115, 116, 117, 118, 119, 120, 136, 172, 173, 175
Higham, Mrs, 21
Highams store, 173
Hood, HMS, 21, 214, 215
Hooper, William, front flap, jacket
Hoover, Herbert, 204
Horse, 69, 162, 190
Hospital, Fremantle, 81, 124
Hospital silos, 75, 221
Hotels: Albert, 94; 190; Bridge, 191; Castle, 12, 87; Cleopatra, 132, 133; National, 113, 115, 120; P&O 175; Pier, 121; Richmond, 191
Hugall, 152
Hurley, Frank, 14, 77
Immigrants, 51, 225
Immigrants' Hostel, 150, 151
Immigration buildings, 53, 71
Infantry, 86th, 149
"Ivanhoe," 148, 149
Jenkins, Edna, 11
Jewell, Agnes, 188
Kangaroo, 197
Keane, George (photographer), 174
King's Square, 137
Knockagow, 167
Kodak, 10, 13
Kormoran, 218
Lacey's store, 207
Leach's Store, 94
Lead smelting, 186
Leake, James, 108
Leake Street, 194, 195, 201
"Lenaville," 18
Lighthouse (1st), 26, 27, 30, 31, 86
Lighthouse (2nd), 28, 29, 30, 31, 33
Lighthouse-keeper's residence, 29
Lilly, James, 148
Locomotive, 43, 180
London House, 172
Long Jetty, 35, 103
Lovegrove, 152
Lumpers' picnic, 169
Lunatic asylum, 85, 126, 127, 159
Lyons, John, front flap, jacket

Lyons, Netta, front flap, jacket
Lyons, William, 125
Mailboat, 53
Mandelstam, M & S, 116
Mandurah Road, 170, 190
Manning's Folly, 87, 95, 105, 174
Manning, Charles Alexander, 95
Manning daughter, 82
Manse, Wesleyan, 107
Manse, Congregational, 92
Manx ferry, 132
Maps, 22, 23, 62, 80
Marine Terrace, 146
Maritime Museum, 44
Market Street, 76, 100, 101, 103, 205
Mayhew, Edward, 140, 188, 189
Mayhew's warehouse, 136
McKenzie, K., 116
McLaren, F.J., 173
Mews family, 108
Mews, 152
Mews boatshed, 33
Mews, F.W., 108, 109
Migrants, 51, 217
Mills & Ware, 200
Minciullo, Ernie, 204
Mitchell, E.L., 211, 212, 214
Monument Hill, front cover
Moore, W.D., 141
Moreton Bay fig trees, 135, 137
Motor vehicle bodies, 180
Mouat Street, 204
Mulcahay girls, 167
Mulligan's providoring, 196
Mummery's chemists, 207
Mummery, Cynthia, 55, 207
Nairn Street, 122
National Hotel, 115, 120
Newman Street, 188, 189
Newton, Vic., 111
Nirimba, 9
Nixon, C.M., 12, 58, 59, 67, 112, 129, 142, 161
Nixon & Merrilees, 46, 47
Nobel's explosives, 204
Norfolk, SS, 49
North Fremantle, 5, 20, 23, 32, 43, 60, 62, 63, 70, 130, 131, 147, 164, 194, 220, 221, 223
North Quay, 2, 20, 22, 23, 43, 70, 72, 221
Oaklands Tea Rooms, 173
Obelisk Hill, front cover
Oblate Fathers, 140

Oceania Trading Exchange, 204
O'Connor, C.Y., 21
Old Women's Home, 159
Orizaba, 132, 133
Orloff, Izzy, 14, 136, 214
P&O Hotel, 175
P&O, 76, 128, 204
Pakenham Street, 185
Pamment, 152
Parer, Damien, 224
Parmelia, 40
Passey Collection, 12
Pearson, John Coulsen, 12
Pelican, 76
Pelican Confectionery, 188
Perth Girls' Orphanage, 148
Perth, SS, 7, 36
Pet shop, 197
Peterson, Frank, 13
Pharmaceutical Society, 188
Pier Hotel, 121
Pioneer Park, 100, 174
Plimsoll, Samuel, 47
Point Walter, 162, 163
Polgowan, SS, 21
Post office, 121, 109
Posts and Telegraphs, 185
Prawning, 167
Premier, 39
Presbytery, 93
Preston Point Road, 67
Princess May Girls' School group, 157
Prison, 91, 124, 125, 136
Prisoners of war, 218
Propeller, 48
Queen Street, 134, 135
Railway bridge, 55
Railway workshops, 100
Railways, 45, 180
Ratazzi, L., 142
Recreation Ground, 82, 83
Renown, HMS, 216-217
Residency, 24, 25, 26
Richardson, Frank, 209
Richmond, 57
Richmond Hotel, 191
River Jetty, 24, 128
"Riverview", 140
Robb's Jetty, 69
Rocky Bay, 42, 65
Rome, E.G., 12

Round House, 90, 99
Rous Head, 32
Rowing 152
Sacred Heart Girls' School, 140
Salt, transport of, 56
Samson family, 11
Samson, Michael, 168
Sandalwood oil, 188
Sandover, William, 140, 187, 188
Scots Church, 110
Second Rates Junior Football, 156
Sgro, Con, 204
Shark, 166
Shaw, F.E., 153
Sheepskin store, 206
Shenton, George, 26, 83, 180, 204
Short Jetty, 34, 103
Short Street, 100
Sicilian fishermen, 193
Sister Kate's, 164
Smelting works, 186
Smoke screeen trials, 223
Soap manufacture, 189
South Bay, 98, 193
South Beach, 165
South Quay, 46, 47
South Terrace, 102, 185, 196
Spanton, John, 218
Spicer's, 105, 137
St John's Church, 89, 137
Stirling, Edmund, 185
Stone, Alfred Hawes, 12, 83, 95
Stout, Stephen Montague,12, 66, 84–94
Submarines, 218, 220
Sumpton & Coy., 202-203
Sunday school group, 161
Sunshine harvesters, 45
Superphosphate, 52
Swan River, 2, 9, 20, 22–25, 38–41, 43, 46–48, 50–51, 53–59, 62 (map), 63–65, 67, 72–73, 75–77, 80 (map), 104, 152, 162–163, 166, 169, 194, 216–217, 221
Synagogue, 185
Taxis, 135
Telegram, 185
Telephone system, 187
Teredo navalis, 39
Thornett, Marjorie, 11
Tilleys, 5
Tolleys, 174
Town Hall, 111, 117, 119

Train, first, 180
Trains and Trams (section), 171
Tram (tickets), 171
Trams, 16, 78, 101, 130, 170–179
Tuckfield Street, 140
Tydeman, Frank, 26
Ulysses, SS, 21
United States Consul, 140
Vacuum Oil Company, 122
Venn, Harry, 186
Vere Scott, R., 18
Vic's Pictures, 111
Victoria Hall, 136
Victoria Quay, 39, 43–47, 54, 69, 169
Victoria Road, 191
Victoria Street, 131
"Villa Maria," 142, 143
Walker, Charles, 54
Warders' cottages, 110
Wedding, 160
Wesley Church, 106, 107
Wesley Hall, 106, 107

West Australian, 94, 180, 192, 220
West Australian Newspapers, 134
West Australian Turtle & Fish Preserving Co. Ltd, 192
Western Mail, 13, 192, 194–195, 214
Whalers' tunnel, 90, 99
Wharf construction, 1, 20, 39
Wharf, 75, 76
Wharfies (lumpers), 52, 70, 169
William Street, 105
Wilson, Edward, 11
Wollaston, Revd John, 89
Woodhouse, Surveyor General, 80
Woolstore, Northern, 144
Workshops, railway, 45
World War I, 211-213
World War II, 209, 218-224
Wright, Percy, 165
Yagan, 66
Yeldham Photographic Studio, 12
Zephyr ferry, 147, 216
Zunini, L., 62, 192

The *Western Mail* often framed their photographs with artistic embellishment, here using none other than May Gibbs for their 1906 Christmas issue.